T0362730

Naomi Arnold is a journalist and natural history writer. She writes about everything, but particularly loves working on stories about human connections with the natural world – whether through travel, adventure or science. She is a nine-time finalist or winner of New Zealand media awards, and is a regular contributor to *New Zealand Geographic* and *Heritage New Zealand* magazines. In 2014, she founded Featured.org, a library of great New Zealand true storytelling. Naomi has written extensively on science and the environment, including spending three months reporting from Antarctica.

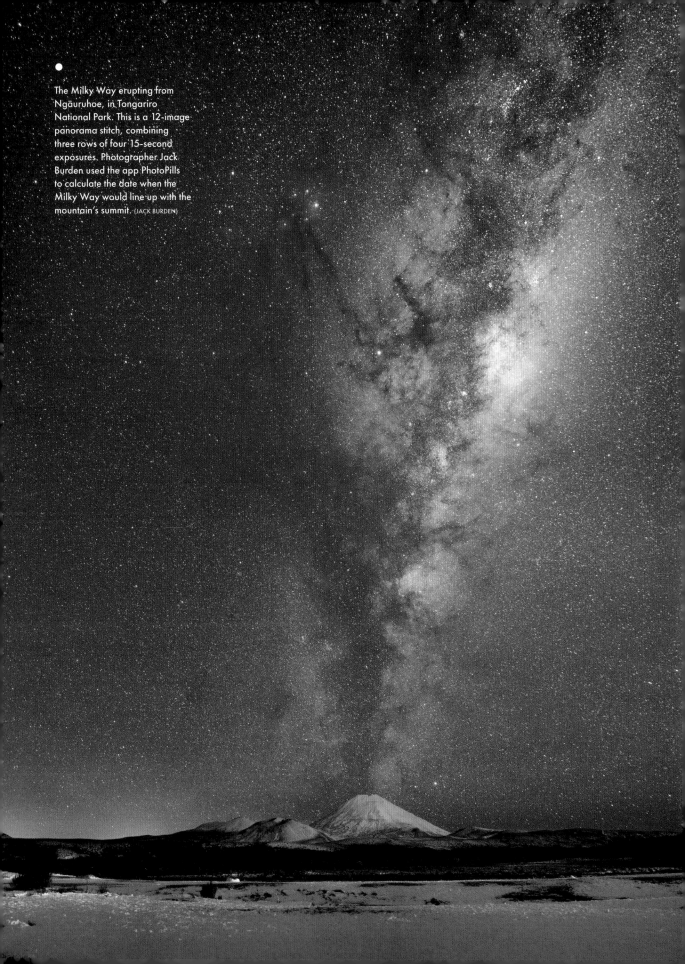

The Milky Way erupting from Ngāuruhoe, in Tongariro National Park. This is a 12-image panorama stitch, combining three rows of four 15-second exposures. Photographer Jack Burden used the app PhotoPills to calculate the date when the Milky Way would line up with the mountain's summit. (JACK BURDEN)

Southern Nights

The story of New Zealand's night sky
From the southern lights to the Milky Way

NAOMI ARNOLD

HarperCollins*Publishers*

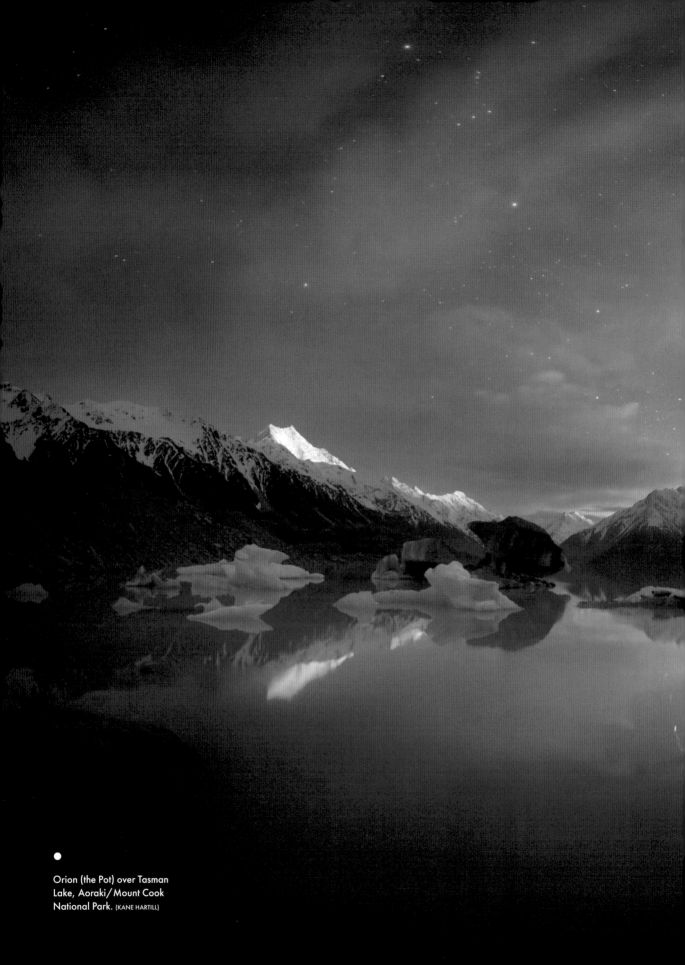

Orion (the Pot) over Tasman Lake, Aoraki/Mount Cook National Park. (KANE HARTILL)

For Alice, Nate and Greta

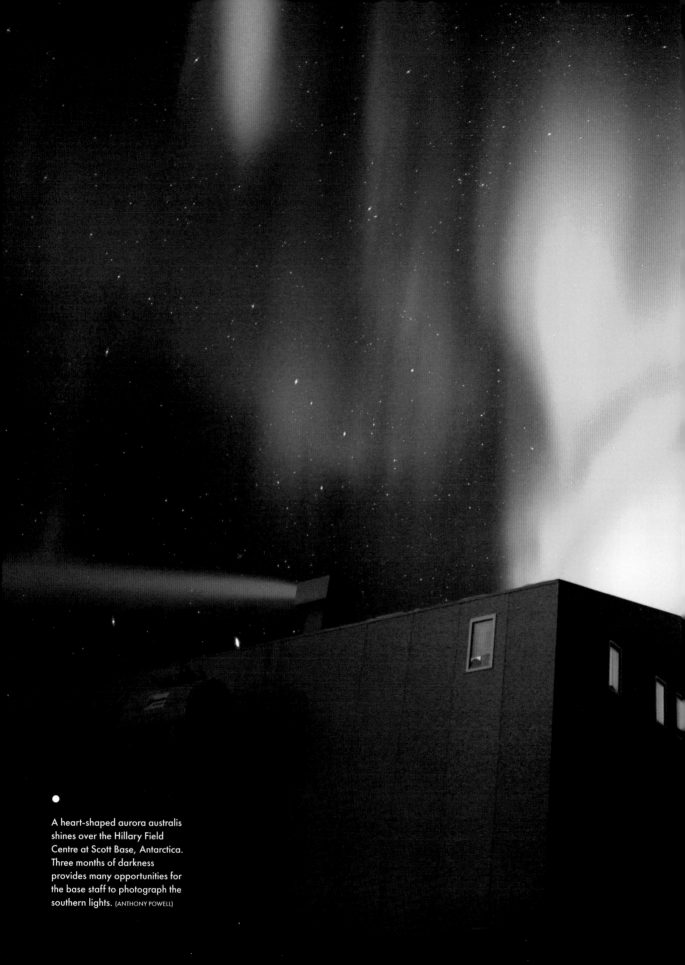

A heart-shaped aurora australis shines over the Hillary Field Centre at Scott Base, Antarctica. Three months of darkness provides many opportunities for the base staff to photograph the southern lights. (ANTHONY POWELL)

Contents

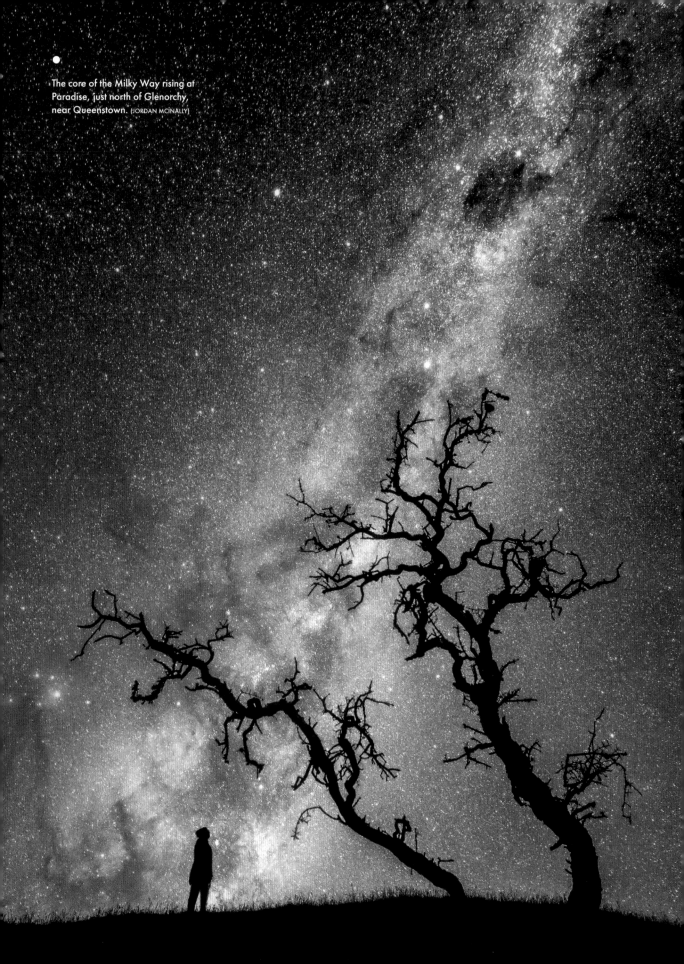

The core of the Milky Way rising at Paradise, just north of Glenorchy, near Queenstown. (JORDAN MCINALLY)

Introduction

**The more clearly we can focus our attention on
the wonders and realities of the universe about us,
the less taste we shall have for destruction.**

RACHEL CARSON

There aren't many countries in the world that you can say were founded on
stargazing, but it was stars that brought the first humans to New Zealand.
Polynesian people arrived on our shores using only the celestial bodies, the
wind, the birds and the currents, carrying with them centuries of knowledge about
the essential science of astronomy and how you could find your way by the lights in
the sky.

That was true for European settlers, too. When James Cook sailed south in August
1768 to observe the transit of Venus at Tahiti in June 1769, he carried with him
instructions for a secret mission: to move on, south and west, and find Terra Australis
Incognita, the great southern continent that Europeans thought must be there to
balance the land masses of the north. On reaching New Zealand, he found a night
sky that was richer and more interesting than that in the north, and home to some of
Earth's greatest celestial sights. The transit is thus a powerfully symbolic event in the
history of our country, the reason our Pākehā and Māori cultures met for the first time.

As technology has advanced in the intervening centuries, the stars have become
both closer to us and further away. Though we now know more about the universe,
we're less personally connected to it than humans have ever been before.

On a clear night, out on a valley floor or a country road, you might look up and be
stunned by the realisation you're surrounded by light, the glow of other worlds – light
that left its star thousands of years ago, and travelled quadrillions of kilometres to reach

your eye here on Earth, in this second, under this night. Stars that may in fact not be there any more – an uncertainty we won't be able to resolve for many more lifetimes.

I remember standing on our front lawn with my dad in suburban Te Puke, squinting my eyes to try to see into the night sky. It was early in 1986, and I was four years old. Being outside on the dark lawn in my pyjamas lent the night a solemn sense of occasion. I leaned back against my father's legs as he pointed out Halley's Comet.

I don't remember what it looked like. We probably didn't even see much at all – the comet of the 1980s was universally disappointing compared to the one that wowed the country in 1910. Paintings of that time show a broad, tapering white streak taking over the entire sky, whereas our 1986 comet was the least favourable appearance for 2000 years; at its brightest it was on the far side of the Sun. But what I do remember is how I felt when my father said if I was very lucky and lived until 2061 I would be nearly 80, and might get the chance to see this twice in my lifetime. For people like him, born in 1955, or my impossibly ancient grandfather, born in 1922, now was their only chance. I'm not sure how much of that I grasped at age four, but the feeling of awe remains.

That this light was moving so slowly we could see it for nights on end, but at the same time so fast it could zip around Earth several times in an hour; that it would go back out into space and continue its trajectory, returning at a time that could already be predicted; and that it was tied in this endless loop by the Sun: all were major flashes of wonder to me. It was the first of those rare moments when you step outside of yourself and feel your perspective zoom out, flooded with a dizzying sense of being a microscopic inhabitant of a pixel-sized planet hanging in space.

In the years since that moment on the lawn in Te Puke, Halley's Comet has left us and has been shooting through space. As I write this, it is in the distant reaches of our Solar System at the farthest loop of its orbit, crossing over the path of Neptune. In 2030, it will make its turn, slowing at the top of its orbit like a ball thrown into the air, and then 'fall' back towards the Sun, accelerating as it does so. When it reappears in Earth's sky in 2061, it will come between the Earth and Sun, an alignment favourable enough to make it a better sight than in the 1980s – and those of us who are lucky enough to make it that far will get to see it.

After Halley's Comet, other powerful experiences followed. When I was 23 and a student at the University of Otago, I went tramping up the Mackenzie Country's Huxley River, one of the waterways that drains into Lake Ohau. The tiny two-bunk South Huxley Bivvy was full, so we slept outside in the flat open clearing. There was snow on the tops and the night was cold. We made dinner and, as night fell, spread out

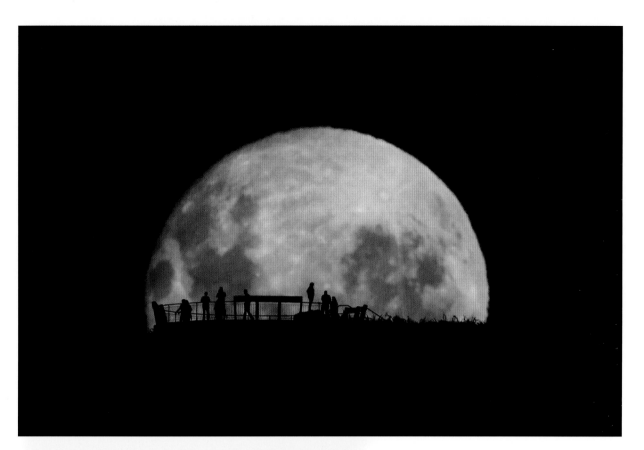

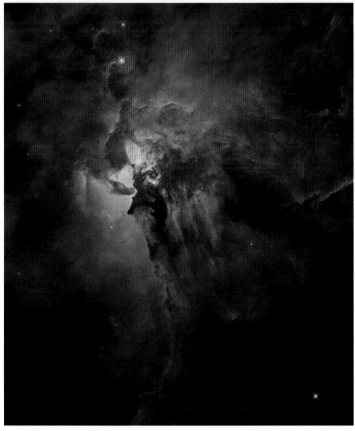

A full moon rises in front of Mount Victoria Lookout, in Wellington. This was shot from 2.1 kilometres away, and was one of the images that won its creator Astronomy Photographer of the Year in 2013. (MARK GEE)

The Lagoon Nebula, a stellar nursery in the constellation of Sagittarius, 4000 light years away. This image was taken by the Hubble Space Telescope; through binoculars, the nebula looks like a smudge of light with a bright core. (NASA, ESA, AND STSCI)

mats and lay down. As the blue of twilight faded to black, the world was overwhelmed with luminosity, the mountain peaks picked out in whitish light. Satellites moved steadily across the vault of the sky, shining with the reflected light of the Sun still drifting down below our horizon. There was the occasional burst of a shooting star, always on the very edge of my vision.

I didn't sleep much, but dozed on and off, waking stiff and chilled throughout the night. Each time I did, I saw that the stars had changed position, and I got that powerful sense that I was on a moving globe, the Earth rotating silently through the night towards dawn. It was a feeling of security and wonder, awe and peace – 'a consoling encounter of grandeur', as Alain de Botton wrote in *The Book of Life*. I felt myself, as he said, 'pleasantly diminished' in contemplation of forces stronger, more timeless and more mysterious than me and everything I knew or did.

Ten years later, on a trip to Uluru, I began to get a truer sense of the immensity that lay beyond my field of vision. After night fell, I went to a stargazing session, tagging along with a group of two dozen enthusiasts from a United States planetary club, some of whom had travelled down under to see the southern hemisphere sky for the first time in their lives. With little artificial light on any horizon, Uluru is one of the most impressive places in the world to stargaze. We shuffled through cooling red sand to meet our guide, Eddie, at a clearing spiked with telescopes.

The Americans had been anticipating this for months: finally, a glimpse of the other half of the sky. I had never looked through a telescope. But, when I saw first Jupiter and then Saturn boldly filling the eyepiece, my body stilled in shock. I could not stop staring, could not give up the view to the next person in line. The single white points of light had exploded into that famous red spot, the classic rings. A curtain lifted for me and the universe collapsed in on itself. Our neighbourhood planets were just within reach, beyond my feeble sight, and they'd been there all along.

Then I saw another crowd-pleaser: Omega Centauri, the biggest, brightest globular cluster in the Milky Way, a huge ball of stars older than our Sun that may actually hold the leftover core of a small galaxy which has merged with our own. Again, I looked at the pinpoint of light, and then into the telescope, seeing the dot burst into a city of stars. It was a magic trick; a profoundly blind-siding, unsettling moment, and I had the sensation that I was flying, looking down onto a city, with houses, cars and streetlights glowing as they ringed back from a bright white central core.

There were murmurs and quiet gasps from the Americans around me as they, too, saw things they had never seen before; and, as happens with strangers grouped together

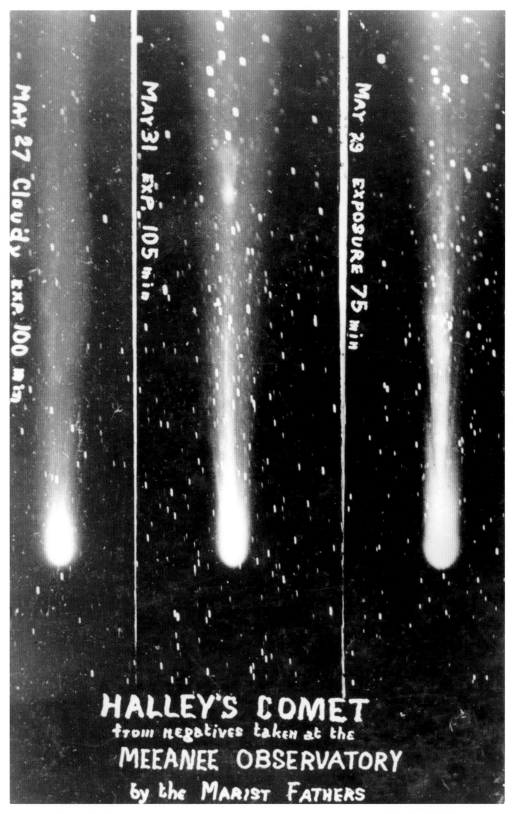

Some of the first photos of Halley's Comet, taken in 1910 at the observatory at St Mary's Scholasticate, Meeanee.

in the dark, an easy intimacy bloomed and we struck up small conversations as we stood, mouths open and heads dropped back, gazing up at the altar of the sky. Every star a little sun. In some cases, the light we saw was thrown out before the Aboriginal people who first walked those desert sands were there.

Most of us spend our lives wandering about, never paying much attention to the stars until we get out of the car on a country road or chance upon a particularly bright night. Every person who looks through a telescope or a pair of binoculars for the first time is like a new Galileo. Our world shifts, our horizons lengthen to include not just Earthly concerns but also the beginnings of the universe itself. The sense of magic I experienced on each of those nights has stayed with me, and it's what hooks many people on astronomy for good.

What's in this book?

Southern Nights explores astronomy in New Zealand, situating it within a global context where appropriate. It traces what is special about our southern skies, which have been explored only very recently compared to those in the northern hemisphere.

Since there is no single way to tell this story, the book brings together the scientific, social and cultural stories of astronomy in New Zealand, weaving three very different narratives together. This is because the stars, though relatively fixed and unchanging in our lifetimes, are actually many things at once to many people, personally, culturally and globally.

A good illustration of this is the Southern Cross, our familiar kite-shaped local constellation. One of the names Māori have for it is Māhutonga, and another is Te Taki-o-Autahi. For New Zealanders, who are always half-aware that they might one day be lost in the bush, it looms large as a way to find south when all other options fail. Most kids will have had it pointed out to them by an adult, or on a night walk at school camp. And it helped New Zealand become what it is today; as Polynesian settlers sailed south, it rose over the horizon and told them where they were on their mental compass. It is on our flag, an important symbol of our nationhood and sense of honour. When New Zealand soldiers sailed to fight in South Africa during the Boer War, they sang: 'We are the boys of the Southern Cross, our stars shine on our flags.' Today, the cross is engraved on the Tomb of the Unknown Warrior, the stars having guided the soldier – and others who lost their lives on distant battlefields – back home to New Zealand.

Astronomically speaking, the Southern Cross is Crux, the smallest of all 88 constellations but one of the brightest. In the city, it's made up of four or five bright stars; in the black night of the country, you might see 34. With a telescope, there are thousands. It holds the Jewel Box cluster and the Coalsack Nebula – both rewarding sights for new stargazers.

But, while it seems indelibly engraved on our collective memories, the Southern Cross hasn't always been ours. Thanks to a phenomenon known as precession, which sees the Earth wobble like a top over tens of thousands of years, it formerly belonged to the northern hemisphere skies. For those living in what is now Europe during the early Bronze Age, it was as familiar in their skies as it is in ours, and though it gradually disappeared below the horizon and was forgotten, it will return there one day.

Thus, the Southern Cross matters as 'ours' only to the humans who have lived in this part of the world for around 2000 years. These four bright points in the sky tell a vastly different story depending on who is looking at them (as well as where, when, and with what).

The first strand of this book tells of the importance of the stars to the people of New Zealand: the first Polynesian settlers, the evolving Māori culture, and the later colonists. There is also discussion of the twentieth-century revival of Polynesian celestial navigation and Māori tātai arorangi (general star knowledge) and kōkōrangi (astronomy).

The scientific strand looks at some astronomical work done here. New Zealand has always been significant, astronomically speaking, because of its position on the globe as a convenient place to mount a telescope in the landless expanse of the Southern Ocean. We are an important place from which to track the movement of stars and planets as the world turns. Much of this work is done observationally (by looking through telescopes) at the University of Canterbury's Mount John Observatory, which was founded in the 1960s. We have also branched into radio astronomy (studying celestial objects using radio frequencies). *Southern Nights* traces both of these disciplines, as well as the contributions of some outstanding amateur and professional astronomers and institutions. It tells the stories of the first tent observatories, and later government and city observatories, and their importance to early New Zealand life in such basic functions as pinpointing time and location.

As technology developed and the stars' early use as a calendar and time-telling device waned, telescopes became more widespread, and enthusiasts formed astronomical societies, which began to contribute to global knowledge of the stars. This

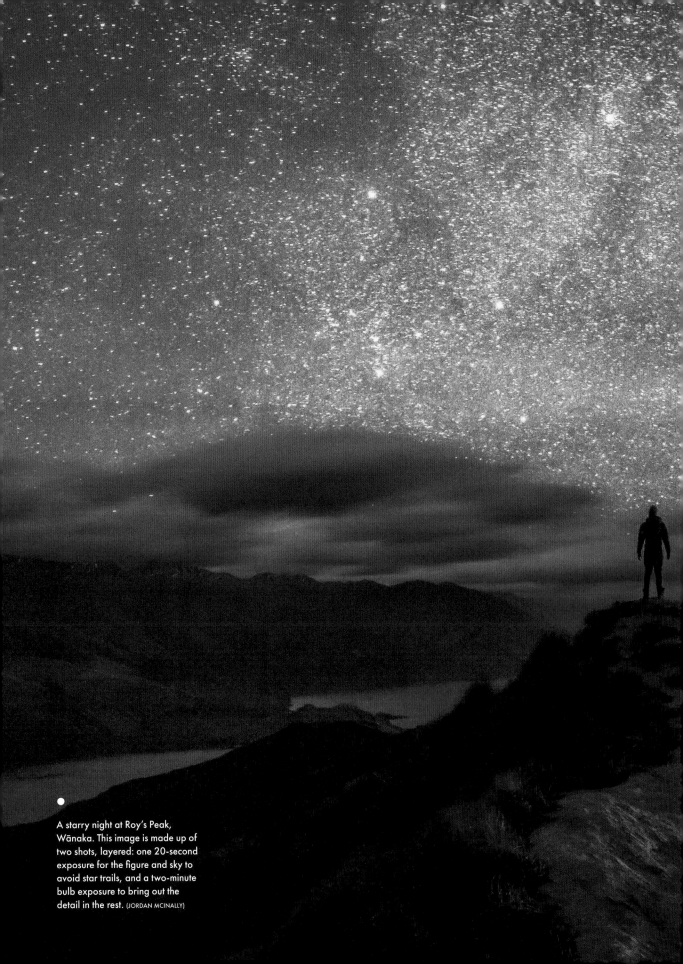

A starry night at Roy's Peak, Wānaka. This image is made up of two shots, layered: one 20-second exposure for the figure and sky to avoid star trails, and a two-minute bulb exposure to bring out the detail in the rest. (JORDAN MCINALLY)

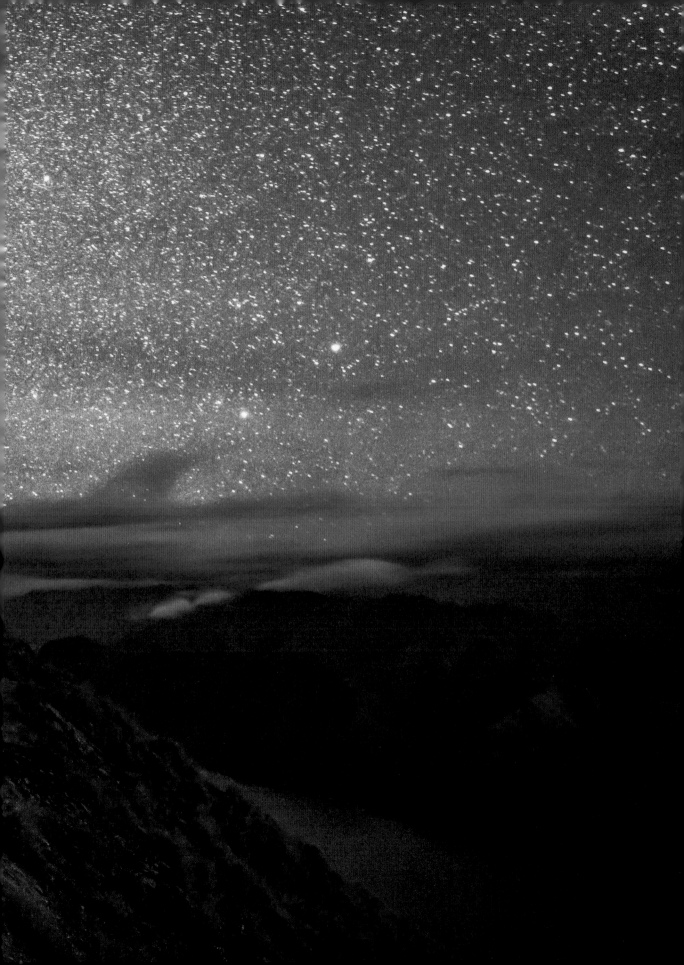

book briefly explores the history of astronomy and its importance to civilisation, along with major astronomical events of recent centuries and their impact on public life. As well as comets and meteors, these events include the transits that allow us to see Venus and Mercury outlined against the Sun for a brief moment in time, and thus help us to measure the universe.

The book also argues for dark-sky conservation as a way to preserve what is special about our night sky, which is rapidly becoming scarce around the world as light pollution increases. That's important because the night sky quite literally contains our ancestors, te whānau mārama (family of light). Māori knew, long before the European scientific world did, that we and everything in and of this world are made of the ashes of stars. Every element in the universe, right down to our fingernails, blood and eyelashes, was originally cooked in the nuclear centres of stars. Knowing that is part of understanding how we are connected to every natural element on Earth, and has important implications for how we see our responsibilities to our planet. Also, light pollution means we don't just lose the stars; it has a significant impact on human and animal health.

Southern Nights tells the story of New Zealand stars; what we see when we look up from our islands in the ocean at the bottom of our watery globe – the third one from the Sun, on an outer arm of the Milky Way, one of an unfathomable number of galaxies in the infinite universe.

We should pay attention. There is a huge treasure in the sky, a valuable store of cultural, scientific, historical and philosophical knowledge. It's only through a deep appreciation for this treasure that we can protect this endangered resource, and keep the traditions and science of our ancestors alive to enhance our existence today and into the future.

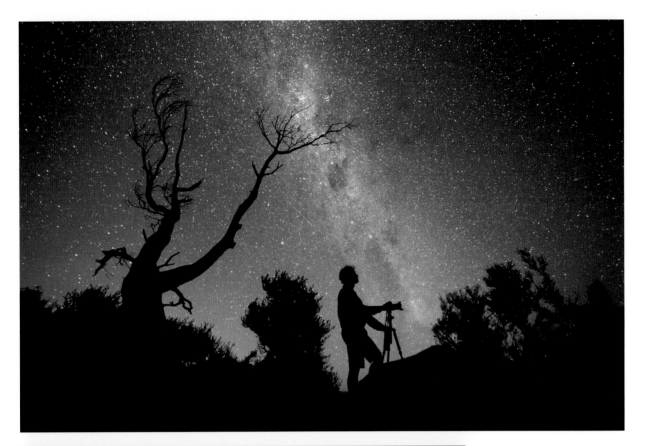

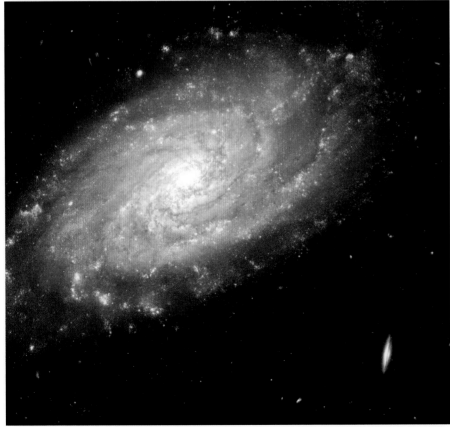

Photographer Richard Sidey shooting the night sky at Mou Waho, an island in Lake Wānaka. (ALISCIA YOUNG/GALAXIID)

A spiral galaxy around 98 million light years away, NGC 3370 is also known as the Silverado Galaxy. It is in the constellation Leo. (NASA, ESA, THE HUBBLE HERITAGE TEAM [STSCI/AURA], AND A. RIESS [STSCI])

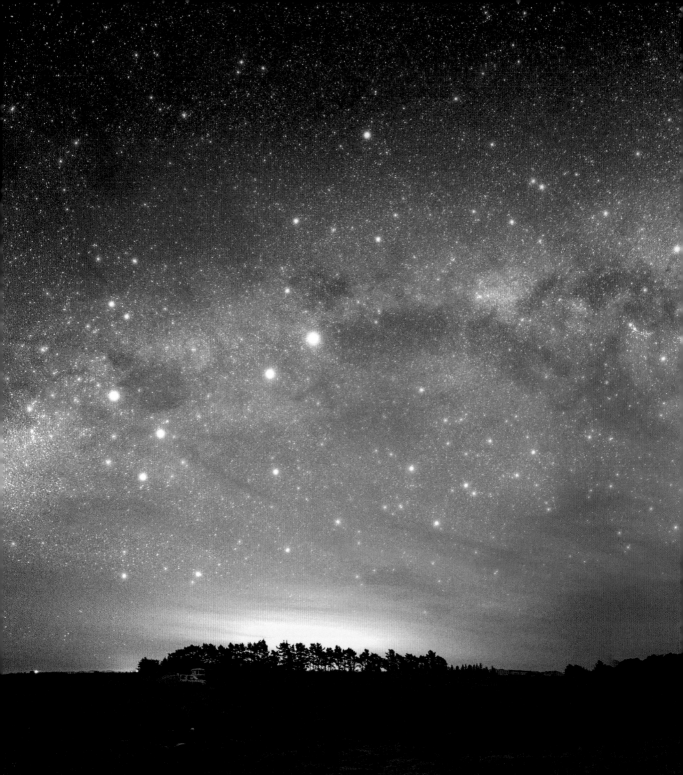

The Milky Way stretching from
the Kaikōura Ranges to the sea.
The Southern Cross and the
two Pointers are on the far left;
Scorpius is in the centre. (MARK GEE)

Understanding the Universe

CHAPTER 1

The oldest science

●

In the midst of all dwells the Sun. For what better place
could you find for the lamp in this exquisite temple,
where it can illuminate everything at the same time?

NICOLAUS COPERNICUS

●

The word 'astronomy' comes from a Greek term meaning 'star arranging'. Astronomy is the oldest of our natural sciences, having evolved over many millennia. Evidence shows neolithic and Bronze Age humans drew constellations upon the sky, used them to mark the passage of time, and associated the stars and planets and their movements with the gods. To understand New Zealand astronomy – to know where our constellations and star names came from, as well as our contribution to global study – it's useful to know how the scientific tradition of astronomy has developed over the centuries.

The story begins in ancient Egypt, Mesopotamia (now southern Iraq) and Greece, where the constellations that have passed into common Western use were first recorded. Each culture has its own, fitting into its way of life; China's sets of ancient constellations spread across Asia and are still in use today, differing wildly from the 88 modern constellations officially recognised by the International Astronomical Union.

Modern as they are, many of our official constellations bear the names of classical deities, animals, human-made objects (such as scales and a lyre), and heroes of legend.

Some can be traced back to Akkadian and Sumerian groups living in Mesopotamia during the thirty-fifth century BCE. The 12 signs of the zodiac, which are grouped around the ecliptic – the apparent path of the Sun and planets across the sky – also began to develop during this time. So, when you are gazing at Scorpius, Orion, Taurus or Leo, you're seeing patterns picked out by humans around the time tin was discovered, the Sahara Desert began to form and writing was invented – indeed, at the beginning of recorded history itself.

In an attempt to understand and predict the celestial motions, the Ancient Greeks created the first mathematical models of the universe, some of them quite advanced; in 1900, an archaeologist diving a shipwreck off the coast of the Greek island of Antikythera discovered a lump of bronze and wood that turned out to be an Ancient Greek clockwork computer. Known as the Antikythera mechanism, it is a little over two thousand years old, and was most likely designed to map the Sun and Moon, and predict eclipses by the movements of more than 30 bronze gears assembled within a wooden case. It also regulated the calendar and timed the Olympic Gamer.

But it was Claudius Ptolemy, a Roman-era scholar of Egypt, who in the second century CE put together his *Almagest*, a mathematical and astronomical treatise on the apparent motions of the stars and planets, with a list of 48 constellations and 1028 celestial objects. First printed in 1515, it has become the major source of information on Greek astronomy. Notably, it omitted some of our southern hemisphere constellations.

Ptolemy's work also involved creating a geocentric model of the universe: that is, one putting Earth at the centre of it all, with the planets and Sun spinning around us. The idea stayed in place for 15 centuries. Though this was the most sophisticated model to date, it required complicated orbital contortions – circles inside orbits inside spheres – and Polish astronomer Nicolaus Copernicus offered a simpler explanation: the Sun was the centre of it all. He challenged Ptolemy's ideas in *De Revolutionibus Orbium Coelestium* (*Six Books on the Revolutions of the Heavenly Spheres*), written in 1514. But he hesitated to publish it until three decades later, and only saw the final printed pages when lying on his deathbed after a stroke – he died later that same day.

It wasn't the first time the heliocentric (Sun-centred) model had been proposed: Aristarchus of Samos, who lived several hundred years before Ptolemy, outlined the same understanding of the heavens, but his work was rejected in favour of Ptolemy's. Astronomers in the medieval Islamic world also rejected it. When Copernicus revived the idea, it was debated for the next hundred years.

In the seventeenth century, German astronomer and mathematician Johannes Kepler wrote a set of laws (around the paths, areas and periods of planetary orbits) that advanced our understanding of planetary motion. Astronomy took another leap forward when Galileo, a supporter of Copernicus, looked through his 'optick tube' in 1609. He wasn't the first to use a telescope – the previous year, a German-Dutch spectacles maker named Hans Lippershey had applied for a patent registering a device to make far things seem near (his request was denied; the government thought the concept was too simple to be kept a secret). But Galileo realised what it could mean for stargazing, and modified the idea until he had built 'an instrument so excellent as to show things almost a thousand times larger, and above thirty times nearer than to the naked eye'.

Galileo was astonished by what he saw through the new device. The pock-marked Moon had hills and valleys, the Sun had spots, and Jupiter had moons. With the scope, he added 80 more stars to the constellation of Orion, and learned that the God-created universe wasn't perfect, Earth wasn't unique, and there was much more out there than what we could see.

Galileo's observations were such a threat to the established Catholic world view that he was arrested for illegally teaching that Earth moved. Forced to renounce his work, he was convicted and banned from publishing any more scientific discoveries, and placed on house arrest for the rest of his life. He was lucky to avoid being stripped naked, tied to a stake and burned alive – the fate that had befallen his fellow Copernican, philosopher Giordano Bruno, in 1600.

In the late seventeenth century, Isaac Newton developed his universal law of gravitation, which also helped explain Kepler's laws, the shape of Earth, and precession (the way Earth changes its tilt approximately every 25,772 years, so that some stars 'moved' from the northern hemisphere to the southern, with the poles pointing to different stars).[1] It also explained variances in the motion of the planets, which showed that another planet, Neptune, existed long before it could be seen with telescopes.

Despite all this, the dominant view of the universe was still that it had no beginning and no end, staying the same forever. It was thought that everything in the dark sky was part of our neighbourhood – inside our Milky Way – and that there were no other galaxies. Stars were thought to be immutable and static.

By 1901, that began to change. Electromagnetic radiation from stars demonstrated that they weren't all the same. Working independently, Ejnar Hertzsprung of Denmark

and American Henry Norris Russell discovered that stars had a life cycle and their luminosity was related to their surface temperature, which could be identified by colour. A diagram combining their work, called the Hertzsprung-Russell diagram or HRD, first appeared in 1911 and would lead to future studies into stellar evolution.

An expanding universe

In 1920, it was proposed that the Milky Way was 'an island universe'.[2] But proof of the spiral structure took much longer, as beliefs about the origin of the universe slowly evolved over the ensuing decades. In 1917, Einstein had released his general theory of relativity, using it to support the idea of a static, unchanging universe. (He was later to admit he was wrong, and New Zealand cosmologist Beatrice Hill Tinsley, among others, would use his theory to argue the opposite: that the universe was constantly evolving.)

The 1920s brought evidence that not only were stars not all the same, but they also changed over time. Scientists began to believe there was structure to the universe, and that there were indeed more galaxies outside our own. The International Astronomical Union, then brand-new, adopted official constellation boundaries.

In 1922, Russian physicist Alexander Friedmann solved Einstein's general relativity equations that predicted the universe was expanding. In 1924, American astronomer Edwin Hubble revealed that the Milky Way wasn't alone in the universe. He announced that Andromeda, thought to be a spiral nebula, was actually a galaxy – and that the Milky Way was just one of many galaxies, expanding our entire perception of the universe.

Then, in 1929, Hubble corroborated Friedmann's findings by demonstrating that galaxies were moving away from us, and that the most distant galaxies appeared to be moving the fastest. Scientists were beginning to think the universe had one explosive beginning.

It was a Belgian Catholic priest, Georges-Henri Lemaître, who famously suggested in 1927 that an expansion of matter created the universe, complementing the Bible's account of a single moment of creation. In his 'hypothesis of the primeval atom', he described the initial state of the universe as a 'Cosmic Egg'. He used Hubble's theory to support his idea: if the galaxies were moving away, what were they moving away from? It was a simple enough idea to run the tape backwards and come up with a single point of origin for all matter in the universe.

In the late 1940s, British astronomer Fred Hoyle pejoratively dubbed the idea the 'Big Bang theory', and by the 1960s it had stuck fast, to Hoyle's disgruntlement. He had disagreed with it, preferring the more mathematically satisfying Steady State theory (in which an expanding and infinite universe remains unchanged over time due to the continual creation of new matter). The competing ideas split cosmologists into two camps of ongoing debate until 1965, when astronomers detected an afterglow of radiation that could only be explained by the Big Bang.

In the wake of this new evidence, it was lights out for Steady State, leading some scientists to mourn. As astronomer and science writer Heather Couper would recall, her Oxford colleague Dennis Sciama lamented, 'I cried that day. It was such a beautiful theory.'[3]

By the late 1960s the Big Bang theory had caught on in scientific literature. An expanding universe that can be traced back in time to a single extremely hot, extremely dense point of origin remains the leading explanation for the beginnings of the universe.

Recently, we've learned that on a universal scale, our Solar System is a bit of an anomaly. Scientists used to think that ours was a template for other systems – smaller, rocky planets closer to our big star, with larger, gaseous bodies further out, and planetary orbits that are roughly circular or elliptical. But after studying several thousand exoplanets (extra-solar planets, i.e. those outside our Solar System), they believe it matches nothing else we can find.

However, in 2015, three planets were discovered orbiting TRAPPIST-1, a tiny star 39 light years (or 232 trillion miles) from Earth. This was huge astronomical news – and in 2017 it was revealed there were in fact seven planets in total.

We know more about this system than any other outside our own. The planets are mostly made of rock and are all the same size and mass as Earth, but would fit into one-sixth of the distance between our Sun and Mercury – so if you were to stand on one, you'd see the six others looming massively in the sky. With three of the planets in the 'Goldilocks' habitable zone (not too hot, not too cold) in their orbit around TRAPPIST-1, research is continuing to understand the composition of their atmospheres and whether they could support life.

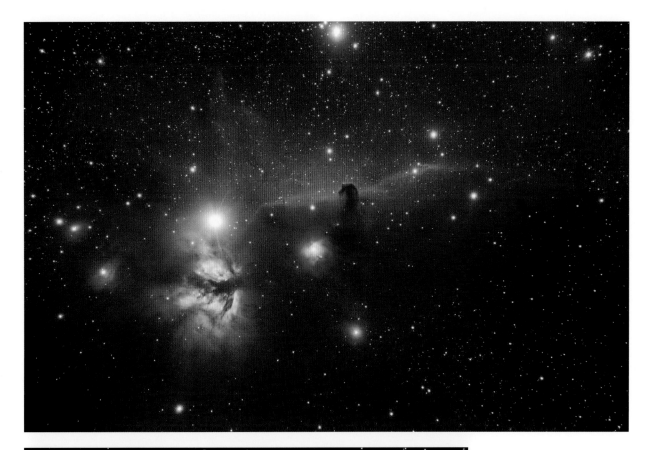

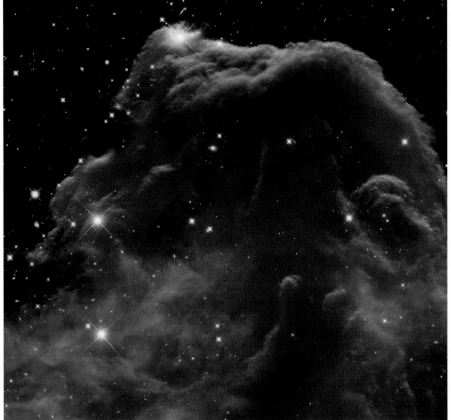

The distinctive Horsehead Nebula, located in a star-forming complex in the constellation of Orion, is a favourite shot for astrophotographers. (FRASER GUNN)

The Horsehead Nebula as seen by the Hubble Space Telescope. Shadowy in optical light, it appears transparent and ethereal when viewed, as here, at infrared wavelengths. It will disintegrate in about 5 million years. (NASA)

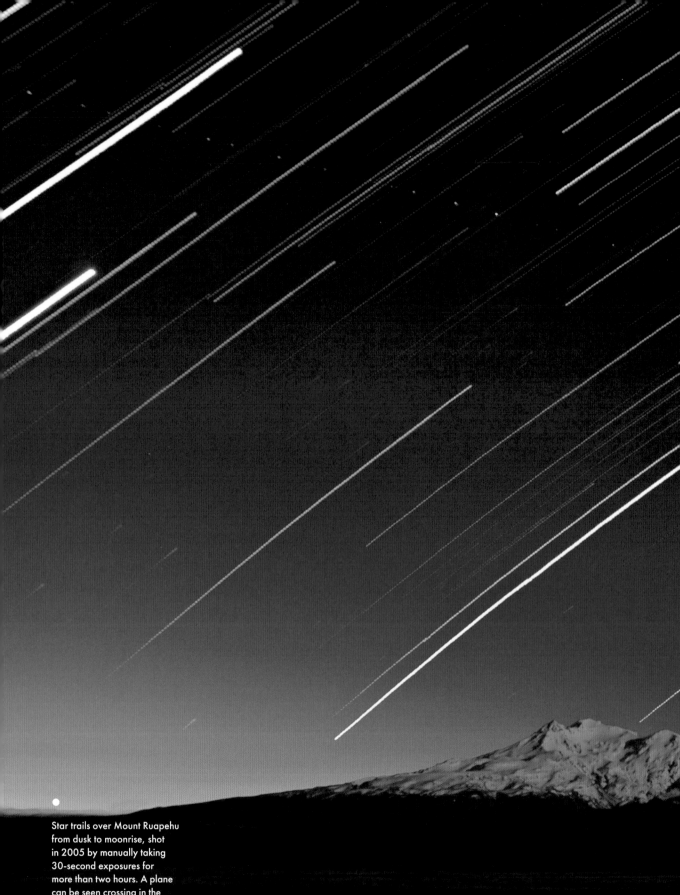

Star trails over Mount Ruapehu from dusk to moonrise, shot in 2005 by manually taking 30-second exposures for more than two hours. A plane can be seen crossing in the background. (STEPHEN VOSS)

Patterns in the night sky

●

Space is so vast that even though Earth is whipping around its orbit at the incredible pace of 30 kilometres a second – much faster than a speeding bullet, which travels at a paltry 760 metres a second – it still takes a year for us to get all the way around our Sun.

But the Sun is also held in an orbit – one much more massive. The star, along with its collection of planets, is orbiting the Milky Way, making one loop every 250 million years. It's held in this orbit because of the gravity exerted by dense old stars at the galaxy's centre, not to mention the supermassive black hole thought to be in the middle of our Milky Way. This is why the galaxy's arms are all twisted – the black hole's incredible force is slowly drawing in all the suns, planets and other debris, like water swirling down a plughole. Eventually the arms will spin together and coalesce, and the whole will become more blob-like, which is characteristic of older galaxies. In younger galaxies like ours, you can still see these spiral arms.

Our galaxy is shaped rather like a fried egg. It's about 100,000 light years in diameter, but it's relatively flat – only about 1000 light years thick. (One light year is the distance light travels in a year: 9.6 trillion kilometres. In the vacuum of space, light moves at approximately 300,000 kilometres a second.) We live on one of the Milky Way's outer arms, about 26,000 light years from the centre. Our Solar System is what's left after billions of years' worth of debris collisions, with large planets such as Jupiter acting as a kind of vacuum and hoovering up loose material via collisions. These collisions in our young Solar System slowly became less frequent as less material was available. Simply put, matter is attracted to matter, and gravity will tend to draw matter together in lumps, which eventually become dust, then planetesimal, then protoplanets, then

planets. The resultant near-circular orbits of our eight home planets[1] around the Sun have survived because they are simply the ones that were the most stable. The inner planets migrated inwards, and the other planets were thrown outwards as a result of their gravitational interactions with Jupiter and Saturn.

So, when we look up into the southern sky on a winter night and see the dappled band of the Milky Way stretching across the sky, we are gazing edge-wise through our disc-like, spiral-shaped galaxy. All the naked-eye stars we can see are in the Milky Way, apart from those in our neighbouring galaxy Andromeda – into which we will collide in approximately 4.5 billion years – and the other two visible dwarf galaxies, the Large and Small Magellanic Clouds (though we can't see individual stars in these unaided). We can, however, see the combined light of billions of stars that are outside our galaxy.

On a clear, dark night, along with the white blush of stars and individual pinpricks of light, you can also see dark, purplish patches or holes in the Milky Way. These are masses of dust, gas and debris that are blocking our view of the stars behind them, and these are the materials that give rise to new stars.

The stars in 3D

Inventing a pattern of constellations in the sky is an illusion, a way for us down on Earth to recognise and use what we see. It ignores the depth and distance in the universe, and whether, or how, each element interacts. The stars in a constellation do not necessarily have any physical link to each other outside of how they appear from our line of sight. Stars may appear to be neighbours from our viewpoint, but be very far apart from each other in three-dimensional space.

The exception is stars in an open or globular cluster. An open cluster, such as Pleiades/Matariki, contains a few hundred stars spread out, usually about 30 light years apart. A globular cluster such as Messier 13 (M13) is quite different; it's a tight ball of hundreds of thousands of very old stars. These are still loosely gravitationally bound, and the typical distance between stars in a globular cluster is about one light year.

But, to our naked eye, most of the stars we think of as constellations look as though they're on a curved plane: speckles on a thin, dark bowl dropped over our globe. Imagining Earth as the core of an onion, with the stars of a constellation dotted on different concentric layers, is a helpful way to visualise them in the depth of space.

From our perspective, the stars and constellations are fixed in their orbits in relation to each other, the entire sphere turning nightly around the south celestial pole. The

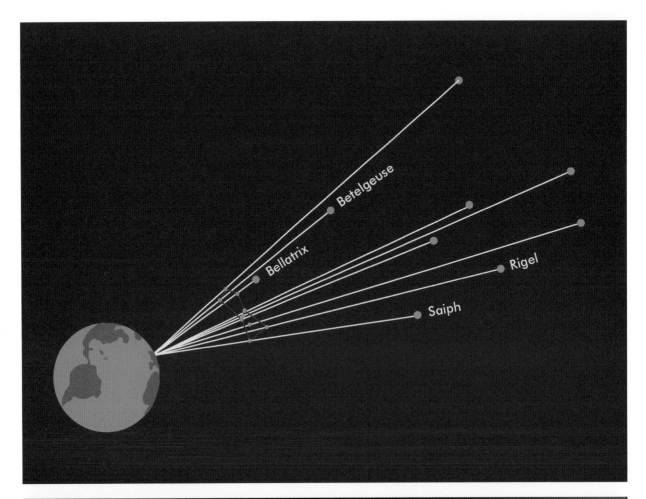

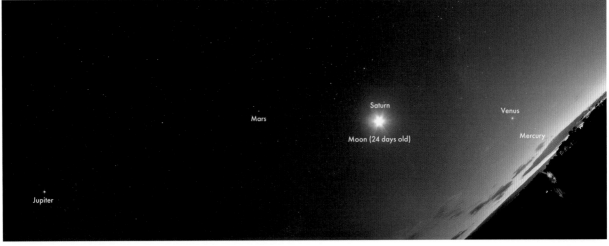

Top This diagram shows the constellation of Orion as seen in three-dimensional space. Though it appears as a flat plane to us, the stars that make it up are unrelated and very far apart.

Above Jupiter, Mars, Saturn, the Moon, Venus and Mercury aligning across the ecliptic. (JOHN DRUMMOND)

planets, the Sun and the Moon, however, travel along the aforementioned ecliptic. They move in and out of the 12 constellations of the zodiac, which are arranged along the ecliptic in a big loop around our planet, each believed to take up 30 degrees of sky: Aries, Taurus, Gemini, Cancer, Leo, Virgo, Libra, Scorpio, Sagittarius, Capricorn, Aquarius and Pisces. This is what is meant by astrological deductions such as 'Jupiter is in Scorpio'. (If you follow your horoscope, bear in mind that it's still based on star positions set by the Ancient Greeks, and that, because of precession, modern horoscopic dates are about a month out of sync with the arrangement of bodies in the sky. So astrology is not merely pseudoscience – it is also based on inaccurate science.)

And what are stars, anyway? When we look into the sky, we call all of those points of light 'stars', but they are in fact many different celestial bodies. Some are planets. Some single points of light are two stars – or a million.

A star is a faraway sun, a nuclear explosion both induced and held together by gravity. Stars are masses of gas that generate and emit heat *and* light; the planets that orbit them generate heat, but not light. Made up of gas or pieces of debris from the star's beginnings and descendants of the sun that created them, planets are mirrors, which shine by reflecting light. Usually, stars twinkle due to atmospheric disturbance, whereas our planetary neighbours bounce back a steady glow.

On certain nights, you can see some of the brightest planets in our Solar System at once as they rise up in a line from the eastern horizon. Spotting them offers a momentary departure from your Earth-based daily life and the vertiginous sense that you're a speck on a planet held in orbit around the Sun, looking out from your home planet at your neighbours in the Solar System. Alignments of our five brightest planets are fairly rare, lasting for a few days to a week until the planets reshuffle. At such times, if you locate Mercury just before the Sun sets, you can see Mars, Venus, Jupiter, Saturn and Mercury stretched out in a line across the ecliptic of our Solar System. Using a pair of binoculars or a telescope, you should be able to capture Uranus and Neptune, too. This happened in July 2018 in the southern hemisphere, when Mars was the closest it had been in 15 years, delighting stargazers.

Every day, Earth turns once upon its axis, and also travels further along its yearly path around the Sun. Because it takes about 365 days to make the round trip, Earth moves about one degree in its orbit each day. As it does so, the stars appear to move across the sky, from east to west, at a rate of 15 degrees an hour, seeming to circle the south celestial pole. To us, the stars look as though they are rising and setting a little earlier each day – four minutes, in fact – on their slow rotation to the west. As the year

This image, 'Mystic Mountain', was released to celebrate the Hubble Space Telescope's twentieth anniversary. It's a composite image of a stellar nursery in the Carina Nebula. (NASA, ESA, AND M. LIVIO AND THE HUBBLE TWENTIETH-ANNIVERSARY TEAM [STSCI])

progresses, a star or constellation comes out earlier and earlier in the night until it emerges just as the Sun is setting, disappearing into dusk and from our view as the world turns, under blue daytime. A month later, a star will begin to shine in the east just as the Sun is rising, and then slowly become brighter earlier, as the cycle continues.

Brighter stars aren't necessarily closer, larger or more luminous. Star brightness – not how much light it gives out, but how bright it looks to someone on Earth – is measured on a logarithmic scale called apparent magnitude where the lower number is brighter. The brightest object in our sky, the Sun, is magnitude −27. The Moon is −13. Sirius, the brightest star, is −1.46. On a clear night, it is possible for us to see stars of a magnitude 6.5, the faintest naked-eye star, without binoculars or a telescope. That gives us around 10,000 stars in both hemispheres that we can see without help, and 5000 in our own, out of a possibly infinite number in the universe. The rest of them look like dust, or floating clouds crossing the night sky. On a dark night in the country, it seems like there are a lot of stars up there, but in fact stars only make up about 0.5 per cent of the universe – the remaining 95 per cent is mostly still a tantalising mystery.

How big is space?

The mental gymnastics involved in picturing the immensity of space, what it contains, and how it began can be challenging even for astronomers. As noted earlier, a light year is the distance light travels in a single year – 9.6 trillion kilometres – and light moves at approximately 300,000 kilometres a second. Nothing else moves as fast. That means light reflected from the Moon reaches us in about a second; light direct from the Sun arrives, on average, in eight minutes and 20 seconds, depending on the time of year.

This is a useful way to begin to grasp the sheer magnitude of space – knowing that if you could travel at the speed of light you'd circle Earth in 0.13 seconds, travel to the Moon in one second, and reach the Sun in eight minutes. It also means that when you are looking at the Sun you are looking into the past, seeing life as it was eight minutes ago. Thus, we're not seeing the universe as it is now, but how it was. The deeper we look into space, the further back in time we go; current estimates put the age of the universe at 13.8 billion years. Our nearest galaxy is 2.5 million light years away, and so we see it as it was then. That's how long its light has taken to reach us.

Space is big, and that's a problem for us in trying to visualise it, to get it all in our head at once so we can mentally twist and turn, zoom in and out to gain a working understanding. We need to use several different human-sized scales at once to make

sense of it. Though most New Zealanders will probably have a memory of their primary-school teachers making approximations on the rugby field with basketballs, tennis balls and golf balls, there is no single scale that allows us to physically see the relative sizes of the planets and the distances between them, to conceptually grasp the immensity of the Solar System all at once. The Solar System shrunk down to a 100-metre field would make the Sun the size of a Giant Jaffa, and Earth just 0.2 millimetres across – about twice the diameter of a human hair.

As an approximation, say you were to lay out the Solar System from Pluto to the Sun on 88-kilometre-long Ninety Mile Beach, and decided to run between all the planets. You'd start by standing at the Sun, which, by the way, would be a massive ball around 21 metres in diameter – the height of a seven-storey building.[2] You'd run 862 metres to reach Mercury, which would be about the size of a cricket ball. You'd then jog another 746 metres to get to Venus, which, at 18 centimetres, would be the diameter of a large cake tin. Earth, a little bigger, would be two kilometres away from your starting point, Mars more than three kilometres away.

After Mars, your run would start to get a little tiring. It would be 12 kilometres from the Sun to Jupiter, which would be about the size of a smallish Zorb. After a half-marathon from the Sun, you'd reached Saturn (nearly two metres wide). A full marathon from the Sun would take you to Uranus, which would be the size of a Swiss ball. Neptune, your final stop before Pluto, would also be the size of a Swiss ball, but it would be 67 kilometres away from the Sun. At the end of Ninety Mile Beach, having completed your 88-kilometre run, you'd reach Pluto and collapse in relief at the sight of the dwarf planet, if you could see it – it would be only three centimetres wide.

To conceptualise how our home Solar System compares to the stars, we have to switch to a different scale, leaving Ninety Mile Beach and going to Auckland to make the Sky Tower the centre of our universe. But it's a lot harder to see. Put a table tennis ball in the tower's foyer – that's the Sun. Earth, then, is a speck of dust on the floor four metres away, and Jupiter is a tiny plastic bead 18 metres down Federal Street.

This scale is so small because we have to shrink Pluto's orbit down to 170 metres to fit our nearest star system into New Zealand territory. And it only just fits: on this scale, the Alpha Centauri system is about 1200 kilometres away; three small balls washed up on the high-tide line in Toetoes Bay, a long, empty beach on the Southland coast, bordering Foveaux Strait. Imagine standing in Auckland and being able to see those balls glowing from so far away. Not forgetting, of course, that their light left more than four years ago.

So space really is enormous. It's lonely out there, and thinking about it can be overwhelming. But it's also close. As British astronomer Sir Fred Hoyle once famously pointed out, if you could drive upwards at 60 miles (96 kilometres) per hour, you'd be there in an hour or so. It's only expensive to visit because we have to dump the vehicle every time we travel, and it requires a huge amount of energy to overcome gravity. With Elon Musk's SpaceX demonstrating the success of the reusable booster rocket in February 2018, and Dawn Aerospace developing the first ever reusable space plane, which is set to take flight in 2020, we are on the brink of seeing the broad industrialisation of space travel. And in twenty or fifty or a hundred years, when we might find ourselves streaking through Earth's atmosphere on a passenger rocket, we'll essentially be going home. We are descendants of the universe; as University of Auckland astrophysicist Dr J.J. Eldridge puts it, the whole of humanity is simply 'radioactive stellar waste'.[3]

Guiding lights

●

The night sky was [once] of more immediate concern than it is to the modern city-dweller. It was a newspaper, at once mysterious and dependable, filled with terrifying predictions, larger-than-life characters and unexpected events, yet presenting itself daily in fixed and familiar patterns, as if to reaffirm the permanence of things. It was a calendar, confirming the seasons for planting and certifying the annual renewal of life after winter, and it was a comic book, full of stories of adventure and intrigue.

GRAHAM BLOW AND STAN WALKER, *AN ENCOUNTER WITH HALLEY'S COMET, 1985–86*

●

Astronomy was for so long so embedded in human history that it seems extraordinary that many of us today have largely lost touch with it. For our ancestors, astronomy not only mapped time, but also offered predictions for the future, as well as explanations of past events. Some of these predictions were based on reality, such as when a constellation's movements correlated with our seasons, while others were early forms of astrology, ascribing Earthly events to celestial influence.

Stars, planets, the Moon and constellations were used to predict seasonal changes in food sources and the environment, and for navigation and travel. For those sailing the oceans, walking the deserts, or dependent upon the weather and seasons for their food, astronomy wasn't idle night-time chat about patterns in the sky as you digested your evening meal. Nor was it a fun hobby, as it is for many of us today. It was a matter of survival. The sky was life and death, progenitor and ancestor, holder of secrets and portents, as much a part of Earth as the soil, rivers and animals. We mapped and drew in the sky to remind ourselves of important events on Earth and to help us make sense of a sometimes terrifying world.

If you lived on a capricious river, you needed to know what time of year the rains came, to prepare for the threat of floods and the fertility that followed – that's how the constellation Aquarius, the pouring water jug, acquired its name. If you were a farming society, you needed to know how the seasonal patterns of the night sky predicted the coming of frosts, rain, drought and insect infestations. If you lived with the threat of dangerous animals, the rise of a star in the dawn sky heralded their seasonal hibernation or mating patterns. If you were a mariner, your star compass reflected the wide horizons of the ocean and the locations of nearby islands.

To this day, every major religion in the world has festivals around the equinoxes and the solstices, the four turning points that mark the seasons. They were signalled by regular changes in the night sky, and could easily be identified using a stone circle as a compass to create marks on the horizon. Many astronomy writers pinpoint this relationship between the star-calendar and the seasons, and the idea that the stars had some impact on what happened on Earth, as the beginning of religion and astrology. 'In antiquity, I wouldn't even distinguish between astronomy and astrology,' American archaeoastronomer Ed Krupp says.[1] Scientists today might scoff at astrology, but religion and science weren't separate and often-competing principles until quite recently.

Indeed, in continuous civilisations such as Japan and China, astronomical patterns and events were observed and recorded in a way that we would today recognise as science, but interpreted in a way that we would call religion or astrology. These records are still used for modern research, and without them we wouldn't have as much insight into how early cultures gained meaning and developed their religions. For instance, a comet was often a sure sign of destruction – or a sign to make a political or personal move. The stars not only 'predicted' coincidental events – deaths of kings and chiefs, illness – but they also 'caused' them, by humans acting upon what they read in the sky.

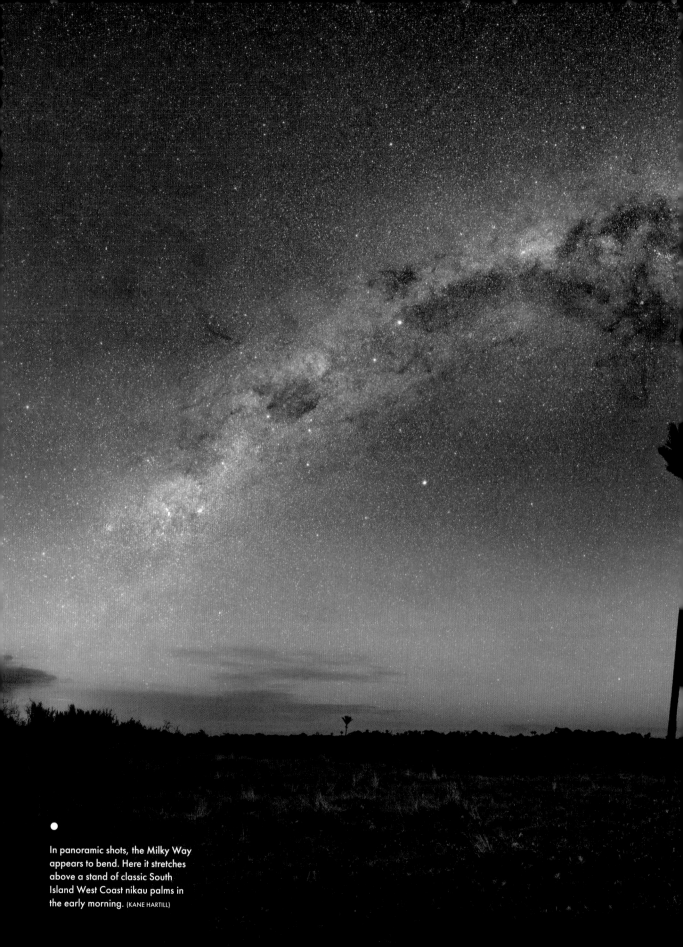

In panoramic shots, the Milky Way appears to bend. Here it stretches above a stand of classic South Island West Coast nikau palms in the early morning. (KANE HARTILL)

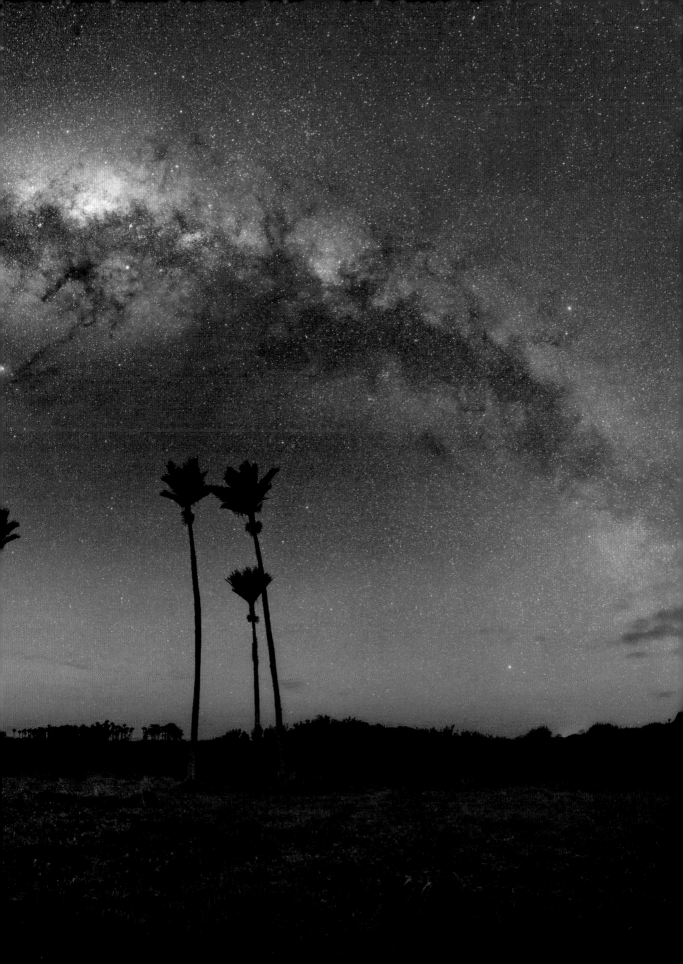

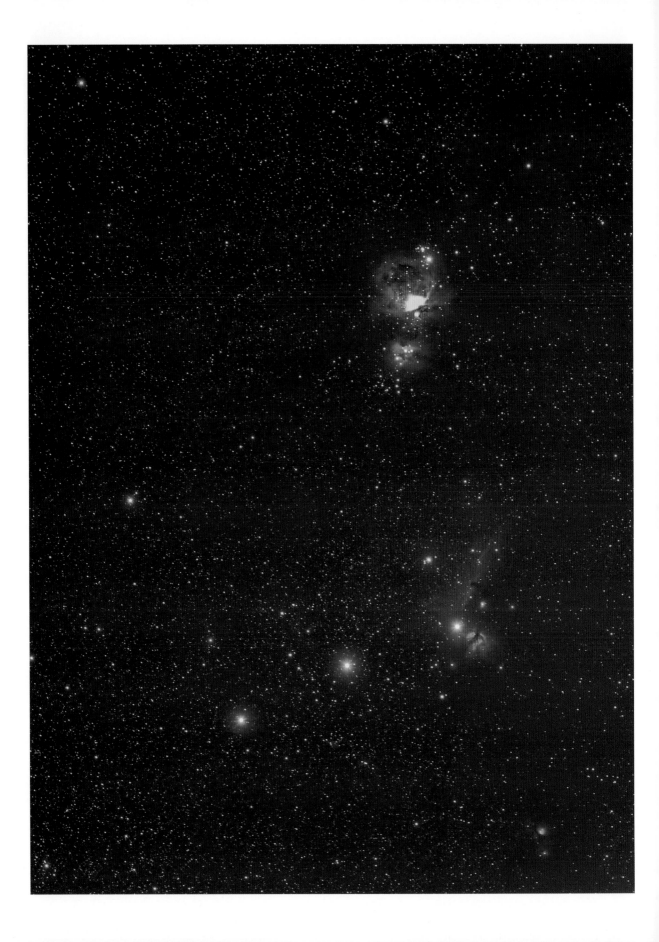

While many constellations share a story origin across diverse peoples, such as the Pleiades (Seven Sisters/Matariki), some constellations are particularly special for a few cultures, with a meaning that is very specific to their language and way of life. In Arnhem Land in the Northern Territory of Australia, the wet season occurs when Orion is high in the sky. Aboriginal people from this place have a story about three fishermen paddling along a river, the three prominent stars of Orion's Belt making up the three men in the boat. When the constellation is in the right place, so are the fish. And in Egypt, the constellation Aquarius forewarned inhabitants of the spring rains that suddenly flooded the Nile.

The keepers of this knowledge were those with special training in the lore of the universe, and it was passed down as a living library, a store of all that humanity knew and wanted recorded to date. For Māori, this person was a tohunga tātai arorangi, an expert at reading the stars, or a tohunga kōkōrangi, an expert in studying the celestial bodies. The Society for Māori Astronomical Research and Traditions (SMART) is today rekindling this knowledge with cultural and scientific research.[2]

For many cultures, the heliacal rising of a certain celestial body marked the point at which the seasons changed, a special time could be observed, or plans could be made for travel, food, game hunting and weather. A heliacal rising is when a star or constellation – for example, Matariki – first appears in the eastern dawn sky, fading as the Sun rises higher. The importance of heliacal appearances is almost universal in cultures throughout the world. Many believed that the stars were being reborn when they returned to dawn skies like this, in a cycle of death and rebirth. It's not too crazy to compare the birth and death of a star to the cycles of a human life. We are made of the same substances, after all.

●

The three prominent stars that make up Orion's 'belt' – the base of the Pot for us – have meanings for many different cultures around the world. The Horsehead Nebula is just visible. (FRASER GUNN)

Signs and wonders

●

I t's no surprise that we are so drawn to dramatic celestial events. The idea that an apparition in the sky brings death, misfortune and destruction is embedded so deep in our culture that it's stuck in our language, too. The word 'disaster' is from the Italian *dis-astro* – a star not in favourable alignment. Romeo and Juliet were 'star-cross'd', their love thwarted by a malign star. To earlier cultures, sudden objects such as comets, supernovae and meteors were even more powerful. The sky was so predictable, familiar and unchanging that an unusual sight in the sky, the home of the gods, was deeply unsettling.

Explaining the science behind some of these dramatic events helps us understand what a huge impact they have had on humans at various times throughout history.

Eclipses

We are most familiar with two kinds of eclipse: solar and lunar. A total solar eclipse occurs when the Moon moves between Earth and the Sun and blocks (or occults) the Sun's light, causing points on Earth to pass through the shadow (umbra) and into darkness. Partial solar eclipses happen when only part of the Sun is blocked out. It is undoubtedly one of the eeriest astronomical events you can experience on Earth, and it's common for even modern-day people to scream in fright as the Sun is covered and the world plunged into a silvery darkness. Total solar eclipses are quite rare, because of the timing of the Moon's orbit, and last for only a few minutes.

Edmund Halley – of comet fame – wrote about the 'Chill and Damp which attended the Darkness' of an eclipse in 1715, causing 'some sense of Horror' among

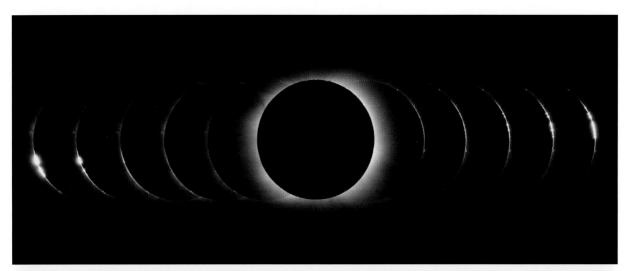

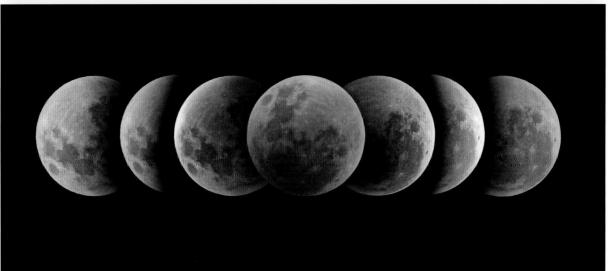

Top It's rare to be in the path of a total solar eclipse, and many people will travel great distances to have this experience. This stacked image by New Zealand astrophotographer Stephen Voss shows the progression of an eclipse seen from Hikueru Atoll near Tahiti, in July 2010. (STEPHEN VOSS)

Above A lunar eclipse, when the Moon passes behind the Earth and into its shadow, is much more common than a total solar eclipse. This series was shot in Central Otago in August 2007. (STEPHEN VOSS)

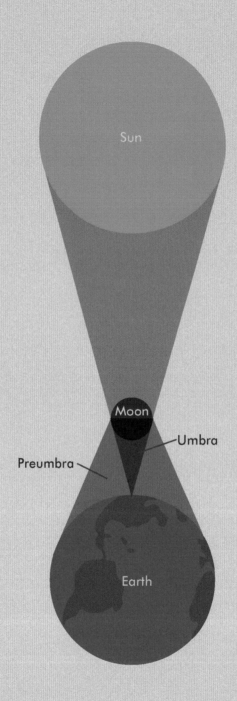

Sun

Moon

Umbra

Preumbra

Earth

During a total solar eclipse, when the Moon completely occults (conceals) the Sun, the shadow that falls across the Earth is called the path of totality. This diagram shows how an eclipse causes varying levels of darkness, depending on where you are on Earth.

the people gathered to watch it. It's a time when we can feel especially close to our ancestors, because, despite all our astronomical knowledge today, this visceral horror doesn't lessen with time. In fact, it's perfectly captured in American writer Annie Dillard's classic literary essay 'Total Eclipse':

> The second before the sun went out we saw a wall of dark shadow come speeding at us. We no sooner saw it than it was upon us, like thunder. It roared up the valley. It slammed our hill and knocked us out. It was the monstrous swift shadow cone of the moon. I have since read that this wave of shadow moves 1,800 miles an hour. Language can give no sense of this sort of speed—1,800 miles an hour. It was 195 miles wide. No end was in sight—you saw only the edge. It rolled at you across the land at 1,800 miles an hour, hauling darkness like plague behind it. Seeing it, and knowing it was coming straight for you, was like feeling a slug of anaesthetic shoot up your arm. If you think very fast, you may have time to think, 'Soon it will hit my brain.' You can feel the deadness race up your arm; you can feel the appalling, inhuman speed of your own blood. We saw the wall of shadow coming, and screamed before it hit.
>
> This was the universe about which we have read so much and never before felt: the universe as a clockwork of loose spheres flung at stupefying, unauthorized speeds. How could anything moving so fast not crash, not veer from its orbit amok like a car out of control on a turn?[1]

Dillard's piece shows the power of an eclipse has not waned despite our advanced scientific knowledge. There have been 26 total or partial solar eclipses visible from New Zealand in the last 800 years, and later sections in this book will discuss what happened during some of the most dramatic of these. But total eclipses are very rare in a human lifetime. New Zealanders will get their next chance to experience totality on 22 July 2028, as it crosses a swathe of Central Otago, Te Anau, Wānaka, Queenstown and Dunedin down to Owaka and Gore.

Lunar eclipses are more common, occurring up to four times annually. They happen when the Moon passes behind Earth and into its shadow, with Earth directly between it and the Sun. The Moon appears reddish, because the only light reaching it is light that hasn't been refracted by Earth's atmosphere. This is why we get what is called a 'blood moon', and it can last for a few hours.

The Butterfly Nebula in the
constellation Scorpius, as seen by
the Hubble Telescope. Gas released
by a dying star races across space
at more than 965,000 kilometres
an hour, forming the delicate
shape of a celestial butterfly. (NASA,
ESA, AND THE HUBBLE SM4 ERO TEAM)

Aurorae

Seeing the *aurora australis*, the southern lights, is a lifetime goal for many people. Aurorae are formed when solar flares – powerful streams of protons and electrons pinched off the Sun's magnetic field like a lava lamp – stimulate Earth's own magnetic field and make the atmosphere glow. They start about 100 kilometres high, and a very active aurora will form a draped curtain of colours in the sky: green, red, blue, pink and yellow.

New Zealand is one of the best places in the world to see the southern lights. To do so, you're best to choose a moonless night somewhere far from artificial light, on an evening with a high Kp index. This is a measure of the strength of aurorae (from the German *planetarische Kennziffer*, 'planetary index'). A Kp of 0 is very weak, with anything over 5 being a geomagnetic storm; the maximum of 9 is a major geomagnetic storm, creating strong, vivid aurorae. In New Zealand, an aurora strength of Kp 7 will mean you can view the spectacle from approximately Dunedin and south; it will take a strength of Kp 9 to see it from Dunedin to the top of the South Island. Aurorae can, however, be seen further north, too; they have been spotted from Auckland and the summit of Mount Ruapehu.

Mobile apps such as My Aurora Forecast send you notifications when aurora activity is high, and show you the likelihood of one being seen in the area. The website aurora-service.net provides an aurora watch and aurora message alerts, using real-time solar wind data from NASA's *ACE* spacecraft, matched with data provided by a worldwide network of magnetometers. Both have 'maps': pictures of the globe that show how the lights usually cling to Antarctica, creating a ring about the bottom of Earth, and how they occasionally move north to venture within the view of New Zealand. If you go out hunting an aurora, keep an eye on the website or your app, and take your camera – the vivid pinks and greens are better picked up by camera than by the naked eye.

Aurora-hunting has become more popular as striking images and time-lapses have been shared on social media and better mobile technology has been introduced that sends accurate predictions to your phone. In 2017, local aurora fever reached new peaks when Dr Ian Griffin, Otago Museum director and former NASA Space Telescope Science Institute public outreach head, organised the first aurora flight, Flight to the Lights.

One hundred and thirty very excited passengers flew to the sixty-sixth parallel on a Boeing 767, into the skies near Antarctica to get as close as possible to an aurora. The price was NZ$4000 for two economy-class tickets or $8000 for two in business class, but that didn't put people off; Griffin reported that he could have sold the plane out three times over, and there was enough interest for several flights a year, with enthusiasts

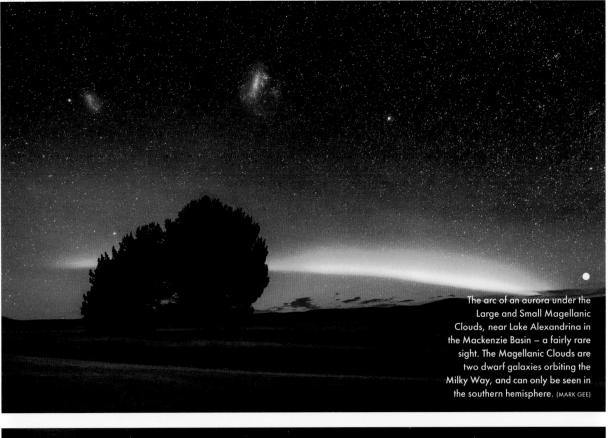

The arc of an aurora under the Large and Small Magellanic Clouds, near Lake Alexandrina in the Mackenzie Basin – a fairly rare sight. The Magellanic Clouds are two dwarf galaxies orbiting the Milky Way, and can only be seen in the southern hemisphere. (MARK GEE)

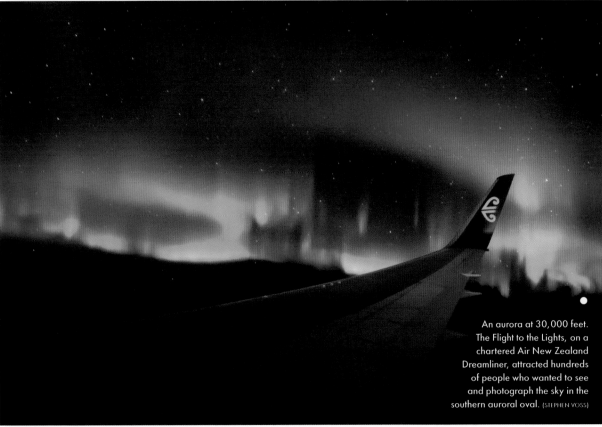

An aurora at 30,000 feet. The Flight to the Lights, on a chartered Air New Zealand Dreamliner, attracted hundreds of people who wanted to see and photograph the sky in the southern auroral oval. (STEPHEN VOSS)

arriving from as far afield as Spain. Everyone had a window seat. They left New Zealand at 9 p.m., returning at 5 a.m. after a night of breathless wonders, with three hours spent flying among the aurorae. Invercargill GP and keen astrophotographer Stephen Voss, whose images appear in this book, was one of the passengers. The flight ran again on 22 March 2018, this time with a Boeing 787-9 Dreamliner giving 150 people the chance to sit among the aurora for five hours at 70 degrees south. Clearly, people cannot get enough of the magical lights in the sky.

Meteoroids, asteroids and comets

Living on Earth, we're blithely unaware that mobile members of the Solar System are constantly showering our planet in dust and rocks. What's the difference between a comet, an asteroid, a meteoroid, a meteor and a meteorite? They're all different, and all fascinating celestial phenomena. Some have caused calamitous global change, and may do so again; others simply offer a brief spark of amusement on a night out.

An asteroid is a small, rocky body orbiting the Sun, a chunk of rock from the massive, doughnut-shaped asteroid belt between the orbits of Mars and Jupiter and left over from the creation of our Solar System. Asteroids range widely in size – some are no bigger than a bus, while the largest can measure hundreds of kilometres across – but are too small to be called planets. NASA estimates that there are currently nearly 800,000 known asteroids.

A meteoroid is a fragment of an asteroid, comet, moon or planet, and is less than a kilometre in size (and often only millimetres across). If it comes close enough to Earth and enters our atmosphere, it burns up, and the flash of light is what we call a meteor, or a shooting star. If it hits the ground intact, it's a meteorite. Only two meteorites have ever been witnessed in New Zealand.

The biggest meteorite scar on Earth – and also one of the oldest – is the Vredefort Crater in South Africa, originally measuring 300 kilometres across. A crater called Chicxulub, underneath Mexico's Yucatan Peninsula, is thought to mark the impact of the meteorite that contributed to the mass extinction of dinosaurs 65 million years ago through climate disruption. The megatsunami created by the impact would have been more than 100 metres tall – though if the crash had happened in the deep ocean, the wave would have towered up to 4.6 kilometres.

By the time they land on Earth, most meteorites are pebble-sized. It's estimated that several million tonnes of dust hit the outer layers of our protective atmosphere

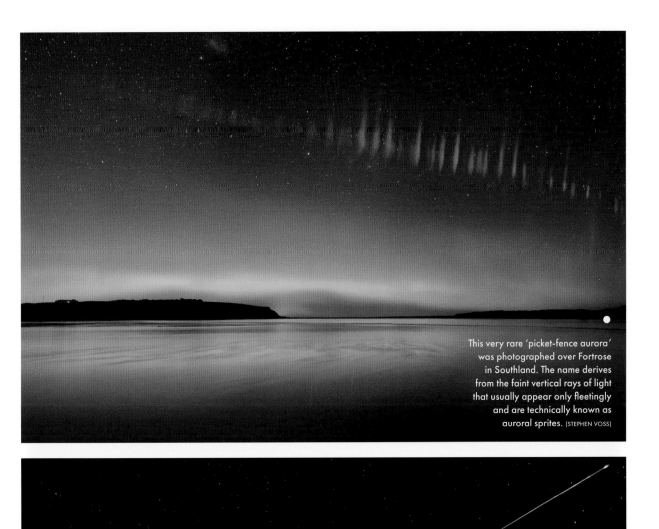

This very rare 'picket-fence aurora' was photographed over Fortrose in Southland. The name derives from the faint vertical rays of light that usually appear only fleetingly and are technically known as auroral sprites. (STEPHEN VOSS)

A composite image of the Eta Aquarids Meteor shower, taken in the early morning of 7 May 2013 at Aramoana, near Dunedin. The Eta Aquarids is one of two meteor showers created by debris from Comet Halley. (STEPHEN VOSS)

every day, with some big enough to become shooting stars. It's hard to believe, but the typical shooting star that you see explode briefly in the sky is a burning meteor the size of a grain of sand, travelling at high speeds of between 11 kilometres per second and 72 kilometres per second. A meteor the size of your fist would momentarily turn the night sky to broad daylight. We are more likely to see them after midnight, when we're facing out into the direction Earth is travelling and the planet picks up particles in its path.[2]

Indeed, we're pretty safe on Earth; most of the crashing debris from the first 500 million years of our Solar System's evolution has long since been mopped up by planets. Mercury, the Moon, Earth and Mars all show signs of bombardment from space, and Earth actually gains weight from meteor showers, with one estimate putting it at 40,000 tonnes of cosmic dust per year.[3]

Nonetheless, NASA remains alert. Asteroids that pass close to Earth are called near-Earth objects (NEOs) and are closely observed, because there is a distant threat that one might hit us; on average, an asteroid with a diameter of 500 metres can be expected to strike Earth about every 130,000 years. In March 2018, NASA was preparing for the very small but significant chance that an asteroid named Bennu – the size of the Empire State Building and discovered in 1999 – might one day smash into Earth, releasing the TNT equivalent of 1200 megatons and wiping out a good portion of life. By comparison, the atomic bombs dropped on Nagasaki and Hiroshima were 0.02 and 0.015 megatons each.

In fact, at the time of writing NASA is proposing to launch two independent spacecraft some time between December 2020 and May 2021 to investigate an asteroid, Didymos, and crash into its moonlet, informally known as Didymoon, to gather data for future planetary defence challenges. Doing so would affect Didymoon's orbit – marking the first time humanity has altered the dynamics of a Solar System body in a measurable way.

Comets

A comet orbits the Sun and is made of ice, dust, methane, ammonia and other compounds, which create a fuzzy, cloud-like shell called a coma. When a comet nears the Sun and begins to vaporise, it sometimes makes a visible tail, and its debris sometimes creates meteoroids. Later in this book, we'll discuss some of the most famous comets to shine above New Zealand shores.

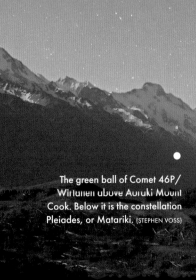

The green ball of Comet 46P/
Wirtanen above Aoraki Mount
Cook. Below it is the constellation
Pleiades, or Matariki. (STEPHEN VOSS)

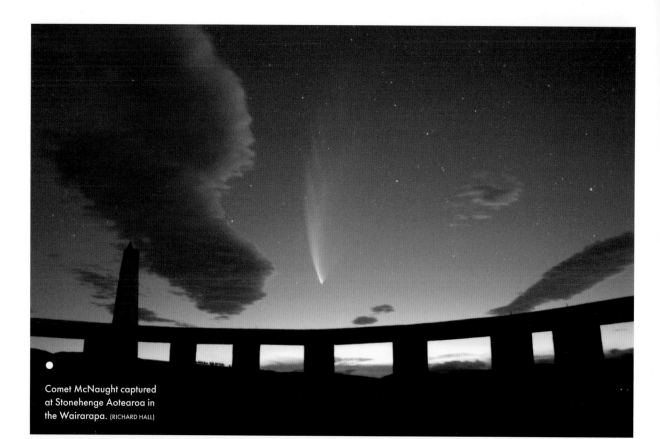

Comet McNaught captured at Stonehenge Aotearoa in the Wairarapa. (RICHARD HALL)

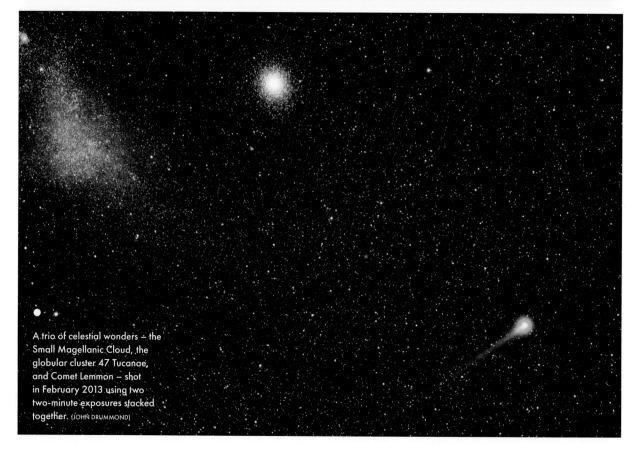

A trio of celestial wonders – the Small Magellanic Cloud, the globular cluster 47 Tucanae, and Comet Lemmon – shot in February 2013 using two two-minute exposures stacked together. (JOHN DRUMMOND)

Wherever and whenever comets have appeared, we've recognised them as bringers of evil, death, misfortune and political downfall. Comets do not burn across the sky in a streak of light and go out, like shooting stars. Instead, they stay in the sky for days at a time, growing brighter and bigger, then slowly dying out as they move further away. Seeing one would have been profoundly unsettling for our ancestors.

The Greeks dubbed comets 'hairy stars', from *komete*, meaning 'long flowing hair'. The Chinese called them 'broom stars' – *hui* or *sao-hsing* – after household twig brooms, and believed they were a portent of sweeping away the old. The Egyptians also likened them to hair, thinking them the flaming tresses of the sky goddess Nut. Babylonians called them the glowing beards of gods in the heavens. Arab people saw them as a scimitar.

Pliny the Elder's *Natural History* reveals that the ancients thought of a comet as 'a very fearful star; it announces no small effusion of blood'. He cited one of the brightest comets in recorded history on the death of Julius Caesar in 44 BCE:

> We have, in the war between Caesar and Pompey, an example of the terrible effects which follow the apparition of a comet. Towards the commencement of this war the darkest nights were made light … by unknown stars; the heavens appeared on fire, burning torches traversed in all directions the depths of space; the comet, that fearful star, which overthrows the powers of the Earth, showed its terrible locks.[4]

Shakespeare took up the tale in his play *Julius Caesar*: 'When beggars die there are no comets seen; The heavens themselves blaze forth the death of princes.'[5]

Scientific investigation of comets took a great leap forward with Danish astronomer Tycho Brahe's study of the Great Comet of 1577; he showed that it wasn't what Aristotle and other scientists of the time believed – that is, a 'fiery exhalation' in the atmosphere, or an explosion of gas from volcanic activity. Rather, comets lay beyond the Moon and the planets and passed through the fundamental universal arrangement of the time: the celestial spheres, immutable globes around Earth made of an unknown fifth element, embedded with planets and stars and rotating on their planes.

Today, we know comets are born in the Oort Cloud, the flattened, doughnut-shaped gas and dust star nursery surrounding our Solar System. Many are faint and tailless, but the bright ones, with the long tails so distinctive in our sky, are dusty snowballs that can be from 100 metres to 100 kilometres in diameter. Dust and gas evaporate as a comet

approaches the Sun, creating two or sometimes three tails; one is made from dust and heavier particles that lie on the comet's path, and evaporating material. Each time a comet comes close to the Sun, it dies a little, losing ice and gas.

The comet's deathly portent echoes down the years into modern times. Mark Twain shared a strange relationship with it; his biographer quotes him as saying:

> I came in with Halley's Comet in 1835. It is coming again next year, and I expect to go out with it. It will be the greatest disappointment of my life if I don't go out with Halley's Comet. The Almighty has said, no doubt: 'Now here are these two unaccountable freaks; they came in together, they must go out together.'[6]

He did indeed die of a heart attack one day after the comet appeared at its brightest.

It's estimated that we're seeing Halley's Comet only halfway through its lifespan, but it's been with humanity for all our recorded time on Earth.[7] More properly known as 1P/Halley, it is the most famous of all the comets, on account of its regular return roughly every 75 years (allowing some people to see it twice), and its dramatic appearance in 1910.

Like all comets, Halley's Comet has been blamed for a lot in its 29 returns to date, appearing like clockwork as Earth's inhabitants spent the intervening years living, loving and fighting relentlessly over resources. For example, when it showed up in April 1066, it prompted William of Normandy's invasion of the British Isles, which led to the death of the English king Harold and the end of Anglo-Saxon Britain.

William the Conqueror is said to have sighted it as he sailed across the English Channel, taking the 'wonderful sign from Heaven' as a good omen and using it to invigorate his soldiers. The comet features in the Bayeux Tapestry, sewn by William's wife Queen Matilda and her court, which records the story of the invasion. In the tapestry, we see the freshly crowned Harold at Westminster, looking at the comet with fear in his eyes, under the title *Isti mirant stella*: 'These men wonder at the star.'

Apparently streaking across a third of the sky, the 'long-haired star' was recognised by the monk, astrologer and eleventh-century aviator Eilmer of Malmesbury, who realised it was the same that had appeared 75 years earlier; he was duly terrified:

> A comet, a star foretelling, they say, change in kingdoms, appeared trailing its long and fiery tail across the sky. Wherefore a certain monk of our monastery,

Eilmer by name, bowed down with terror at the sight of the brilliant star, sagely cried 'Thou art come! A cause of grief to many a mother art thou come; I have seen thee before; but now I behold thee much more terrible, threatening to hurl destruction on this land.'[8]

The earliest mention of Halley's Comet was by Chinese astronomers in 240 BCE, who saw a 'broom star' moving from east to west. Chinese, Korean and Japanese court records of cosmic events were of huge help to later scientists, who used them to calculate the precise orbit of Halley's Comet. They were able to send the unmanned spacecraft *Giotto* to within 600 kilometres of it in 1986, providing the first close-up images of its dusty, icy heart, its black, lemon-shaped body, and its geyser-like jets.[9]

English scientist Edmond Halley observed the comet in 1682. His contemporary and friend Isaac Newton, who discovered much about the comet's origins, pointed out that his theory of elliptical orbit meant that it would be seen both approaching Earth and leaving it again. He also proved that it was a member of our Solar System. Halley thus decided that comets seen in 1456, 1531, 1607 and 1682 were one and the same. He predicted the comet would come back in 1758–9; and though he died in 1742 at the age of 86, he was posthumously vindicated when it appeared on Christmas Day in 1758.

CHAPTER 5

The stars down under

●

Gentlemen, you live under the wrong half of the sky.

ASTRONOMER DR BART BOK, GIVING A TALK TO THE
ROYAL ASTRONOMICAL SOCIETY IN LONDON

●

For centuries, our southern hemisphere sky was invisible to the astronomical minds of Europe, who prefigured it as a match to the unknown but presumed southern-hemisphere continent at the bottom of the globe.

Europe's very first printed star map of our night sky, dated 1515, was a woodcut by famed artist and polymath Albrecht Dürer. It was based on Ptolemy's catalogue of 1022 stars compiled in 200 CE – and has a hole surrounding the south celestial pole. Portuguese explorer Ferdinand Magellan, who sailed around the globe in 1519, added more constellations, and later navigators and sailors contributed further to European knowledge.

But those living in the northern hemisphere were missing out. In astronomy circles it's sometimes said that God, in creating the universe, put all the best parts of the galaxy in the southern hemisphere, but all the astronomers in the north. When renowned Dutch-American astronomer and Milky Way expert Bart Bok left Harvard in the 1950s to become director of Australia's Mount Stromlo Observatory, he was happy to go, telling reporters: 'The southern hemisphere holds all the good stuff.'

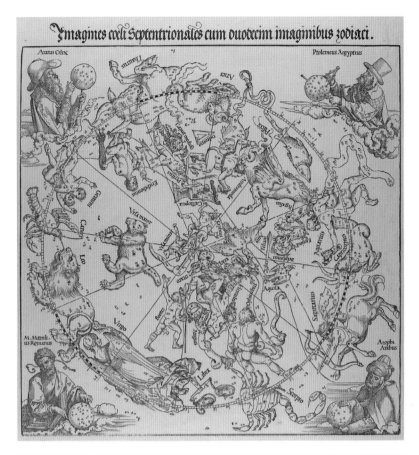

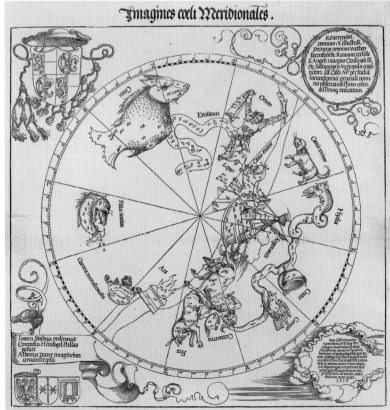

In this pair of 1515 woodcuts by Renaissance artist Albrecht Dürer — the first celestial maps ever published — the unexplored heavens of the southern hemisphere are empty compared to the northern hemisphere, having only a few constellations. The maps show the celestial vault surrounding Earth as seen from the outside, not from our viewpoint on the planet itself. (THE METROPOLITAN MUSEUM OF ART)

New Zealand astronomer A.D. Thackeray once dubbed the southern hemisphere sky 'an underworked goldmine'. Free of major atmospheric pollution and light noise, New Zealand has some of the best places in the world for stargazing. With a simple pair of binoculars, the sky deepens, revealing more of its secrets. Yet, as Thackeray added, large telescopes in the north outnumbered those in the south by a factor of about three, while northern astronomers outnumbered those in the south by a factor of about twenty. He was writing in 1963, but the sentiment stands today.

Southern highlights

What's so special about our southern hemisphere night? For one, we have the best view of our galaxy. In May, we can see the lower third of the southern Milky Way, from Scorpius to Orion, in its entirety – something the northern hemisphere never gets to see. Winter, in fact, is the best time to see the rest of our home galaxy; astrophotographers refer to it as 'astro season'. (It is a strange feeling to look up at a summer noon and realise that the glitter of the Milky Way's core is currently dashed across the sky, but won't be visible again until the southern hemisphere tilts back into wintertime.) Not only are winter nights earlier and longer, but the skies are clearer; we can see the Milky Way arching from horizon to horizon, a great glowing splash across the sky. From February it begins to rise in the early hours of the morning in the south-east, a little later day by day. As the year passes, it makes its way further to the west, where eventually it won't be visible from November, having dipped below the horizon at night. Around May or June is when you can observe it at a reasonable time, such as after sunset.

We can see Centaurus, one of the most majestic constellations in the sky, including our closest stars and Southern Cross pointers, Alpha and Beta Centauri. Alpha Centauri, Canopus and Sirius are the three brightest stars in the sky in either hemisphere, although Canopus can be seen in the North. The light shining from Alpha and Beta Centauri left more than four years ago – an exceptionally close neighbour on the time scale of the universe. And, because the stars are always travelling, in a few thousand years our closest star will be something different.

We also have the Southern Pinwheel Galaxy (in Hydra), one of the closest and most luminous to us; the two best globular clusters, 47 Tucanae and Omega Centauri; and some of the largest and brightest neighbouring galaxies visible to the naked eye. These are the Small and Large Magellanic Clouds, which with a declination (distance from the celestial equator) of 70 degrees can't be seen at latitudes further north than 30 degrees;

Orion lying on his side. You can see how in the northern hemisphere, the orange star of Betelgeuse (the tenth brightest in the sky) becomes his 'head', and the pot handle his belt. (FRASER GUNN)

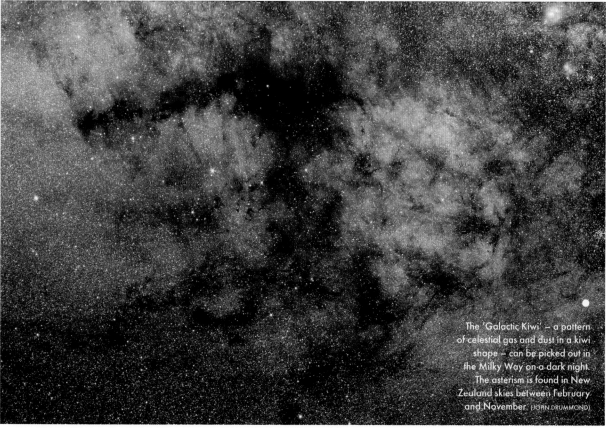

The 'Galactic Kiwi' – a pattern of celestial gas and dust in a kiwi shape – can be picked out in the Milky Way on a dark night. The asterism is found in New Zealand skies between February and November. (JOHN DRUMMOND)

you have to go south of the equator just to get a good glimpse of these spectacular sights. We have the Helix Nebula; the impossibly dark Coalsack Nebula, just adjacent to the Southern Cross, which looks like a hole right through the Milky Way and is where stars are born; and the Jewel Box open cluster, containing about 100 stars in red, white and blue.

With 88 per cent of the Earth's population living in the Northern Hemisphere and light pollution affecting most of us, New Zealand is among the few places on Earth where such celestial spectacles are easy to experience.

Orienteering

Imagining Earth and our view of the celestial sphere can be a little difficult at first, but it may help to picture our planet as a marble encased inside a clear bubble, with the stars stuck on the bubble's rounded surface. As the marble turns, the stars seem to disappear and reappear above our horizon.

It can be hard, too, to comprehend why constellations are 'upside down' in the southern hemisphere, when we're so used to seeing them as they appear in the north, due to popular books and film. An easy way around this is to picture a tree or a stick figure painted on the ceiling. People at one end of the room will see the image the right way up, while those at the other end will see it upside down.

The most familiar example of this is what we call the Pot, which in the north is Orion's belt and dagger. Orion is over the equator, so people in the northern hemisphere look south onto his 'head', while we in the southern hemisphere are looking north towards his 'feet', so we see him upended. At the equator, Orion would lie sideways – rising in the east, his head would be to the left-hand side. And if we southerners lay down with toes pointing south, approximating the position of those in the northern hemisphere, then Orion would appear the right way up.

Incidentally, Orion's prominent red star, Betelgeuse, is a curious remnant of the Arabic names from which most of our star names are descended. Arabic astronomers didn't have Orion the hunter; they had a figure they identified as *al jauza* – a woman, known as 'the central one'. Betelgeuse was *yad*, her hand. But a transliteration error where the Arabic *y* looks similar to *b* meant the star's name became known in Europe as 'bat al-jauza'. Our heritage of modern stargazing includes the cultural memories of many.

In New Zealand, there isn't a large variation in where the stars can be seen in the latitudes from the north to the south; we don't have that much longitudinal separation

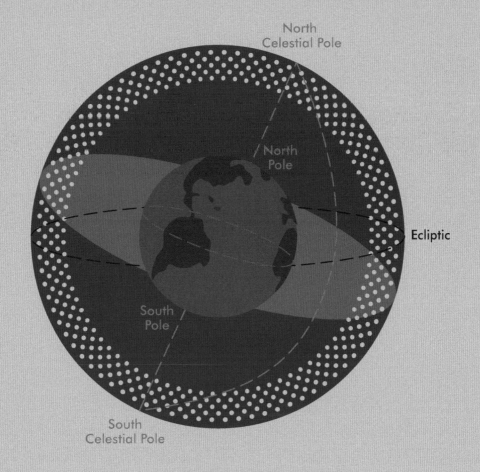

North
Celestial Pole

North
Pole

Ecliptic

South
Pole

South
Celestial Pole

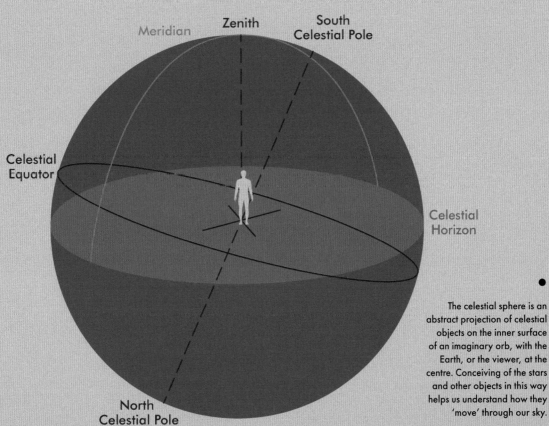

Meridian Zenith South
Celestial Pole

Celestial
Equator

Celestial
Horizon

North
Celestial Pole

The celestial sphere is an
abstract projection of celestial
objects on the inner surface
of an imaginary orb, with the
Earth, or the viewer, at the
centre. Conceiving of the stars
and other objects in this way
helps us understand how they
'move' through our sky.

between Bluff and North Cape. Though some stars important to Polynesian navigators and Māori, such as Vega, may only graze the horizon in a southern latitude such as Tekapo, you need to go to a place like Cairns before stars like Canopus are not circumpolar and dip below the horizon. In fact, it's around northern Australia that we have to go to see arguably the world's most famous constellation, Ursa Major, the Big Dipper, or the Plough. The iconic northern hemisphere constellation that featured in Van Gogh's *Starry Night* is just visible in winter. To see the whole thing, you have to go north of 25 degrees south, and it eases along the horizon there upside down, not long after sundown, the precise timing dependent on the time of year.

Official star names are agreed upon by the International Astronomical Union (IAU), and have a variety of backgrounds. The brightest stars in the sky are often the ones with the most ancient names. Although there are about 10,000 stars visible to the naked eye, there are only a few hundred proper names, agreed upon by the IAU's Working Group on Star Names. Each star also has what's known as a Bayer designation, consisting of the name of a Greek or Latin letter followed by the Latin name of the constellation, which also indicates its position in the order of brightness: hence the stars of Crux – Acrux, Mimosa, Gacrux, Imai and Ginan – are also called Alpha Crucis, Beta Crucis, Gamma Crucis, Delta Crucis and Epsilon Crucis. The system is named after German astronomer Johann Bayer, who created it in 1603.

But most people are more familiar with their own local variations for prominent stars or constellations. These are called asterisms, a colloquial definition similar to a constellation but not officially recognised. Thus, the Pot is the right way up to us.

A great way to learn about our local stars and the global histories behind them is to visit a local observatory, which might be operated by the local astronomical group and have a museum and space centre attached. There are also star tours and planetarium showings, such as at Auckland's Stardome, Wellington's Carter Observatory, and Tekapo's Dark Sky Project (formerly Earth and Sky).

In New Zealand you'll often see the smaller astronomical observatories housing optical telescopes to examine the heavens. Some take the form of concrete bunkers with a domed metal roof; a slit in the roof allows an optical telescope to be swung in a full circle. Not all observatories are topped by a dome; and of course, visible light is not the only thing we can detect in the universe. We can also examine X-rays, ultraviolet light, microwave radiation, infrared light and radio waves.

Radio waves are collected by radio telescopes. These don't observe visible light but can detect radio waves from deep space that were often emitted when early galaxies

were forming. They usually have an antennae and giant dish, and don't have to be housed in domes. The Square Kilometre Array, the first phase of which is slated to be completed in 2027, will be the world's largest radio telescope. It's a matrix of thousands of dishes and up to a million antennae scattered across desert sites in Australia and South Africa, and its total collecting area will be around 1 square kilometre, or 1 million square metres.

The best locations for optical observatories are areas with dark skies, a high number of dry, clear nights, and a high elevation, so the air is thinner and there is less atmospheric disturbance. Those conditions can be difficult to find – research has shown that the best place on Earth for an observatory is, in fact, Antarctica. But you can still stargaze with the naked eye, using the current month's star chart, which can be downloaded free from observatory websites such as Aucklands' Stardome or by getting to know your local astronomy society. It's also rewarding and fun to use an app like Night Sky or SkyView, which shows planets, meteor showers, stars and satellites in real time and helps you track their movements, as well as offering explanations and history about the object.

Whatever you choose, it's important to find the darkest place possible for stargazing, since light robs you of your deep-space vision. Dress warm and stay out a while – when your eyes are properly sensitive to the dark (the way they used to be before artificial light invaded everything in our night world), the stars in the sky truly come alive, and you will wonder how you have spent every night missing the light show before.

Once you have left the bounds of artificial light it takes a while for your vision to become accustomed to the dark. There are two types of dark adaptation. First of all, there's that quick shifting sensation you feel when you walk into a dark house and the irises of your eyes open to let more light in. When you're stargazing, however, you'll experience real dark adaptation, which affects your body deeply on a hormonal level as the rods (light-sensitive) and cones (colour-sensitive) in your eyes adapt to the darkness. It can take up to half an hour for your eyes to adjust fully, and even a brief flash of a cellphone screen or torch can disturb your night vision, necessitating another half-hour wait. Your rods are less sensitive to red light – so, to preserve your night vision, use the red torch function on the app (if available) or get a proper red LED or torch. You will be able to read your star charts by red light, but still use it sparingly.

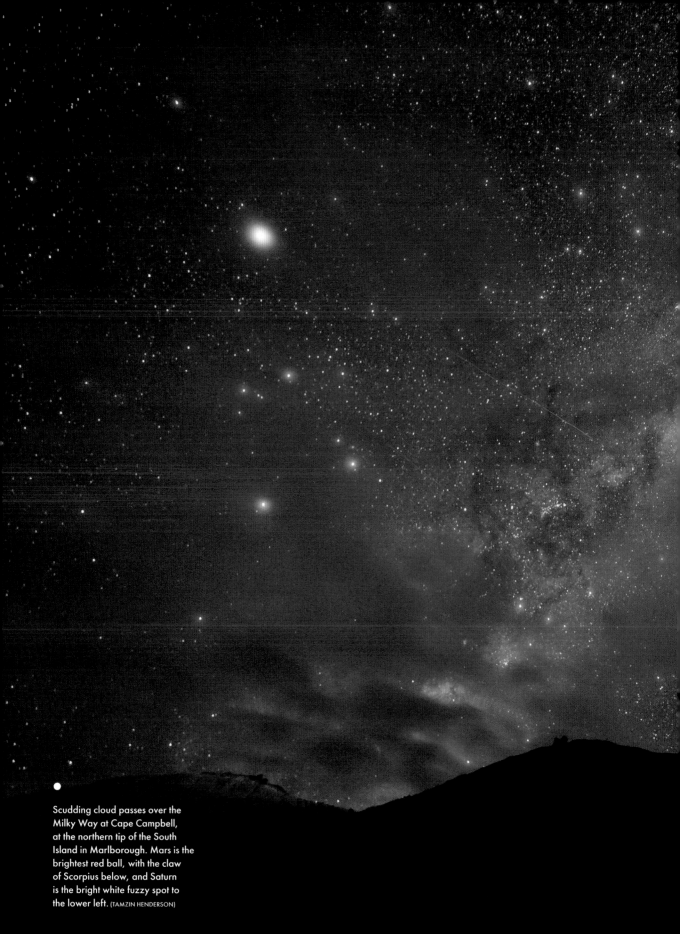

Scudding cloud passes over the Milky Way at Cape Campbell, at the northern tip of the South Island in Marlborough. Mars is the brightest red ball, with the claw of Scorpius below, and Saturn is the bright white fuzzy spot to the lower left. (TAMZIN HENDERSON)

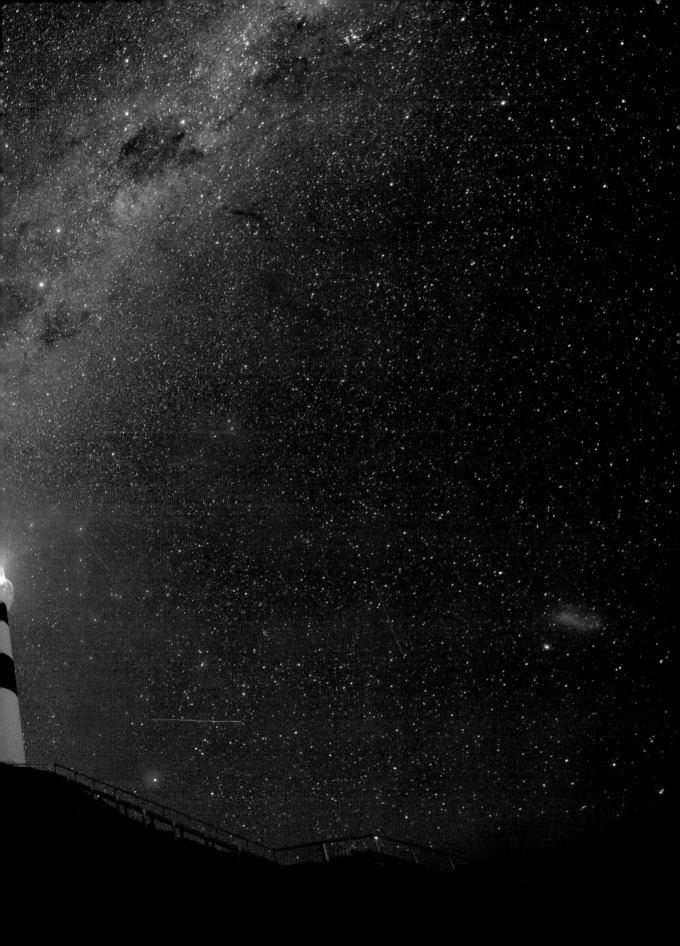

Getting to know the Milky Way

Most of us are familiar with Orion/the Pot, the Southern Cross and its pointers, Alpha and Beta Centauri, and Matariki/Pleiades. Some might be able to pick out their sign of the zodiac, or Sirius, and the Large and Small Magellanic Clouds. But for many of us, that's it. Knowing where you are and how to get to where you're going without the use of instruments is an ancient skill, one that most of us have lost.

In rural New Zealand, the Milky Way can be so bright that you can use it to find your way at night. And if you can locate the south celestial pole, you will always know your bearings. Those in the northern hemisphere have Polaris, the North Star, which is a handy marker for the north celestial pole, a bright star nearly bang on the spot (it's out by one degree, in fact). But no useful bright star marks the south celestial pole – it is, in fact, rather dismally known as the 'south solar pit' – so if you find yourself lost in the mountains, you'll have to do some calculating. (In truth, there is a star there, Sigma Octantis, but it is about one twenty-fifth as bright as the North Star and pretty much invisible to the naked eye.)

So how can you find the compass points using only the stars? The compact, kite-shaped Southern Cross never drops below the horizon when seen from New Zealand, making it a useful year-round sky navigation companion. It's not to be confused with the more diamond-shaped False Cross, which is larger, slightly dimmer and more spaced out, lacking the two pointer stars and the Southern Cross's small fifth star.

There are several ways to identify south using the Southern Cross and its nearby constellations. The South Celestial Pole is the axis about which the stars appear to rotate clockwise, and in New Zealand is about 45 degrees above the horizon; at the south pole, it would be directly overhead, with the stars spinning around it in rings. When summer's coming, the kite begins to dive in the evening; in midsummer, it's lazy, hanging out on the horizon. In winter, it returns to fly high in the sky.

The pointers point towards the Southern Cross, and if you draw a line through them and extend it through the short bar of the cross, you've made a curved, satellite dish–like shape in the sky. South is within this curve. The easiest way to find it, requiring the least knowledge of the sky and neighbouring constellations, is to draw a line through the longer bar of the cross, extending it across the sky. Keeping that in mind, go to the midpoint between the two pointers and draw out a second line, this time perpendicular. Trace them across the sky until both lines meet, then drop straight down to the horizon to find south. Incidentally, on either side of this line you'll find two cloud-like formations glowing with stars. They are the Large

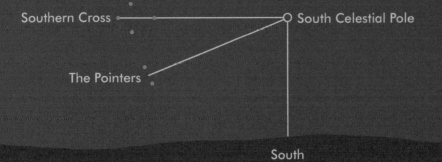

Southern Cross — South Celestial Pole

The Pointers

South

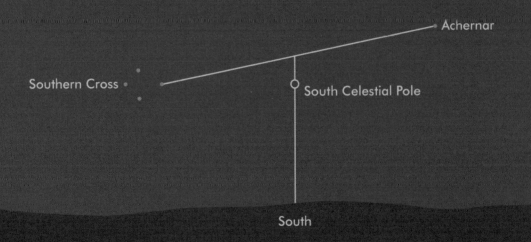

Achernar

Southern Cross — South Celestial Pole

South

The Southern Cross never sets
below the horizon in New Zealand,
so it can always help you find south
if you use some of the brightest stars
in the sky, such as the two Pointers
and Achernar, as additional guides.
(TE ARA – THE ENCYCLOPEDIA OF NEW ZEALAND)

and Small Magellanic Clouds, two of the most amazing features of the southern hemisphere sky.

Another method is to draw the line of the Southern Cross's long axis across to one of the brighter stars in the sky, Achernar, which also never sets when seen from New Zealand. Go back halfway, drop straight down, and you'll find due south.

While you're at it, you can also use your hand to measure distances in the sky in degrees. For a start, the whole universe is 360 degrees, and we can see 180 degrees from horizon to horizon. The angle between the horizon and the zenith – the point right above our heads – is always 90 degrees. The next time you're outside at night, hold your hand out in front of your face at arm's length. When measured against the sky, a handspan with fingers outstretched measures about 20 degrees; the tip of your little finger is one degree. A hand held out with fingers together will cover 10 degrees of the sky, and three fingers 5 degrees. This holds true whether you're a child or an adult, for as your arm lengthens, the hand stays in the same proportion to the sky.

Features of the night sky

Listed below are some of the most impressive, dominant and rewarding stars, planets and sights of the southern hemisphere sky, some in the Milky Way and some without. They are best seen through a decent pair of binoculars or a telescope. The stars are listed under their official modern proper name, followed by the star's Bayer designation and other common English and Māori names.

Though much early Māori knowledge has been lost due to urbanisation and early missionaries suppressing non-Christian spiritual practices, some has survived. Some of the more well-known Māori names and stories are described below – some of which is traditional knowledge shared in personal conversation with Professor of Māori and Indigenous Studies Dr Rangi Matamua (Tūhoe), of the University of Waikato. Each iwi has different interpretations and different names for stars and star groupings, sometimes changing throughout the year or time of day. Thus there is no single correct narative for all.

STARS

SIRIUS

(Alpha Canis Majoris; The Dog Star; Takurua)

Sirius, in Canis Major (Kāhui Takurua), is the brightest star in our sky. It's actually a binary star system of two white stars orbiting each other, though it looks like one point of light to us.

It's important to many vastly different cultures, which have often attached to it mythologies around dogs or wolves. The name Sirius is said to derive from the Greek for 'scorcher' or 'glowing', due to its heliacal rising (appearance in the morning sky) at the summer solstice in ancient Egypt, and it is the origin of the phrase 'dog days of summer', with the hot, dry conditions that followed.

Held as a powerful portent of good or ill fortune, to those in the northern hemisphere it marked the annual flooding of the Nile and its subsequent rush of fertility. To Polynesians in the southern hemisphere, bright Sirius was an important winter star for direction-finding and made up the body of Manu, the Great Bird constellation that split the sky into two halves.

For Māori, Sirius' rising meant the onset of winter. Takurua means both the star itself and the second month of the Māori lunar calendar, about July. A letter to the editor in an 1899 edition of the Māori-language newspaper *Pipiwharauroa* suggests how deeply astronomy is embedded in early Māori culture:

> Ko te tahi o Pipiri kua pipiri tonu ngā turi i taua tāima. He tohu nui nā ō tātou tūpuna. Kei tēnei marama ko ngā whetū, ko Puanga, ko Matariki, ko Tautoru, ko Takurua, e mana ana te whakataukī, 'Takurua hūpē nui.'

> In the first month of Pipiri [June] the knees are close together. That was an important symbol of our ancestors. In this month it is the stars Rigel, the Pleiades, Orion's Belt and Sirius, which is reflected in the saying, 'Sirius of much nasal discharge.'[1]

Sirius is also Hine Takurua, the winter maiden, one of two wives of Tamanuiterā (or Rā), the Sun. His summer maiden wife is Hine Raumati. The Sun moves between his two wives throughout his year-long journey across the sky, from the ocean-dwelling Hine Takurua to the land-dwelling Hine Raumati. Hine Takurua rises before Rā on

NORTHERN HEMISPHERE

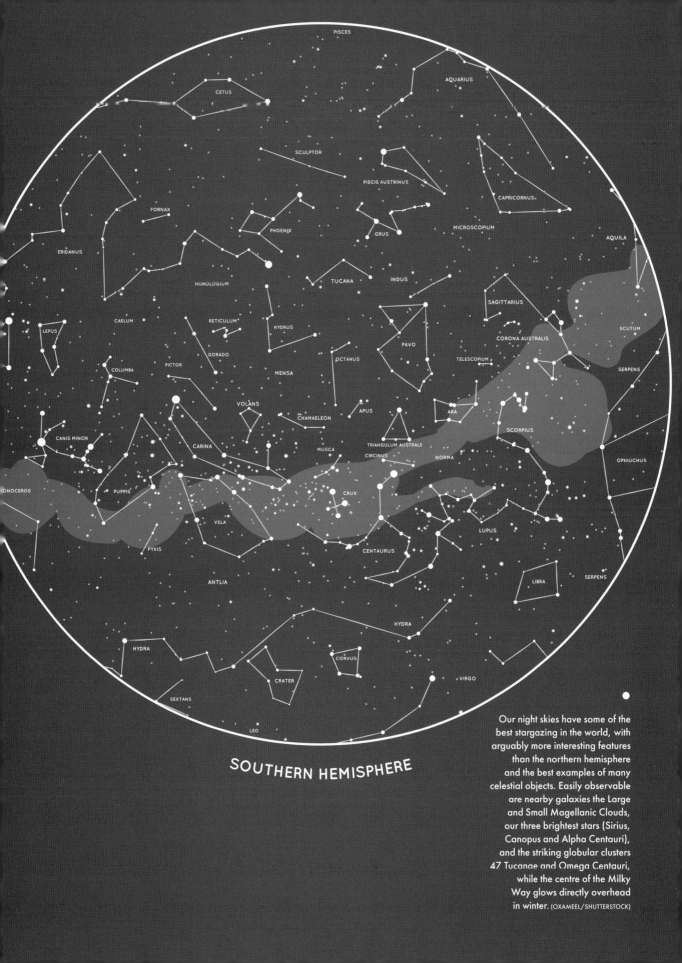

SOUTHERN HEMISPHERE

Our night skies have some of the best stargazing in the world, with arguably more interesting features than the northern hemisphere and the best examples of many celestial objects. Easily observable are nearby galaxies the Large and Small Magellanic Clouds, our three brightest stars (Sirius, Canopus and Alpha Centauri), and the striking globular clusters 47 Tucanae and Omega Centauri, while the centre of the Milky Way glows directly overhead in winter. (OXAMEEL/SHUTTERSTOCK)

●

An artist's impression of the
binary star system we see as one
star, Sirius, which includes the
large, bluish-white star Sirius
A and the smaller dwarf star
Sirius B. Our Sun is the small dot
at the bottom right of Sirius A.
(NASA, ESA AND G. BACON [STSCI])

cold mornings, pulling him out of bed, until winter solstice, when the Sun returns to his summer wife. At the solstice, he moves more slowly, not wanting to leave the comfort of a wife; but at the time of the equinoxes, when the Sun's movement seems to advance faster every day, both wife-stars are in the sky, and he moves more quickly between them.

CANOPUS

(Alpha Carinae; Atutahi, Autahi, Aotahi, Autahi)

Canopus, in the constellation of Carina, is the second-brightest star in the sky after Sirius, 10,000 times more luminous than our Sun. A white, circumpolar bright giant, it is most visible in early summer. In November in New Zealand, Canopus rises on the horizon at dusk, roughly in the south, meaning you can find south at that time of year. Conversely, it rises in the south at dawn in April.

For Māori, Atutahi ('first light' or 'single light') is the oldest of all stars. He is the brightest outside the Milky Way; dwelling alone, he is tapu (sacred). The cousin of Whānui (Vega), he is the chief of stars who pulls up the anchor Māhutonga, the Southern Cross, setting off the seasonal cycle anew. Along with others such as Takurua (Sirius), Atutahi was one of the stars to whom Māori would offer karakia (prayers) to protect crops from frost.

Māori say that when baskets were woven to carry the stars into the sky, the forest atua (god) Tāne hung Atutahi on the outside of the basket, because if he was inside the galaxy he would affect everyone else with his tapu status. Along with the star Rigel (Puanga), Atutahi could be used to predict the weather, and the two stars' appearance in the eastern sky meant it was time to plant kūmara.

Atutahi is also well known in Polynesian cultures as the southern wing-tip of the great bird constellation Manu. In China, it is known as the Taoist deity 'The Old Man of the South Pole'. Though rarely seen in the northern part of China, it can be seen near the horizon further south, often appearing red. According to Dominion Museum ethnographer Elsdon Best, who in the late nineteenth and early twentieth centuries was one of the few people to gather and publish Māori knowledge of astronomy, 'When Autahi is seen standing far out from the Milky Way about October a dry summer will follow; if close to it an inclement season follows. Another, however, reverses this dictum.'

Best also notes that the expression 'Kohi o Autahi' denoted the heavy rains of early winter and the sign for the inanga (whitebait) to go to sea to give birth to their young. Named after the star, this was called the migration of the Kohi o Autahi, or Autahi-ma-

Westerlund 2, a giant cluster of about 3000 stars in the constellation Carina. It is circumpolar in New Zealand, meaning it can be seen throughout the year. (NASA, ESA, THE HUBBLE HERITAGE TEAM [STSCI/AURA], A. NOTA [ESA/STSCI], AND THE WESTERLUND 2 SCIENCE TEAM)

The small group of stars at the centre of this image is the Gem Cluster, a small, pretty, very bright open star cluster with a bright red supergiant at its centre. It's a great sight through binoculars. (JOHN DRUMMOND)

Rehua. The second migration is called that of Takero, and occurs when the star Takero appears. Finally, when the fourth month arrives, the young fish, 'the children of Rehua', as they are termed, go up the rivers.

VEGA
(Alpha Lyrae; Whānui)

Vega is the fifth-brightest star in the sky, the brightest star in the constellation of Lyra. Due to precession, it used to be the northern pole star. It was the first star after our Sun to be photographed.

For Māori, many stars were known as food providers, and Whānui is one of the sources of kūmara, bringing its bounty every year around the end of February. Māori gardened in massive quantities, but didn't harvest until the star was seen in the east before the rising of the Sun in Poutūterangi, the tenth lunar month (usually March or April). The Moon also had to be correct: the lunar phase should be full – rākau nui – when everything was big and lush and could be harvested.

Whānui is the great chief who sails from the homeland of Hawaiki, and the star had a number of children who were seedlings, the first nine varieties of kūmara. He has always lived in the sky, while his brother Rongo, the atua of cultivated plants, lived on Earth.

In a Ngāti Awa story, a man called Rongo Māui wanted some of the kūmara children of Whānui and asked the star if he could take some down to Earth. Whānui declined, so Rongo Māui kidnapped them, and this was the origin of theft. Whānui sent down grubs to destroy the kūmara harvest and punish Rongo Māui for his misdeed, so the star Whānui had to be acknowledged with proper rituals to ensure a good harvest, and statues of the god Rongo were sometimes placed alongside fields.

ACHERNAR
(Alpha Eridani; Marere-o-tonga)

Achernar, another binary system, is a bright spot in the deepest part of the southern night sky. Its apparent luminosity fluctuates, so it's known as a variable star. It spins so quickly that it's squashed itself, and is the flattest star known – it's shaped rather like an M&M.

In New Zealand, Achernar is circumpolar, never setting on the horizon. It was invisible to ancient Egyptians and Ptolemy, but to Polynesians it was an important navigational beacon. According to Elsdon Best, for the Tūhoe people, Marere-o-tonga was the conductor or guide of Autahi.

ANTARES

(Alpha Scorpii; Rehua)

Antares is a red, variable supergiant. Sometimes called the heart of Scorpius, it is the constellation's brightest star, and its distinctive reddish hue can be seen even with the naked eye. (The name means 'opponent of Ares', referring to the war god Ares or Mars.) It's due to explode into a supernova sometime in the next 10,000 years, and should be visible in the daytime, as bright as the full Moon.

Māori know Antares as Rehua, the chief of all stars and father of Puanga (Rigel). Rehua – also the name of the eighth lunar month – rises just before dawn in summer; the phrase 'ko Rehua whakaruhi tangata' translates as 'Rehua gives energy to people', which is apt considering it is seen in the dawn sky when the days are lengthening. Summer was also a time of potential conflict or war over precious food resources, hence the whakataukī (saying) 'Rehua kai tangata' – 'Rehua, the consumer of people'. Another common saying is, 'Te tātarakihi, te pihareinga; ko ngā manu ēnā o Rehua', which means, 'The cicada and the cricket are the flying creatures of Rehua'. When the insects sing and Rehua is seen in the morning, summer has arrived.

ALTAIR

(Alpha Aquilae; Poutūterangi)

The appearance of this star in the sky signalled it was time to inspect the kūmara and prepare the underground pits that would hold them over winter. This was true in the case of iwi on the east coast of the North Island, but other iwi had different stars that meant something similar; in the Mataatua district it was the star Whānui (Vega) that heralded the first careful lifting of the kūmara. It was a time of great anticipation and hopes for a robust harvest; a failed or diseased kūmara crop could mean starvation.

ALDEBARAN

(Alpha Tauri; Taumatakuku)

The brightest star in the constellation Taurus, the red giant Aldebaran is a binary star 44 times the diameter of our Sun. It's easily found in the southern night sky by following the three stars of Orion's belt, or the Pot, right to left, and looking for the first bright star in that line.

The Witch Head Nebula, also known as IC2118, is a faint reflection nebula that is lit up by the nearby star Rigel, in the constellation of Orion. The nebula's dust particles reflect blue light better than red, which gives it its bluish colour. (FRASER GUNN)

RIGEL

(Beta Orionis; Puanga)

The seventh-brightest star in the sky, Rigel, a white or blue-white star, is the brightest in the constellation of Orion and the first visible as the constellation rises. It is actually a system of three to five stars, though it looks like one to us.

Puanga – known as Puaka in southern dialects – is the daughter of Rehua (Antares), the chief of all the stars, and is an important star in the Māori lunar calendar. While some iwi marked the new year by the dawn rising of Matariki in winter, others – including Whanganui, central North Island, Taranaki, parts of the Far North and parts of the South Island – recognise it as the dawn rising of Puanga, which occurs before Matariki. Far North experts in mātauranga Māori (Māori knowledge) say the new year in that region is observed during the first full moon, rākau nui, after the dawn appearance of Puanga and when the tide is coming in.

Puanga is a star, but is also a time of the year, covering the months of early winter. When Puanga, Matariki and Vega set in June–July, it is time to look back on the year that has gone and remember loved ones. When the stars return in the dawn sky shortly after, loved ones are acknowledged and their spirits become stars after being released from the waka of Taramainuku (see below). It's then time to prepare celebrations for the new year. As suggested by the whakataukī 'Puanga kai rau' ('The abundant harvest of Puanga'), the appearance of Puanga was important to the security of food supplies for the winter ahead.

THE POINTERS

(Alpha and Beta Centauri; Uruao Ranginui, Ngā Whetū Matarau)

Alpha Centauri, our nearest star system outside of the Sun, is 4.37 light years from it, and looks like one point of light to the naked eye. But it's actually a triple-star system: three stars bound by gravity. They are Alpha Centauri A (Rigel Kentaurus), Alpha Centauri B and the red dwarf Alpha Centauri C (Proxima Centauri). The last is actually the closest star to us at 4.24 light years, even though we can't see it unaided.

PLANETS

Māori were very aware that the planets looked and moved differently than stars, orbiting Earth on a line across the sky. Planets were known as whetū rere, meaning 'wandering stars', and Māori monitored them moving differently from season to season. They tracked Mercury, Venus, Mars, Jupiter and Saturn, but did not know Uranus

and Neptune, too far out to be observed by the naked eye. Their eyesight and ability to pick out detail in the night sky was also exceptional. Nineteenth-century printer and missionary William Colenso recorded setting up a telescope at Waitangi and testing the eyesight of Māori. They told him the position of two of Jupiter's moons coming across the face of the planet, describing where they appeared. A week later, they told him there were three. They were right.

MERCURY
(Apārangi, Takero, Whiro)

Mercury, the closest planet in our Solar System to the Sun, was named after the Roman god associated with speed. Māori knew it as Apārangi, Takero (which also means 'a star') or Whiro, which is a word for the new moon, and is also the name of Tāne's elder brother, the lord of darkness and the embodiment of evil. Beyond that, little can be said; no Māori narrative account is known that explicitly places Whiro the god in the sky.

VENUS
(Kōpū)

Venus, a white point of light brighter than any other, has played a major role in human mythology since records began. A rocky planet with a dense cover of gas and clouds, Venus changes from Earth's evening star to the morning star every 584 days as it moves on its orbit between Earth and the Sun. It can also sometimes be viewed in the daytime. Observing the transit of Venus was the reason that James Cook sailed to Tahiti, and thence to New Zealand, in 1769.

Venus is generally Kōpū for Māori, though it has several different names depending on whether it's seen in the evening (Meremere, Meremere-tu-ahiahi) or morning (Kōpū Tāwera). A lament from the Waikato shows how Venus' proximity to other heavenly bodies could be an ill omen bringing death. As Āpirana Ngata's *Ngā Moteatea: The Songs* translates, in this case Venus is about to be occulted:

> Breaks the dawn
> And Tāwera (Venus) is biting (the Moon)
> 'Tis the dread omen of death.[2]

MARS

(Matawhero)

The Māori name for Mars is Matawhero, a reference to the planet's red face. But another name is an example of how ongoing colonisation has affected Māori astronomical knowledge, as well as how little this knowledge is understood by the rest of society. The Māori Language Commission still has a resource for school students that refers to Mars as Tūmatauenga, the god of war – which is a direct translation from Roman mythology, in which Mars is the war god.

SATURN AND JUPITER

(Kōpūnui and Hine-i-tīweka)

Māori knew Jupiter as a woman – Hine-i-tūweka or Pareārau, the latter also being a name for Saturn. Although it wasn't until 1655 that Europeans realised Saturn had rings, the fact is embedded in the Māori name for the planet. Elsdon Best recorded in 1922 that the bright celestial body Pareārau was either Jupiter or Saturn and was the 'puller' of the Milky Way – and was surrounded by a ring.[3] One translation of Kōpūnui is 'giant belly', suggesting Māori knew of Saturn's enormous size. Best wrote:

> Pareārau, say the Tūhoe people, is a wahine tūweka ('wayward female'), hence she is often termed Hine-i-tūweka. One version makes her the wife of Kōpū (Venus), who said to her, 'Remain here until daylight; we will then depart.' But Pareārau heeded not the word of her husband, and set forth in the evening. When midnight arrived she was clinging to another cheek, hence she was named Hine-i-tūweka.[4]

A number of old sayings recorded by Best indicate that Māori could see either the rings of Saturn or the bands of Jupiter with the naked eye, such as 'Her band quite surrounds her, hence she is called Pareārau', and 'That green-eyed star is Pareārau; that is the reason why she wears her circlet'. Best couldn't know then that Jupiter also has rings. But back in 1922, Best decided the ring of Pareārau, if it were Jupiter, would be its distinctive weather bands.

●

Opposite top Our neighbour Mars has captured our imaginations for centuries – and now we can visit. This white-balanced mosaic was taken by NASA's Mars *Curiosity* rover and looks uphill at Mount Sharp. (NASA/JPL-CALTECH/MSSS)

●

Opposite bottom A mosaic of the vast Valles Marineris canyon system projected into point perspective, providing an image similar to what we would see from a spacecraft 2500 kilometres above Mars. The dark red spots are the three Tharsis volcanoes. (NASA/JPL-CALTECH/MSSS)

Taken on 19 May 2017 by NASA's *Juno* spacecraft, this enhanced image of Jupiter reveals its stormy atmosphere in its many colours. Each of the contrasting bands is wider than Earth. The white oval storms are part of the feature known as the 'String of Pearls'. (NASA/JPL-CALTECH/SWRI/MSSS/GERALD EICHSTÄDT/SEÁN DORAN)

PLEIADES
(Messier 45; Seven Sisters; Matariki)

Matariki atua ka eke a ii te rangi e roa,
E whāngainga iho ki te mata o te tau e roa e.

Divine Matariki come forth from the far-off heaven,
Bestow the first fruits of the year upon us.

Ka puta Matariki ka rere Whānui.
Ko te tohu tēnā o te tau e!

Matariki reappears, Whānui starts its flight.
Being the sign of the [new] year!

Matariki seems to be a constellation, but is in fact an open star cluster. It is the shortened name of Ngā mata o te ariki o Tāwhirimātea – the eyes of the god Tāwhirimātea. Māori recognise nine stars in the group, as did the Ancient Greeks.

Matariki is often incorrectly translated as 'little eyes', but there is no narrative in Māoridom to support this.

Its distinctive shape works as a calendar; in May, the star cluster disappears, setting in the western sky next to the Sun just as it sinks below the horizon, effectively wiping it from our view of the heavens. This is the time to gather and preserve crops and the constellation stays absent from the skies throughout April. It rises again with the Sun around early July, reappearing in the eastern sky just before dawn, and progressively rising earlier and earlier – ascending higher each day – until it is high in the sky again during summer nights. Its reappearance marks the beginning of Te Tau Hou, the Māori New Year. It's a time to gather with whānau, reflect on whakapapa and remember those who have passed, expressing grief and love.

The cluster is made up of very young, very hot bluish-white stars. Traditions around Matariki differ, but one Ngāi Tūhoe story tells of Tāwhirimātea, the god of wind, who tore out his eyes and flung them into the skies after Ranginui, the sky father, and Papatūānuku, the Earth mother, were separated by their children.

Another story says Matariki is the mother surrounded by her six daughters, Tupu-ā-nuku, Tupu-ā-rangi, Waitī, Waitā, Waipuna-ā-rangi and Ururangi. Another says the

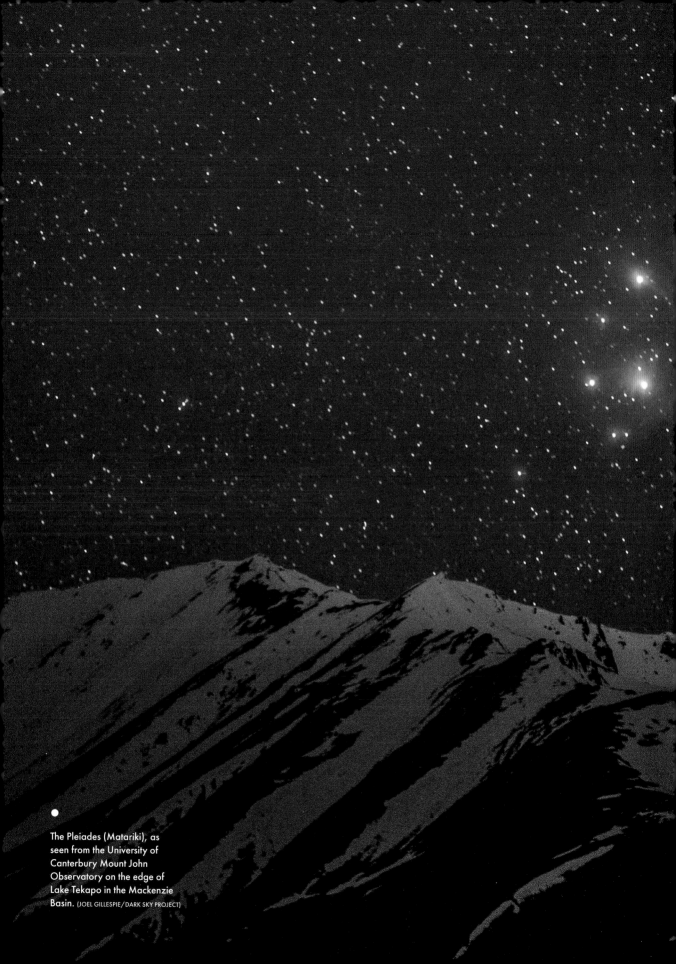

The Pleiades (Matariki), as
seen from the University of
Canterbury Mount John
Observatory on the edge of
Lake Tekapo in the Mackenzie
Basin. (JOEL GILLESPIE/DARK SKY PROJECT)

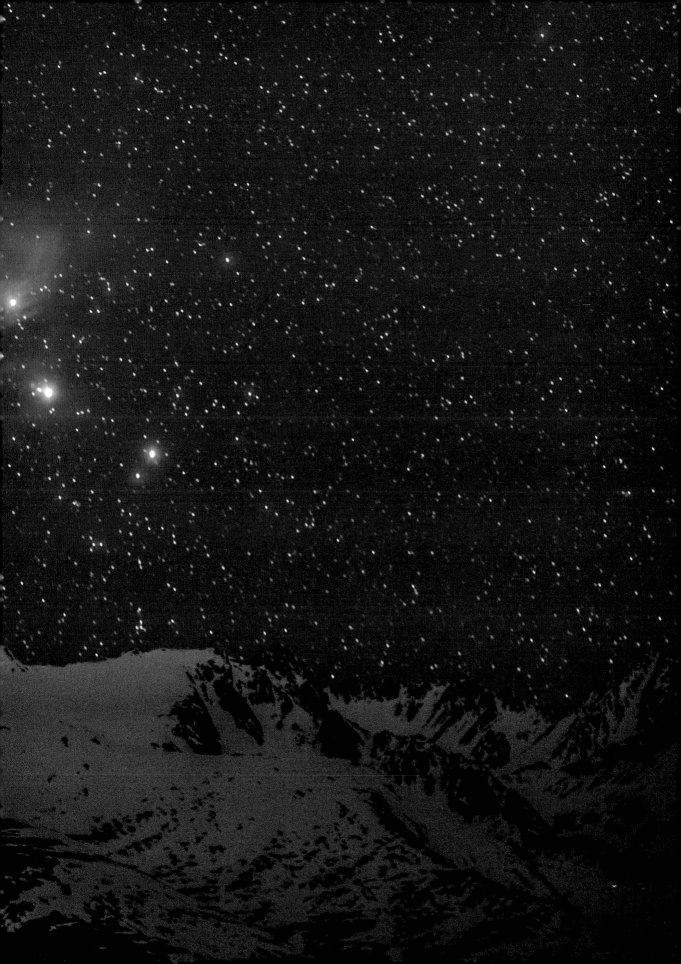

constellation appears in order to help the Sun, Te Rā, who is weak from his winter journey from the north. There are many stories, but Dr Rangi Matamua, University of Waikato professor in Māori and indigenous studies and author of *Matariki: The Star of the Year*, recalls that when he was researching this famous constellation every iwi he visited from Bluff to the Far North recognised Matariki. So do many cultures across the world, each of which has its own tale of Pleiades.[5]

CONSTELLATIONS

CRUX

(Crucis; the Southern Cross; Māhutonga)

It's on our flag; it never leaves our skies; it's home. The most important constellation for New Zealanders, both here and abroad, is the Southern Cross, an asterism for the Latin name Crux. The Southern Cross is the smallest of the 88 constellations in the sky, with all four stars within 6 degrees of each other.

Above the equator in Hawai'i in May or June, the Southern Cross appears on the southern horizon standing up, pointing towards the south pole. In fact, from Hawai'i (which is around 20 degrees north of New Zealand) you can see both Polaris, the pole star, and the Southern Cross. As you move further north, you will see the Southern Cross for shorter and shorter periods of time until it disappears completely; at a latitude of about 26 degrees north, such as southern Florida or Texas, it will just skim the horizon in the early summer evening sky.

For locations below 34 degrees south, the Southern Cross never sets. That, by the way, includes all of New Zealand; the thirty-fourth parallel passes just north of the Three Kings Islands above Cape Reinga. Australians might also claim the Southern Cross as theirs, but it's only in New Zealand that the entire country can see it all year round. Crux also appears on the flags of Brazil, Papua New Guinea and Samoa, as well as several South American provincial regions.

If you've ever stayed out all night, you might have noticed how Crux changes its orientation as the clock ticks closer to dawn and Earth turns its face back towards the Sun. The cross moves from being upright to lying on its side to upside down. At midnight in winter, it will be high, seemingly hanging in the very coldest and darkest part of the sky. But at midnight in January, when Earth is tilted nearly at its maximum towards the Sun, it will be low and lazy on the horizon, relaxing on its side in the south-east portion of the sky.

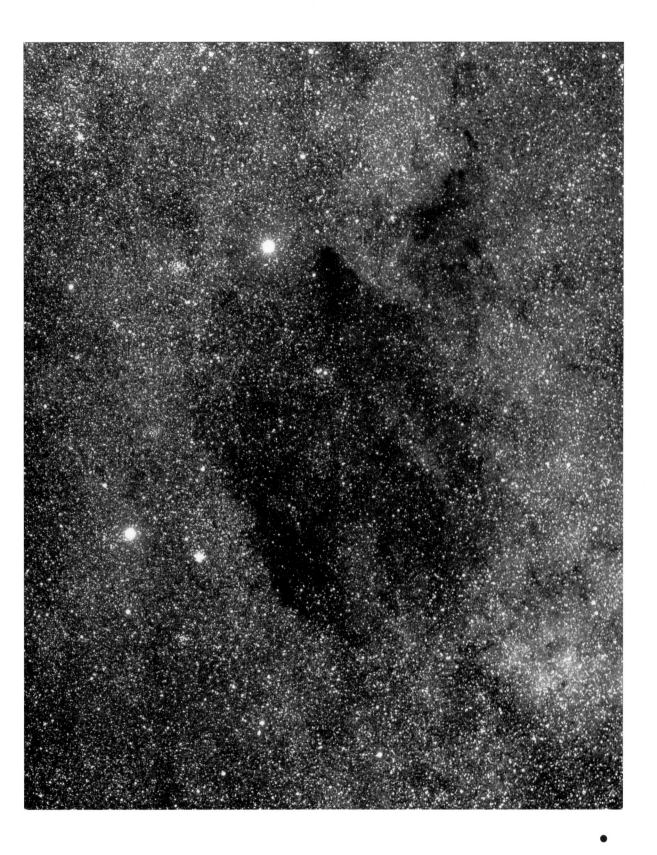

The Coalsack Nebula in Crux —
what we usually refer to as the
Southern Cross. (JOHN DRUMMOND)

So, in summer, the Southern Cross and Centaurus – the former tucked into the 'legs' of the latter – are both low on the horizon, beginning to rise again in January. By autumn, the Southern Cross is high in the sky. The first stars that begin to come out at dusk are the pointer stars of Centaurus, with the Southern Cross appearing as the night deepens. The stars of the cross are the brightest: Alpha Crucis (Acrux, actually a triple star), Beta Crucis (Mimosa), Gamma Crucis (Gacrux), and the dimmest, Delta Crucis. Under Mimosa is the open Jewel Box cluster, as well as the Coalsack Nebula (Te Pātiki), which is the most obvious nebula in the southern Milky Way.

Due to precession, Crux is no longer visible in the northern hemisphere. But it was once known to the Ancient Greeks as part of the constellation Centaurus, and people in the British Isles could see it 4000 years before Christ. Slowly, however, it lowered beneath the horizon and passed from northern memory.

For Māori, different people had different interpretations, and Crux is known by at least eight different names. It was the constellation that guided their ancestors safely to New Zealand: for Tainui Māori, it was Te Punga o Te Waka o Tamarēreti, an anchor of the great sky canoe of Tamarēreti. Wairarapa Māori saw it as Māhutonga, a gap in the Milky Way (Te Ikaroa, or 'long fish') through which storm winds escaped. Others called it Te Taki-O-Autahi or Te Whai-a-Titipa (Titipa's stingray).

As for the Coalsack Nebula, James Cowan wrote in 1930: 'The Coalsack at the foot of Maahutonga, looking blacker than ever as "the Cross swings low for the morn," is "Te Rua o Maahu," or again "Te Riu o Maahu"; the first means Maahu's Chasm or Pit, into which the ancient ocean pathfinder is supposed to have vanished; the second likens the Coalsack to the deep hold of his canoe.'[6]

FALSE CROSS

(Vela and Carina; Pīawai)

The False Cross isn't an official constellation, but a local asterism. It's made up of stars from the constellations Vela and Carina. Stargazers sometimes confuse it with the Southern Cross, especially as it's higher earlier than Crux and has its own two pointer stars, Velorum and Y Puppis. As it's larger, it tends to be the one that new stargazers immediately pick out. But it's not far away: about 25 degrees west-north-west of the Southern Cross and about 20 degrees north-north-east of the Large Magellanic Cloud.

THE POT

(Orion; Tautoru; The stern of Te Waka o Tamarēreti)

In New Zealand, part of Orion is universally known by the asterism the Pot, or sometimes Tautoro, the three stars that make up a perch for a bird. It includes the bright blue giant star Rigel (Puanga or Puaka). Maori considered Puanga to be a fruit, and birds would sit on the perch, much like a tree branch in the sky, to pluck the fruit. Māori knew that Rigel appearing in the constellation of Orion meant rain; it was the lunar month of Haki-haratua, or May.

Orion is one of the most obvious sets of lights in the summer sky, but it looks different depending on where you are on Earth. To the Ancient Greeks Orion is the hunter, with a distinctive set of stars forming his belt, upon which hangs his dagger or sword. The giant red star of Betelgeuse, Pūtara, marks the hunter's shoulder.

TE WAKA O RANGI

This Māori constellation, a canoe with Matariki at the front and Tautoro (the belt of Orion) behind, is captained by a star called Taramainuku, who fishes with a net, Te Kupenga a Taramainuku. During the nights that the constellation is in the sky, Taramainuku casts his net to Earth and collects the souls of those who died that day. For the next 11 months, until the constellation sets next to the Sun around May, he carries the souls in his waka. When it rises again around June, he releases the souls of the dead, saying, 'Kua wheturangihia koe' – 'You have now become a star' – and they become stars in the night sky. The story is often regionalised to a local iwi – becoming, for example, Te Waka o Tainui.

TE WAKA O TAMARĒRETI

The southern part of the Milky Way is Te Waka o Tamarēreti, the great waka of Tamarēreti. Scorpius forms its prow, Orion the stern, and Crux and the Pointers its anchor and rope. All were vital navigational stars and the entire waka can be seen in the sky at the time of the Māori New Year.

One story of its origin tells of Tamarēreti taking his waka out onto a lake and finding himself far from home as darkness fell. There were no stars then, and he was in danger from taniwha. Tamarēreti went ashore, cooked some of his fish and ate it. When he finished cooking he noticed that the pebbles in his fire were shining and luminescent, which gave him an idea. He sailed his waka along the river that emptied into the heavens (which caused rain) and scattered the pebbles into the sky. The sky god, Ranginui, was

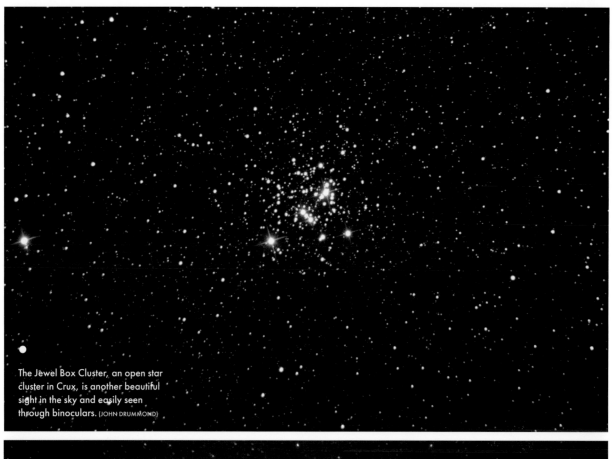

The Jewel Box Cluster, an open star cluster in Crux, is another beautiful sight in the sky and easily seen through binoculars. (JOHN DRUMMOND)

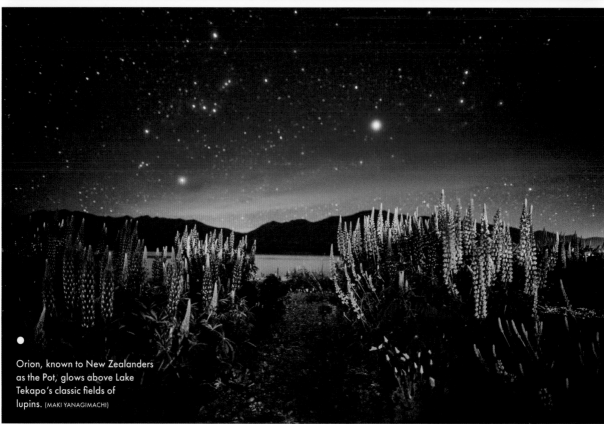

Orion, known to New Zealanders as the Pot, glows above Lake Tekapo's classic fields of lupins. (MAKI YANAGIMACHI)

pleased by this, as it made the sky more beautiful, and the people were pleased because they now had light at night-time. Ranginui placed the waka in the sky as a monument to how the stars were made.[7]

SCORPIUS
(Scorpii; the Scorpion; Mairerangi [body] and Te Waka o Tamarēreti [tail]; Prow of Te Waka o Tamarēreti; Māui's fish-hook)

One of the brightest and most distinctive constellations in the sky, and the one most reflecting its name, Scorpius is ancient, pre-dating even the Greeks. It lies between the constellations of Libra and Sagittarius (Kaikōpere) and appears high in the winter sky, within the Milky Way but easily picked out by its curved pattern of stars. It takes over the sky as the summer constellation of Orion, on the opposite horizon, begins to leave.

In Greek mythology, this cluster is explained by the story of Scorpius and Orion, who boasted he would kill every animal on Earth. Artemis and her mother, Leto, (or in some versions, the Earth goddess Gaia) sent a giant scorpion to kill Orion, and after it won, Zeus put the scorpion in the sky. They still chase each other over the horizon and through the underworld as the year moves on, never appearing in the sky at the same time. Scorpius used to have claws, but during the reign of Julius Caesar the Romans broke these off into the 'scales' of Libra, our symbol of justice.

Scorpius contains many bright stars, including Rehua (Antares). It also contains M4, a globular cluster; M6, the Butterfly open cluster; and M7, another open cluster of stars, which can be seen with the naked eye in a very dark sky.

JEWEL BOX CLUSTER
(Kappa Crucis Cluster; NGC 4755)

The English astronomer John Herschel christened the Jewel Box, saying that 'this cluster, though neither a large nor a rich one, is yet an extremely brilliant and beautiful object when viewed through an instrument of sufficient aperture to show distinctly the very different colour of its constituent stars, which give it the effect of a superb piece of fancy jewellery'.[8] It has also been likened to a clutch of diamonds containing a single ruby.

Top Omega Centauri is the largest and finest globular cluster visible to the naked eye. (FRASER GUNN)

Bottom left A detail of Omega Centauri, taken by the Hubble Space Telescope. (NASA, ESA, AND THE HUBBLE SM4 ERO TEAM)

Bottom right The globular cluster 47 Tucanae. (NASA, ESA, HUBBLE HERITAGE TEAM, J. MACK [STSCI]; G. PIOTTO, UNIVERSITY OF PADOVA)

OMEGA CENTAURI
(NGC 5139)

To the naked eye, this unusual cluster looks like a small hazy patch, but examining it through a telescope will reveal its stunning, deeply layered beauty, bright and grainy like glowing sand. In the constellation of Centaurus, it's the largest and closest cluster in our Milky Way: 10 million stars packed in tightly, with the mass of four million solar masses.[9] Though known as a globular cluster, scientists now think Omega Centauri is the remains of a dead galaxy; a core, with the rest of it eaten up by the Milky Way a billion years ago. This is because it's made up of many different types of stars of different ages; globular clusters usually have stars that are similar and which formed at once. The Hubble Telescope has detected unusually swift motion at Omega Centauri's centre, which may indicate a black hole. Viewed from a very dark, rural place, Omega Centauri appears nearly as big as the Moon.

47 TUCANAE
(NGC 104)

As Wairarapa astronomer Richard Hall imagines, if you lived on a world near the centre of this brilliant globular cluster, the stars would be so thick and bright that you could see hundreds of them during the day. This vast and ancient city of stars is indeed one of the oldest objects in the galaxy, full of dead, dying and once-brilliant stars, faint white dwarfs and neutron stars. You can see it in the summer night sky.

LARGE AND SMALL MAGELLANIC CLOUDS
(Nubeculae Magellani; Ngā Pātari [both]; Pātari-rangi or Tīoreore [Large] and Pātari-kaihau or Tītakataka [Small]

We're lucky to be able to see these two irregular dwarf galaxies down south – they're a wonder for visiting northerners. These two cloud-like patches of light are our galactic near-neighbours, with the larger cloud about 170,000 light years away. They're tied to our Milky Way by gravity, but will be absorbed into it over time as our galaxy grows.

The Large Magellanic Cloud (LMC), about the farthest object you can see with the naked eye from the southern hemisphere, contains the Tarantula Nebula, which has a spidery look about it. Incredibly, if the Tarantula Nebula was as close to us as the Orion nebula, it would appear to us as big as a palmspan across the sky if we held our hand out to the heavens.

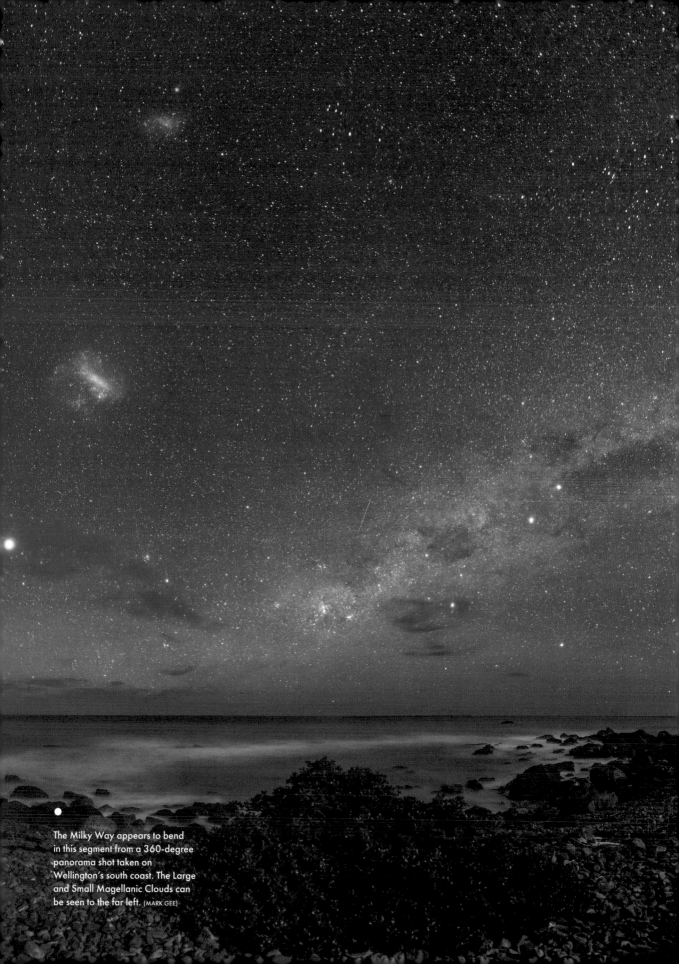

The Milky Way appears to bend in this segment from a 360-degree panorama shot taken on Wellington's south coast. The Large and Small Magellanic Clouds can be seen to the far left. (MARK GEE)

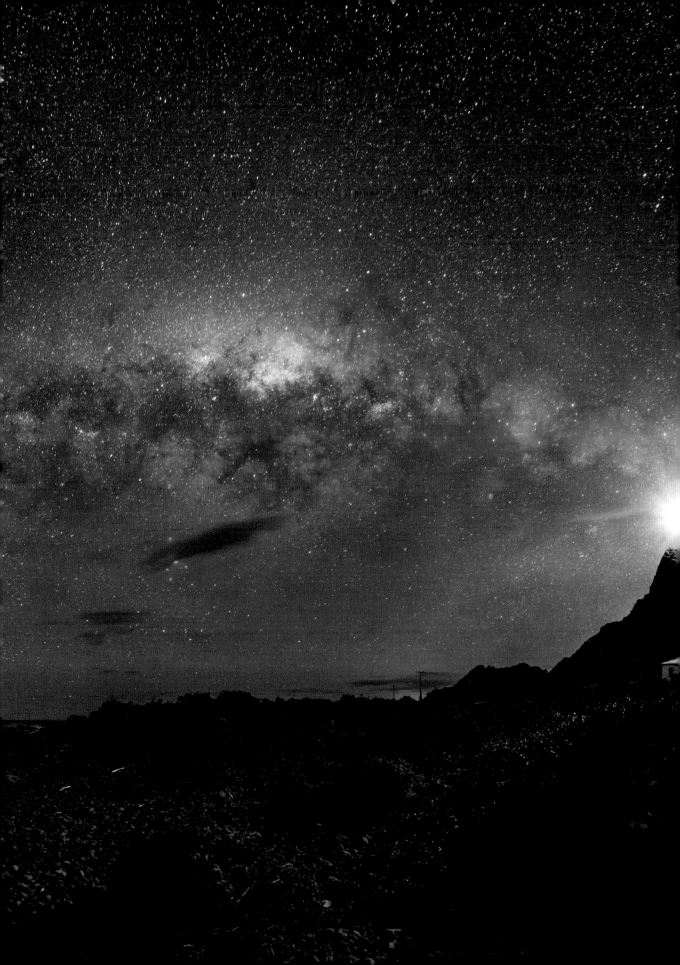

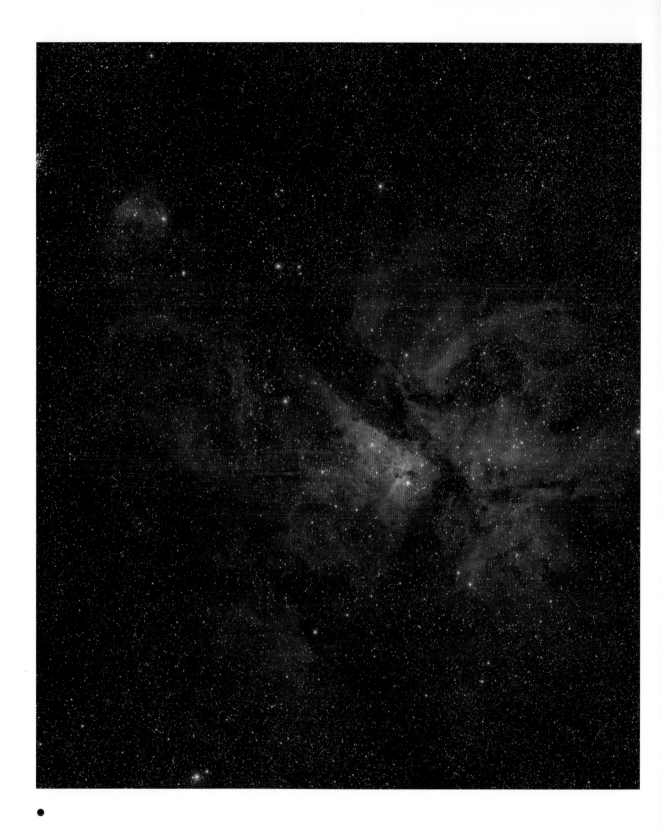

The gas clouds of the Eta Carinae
Nebula, approximately 8500
light years from Earth, form one
of the most spectacular sights of
the southern sky. (FRASER GUNN)

ETA CARINAE NEBULA

(Eta Argus)

Eta Carinae exploded 8000 years ago, shooting out dust and gas at more than 600 kilometres per second. In April 1843, astronomers suddenly noticed that the star had grown a lot brighter, but then it faded and by 1900 was invisible to the naked eye. (The sudden increase in luminosity was due to an outburst in which Eta ejected 10 solar masses' worth of matter into the nebula.) Now we can see it again, in shades of deep red and violet – the gas and dust. The star is 120 times bigger than our Sun. In around a thousand years, Eta Carinae will be bursting into a supernova in an explosion so bright that scientists expect you could read a book by it at night.

This composite of shots taken
by the Hubble is the largest and
sharpest image ever taken of the
Andromeda galaxy, a flat, disc-
shaped spiral galaxy that is the
closest galaxy to the Milky Way.

(NASA, ESA, J. DALCANTON. B. F. WILLIAMS, L. C.
JOHNSON, THE PHAT TEAM, AND R. GENDLER)

·

The
Age
of
Discovery

·

Lighting the way

●

These voyages, ranging around more than half the globe
at a time when Europeans had not yet ventured beyond
the Mediterranean or the coast of their continent, were
analogous in daring and accomplishment to the later
exploration of space. Indeed the Pacific Ocean with its
widely spaced islands dotted across a vast surface, was
a kind of terrestrial mirror for the galaxy, the Milky Way,
which provided Polynesian sailors with stellar markers
for celestial navigation. Peter Buck, the great Māori
anthropologist, called his forebears 'Vikings of the Sunrise'.
He would have done them, and Northern Europeans, greater
honour had he referred to the Vikings as Polynesians.

MICHAEL KING, *THE PENGUIN HISTORY OF NEW ZEALAND*

●

The Pacific was a highway for the first people who lived there, and as well signposted as our road networks today. Rather than keeping people apart, the waters of the ocean connected them. New Zealand historian Michael King writes that there is evidence the people of Polynesia were making 'extraordinarily widespread return voyages' throughout the central and South Pacific by the first millennium of the Christian era.

With our lack of star knowledge today, it might be difficult for us to understand how they did so – after all, the Pacific is the world's greatest ocean, covering 30 per cent of Earth's surface. In 1956, English geographer and science historian Eva Germaine Rimington Taylor wrote about how the ordinary human being has long been separated from personal reliance upon the stars, depending instead on astronomers, mathematicians, clockmakers, calendars and instruments to tell them what they need to know. Because of this, she said, 'he himself never has occasion to consult the sky [and] finds it impossible to imagine how the seaman makes his confident way across the pathless and unpeopled ocean waters'.[1]

But, for those who know the night sky intimately, the ocean is not as scary or impassable as we imagine, marooned as we are on tiny islands in its deep blue immensity. The navigators of sometimes-massive double-hulled ocean-going canoes used every piece of information available to them to track where they'd come from, where they were going, and how to get there safely: clouds, bioluminescence, winds, animals, birds, current flow and temperature … and the Sun, the Moon and the stars.

Wayfinding

In some parts of the Pacific, astronomy and navigation are so closely intertwined that the navigators *are* astronomers. The science of astronomy *is* the science of navigation. As the ones to bring their people safely home, navigators are held in the highest regard. In 1960, University of Otago historian Gordon Parsonson wrote:

> The inhabitants of Oceania, it is clear, had been from time immemorial denizens of the sea. They passed their days on heaving canoe platforms, or on small islands hemmed in by closely circumscribed clan boundaries or narrow atoll shores, surrounded by a vast ocean upon which they were almost entirely dependent. They thus viewed it with an indifference born of familiarity and of complete acceptance. There can be no gainsaying their mastery of their environment.[2]

The first Europeans to encounter the inhabitants of Oceania found this difficult to grasp. When they visited the Pacific islands, they were flummoxed by their hosts' obvious seafaring capability, with their simple canoes and lack of navigational instruments. They couldn't possibly have sailed there with these Stone Age tools, the Europeans said. So they created theories to match this disbelief.

In the sixteenth century, Portuguese explorer Pedro Fernandes de Queirós was involved in Spanish voyages into the Pacific to search for the reputed Terra Australis Incognita, the unknown southern land. He was the first recorded European to set foot on the Cook Islands, and in 1597 the first to argue that the Polynesians could not have accomplished what they had. Surely, he believed, they must have island-hopped or walked along a still-undiscovered continent, and peopled and discovered the islands by accident, as he did not believe the winds were favourable or their skill equal to sail. He wrote:

> It may be religiously believed, that there are to the SE, S, SW, and more westward, other islands which lye in a chain, or a continent running along, till it joins NEW-GUINEA, or approaches the PHILIPINAS or the SOUTHERN-LAND of the strait of MAGALHANES, since no other places are known, whereby they who inhabit those islands could have entered them, unless by miracle … what can be said of the four [islands] now discovered in so wide and extensive an ocean, inhabited by a people so ignorant, and all those of these parts as much without art as them?[3]

The theory influenced European thinking about the South Seas. There were other explanations, too; French Pacific explorer Jules Dumont d'Urville decided there must have been a sunken continent, and the Polynesians had fled to the mountaintops as the waters came in. Another asserted they had been dropped off in the islands by Spanish ships, or simply been blown to the islands in their 'frail canoes' by winds during fishing expeditions.

When Cook visited Tahiti to observe the 1769 transit of Venus, he was surprised, too. It was a couple of years after British naval officer Samuel Wallis had made first contact with the Tahitians. Cook learned some rudiments of the language and culture through discussions with Tahitian native Tupaia, who went on to become a vital navigator throughout the Pacific and key to Cook's early arrivals in New Zealand. From Tupaia, Cook discovered how the trade winds changed in that portion of the globe, and learned about the star compass (also known as a sidereal compass), which uses the locations of the stars in the sky as a navigational aid.[4]

In Ra'iātea, Tahiti (which is thought to be the starting point for Polynesian migration to Hawai'i and New Zealand), Cook learned that the winds blew variably in different directions, and that in summer they blew constantly from the west with rain. He wrote in his diary that the inhabitants could sail

from Island to Island for several hundred Leagues, the Sun serving them for a compass by day and the Moon and Stars by night. When this comes to be prov'd—[after 'prov'd' he writes, and then deletes, the parenthesis 'which I have not the least doubt of'] we Shall be no longer at a loss to know how the Islands lying in those Seas came to be peopled, for if the inhabitants of Ulietea [Ra'iātea] have been at islands laying 2 to 300 Leagues to the westward of them, it cannot be doubted but that the inhabitants of those Western Islands may have been at others as far to the westward of them and so we may trace them from Island to Island quite to the East Indies.[5]

Later, however, he would ignore his own evidence and return to the accidental voyage theory so popular in Europe. In 1778 Cook wrote in his journal: 'How shall we account for this Nation spreading itself so far over this Vast ocean?'

For Europeans, ancient methods became useless as the complexity of science developed and the drive to know more took over. A gridded cage of longitude and latitude was set over the world, the forerunner to modern GPS. With a new focus on measurement and mapping, the European seaman's ancient seafaring world 'had been invaded by scholars', as Gordon Parsonson said.

Simple-minded sailors had now to solve not the comparatively simple problem of running in a general direction towards an island or a particular point on a coast—which they knew well how to do—but of establishing its position to a nicety upon a flat map in terms of the intersection of lines of latitude and longitude. They had also to learn how to plot their precise whereabouts at sea, in brief, how to navigate. This inquiry occupied the best brains of Europe for more than 300 years during which men nevertheless continued to find their way across the seas. Even the invention of the chronometer did not wholly settle matters since seamen had still to learn to sail along the hypotenuse of their navigational triangles rather than along the two sides and then to establish a practical means of sailing over a great circle route. When at last this was mastered in the early 19th century, sophisticated Europeans had only arrived at a more complicated method of doing what the Polynesians and the Micronesians, the Arabs and the Vikings had long since achieved.

The key to this paradox lies in the fact that a literate society faces the peculiar difficulty that it must be able to set down on paper, in this case maps, charts and

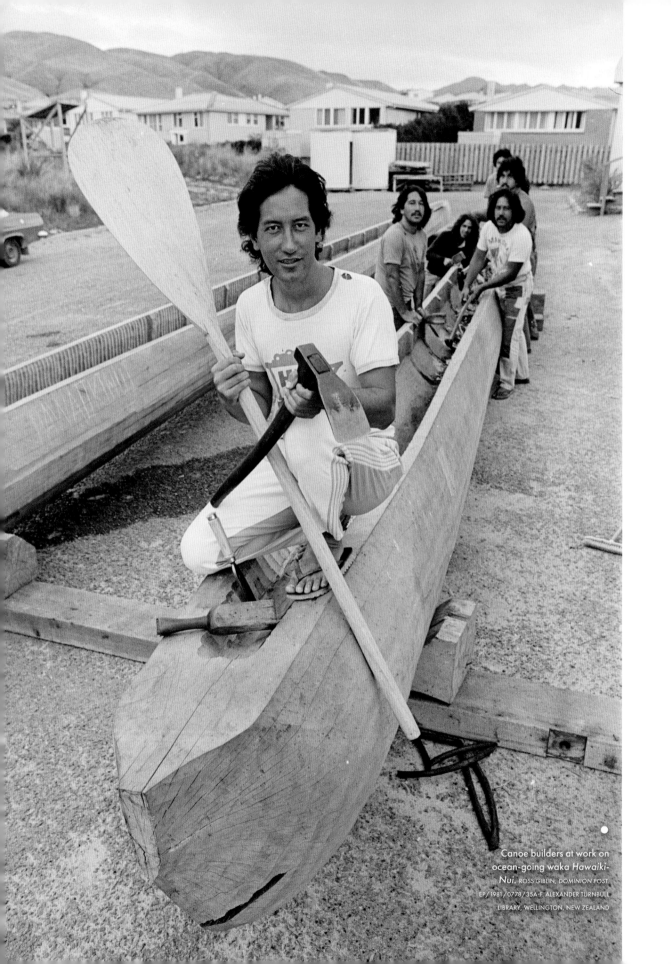

Canoe builders at work on ocean-going waka *Hawaiki-Nui*. ROSS GIBLIN, DOMINION POST. EP/1981/0778/35A-F. ALEXANDER TURNBULL LIBRARY, WELLINGTON, NEW ZEALAND

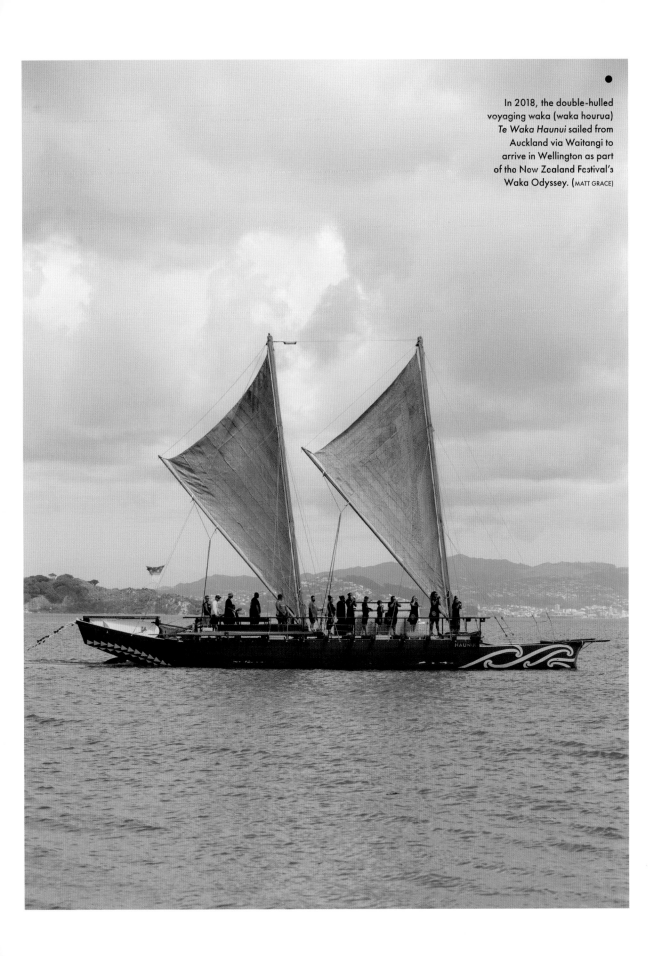

In 2018, the double-hulled voyaging waka (waka hourua) *Te Waka Haunui* sailed from Auckland via Waitangi to arrive in Wellington as part of the New Zealand Festival's Waka Odyssey. (MATT GRACE)

almanacs, what non-literate folk might easily read in the sky and carry in their heads. In the end, it comes to imagine that the job can be done in no other way.[6]

Hence European attitudes to the supposed ignorance and backwardness of Polynesian and later Māori celestial knowledge and associated traditional practice.

This attitude was also reflected in theories of New Zealand and Pacific settlement that assumed Polynesians had in fact once possessed more advanced technology, but in moving to the islands had degenerated. As Victoria University of Wellington Māori history and culture expert Peter Adds says, 'It's somewhat ironic that ... Cook would be in Tahiti in the heart of the Pacific making his observations as a way to measure space, when he was in the middle of some of the greatest navigators ever known.'[7]

Indeed, Cook's companion Tupaia was, according to German naturalist Georg Forster, 'so skilled in this [knowledge of the stars and points of the compass] that wherever they came with the ship during a navigation of nearly a year, previous to the arrival of the ship at Batavia [present-day Jakarta], he could always point out the direction in which Taheitee was situated'.[8]

Regardless, there was a persistent, strongly held belief, dubbed the 'drift theory', that the Polynesians didn't sail to New Zealand on purpose, but instead drifted here on ocean currents. This is most powerfully illustrated by an 1899 painting by Louis Steele and Charles Goldie, *The Arrival of the Maoris in New Zealand*, one of our best-known historical paintings – even in 1930, it was voted the most popular painting in the Auckland Art Gallery collection.

Based on Théodore Géricault's oil painting *The Raft of the Medusa* (1818–19), which depicts hapless survivors of a naval vessel, the work caused a sensation at the time and launched Goldie's career. It shows an emaciated, terror-struck, cannibalised group of Polynesians in a 'mixed-up double Māori canoe of the eighteenth century using a sail form which probably never existed', according to ethnologist David Simmons.[9] As the canoe crests a turbulent swell, an occupant spots land, apparently in the nick of time. It did much to project the image that Polynesians washed up here accidentally, and of Māori as a supposedly dying race.

Today, the painting is considered 'so inaccurate as to be a travesty'.[10] The work did not follow traditional Māori narratives of arrival and settlement, and diminished Polynesian sailing skill and celestial navigation. Māori met it with outrage from very early on. Since then, computer modelling of ocean current patterns has in fact shown that you can't 'accidentally' reach New Zealand from East Polynesia. What's more,

Polynesian explorers are also thought to have populated Enderby Island, far south of NZ, in the thirteenth or fourteenth century, about when mainland New Zealand was first settled. In fact, in 1842 a group of Māori migrated to Enderby and lived there for 20 years (see p. 146). There are also Māori narratives of early explorers sailing south to find great white walls of ice Antarctica – from whence one narrative for the *aurora australis* springs.

So the first people here did not wash up accidentally. They were the recipients of a rich source of knowledge developed by their ancestors as they traded between islands and explored the vast Pacific over thousands of years, voyaging, returning and voyaging again, locating every habitable island in the ocean. The people who became Aotearoa New Zealand Māori arrived in this country in planned migratory waves of settlement – and they did all this by using the stars.

Polynesian navigation techniques

Even Cook, with all the impressive technology of the eighteenth century, needed a clock, sextant and other instruments to fix his location and aim for a point across the distant ocean. So how did the people of the Pacific find their way about the ocean using the sky as a guide? They used their own mental compass, drawn from the heavens.

As well as the Polynesians' own history and traditions, accounts from Europeans' first encounters with the people of the Pacific make it obvious that Polynesians knew their stars as intimately as we might know a street map of our home town today. In 1882, a sailor described the eldest of a group of three small boys from the Pacific's Santa Cruz islands teaching the names of various stars to his younger companions, and was surprised at the number he knew.

> Moreover, at any time of night and day, in whatever direction we might happen to be steering, these boys, even the youngest of the three, a lad of ten or twelve, would be able to point to where his home lay; this I have found them able to do many hundreds of miles to the south of the Santa Cruz group.[11]

The sailing routes between islands are ancient, and are similar to Arab desert-navigating practices as well. Here's how it might have worked if you were an early navigator embarking on such a Pacific voyage.

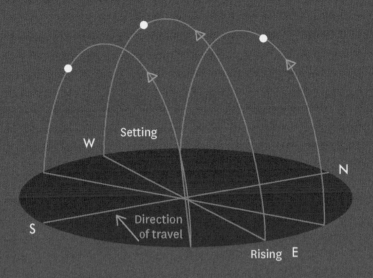

Setting

W

N

Direction
of travel

S

Rising E

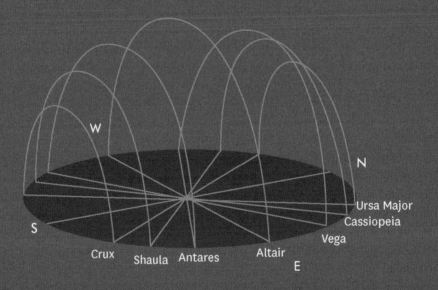

W

N

Ursa Major
Cassiopeia

S

Vega

Crux Shaula Antares Altair

E

Top The stars rise in the east
and set in the west, so if you are
travelling west they will rise behind
you and descend ahead of you.

Above In traditional Polynesian
navigation, the horizon is divided
into points associated with
particular stars. Keeping an eye
on the paths of those stars will
help a navigator stay on course.

Setting off at dusk allows you to still see reference points of land while the first bright stars are shining. For short, known voyages, before your landmarks disappear, you point your bow towards one known guide star on the horizon and look to another at your stern. The guide star rises up from the horizon as Earth turns, and you choose another to replace it. Other stars rising and setting along the horizon serve as reference points. Meanwhile, you factor in all the other information you are receiving about the currents, swells, landforms, winds and animals.

In this way – armed with a formidable library of information and training – you follow a series of stars across the water until a reference star (of which each island had its own) reaches its zenith. With latitude found, you then study the wind and waves to decide whether to turn east or west. The standout navigational stars include Canopus, Orion's Belt, Sirius, Venus, the Pleiades, and the Milky Way's glowing reach itself. Even though you've lost sight of land, the stars provide a reliable path through the ocean (or, for that matter, the desert) in the dark.

As for how the knowledge was taught, Parsonson explains that the system depended on a concept of domelike heavens resting on Earth, creating concentric horizons on its surface.

> In the more democratic Gilberts, the Marshalls and the Carolines, youths were drilled until they had become word perfect in long lists of stars by which courses might be steered to various lands. They then graduated to navigational schools conducted in the great house of the village, the roof with its purlins [beams and framing] serving as an imaginary sky on which the position of the constellations was marked. Every constellation was thus allotted its place in the thatch according to its angular distance from Reigel and its declination north or south of that star, which the pupils, clustered round the central pole of the building, must learn line by line. Only then were the neophytes taken to the eastern beach and introduced to the open heavens.[12]

To understand all this, it may help to recap on how the stars appear to move in the night sky. The first part of this book described Earth within the celestial sphere as being like a marble encased in a bubble dotted with stars in fixed positions. The stars appear to rise and set as you travel over the surface of land or sea, as Earth rotates inside this bubble from day to night, and as Earth moves around the Sun, bringing new seasons in its year-long cycle. The other planets of our Solar System move on their own journeys,

The Māori celestial navigation compass, derived from traditional Polynesian star compasses. (TE ARA – THE NEW ZEALAND ENCYCLOPEDIA)

A waka visualised as the needle at the centre of an imaginary compass. (TE ARA – THE NEW ZEALAND ENCYCLOPEDIA)

with the Sun – 1000 times heavier than the largest planet – holding them in their orbits through gravity. The path that the Solar System bodies, including the Sun and the Moon, appear to take through the sky is called the ecliptic plane.

The Sun always passes steadily from east to west, but the planets don't always move along the ecliptic plane the same way. Sometimes they slow, stop, and even seem to go backwards. This was a mystery until Copernicus deduced that the planets are moving around the Sun in the same direction, but their apparent slowing or retrograde motion is due to the fact that we are on a moving point of view – Earth. This was big news for a world that believed Earth was the centre of the universe.

So if you're an early Polynesian mariner out on the ocean, alone with nothing but blue in every direction, the world becomes a compass face, with the great circle of the horizon divided into 32 segments, and the canoe at the centre, like a needle. (Different cultures also recognised different winds that could be reliably interpreted as originating from these segments.) You can't just look up and know where you are; you need to be constantly observing and comparing what you can see to a large store of knowledge in your memory.

This arrangement is still used today by people reviving traditional Polynesian celestial navigation practices. They call the segments houses, and each house indicates a celestial body's rise and fall on the horizon. If you know the patterns of how the stars, Sun and Moon rise, move and fall during the year, then during a voyage you can figure out which direction they point relative to the star setting or rising in its ascribed house, and which direction you should head, based on how the stars are setting in the houses on the left side of the compass. For example, if your canoe is oriented due south, the Sun will rise in the waka's house of Rā on your left, in the east. If it sets hours later in the house of Rā on your right, you are still travelling due south. To turn south-west, you'd orient the canoe so the Sun is setting in the house at the north-west point of your star compass.

This is not exact; the Sun's rising and setting positions obviously change throughout the year, and cloud cover can obscure all your reference points for days at a time. But the Moon often shines through in bursts, and Society of Māori Astronomy and Research (SMART) staff also point out how the Moon – its movements random and confusing to so many of us – can also help to determine direction. If the Moon in its first or last quarter phase is at its zenith directly above you, then you can get a north–south bearing by drawing a line from one tip of the crescent to the other and extending this line down to the horizon. Direction can then be verified and fine-tuned when the stars shine again.

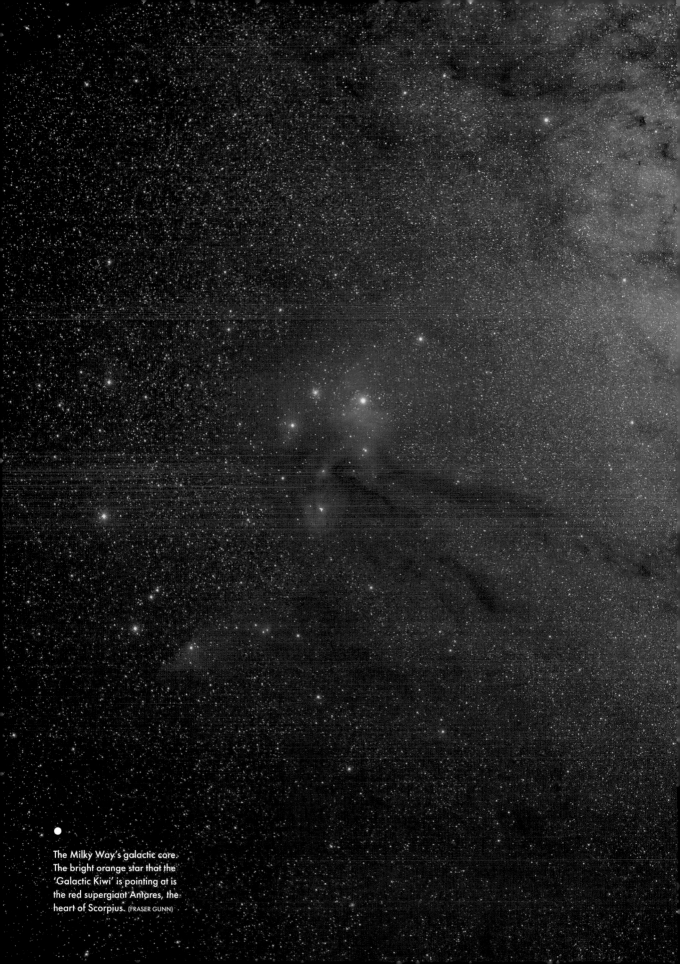

The Milky Way's galactic core. The bright orange star that the 'Galactic Kiwi' is pointing at is the red supergiant Antares, the heart of Scorpius. (FRASER GUNN)

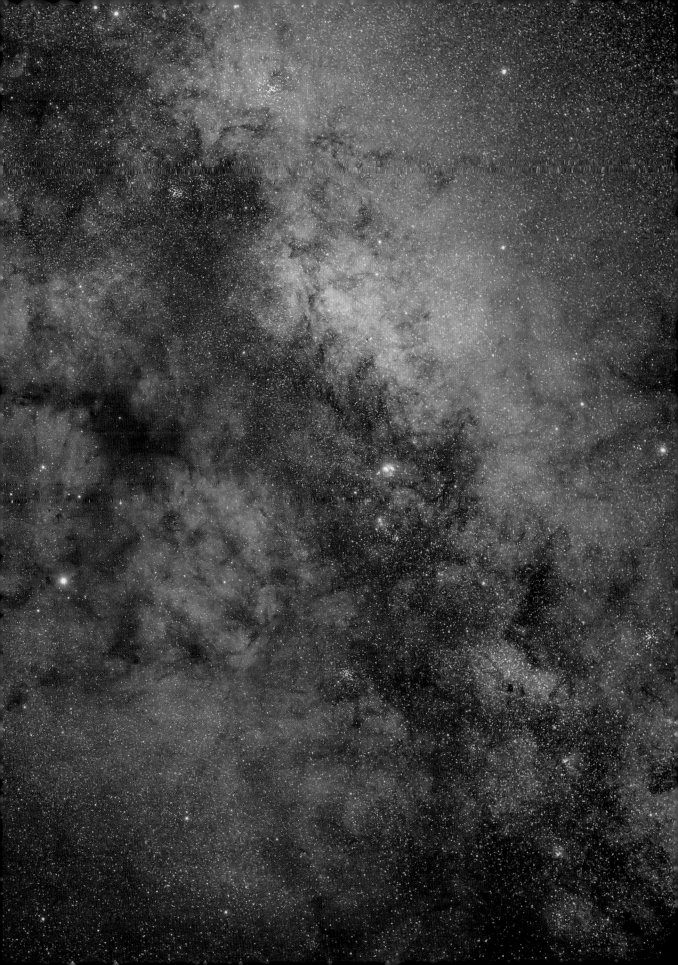

As mentioned earlier, different islands across the Pacific had different stars marking them, called zenith or home stars. These stars were signposts to seafarers and could help determine latitude. New Zealand's is Potiki, or Shaula. When it was overhead, sailors knew they were at the correct latitude for New Zealand and needed only to turn west or east to find land. Hawai'i's was Arcturus (Hokule'a) – sailing south, it would lose its position as Sirius rose. Arriving in Tahiti meant that Sirius was overhead.

However, it can be hard to fix the accurate position of a star when you're bobbing about at sea. An easier method is to measure the angle from the horizon to known star markers indicating the north and south celestial poles. For example, if you are sailing north and see that the bottom of the Southern Cross is six degrees above the horizon, you know you're at the latitude for Hawai'i (six degrees also happens to be the measurement from the bottom to the top of the cross).

As you turn around and sail south over the curve of Earth, the horizon drops to reveal more of the southern hemisphere's night sky, and rises behind you to hide more of the northern. When you are at a latitude of 35 degrees south, the pole star might be hidden beneath the horizon, but you can see the Southern Cross at all hours of the night, all year around, and its distance from the horizon here can tell you how far north or south you have travelled.

To measure distance and degree, Polynesians used their hands as sextants, holding them up to the sky to find the distance between two stars, or between a star and the horizon. Sunrise and sunset were especially important times to take a fix of your position and direction. If you knew the distance between your outstretched thumb and forefinger measured 12 degrees when held against the sky, and that the Sun was currently two of these hands – 24 degrees – above the horizon, and that the point at which it set was a thumb-tip away from Venus as it began to glow in the evening sky, and the Sun was setting in the house of Rā according to the 32-point compass face carved on the waka deck (or inside your head as you faced forward), you could create a reliable mental clock, compass and calendar with no instruments other than your body, brain, songs, stories and training.

In Māori culture, information such as this is passed down through families by song, or from tohunga to student; in Samoan culture it's passed down through tatau, as a tattooed star compass, an encyclopaedia written on the body.

But the compass is just one part of the ongoing calculations required to process the immense amount of information coming in as you sail – information that is invisible to many of us today. The navigators used history, legend, waves, wind, marine animal

behaviour, birds, plant matter, driftwood, building clouds and tipping waves. A large bank of cloud building up on the horizon meant land, because it signified cold air from the sea hitting warm air over land and condensing. Flocks of seabirds – and there would have been billions more a thousand years ago than there are today – meant land was near, too.

The Pacific is also rippled with weather bands and currents that the Polynesians would have understood through hundreds of generations of sailing and voyaging experience. These weather bands are like the swirling patterns of Jupiter, except Earth lacks the thick, ammonia-laden atmosphere to make them as visible from space, and ours are relatively fixed in position and temperament. Water currents and temperature played a part, as well as debris floating in the water that offered clues as to which way the familiar ocean currents were flowing.

Thus, with their deep understanding of how the sky moved, and with a mental map of where the Sun, Moon and each star should be in relation to each other, Polynesians were able to orient the waka in the right direction. Not that it wasn't mentally taxing work for the navigators. They didn't sleep much, if at all. They barely took their eyes off the ocean, and at night they barely lowered them from the sky, constantly adjusting direction as the Earth spun, relentlessly and reliably, inside its celestial sphere.

The voyage to New Zealand

The people who would become Māori have been continuously settled in this country for at least 700 years, sailing from East Polynesia in many waves of migration from about 1300.

Legend says the first explorer to reach New Zealand from Hawaiki, the ancestral homeland, was Kupe, who – as one story has it – left the shores of his island to chase a wheke, or giant octopus, across the ocean to Aotearoa in his waka *Matawhaorua*. Kupe knew, from the annual patterns of migrating birds, that there was land to the south-west. In some accounts, he left with his family; in others, he left with several hundred people to deliberately settle new lands. The stars were his guide, as they were for all celestial navigators leaving the haven of land behind.

However, Michael King, in his *Penguin History of New Zealand*, says that, although Kupe was doubtless an early Māori ancestor who left many place names behind him, the tale of his discovery of New Zealand – including the name Aotearoa – was spread though stories in primary-school textbooks from 1910 to the 1970s. He says

Kupe became a convenient Pākehā narrative that had no basis in Māori tradition, yet nevertheless served a useful purpose in cementing a Polynesian origin story that became so popular it's now accepted as a shared narrative. King cites one 1916 story in particular, saying:

> It was an inspirational account of the discovery of New Zealand. It gave names, Kupe and Ngahue, to Polynesian navigators who would otherwise be nameless. In its full elaboration through a series of adventures around the New Zealand coast involving moa, greenstone and a fight with a giant octopus, the saga gifts New Zealand a founding myth every bit as majestic as the stories that Pakeha settlers carried with them from Europe (Jason and the Argonauts, the labours of Hercules). Its telling was part of a process that fitted Maori tradition into the cultural patterns of late nineteenth- and earth twentieth-century Pakeha New Zealand, which was looking for stories of resonance and nobility to make the human occupation of the country seem more deeply rooted and worthy of pride than it might by virtue of its (at that time) rather thin European heritage... that same account became a source of pride for Maori and an antidote to the concurrent and widespread view that Tasman and Cook 'discovered' New Zealand.[13]

Around the fourteenth or fifteenth centuries the great era of Polynesian voyaging stopped – possibly due either to changing culture or to weather, wind and ocean patterns making journeys more difficult. After Polynesian settlement in New Zealand, the great ocean-voyaging knowledge of the different migratory groups is thought to have weakened. The massive, powerful waka hourua (double-hulled sailing canoes) were no longer needed, and much of this celestial navigation knowledge was gradually lost from New Zealand. SMART researchers estimate the intricate knowledge guiding the great waka navigations may have lain dormant among Māori for a thousand years. But it was replaced by other celestial knowledge, developed and honed to suit life in their new southern homeland.

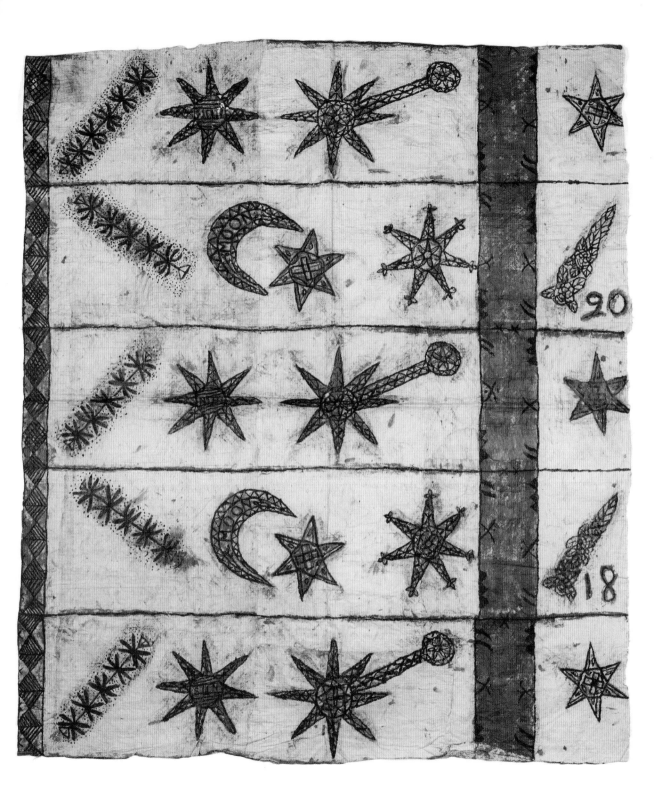

A fragment of a large Tongan tapa cloth made of bark and dye in 1911 to commemorate the 1910 sighting of Halley's Comet. (MUSEUM OF NEW ZEALAND TE PAPA TONGAREWA)

Māori astronomy

●

It is assuredly a fact that in former times the average Maori knew much more about the stars than does the average man among us. When one comes to peer into native beliefs and practices in their systems of astrogeny, sabaeism, astrolatry, and natural astrology, it is then that one sees how closely the Maori of yore must have studied the heavenly bodies, but more especially the stars. There is not only the empirical aspect of their knowledge to survey, but also the genuine form illustrated by the use of the heavenly bodies in navigation and in their system of regulating time.

ELSDON BEST, *THE ASTRONOMICAL KNOWLEDGE OF THE MAORI* (1922)

●

He tātai whetū ki te rangi, mau tonu, mau tonu
He tātai tāngata ki te whenua, ngaro noa, ngaro noa

The starry hosts of heaven abide there forever, immutable;
The hosts of men upon this Earth pass away into oblivion.

WHAKATAUKĪ (PROVERB), ATTRIBUTED TO HARE HONGI,
NGĀPUHI GENEALOGIST AND TRANSLATOR

Once they arrived in New Zealand, Polynesians adapted to the needs of their new home and developed a rich astronomical knowledge and practice called tātai arorangi. Early Māori knew the heavenly bodies and their movements intimately, gathering all the information about the Sun, Moon and stars that was possible: when and where they rose and set, how they moved in relation to each other, their colour and appearance, and associated seasonal changes on Earth. They were much closer to the celestial bodies than we are today, and the stars influenced every aspect of life. The heavens were a clock, map, hunting diary, almanac, family tree and calendar.

But there was no single way the first people of Aotearoa New Zealand read the skies. Nor was there a set of agreed-upon names, as there is in European scientific tradition today. New Zealand's gradual colonisation by different Polynesian groups over centuries, and the subsequent changes in isolation and intermingling, meant heavenly myths developed at different times in different places. There are similar themes and names, but no unifying consensus.

For example, Elsdon Best lists the Magellanic Clouds – large, small and together – under 31 different names, including Kokirikiri, Ngā Pātari, Pātari-kaihau, Tiripua, Whakaruru-hay, Aouri and Aotea. Pleiades was known not solely as Matariki but also Hoko-kūmara, in relation to the harvest of this essential food supply. Which stars to include in constellations or groups varied as well.

It would also be a mistake to think of Māori star learning as primarily Polynesian celestial navigation. Though you don't sail the oceans of the Pacific and settle the challenging land of New Zealand without a profound scientific understanding of the natural world, that is just one small part of the rich knowledge of kōkōrangi (astronomy) that made it possible for Polynesian people to survive in the Pacific, and later for Māori to live in New Zealand. A hapū needed the stars to navigate far less often than they needed them to know when to plant, harvest, fish, predict the weather, or track bird and animal behaviour. Different tribes had different traditions and knowledge depending on the demands and idiosyncrasies of their local area. Māori star names, groupings and meanings are therefore complex and malleable, and, for each iwi and hapū, closely pinned to the environment in which they made their home.

Maori astronomy expert Dr Rangi Matamuo says there are several terms to choose from when it comes to Māori astronomy, with progressive degrees of complexity and thus levels of sacredness. 'Mātai whetū', which means simply 'to stargaze', is more of a lay term – when most people look at the stars and wonder about them, they are doing this. 'Tātai arorangi' is related to the phrase 'tātai whakapapa' – to arrange, recite,

list, name, or set genealogies in order – and means 'to arrange and order the stars'. It is also related to kauwaerunga, or knowledge of creation, time, the gods and the stars themselves. Meanwhile, kōkōrangi is a technical term meaning astronomy: the scientific observation of the heavens.

Everyone can mātai whetū, and anyone can tātai arorangi, but only tohunga tātai arorangi and tohunga kōkōrangi – astronomical experts – can read the sky and deduce the clues that were so crucial to helping the first people to live successfully in Aotearoa New Zealand. Every main community had its own astronomical expert. They also had a whare tohunga kōkōrangi, a house of scientific star learning and a place for knowledge to be passed on. It was a high-status occupation; a tohunga kōkōrangi was interpreting the wishes and desires of the gods, after all. Elders carrying this knowledge were the first astronomers, and, as Māori astronomy expert Dr Rangi Matamua points out, they were learned people – scientists. Using observation and knowledge of the natural world, they were able to decipher the human world.

Sadly, much of this knowledge has been lost through colonisation, the imposition of Christianity, loss of traditional lands and urban migration, scattering whānau and disconnecting them from traditional ancestral history and practices. Colonisation has disrupted, if not destroyed, many oral pathways through which Māori traditional knowledge was remembered, protected and shared for following generations. When European settlers arrived, they brought with them new diseases and new religion, two of the most destructive forces that indigenous peoples have ever encountered. Dr Pauline Harris (Ngāti Rongomaiwahine, Ngāti Kahungunu), a Wellington astrophysicist and chair of the Society of Māori Astronomy Research and Traditions (SMART), estimates that by the 1980s 'just a handful of individuals scattered throughout Māoridom maintained some form of traditional knowledge of Māori astronomy'.[1]

In the subsequent drive for assimilation, traditional cultural practice and languages were forbidden or discouraged through education and legislation; Western science, religion and thought became the dominant methods of understanding the world. Missionaries discouraged traditional karakia relating to crop growth, many of which invoked the power of the heavens. 'By the 1850s,' states a paper from SMART, 'in many tribal districts the pre-colonial system of growing and harvesting crops had already been abandoned in favour of the promise of economic prosperity associated with a European lifestyle.'[2] This meant the astronomical knowledge so closely tied to crops was lost too.

So, knowledge today is severely hampered by lack of records, and few Māori now live in traditional settings. Two hundred years of intermingling of Māori and

Europeans means oral knowledge will be corrupted in any case, and thus 'any attempt to investigate true pre-colonial Maori astronomical knowledge can be challenging'.[3]

Some Europeans did document some Māori astronomy, and Elsdon Best is one of the best known of these early recorders. But New Zealand astronomy researcher Wayne Orchiston has found Cook, d'Urville and du Fresne said nothing about Maori astronomy in all their documents, logs, journals and publications – which he finds 'sad', because astronomers were on all three of Cook's voyages. Indeed, much of the material, he says, is 'superficial, contradictory or downright unreliable', and only fragments of Māori astronomical knowledge have survived colonisation.[4]

The most comprehensive published account of Māori star lore belongs to Best, who died in 1931. His records are rich with the racism and condescension of the time and have gaps that he himself admitted made his records 'meagre and unsatisfactory'. Wayne Orchiston points out that, although Best's overview may be fine for basic astronomical knowledge, 'when it comes to Māori perception of the cosmos, its creation and its evolution, how much is truly "traditional" and how much is an amalgamation of pre-European concepts and elements of Christian-based religion and European scientific precepts?'[5]

But Best's works are among the few written insights we have into how some early Māori used the sky, as well as how they thought about the stars and the impact they had on their lives, though the sources and accuracy are disputed by some Māori today.

Some star knowledge remains – either recorded, embedded in culture, song and landscape, or passed into common knowledge, such as with Matariki celebrations today. Oral histories – incantations, songs – preserved the whakapapa of the stars and other astronomical knowledge. It was precious lore passed down to chosen tohunga kōkōrangi, who would recite cosmogenic genealogies, sometimes with memory prompts such as a ritual, weaving, carving or moko. Names could be chanted to find a route across the land, and the tohunga were an oracle for good times and bad.

As SMART researchers have found in a review of Māori astronomy, this led to a unique astronomical language that passed into Māori idiom, whakataukī (proverbs), moteatea (chants), waiata (songs), incantations and laments, some of which are scattered throughout this book. In the same way, Europeans use 'disaster', 'stellar', 'star-crossed', 'looney' (from Latin *lunaticus*, 'moonstruck') or 'once in a blue moon'. And when Europeans arrived in the latter half of the eighteenth century, Māori also began to read and write, preserving their own oral astronomical stories as well as sharing them with newcomers who wrote some of it down as well.

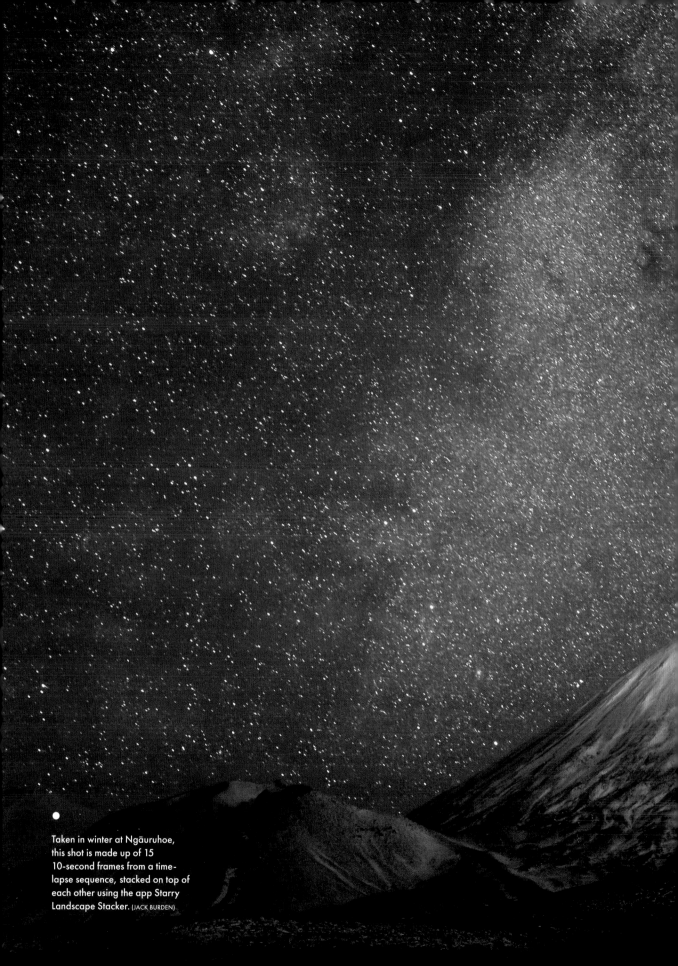

Taken in winter at Ngāuruhoe, this shot is made up of 15 10-second frames from a time-lapse sequence, stacked on top of each other using the app Starry Landscape Stacker. (JACK BURDEN)

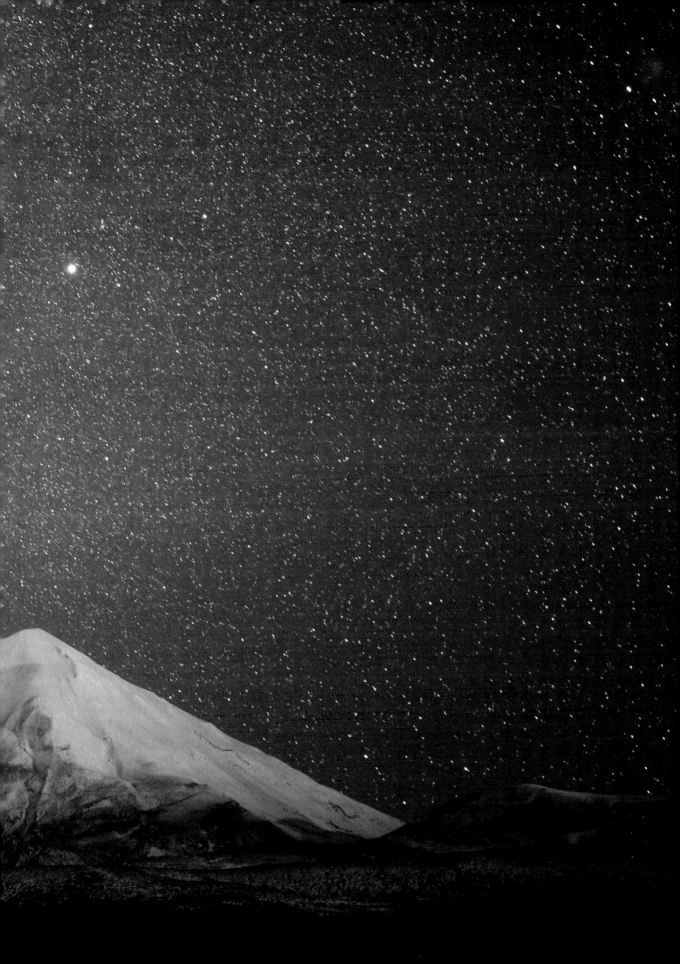

Like many indigenous cultures across the world, Māori are now reclaiming traditional knowledge that was disrupted or lost to colonisation, and astronomy is no exception. The Maori New Year, traditionally signified by the heliacal (dawn) rising of Matariki, grew in popularity in the early 2000s, and this has spurred interest in tātai arorangi.

Though no one Māori star narrative can be said to be definitive, this chapter offers an overview of Māori astronomy and how it ordered the Māori world view, and tells some of the stories and meanings associated with the stars. Some of these stories come from conversation with Dr Matamua, who regularly travels the country sharing the knowledge of his ancestors. As he says, it is vital that Māori are the ones to tell Māori stories.

Creation

Ko Te Kore (the void, energy, nothingness, potential)

Te Kore-tē-whiwhia (the void in which nothing is possessed)

Te Kore-tē-rawea (the void in which nothing is felt)

Te Kore-i-ai (the void with nothing in union)

Te Kore-tē-wiwia (the space without boundaries)

Na Te Kore Te Pō (from the void the night)

Te Pō-nui (the great night)

Te Pō-roa (the long night)

Te Pō-uriuri (the deep night)

Te Pō-kerekere (the intense night)

Te Pō-tiwhatiwha (the dark night)

Te Pō-te-kitea (the night in which nothing is seen)

Te Pō-tangotango (the intensely dark night)

Te Pō-whawha (the night of feeling)

Te Pō-namunamu-ki-taiao (the night of seeking the passage to the world)

Te Pō-tahuri-atu (the night of restless turning)

Te Pō-tahuri-mai-ki-taiao (the night of turning towards the revealed world)

Ki te Whai-aō (to the glimmer of dawn)

Ki te Aō-mārama (to the bright light of day)

Tihei mauri-ora (there is life)

– Māori creation story

Although accounts between iwi vary, one common theme is that the origin of the universe begins with the void, and moves into the night, then to the creation of the sky father Ranginui and the Earth mother Papatūānuku. They had tamariki (children), who were trapped between their bodies; but one son, Tāne, god of the forests and birds, forced his parents apart, effectively creating the sky and Earth. Two of Tāne's siblings, Tangotango and Wainui, produced Ngā Whetū (the stars), Tamanuiterā (the Sun), Te Marama (the Moon), Hīnātore (phosphorescence) and people.

Tāne asked Tangotango and Wainui to give the Sun, Moon and star children to him, so he could place them upon the body of Ranginui, decorating him. His relative Tamarēreti helped him with this task, using his canoe, *Puna Ariki*, into which they placed three baskets. Two had the Sun and the Moon, and the third contained all the stars found in the Milky Way, Te Mangaroa. Canopus (Atutahi), the oldest, was hung on the outside of the basket, and he is still the brightest star outside the Milky Way.

Māori wharenui (meeting houses) were aligned with the positions of sunrise and sunset on the horizon, with the front porch always facing the rising Sun. This reflects the creation story of Ranginui and Papatūānuku, with Papa being the land on which the structure, Rangi, was built, representing Tāne's forcing apart of Earth and sky, and the subsequent creation and division between light and darkness. The path the Sun took through the sky was Te Ara Whānui a Tāne – Tāne's backbone – and at the winter solstice and Māori New Year the Milky Way, gleaming in the night, lies along this same path. This position of the Milky Way was sometimes featured on the wharenui's central ridge beam, and rafters were sometimes painted to resemble star groupings and patterns that tell of seasonal food sources.

The sky itself was visualised as an arch spreading high over Earth, a physical barrier that had to be breached to voyage beyond the horizon. James Herries Beattie, a contemporary of Elsdon Best, recorded stories of South Island tribes who thought the sky was a bowl that came down to the horizon, but when they reached its 'bounds', found they could indeed get through. Māori separated the heavens into different parts, depending on the tribe; the origin myths of objects in the heavens differ according to region. Best tells the story of the Bay of Plenty Ngāti Awa people, who understood that Ngā Whetū, Te Marama, Te Rā and Hīnātore were the tamariki of Tangotango (alternation of light and darkness) and Wainui (the personification of the ocean), themselves the offspring of Ranginui and Papatūānuku, along with Tāne. (Tangotango is also known as Tongatonga, and Turangi.) They say Tāne took these children and placed them on the chest of his father in the sky, bringing light and then the world.

Other iwi include different heavenly bodies on the family tree, including Rona, the woman in the Moon; Te Ikaroa, the Milky Way; and Whiro, personification of darkness and evil. Specific constellations also play a role for some: for example, Puanga (Rigel), Takurua (Sirius) and Matariki as the children of Raro, who personifies the underworld. Others tell of Matariki, a younger brother of Tongatonga, who was taken to the Milky Way to care for the whānau punga (stars), protecting them from being jostled by elders and falling out of the sky.

When a chief, or ariki died, he became a star in the sky – wheturangitia – as in the beginning of a lament by Nawemata of Ngāpuhi for her husband, killed at Ruapekapeka in 1845.

> Tērā te whetū e, kapohia ana mai,
> Ka rumaki Matariki, ka rere Tāwera,
> Kapohia, e hine, te atarau o te rangi,
> Kapua whakatū i runga o Tapuae,
> To tupuna ra e, e moe whakaurunga.

> There is the star, flashing,
> Matariki has set, Tāwera is high,
> O girl, the lights of the heavens are flashing,
> Clouds are standing on Tapuae,
> Your ancestor there, sleeping in the heavens.

It's hard to overstate how essential the movements of the stars, planets and other celestial objects were to early Māori. They counted more than a thousand stars and, as their movements appeared to correlate with seasonal changes on Earth, they signalled when and to whom to pray, when and whom to marry, when to fight, and when to seek peace. The stars advised how to survive; when things were flowering, spawning or fruiting; when the weather was changing; and how the land would react.

The stars are both atua (in the sense of ancestors with supernatural influence) and whānau. They are deeply personal for Māori, some of whom can whakapapa back to the universe's creation. Ngā Rauru tohunga and Anglican priest Rangiahuta Alan Herewini Ruka Broughton wrote of his people that 'they may be regarded as a progeny of both human and divine parentage'. Genealogies can begin in the dark, at the formation of the universe itself, and continue through the ages, with the evolution

of life and the emergence of humankind reflecting the seasonal cycles of the year. In this, Māori developed their own understanding of what science knows to be true today – that we, and everything in the universe, are all products of the Big Bang, made up of the same elements as the stars themselves. Though the creation stories containing cultural knowledge vary from iwi to iwi, there are broad themes, as well as similarities to one another and to modern science, which is catching up to what Māori have always believed and practised. Māori legends include the singularity, compression, the pushing apart, the creation of matter and objects of deep space, echoing elements of astrophysics.

You can even hear echoes of Māori astronomical knowledge and beliefs in the words of astronomer Carl Sagan, who entranced a generation of viewers with the wonders of the natural world in the ground-breaking 1980 television series *Cosmos*. 'The nitrogen in our DNA, the calcium in our teeth, the iron in our blood, the carbon in our apple pies were made in the interiors of collapsing stars,' he said. 'The cosmos is also within us. We are made of star stuff. We are a way for the cosmos to know itself.'

The division of time

The Moon, Marama, holds great importance to Māori. A distinguishing feature of the Māori division of time is that they used a lunar calendar (maramataka) to control when they planted, harvested and hunted, and to help them monitor seasonal change and observe rituals – traditional methods still followed today by some modern gardeners and fishers. The new month was the time after the new moon, when it was said to have died and gone to bathe in the life-giving waters of Tāne – Tāne te Waiora.

In the Western solar division of time, the Gregorian method of timekeeping means the clock rules everything. Today, we use a solar calendar that has 365.25 days in our year, but for early Māori time followed a 354-day year and a monthly lunar cycle of 28–32 days. To bring the moon calendar into synchronicity with the stars when the new year arrived, some sources say that every three years there was a thirteenth month, which reset the calendar at the time of Matariki.

Today, we have developed a more 'accurate' method of timekeeping based on Earth's trip around the Sun, and have separated ourselves from our food supplies to such a degree that we no longer need to monitor the weather, phases of the Moon or time of the year to survive. Thus time passes regardless of what is happening in the world. But when you follow a lunar calendar, you fit into the environment, using it to direct everything in your life. This once held true for many cultures around the world, and still

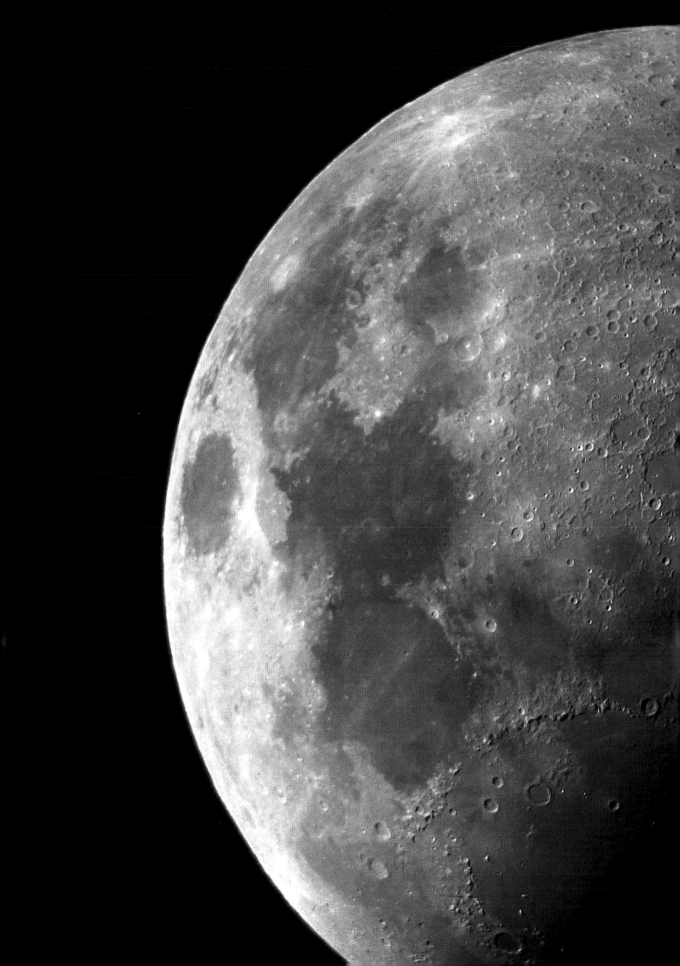

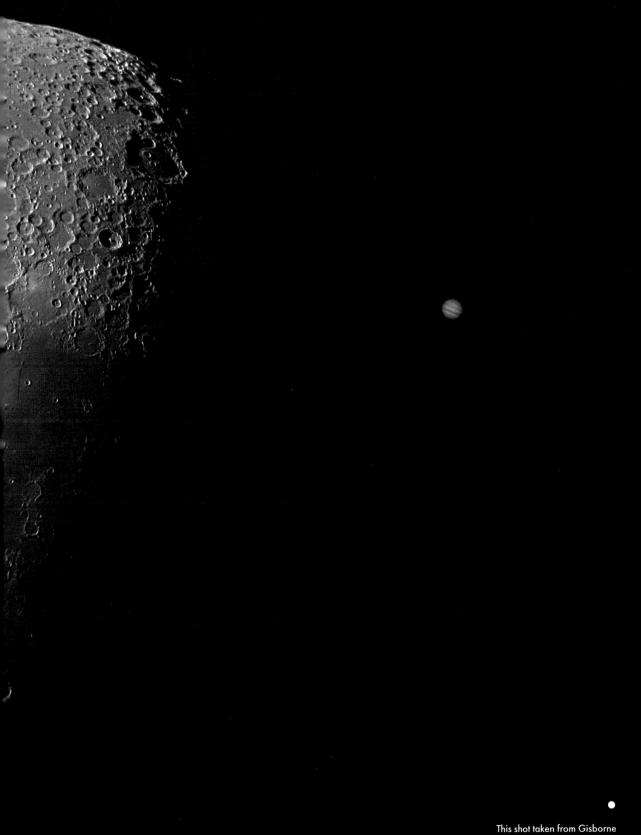

This shot taken from Gisborne
shows our Moon, with Jupiter
far in the background. You can
just make out the faint stripes
of Jupiter's famous weather
bands. (JOHN DRUMMOND)

does for some today. Māori do not separate time, environment and location. Stars are literally embedded into the names of the months, and therefore into an understanding of time itself. Elsdon Best recorded an example of this division of time gathered from the people of Tūhoe. (Names with asterisks are also the names of stars.)

1. Pipiri*: All things of the earth are contracted, owing to the cold, as also man.[6]
2. Hongonui: Man is now exceedingly cold, he kindles fires to warm himself.
3. Hereturi-koka: The scorching effect of fire is seen on the knees of man.
4. Mahuru*: The earth has become warmed, as also plants and trees.
5. Whiringa-nuku: The earth has now become quite warm.
6. Whiringa-rangi: Summer has arrived; the sun is strong.
7. Hakihea*: Birds have now settled on their nests.
8. Kohi-tatea: Fruits have now set; man now partakes of the first fruits of the year.
9. Hui-tanguru: The foot of Ruhi now rests on the earth.
10. Poutu-te-rangi: The crops are now dug up.
11. Paenga-whawha: The refuse of food plants is piled on the margins of the fields.
12. Haratua: Crops are now stored in the pits; the labours of man are over.

Other iwi had different star names for the months. Following are some of the names traditionally used by Ngāti Awa, from a March 1901 edition of the Māori-language newspaper *Te Pipiwharauroa*:

> Ko te putanga mai o Matariki te tohu mo te marama tuatahi, ko nga ingoa hoki enei o nga marama katoa: Te Tahi o Pipiri, Te Rua o Takurua, Te Toru Here o Pipiri, Te Wha o Mahuru, Te Rima o Kopu, Te Ono o Whitianaunau, Te Whitu o Hakihea, Te Waru o Rehua, Te Iwa o Ruhi-te-rangi, Te Ngahuru o Poutu-te-rangi, Te Ngahuru ma tahi, Te Ngahuru ma rua.

> The appearance of Pleiades is the sign for the first month and these are the names of all the months: The first is Pipiri, the second is Takurua, the third is Here o Pipiri, the fourth is Mahuru, the fifth is Kōpū, the sixth is Whiti-ānaunau, the seventh is Hakihea, the eighth is Rehua, the ninth is Rūhi-te-rangi, the tenth is Poutūterangi, the eleventh and twelfth months.[7]

Mahuru is the star Alphard, which appears around springtime as the ground is warming. Kōpū is Venus, the morning star, and also the name of the fifth month, around October. Hakihea is the name of the three stars of Alpha Centauri, which look to us as though they are one. Rehua, roughly associated with January, is Antares, a summer star and the brightest in the constellation of Scorpius. Rūhī-te-rangi (about February) is a star in the constellation Te Waka o Mairerangi (part of Scorpius). Finally, Poutūterangi, the tenth lunar month occurring around March, is the star Altair, which is the brightest in the constellation of Aquila.

The seasons, takurua (winter), ngahuru (autumn), koanga or mahuru (spring), and raumati (summer), were also observed when particular stars rose, combined with the position of the Sun in the sky in relation to the two points of the summer and winter solstice (when the Sun is on its furthest path across the sky during each season).

The arrangement of the heavens

Star knowledge was much more fluid for Māori than is reflected in today's 88 official constellations and fixed star names. Stars could have more than one name, or the same name could be given to different stars. Constellations did not have fixed borders, and could overlap, with some stars belonging to multiple constellations. A constellation's name and structure could change from season to season as Earth moved through its yearly cycle.

The sky, so reliable for tracking and predicting the practical and seasonal aspects of life, was also full of instructions for how to navigate the esoteric. It was full of omens, messages, deities, demons, angels. The stars move upon the body of Ranginui, the sky father, in patterns ordained by the old gods. As the stars rose and changed with the seasons, they also appeared to bring food. In his talks with local Māori, Elsdon Best discovered that first offerings were used to keep favour with the gods, such as the first fruits or birds of the season, the first fish caught in a new net, or the first freshly harvested crops. These were combined with rituals chanted by tohunga to ask favour from the stars.

'Connected with the feeling that prompted these offerings was the peculiar attitude of the Maori toward the stars,' he wrote.[8] Many of the most important stars were viewed as the providers of food, influencing its supply or lack thereof; their appearance or arrival in the sky coincided with the seasons or times when certain foodstuffs were available. From Tutakangāhau, of Tūhoe, he recorded one of the chants offered by tohunga at the beginning of the planting season before work began, which listed several star ancestors.

They collected a quantity of new, young growth of plants, &c … took it to the tuahu, where rites were performed, and there offered or fed it (whangaia) to the principal stars, which are styled atua (supernatural beings). The object was to obtain the favour of these atua, the stars that influenced food supplies, that all food products might flourish; also to prevent any pest or malign influence affecting the same. The invocation is as follows:

Tuputuputu atua ka eke mai i te rangi e roa, e
Whangainga iho ki te mata o te tau e roa, e
Atutahi atua ka eke mai i te rangi e roa, e
Whangainga iho ki te mata o te tau e roa, e
Takurua atua ka eke mai i te rangi e roa, e
Whangainga iho ki te mata o te tau e roa, e
Whanui atua ka eke mai i te rangi e roa, e
Whangainga iho ki te mata o te tau e roa, e &c., &c.

The chant continues, naming as above all the principal stars. Tuputuputu is one of the Magellanic Clouds; Atutahi is Canopus; Takurua is Sirius, and Whanui is Vega.[9]

Best also recorded a traditional lullaby, sung by parent to child, that reflects this. He noted that 'ever in the [Māori] mind … was the idea of associating the star or planet with the past, with remote ancestors, or with friends who had passed away to the spirit-world while, or before, the star was invisible'.

I haere mai koe i te ao o Puanga
I te Huihui o Matariki
I a Parearau, i a Poutu-te-rangi.
Ka mutu, e tama, nga whetu homai kai ki Aotea.

You came hither from the realm of Puanga (Rigel),
From the Assembly of the Pleiades
From Jupiter, and from Poutu-te-rangi.
These alone, O child, are the stars which provide food at Aotea.[10]

Celestial phenomena in the Māori world

METEORS

Like many cultures, Māori generally believed the appearance of a meteor or comet was an ill omen, foretelling death, destruction or ill luck. They had a broad view of meteors and comets generally, though early accounts and recordings of beliefs sometimes erroneously combined the two. Meteors had many names across different regions, and could be playful, clumsy children, errant atua (gods), or bringers of good and bad luck.

One story explaining the origin of meteors is that of Te Ikaroa (the Milky Way) and Tamarēreti, who were in charge of the rā ririki (little suns, little shining ones, or children of light) in the sky. The mischievous little stars would sometimes stray, be punished by their elders with a blow, and fall from the sky, becoming matakōkiri, the Darting Ones.[11] Sometimes, they were from the star children cavorting on the robe of the sky father Rangi. A flash across the night meant one of those children had tripped and fallen.

Meteors could also be personifications of ancestors, gods, or omens of a death or change in tribal leadership; when an atua was expelled from the sky for misbehaviour he became a meteor, sometimes visiting Earth below.

Perceptions of meteors bringing good or bad luck varied across regions and could change depending on what the meteor looked like, its direction of travel, and how bright it was. A brighter meteor could mean good luck, which was also the case if it was travelling towards you. A fainter one was a bad omen.

Other meteor origin stories include that from the Ngāti Awa tribe near Whakatane, which says that Taneatua – the tohunga (priest) of the *Mataatua* (one of the seven original waka of the Great Migration) – brought comets and meteors with him from Polynesia, sending them into the new, southern skies. Ngāti Awa call meteors Rongomai, which is a name also used for a comet.

COMETS

Polynesian people saw comets as a haze or fog, having a tail 'like fire-smoke', with a very small body. They also saw different structures in the tails, calling them rays or streamers. Māori in New Zealand had many names for comets, including Rongomai (also a specific name for Halley's Comet), Auahi-roa and Auahi-tūroa ('long smoke tails'), Upoku-roa ('long-headed one') and whetu puhihi ('a star that emitted rays'), a name that incorporates the name for the rays of the Sun, hihi. According to Ngā Puhi interpreter Henry Matthew Stowell (who also called himself 'Hare Hongi'), Halley's

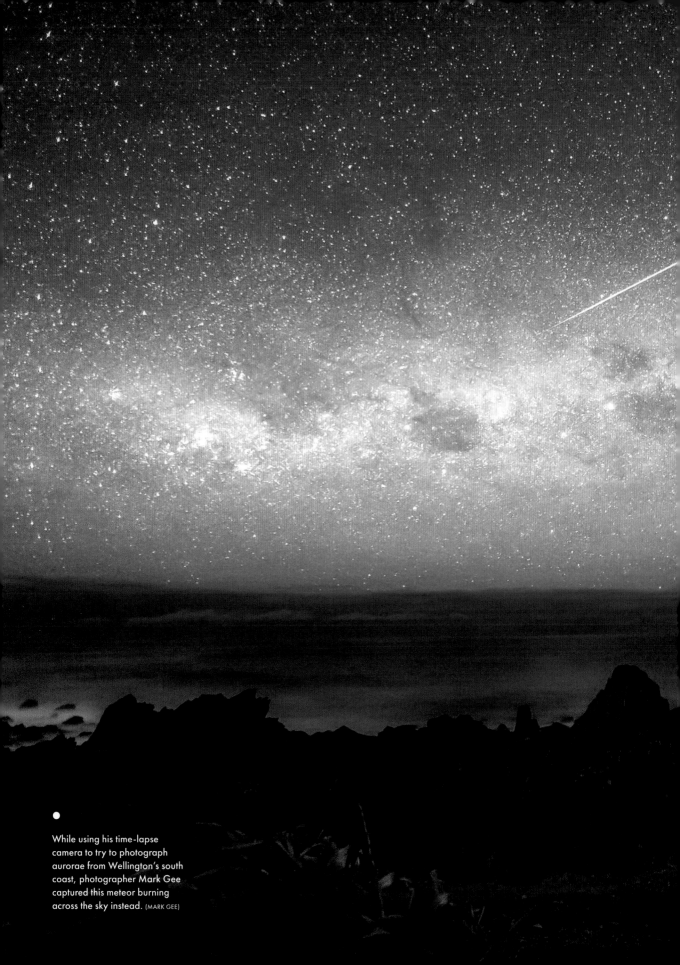

While using his time-lapse camera to try to photograph aurorae from Wellington's south coast, photographer Mark Gee captured this meteor burning across the sky instead. (MARK GEE)

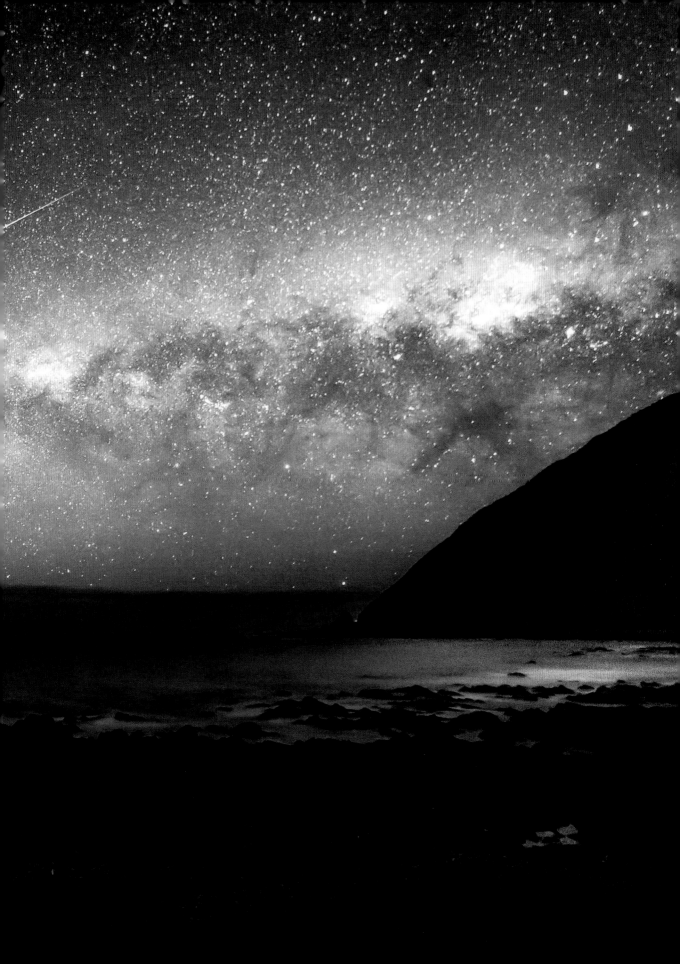

Comet's spectacular appearance in 1910 was also known as Awa-nui-a-rangi, or the 'celestial river of light'.

Comets were often regarded as personified, individual supernatural spirits, with the idea of comets as demons a popular one throughout different iwi. It was thought that humans could command comets through ritual and ceremony. Whether the tail was pointing up or down in the sky could be a good or bad omen, and a comet with an obvious tail of rays predicted a hot summer. If the comet was sparking or flashing, that was a bad sign, whereas a steady-burning tail was favourable.

Tunui-a-te-ika was a malevolent comet demon with a long tail, bright enough to be seen by day. Tunui seems to have been a mercenary who could be summoned up and sent off to maraud and murder in enemy territory. A Tūhoe authority described Tunui as 'not a star, but a spirit that flies through space; it has a big head', and said that its appearance meant that someone had died. In the 1860s, there was a comet in the sky during a battle, and each side took it to mean something different.

There are several Māori legends about the origin of fire, and comets are included in one of them. Auahitūroa, which was often a name for a comet, said to be the progeny of the Sun, was told by his father to go to Earth, proffering a gift for humankind. Once he arrived he wed Mahuika, and they had five fire children, who produced fire for humankind. Fire was sometimes called Te Tama a Auahiroa, 'the son of Auahiroa'.

Halley's Comet (Rongomai) appears in many stories of Parihaka. In the 1870s, after the Land Wars of the 1860s, Te Whiti o Rongomai led a peaceful resistance against the British colonisation of Taranaki, ending in the invasion and occupation of the Taranaki settlement of Parihaka. A large armed constabulary force invaded Parihaka in November 1881, arrested leaders Te Whiti o Rongomai and Tohu Kākahi, raped women, plundered the pā, and evicted hundreds of residents. There is an indelible link between the comet's appearance, Te Whiti, and the Taranaki region, and it appears in other representations of the events at Parihaka as well.

ECLIPSES

For the first peoples of the South Pacific, eclipses of either the Sun or the Moon were unexpected and usually thought to be a sign of death or coming calamity. Anne Salmond, in *The Trial of the Cannibal Dog*, wonders what Tupaia would have made of the Englishmen observing a solar eclipse on an island off Tahiti. The eclipse was a portent of the anger of the gods, but Tupaia looked through the scope at the darkening Sun with interest.

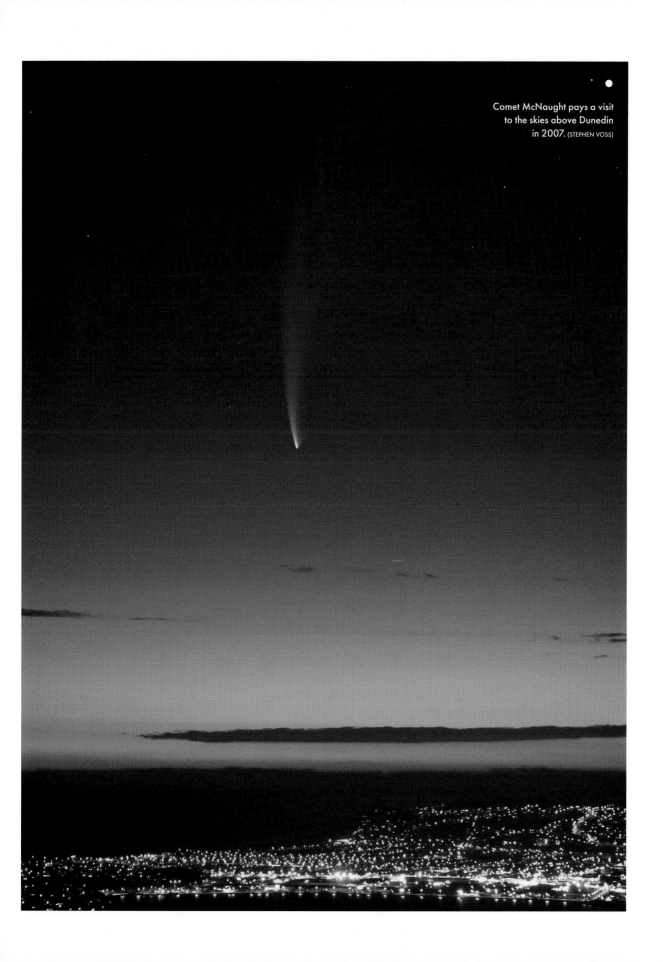

Comet McNaught pays a visit to the skies above Dunedin in 2007. (STEPHEN VOSS)

Elsdon Best records that Māori, who saw the Sun as Te Rā, a grandchild of the sky father Ranginui and Earth mother Papatūānuku, believed an eclipse of the Sun meant Te Rā was being 'attacked and devoured by demons, from which attacks, however, it invariably recovers'.[12]

AURORAE

Though aurorae would have been rarely seen in the more northerly Pacific latitudes, Māori, some of whom sailed far south, knew them as te tahu-nui-a-rangi, 'the great burning in the sky'.

In comparison to, for example, some Australian Aboriginal tribes, aurorae did not hold any serious portents of doom for Māori. One story is that of Māui and Hine-nui-te-pō. James Cowan and Sir Maui Pomare recorded tōtara carvings in wharepuni (sleeping houses) that depicted the demigod trying to pass through the body of Hine-nui-te-pō, the Great Lady of Night, the personification of Death.

> Various interpretations of this ancient myth have been offered, but the original basis of the allegorical tale is lost in the mists of time. Hare Hongi sees in the traditional references to the ihiihi, the streamers or rays of light flashing from Hine, on the verge of the horizon, a reference to the dancing light bars and bands, alternately shooting up and withdrawing, of the Aurora Australis. That way lies death for the daring.[13]

For some early Māori, te tahu-nui-a-rangi sparked a long journey. It was thought that a god kept his temple where the aurora burned in the southern sky, and the sights puzzled tohunga, the holders of celestial wisdom. A great explorer, Tamarēreti, decided to sail south to 'the white land' and discover the aurora's secret.

He sailed in the ocean-going waka *Te Rua o Maahu* (a name also given by some to the Coalsack Nebula tucked into the Southern Cross). Built of tōtara and adorned with plumes of feather and pāua shell, the waka conveyed 70 young chiefs and two tohunga, along with food and fire provisions. In one source, the waka travelled through French Pass in Marlborough and headed for Te Kahui Rua-Māhu. This is another name for the Southern Cross; it translates literally as 'the gathering or constellation of the Coal Sack'.[14]

But on its return, the waka was wrecked on the rocks, and the two exhausted crew members who survived were able to tell the tale. Māori astronomy researcher

Turi McFarlane says this story is embedded more in historical fact than other legends, saying it is universally accepted in te ao Māori (the Māori world) that, upon its return, Reti's canoe *Te Rua o Maahu* brought back with it a 'certain understanding of the physicality of the Antarctic region'.

> The story is brief but concise, the far south was reached as the tale consists of enormous ice cliffs with towering mountain ranges behind them. The ice cliffs were described as having no footing. The season was said to be suited to observation of the Aurora Australis which was a spectacular blaze of colour; and eventually after shortening days the sun disappeared completely, their guide the stars alone. [This] implied that they crossed the Antarctic Circle.[15]

Tamarēreti died, but his memory and feats, and his waka, remain in the heavens. He is remembered in the stars in various ways. One is that the Milky Way represents his canoe, while Scorpius and Orion, which are at opposite ends of the sky, are its bow and stern. The Māori name for Crux (the Southern Cross) is Te Punga, the anchor of Tamarēreti's canoe, the pointers its rope.

Other, possibly related stories say aurorae are the fires of ancestors lost in the cold Southern Ocean, and the smoke and light are from the fires reflecting off the ice. Elsdon Best recorded the story of a Whanganui man who said that when the ancestors arrived 20 to 30 generations ago some stayed in New Zealand, but some continued sailing further south, either in search of new land or simply to explore. Some returned, but others settled in these remote lands. The lights in the skies are the reflection of their fires, signalling to their northern cousins that they need assistance: 'When the light from those appealing fires is seen gleaming in the heavens the Māori knows that the descendants of the castaways are signalling from the drear realm of Paraweranui, but there is no record of any rescue party having sailed southward to help them.'[16]

The legend may have basis in fact. McFarlane also recounts the Polynesian story of Hui-Te-Rangiora, a great explorer who sailed from Rarotonga to the far south of New Zealand in 650 CE. Instead of finding New Zealand, he and his crew discovered 'a white land that was floating' – the icebergs of Antarctica. Similarly, Rarotongans talk of Ui-te-Rangiora, who sailed far south in his waka *Te-Ivi-a-Atea*. He found huge white rocks and white powder on a bitterly cold sea, and this story was commemorated in modern times on the waka *Te Awatea Hou*, built in Marlborough in 1990 for the 150th celebration of the signing of the Treaty of Waitangi in 1840.

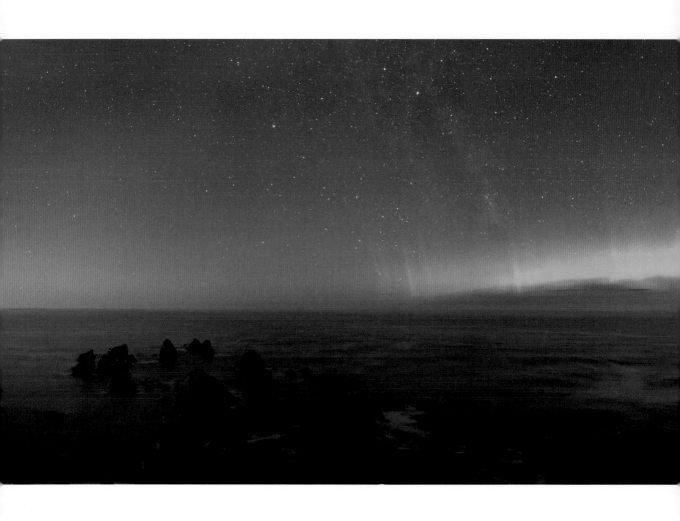

An aurora stretches across the
horizon at Nugget Point in the
Catlins, Southland. (STEPHEN VOSS)

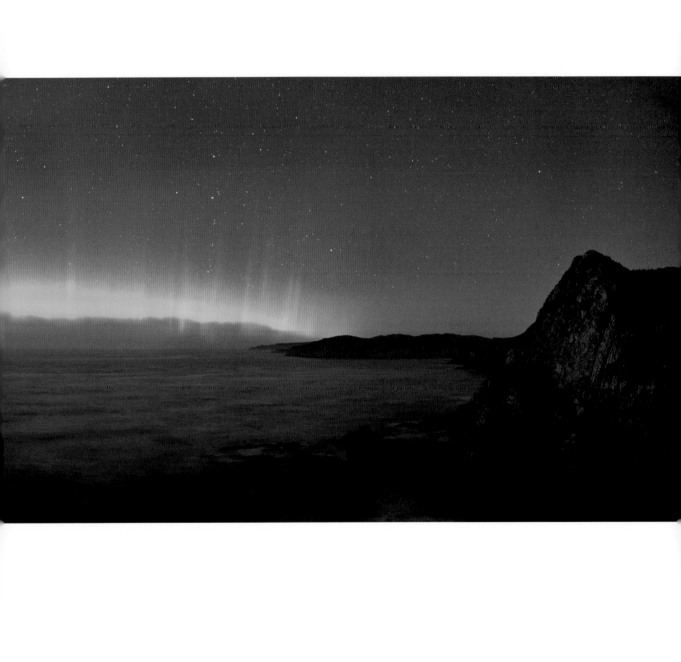

Ui-te-Rangiora called this area of the Southern Ocean Tai-uka-a-pia ('sea foaming like arrowroot'[17]), referring to the ice floes. It is also claimed by some that he reached the Ross Ice Shelf, although he did not land on it.

Some researchers argue that Māori history and connection with the Antarctic has been wiped from the New Zealand consciousness, or never even made it in; the British heroic age of Antarctic exploration supplanting it and in doing so emphasising the continuing histories of the Crown and colonisation.

In 1842, a group of Māori and Moriori from the Chatham Islands settled on the Enderby Islands in the subantarctic Auckland Islands, seeking escape from potential war with the French. They lived on Enderby, 460 kilometres south of Bluff, for eight years, eventually sailing to Rakiura/Stewart Island and then home to the Chathams.

But they didn't know at the time that their cooking fires on Enderby were close to the buried remains of those from another group of Polynesian settlers, who had arrived there 500 years earlier. A 1998 Department of Conservation excavation discovered middens and an oven, and in 2003 archaeologist Atholl Anderson investigated them and carbon-dated the remains to somewhere between the twelfth and fourteenth centuries. Along with charcoal from local trees and brush and burnt hangi (earth oven) stones, there were the bones and remains of sea-lions, fur seals, albatrosses, petrels, fish and mussels. A dog had gnawed some of the seal bones, and the group also made tools and fish-hooks from materials found on the island. They had much the same diet and the same cooking methods as those who settled on the island half a millennium later.

However, there is no sign that those first people lived there for long, nor that they died there. Did they pass through New Zealand? Did they settle elsewhere? Were they lost at sea? For how long did they make cold, tough, inhospitable Enderby their own? It's interesting to consider this settlement in conjunction with New Zealand Māori stories about the *aurora australis* – that the lights were the fires of people who had sailed far south, signals to their northern people for help reflecting off the ice and becoming ghostly streamers in the sky.

●

Rugged up against the cold, two Scott Base staff members stand outside to watch an aurora during the Antarctic winter. (ANTHONY POWELL)

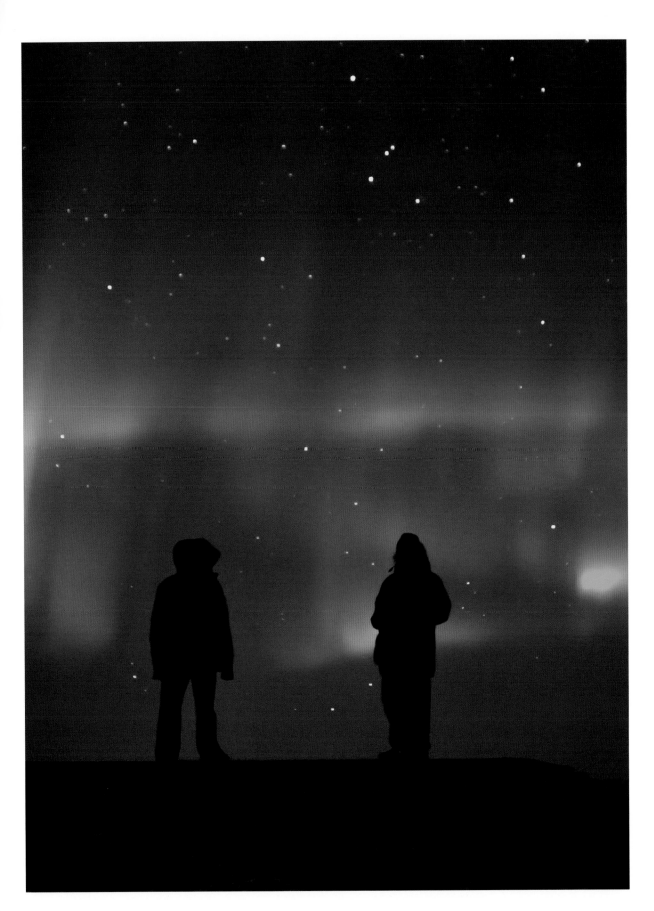

•

Voyage to a new sky

•

New Zealand was peopled because of astronomy. Not only did the heavenly bodies guide the ancestors of Māori across the Pacific to make this land their new home, but it was the planet Venus that was the primary reason for Cook's first voyage to the Pacific, which ultimately laid the foundations of modern New Zealand.

The transit of Venus and the race to measure space

In the southern hemisphere winter of 1769, an extremely rare astronomical event was about to to take place: Venus's orbit would take it between Earth and the Sun and, for about six hours, the star and two planets would form a straight line.

Cook's ship, the *Endeavour*, left Plymouth Dock in August 1768, embarking on what would be a three-year journey. As it did so, Cook carried sealed papers for a second, secret mission – to map *Nieuw Zeeland*, this 'large land, uplifted high', according to Dutch explorer Abel Janszoon Tasman, who had found its edges a century and a half earlier. The central and South Pacific was a mystery to northern minds at that time, with just a few lines drawn on a map. They envisioned it as a place where people walked on their hands, and called it by various names including Terra Australis ('southern land') and Terra Australis Nondum Cognita ('the southern land not yet known'). Cook's

commanders in England believed the transit mission was a good cover for his mission to claim the region before other European powers could do so.

It was a massive investment of resources, at great risk to Cook and his crew, to sail around the globe in order to watch a planet cross the face of the Sun – it was essentially like travelling into space. Why was this so important? Because the measurements taken during the transit would eventually lead to the birth of the astronomical unit (AU) – the distance between Earth and the Sun (also called the solar parallax) – which is the basis for measuring everything else in space. By 1769, thanks to Johannes Kepler's calculations, astronomers knew the distances between each planet and the Sun, and how long each planet took to orbit the Sun, but they didn't know how those distances compared to miles on Earth or Earth's size. Efforts to measure the transit in 1761 had failed, and this was a rare chance for humans to take a massive step forward in their understanding of the universe.

In simple terms, a transit makes this calculation possible because people at different stations on different parts of the globe see tiny, silhouetted Venus – just one thirty-third of the Sun's width – taking different paths as it moves across our home star's massive, blazing backdrop, and starting its transit at different times. (It's a little like having two people standing far apart in a field, both gazing at a house, but having a tractor go past in front – it will interrupt one person's view of the house a few seconds before it crosses the other's line of sight.)

Once you know the distance between the two stations on Earth, in each place you note when the transit starts, time how long the planet takes to cross the Sun, measure the angle at which it travels, and later compare these to measurements taken simultaneously from other places on Earth. Thus, using trigonometry, a big triangle in the sky can be calculated and the distance between the Earth and the Sun worked out.

A transit of Venus has occurred just 25 times in the past 2000 years and is invisible to the naked eye; given that the first telescope was invented in 1608, there have been just seven opportunities to observe it. The year 1769 was the third such occasion, and there wouldn't be another for over a century. It's hard for us to grasp nowadays; when NASA landed another rover on Mars, it beamed back images in real time, though delayed by between 13 and 24 minutes because of the distance. But in Cook's day a transit was a vital chance to take new measurements of space, and Britain was keen to prove its scientific superiority and dominance.

Transits can only occur with Mercury and Venus, the two planets whose orbits bring them between us and the Sun. Where Earth takes a year to orbit the Sun, Venus

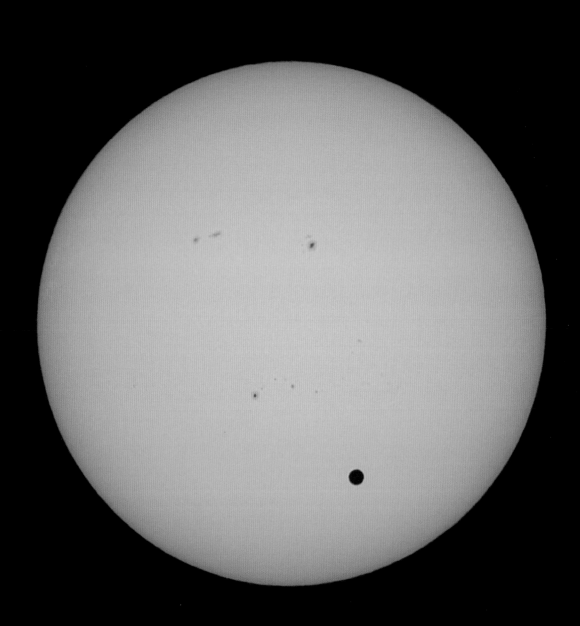

Venus crossing the face of the
Sun, captured in New Zealand
on 6 June 2012. This was the last
chance for most people alive
today to see a transit: the next
pair won't be until December 2117
and December 2125. (STEPHEN VOSS)

loops around in seven and a half of our months. The planets' orbits are at a slight angle to each other, which is why they so seldom line up.

The mathematical quirks of orbit mean that transits of Venus happen in pairs eight years apart, with each pair separated by 105.5 or 121.5 years. The cycle repeats over and over: eight, 105.5, eight, 121.5. Also, the two transits in any one pair occur in the same month. For example, the events of 1874 and 1882 occurred in December, and those of 2004 and 2012 in June. (From June 2012, it will be 105.5 years until the next eight-year pair occurs, in December 2117 and December 2125.[1])

Cook's wasn't the only party setting out to spot the phenomenon. More than a hundred astronomers from several countries dispersed to suitable observation sites around the planet. Luckily for the British, they'd found a new location to complete their set of measurements. In May 1768, Samuel Wallis and the crew of the *Dolphin* had arrived back in England after a trip to the South Pacific, the first Europeans to land in Tahiti. This journey was also vital to Cook's voyages because he met Tupaia, whom Wallis had met on his own voyage. Tupaia would go on to journey with Cook as interpreter and guide.

So there was now a spot in the Pacific from which to observe the transit, along with two other British observation sites in Norway and Canada. Cook was the right person for the job – he had already shown an aptitude for navigation, including astronomy, and the British Transit of Venus Committee chose the Tahitian site as his destination. His voyage was also a chance to test a new method of defence against scurvy, with servings of sauerkraut and malt wort. (Those who refused were lashed.)

When the *Endeavour* made landfall on 13 April 1769, Cook set up a camp and observatory at Matavai Bay, on a black-sand peninsula about eight kilometres from modern Papeete. It was no small operation: the camp had 54 tents for crew, scientists, officers, observatory, blacksmithing equipment and a kitchen. He named the fortified camp Fort Venus and the observatory Point Venus, using casks from the ship filled with wet sand to keep instruments stable. (Point Venus has kept its name to this day and is marked with a large lighthouse, a seaside park, a craft store and a bar.)

It was a beautiful day on Matavai Bay on 3 June. It would have been a long way to sail to be foiled by overcast skies, but the sky was clear, as Cook recorded in his journal.

> This day prov'd as favourable to our purpose as we could wish, not a Clowd was to be seen … and the Air was perfectly clear, so that we had every advantage we could desire in Observing the whole of the passage of the Planet Venus over the Suns disk.[2]

The transit calculations weren't particularly successful, however, with the three separate measurements of three astronomers varying by more than their margin of error; this was due to the 'black drop effect', atmospheric disturbance that appears to bend the edge of the Sun as Venus passes in front of it. As Cook noted:

> We very distinctly saw an Atmosphere or dusky shade round the body of the Planet which very much disturbed the times of the contacts particularly the two internal ones. Dr Solander observed as well as Mr Green and my self, and we differ'd from one another in observeing the times of the Contacts much more than could be expected.[3]

There were also issues in recording, so the Tahitian data wasn't particularly useful. Nevertheless, with data gathered from other parts of the world, astronomers made what would turn out to be a reasonably accurate calculation of the solar parallax, and therefore the Sun's distance from the Earth. Results indicated the Sun was 153 million kilometres from Earth, three million kilometres off the modern measurement and a sound base for astronomers of the time. They could now calculate that Saturn was 1.5 billion kilometres away – stretching the bounds of the known universe.[4]

After the transit was over, Cook opened his sealed set of instructions for the remainder of the trip: to find the great southern continent. In this, Tupaia would be enormously useful, and he was crucial to Cook's success in mapping New Zealand. He was so well thought of by Māori that, when the *Adventure* returned to New Zealand in 1773, a canoe approached the ship, its leader holding up a green bough and calling 'Tupaia! Tupaia!'[5] (Sadly, Tupaia was not there to greet them, having died in Batavia (modern-day Jakarta) in 1770; upon hearing this, the Māori leader asked if the British had killed him.)

In Tahiti, Tupaia immediately proved the depth and complexity of Polynesian astronomical knowledge. He drew a chart showing all 130 islands within a 3200-kilometre radius, naming 74 of them. He was a master navigator, trained in celestial navigation, cosmology, genealogy and more. He knew the bearings of the islands, how long it would take to sail to them, and which constellations and path to follow to arrive at each one.

Cook didn't discover a great balancing southern continent for Britain. Rather, on 6 October, he sighted the tip of a submerged continent: New Zealand. Two cultures, with vastly differing astronomical histories and beliefs, were soon to make their first full encounter.

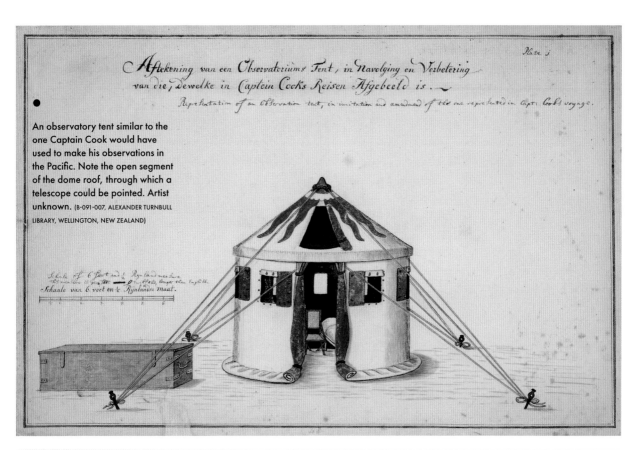

An observatory tent similar to the one Captain Cook would have used to make his observations in the Pacific. Note the open segment of the dome roof, through which a telescope could be pointed. Artist unknown. (B-091-007, ALEXANDER TURNBULL LIBRARY, WELLINGTON, NEW ZEALAND)

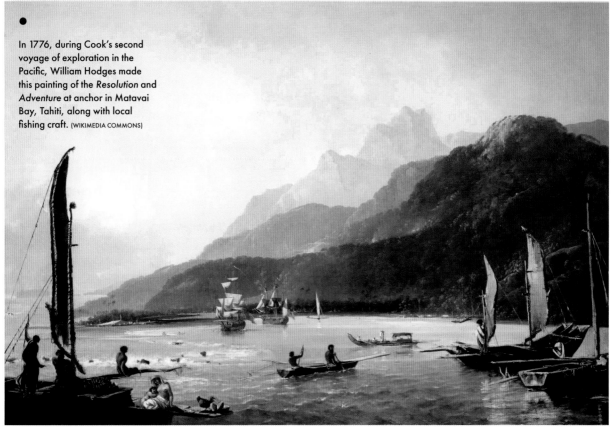

In 1776, during Cook's second voyage of exploration in the Pacific, William Hodges made this painting of the *Resolution* and *Adventure* at anchor in Matavai Bay, Tahiti, along with local fishing craft. (WIKIMEDIA COMMONS)

Mapping the stars, mapping the land

Cook and his crew were New Zealand's first European astronomers, and his voyages to the South Seas were scientific expeditions, with astronomy essential to all of them. Inseparable from navigation, it was also necessary to accurately map the tiny islands they encountered in the vast Pacific. To map the lands was to know them; to know them, own them.

Today, we keep information about location, longitude, stars and their paths on a handful of smartphone apps. But early European explorers needed a great deal of astronomical equipment to find latitude and longitude to navigate, let alone survey and map land. On Cook's first journey, the *Endeavour* carried the latest state-of-the-art astronomical instruments, including telescopes with two-foot focus and wooden stands, an astronomical clock, an 'alarum' clock, a brass sextant, a journeyman clock, and a one-foot astronomical quadrant. All of the instruments on the voyage have been exhaustively researched and in some cases located by Wayne Orchiston, and the following is based on his work.[6]

Knowing the time is the basis of astronomical observations, and on his first voyage Cook took these three clocks with him for different purposes. None, sadly, seems to have survived the intervening years, nor do we have written descriptions. However, we can guess to what purposes they would have been put.

An astronomical clock has dials, gears and mechanisms that track and display astronomical information. As it ticks through the time of day, it can also show the positions of the zodiac and the Sun, Moon and planets along the ecliptic. It can house a rotating star map, and indicate eclipses, lunar phases and sidereal time. Cook's astronomical clock was the largest, most expensive and accurate of the three clocks, and was used only when the astronomers could set up a tent-based observatory onshore. It was also fixed solidly into the ground, with framing built around it to prevent any knocks.

The journeyman, or secondary or assistant clock, was a pendulum clock that ticked loudly, and was used onshore in a tent or observatory alongside an astronomical quadrant. From the seventeenth through to the mid-nineteenth century, such clocks were used to help time transits and other astronomical events. With the heavy tick at his ear, an astronomer could look through his telescope at a star, having set up a wire running top to bottom through the eyepiece (telescopes were illuminated for use at night). As he watched the star moving towards the wire, passing behind it and then moving away, he could check the clock, note the position of the second hand, then look

back at the eyepiece, hearing the clock's ticks as they counted off how many seconds the star took to make its trip across the tiny world of the viewfinder. It was known as the 'eye and ear' method, with the ear judging the seconds from the clock and the eye the fractions of a second through the telescope, as the star wasn't likely to land on the wire at the exact moment the tick sounded.

The alarum clock was a much smaller, cheaper and more portable clock used for astronomical observations. (Alarum is an old spelling of alarm.) The quadrant was used onshore, usually in an observatory tent that also housed the journeyman clock, to find the positions of the Sun, Moon and stars, from which longitude and latitude could be deduced and used to navigate. A sextant measures the angle between two objects, meaning you can measure celestial objects, such as a star, relative to the horizon. It's used at sea for the same purpose as the quadrant, and is so accurate it can measure an angle with precision to the nearest 10 seconds (a degree of latitude is divided into 60 minutes and a minute into 60 seconds). Unfortunately, Cook's sextant and quadrants cannot be reliably located today.

At least four telescopes were aboard. One had a Dolland's micrometer attached, which was then a newish instrument that allowed the astronomer to take very small measurements of angles between objects, or of two parts of the same object. Having mounted the telescope on a very stable support (the sand-filled casks were ideal), the operator manipulated two fine parallel wires inside the viewpiece (before this technology was developed, spider's silk was used). He could place one wire over one object and move the other wire using a screw, which turned a wheel with a gauge engraved on its surface.

Using these instruments, the first professional astronomers to work in New Zealand were Charles Green, assistant to Astronomer Royal Nevil Maskelyne, and Cook himself, who was already a competent astronomer. (He is said to have used astronomical instruments with a skill and accuracy matched by few people, and certainly not many in the navy.[7])

Mercury Bay, on the Coromandel Peninsula, was named by Cook for the spot where he and Green set up their telescopes on the beach and observed the transit of Mercury in November 1769. They also traded with local Māori; they offered beads, buttons, pieces of white paper and red tapa cloth, and received in return fish, shellfish, crayfish, clothing, weapons and ornaments. Cook also formally claimed the area for Britain, carving the ship's name and dates on a nearby tree – though there was no indication in Cook's diaries that he first gained the approval of the local population as stipulated in

his instructions from the Admiralty. Nevertheless, Mercury Bay became the site of the very first European scientific astronomical observation in New Zealand, which lent its name to the scoop of the bay.

The crew spent six months mapping the coastline, taking astronomical observations and sightings to determine their longitude and latitude. In Queen Charlotte Sound's Ship Cove, near a freshwater stream, they overhauled the *Endeavour*, set up a blacksmith's forge, and visited and traded with Māori.

Cook set up cairns on hilltops, secreting silver coins inside and placing flags atop, claiming the land for Britain. A small island, named Hippah, had a fortified pā on it, and Māori visited and traded with them for fresh fish, for which Tupaia was indispensable. Green set up his observatory on board the ship and spent five days deducing the latitude and longitude of Queen Charlotte Sound. The crew made a big impact on the small cove, as Cook's biographer, John Beaglehole, notes.

> As [Cook] collected his last celery and traded for his last dried fish the people made it clear that they were ready to see him leave. The depredations of a hundred men for three weeks on the food supplies of that haphazard community cannot indeed have been small.[8]

Thanks to the new astronomical instruments, Cook was able to write confidently in his diary that few parts of the world were better mapped than New Zealand, 'being settled by some hundreds of Observations of the Sun and Moon and one of the transit of Mercury'. Even today, the accuracy of Cook's first map of New Zealand is astounding to modern viewers – and it was all down to the European sailors' skill at observing the heavens, even with a quadrant that had been damaged on the journey.

Cook left to circumnavigate the South Island, and departed New Zealand waters a month later. By then, he was able to report that the two main islands weren't a part of the great southern continent – at least, not above water.

Measuring longitude

On Cook's second voyage, from 1772 to 1775, the *Resolution* and *Adventure* were tasked with circumnavigating the globe to investigate further the existence or otherwise of Terra Australis. Cook had with him a Kendall chronometer, a new instrument to test whether they could pinpoint the longitude of New Zealand. Finding longitude at

sea was a problem that the best minds of Europe had so far failed to solve, but the chronometer offered hope.

When you're out on the ocean and need to know where you are, latitude – how far north or south you are – is easy. Latitude is fixed by nature, and you can find it by observing the motions of the heavenly bodies. At the equator, the Sun, Moon and planets pass directly overhead; the tropics of Cancer and Capricorn are the farthest latitude at which the Sun can be seen directly overhead.

European navigators found latitude by using a sextant to measure the height of Polaris, which marks the north celestial pole, and its height over the horizon. By the eighteenth century, there were also published tables that showed the Sun's position and elevation at any time of the year and day; a navigator could find latitude just by measuring the Sun's height above the horizon.

But when it comes to finding longitude – how far east or west you are – stars won't help you unless you also know the local time. Actually, you need to know two times: the time at your home port, or another place of known longitude, and the time where you're standing at precisely the same moment – even if it's thousands of kilometres away across the ocean, on a bobbing ship or a foreign shore, with no means of communication. Once you have those, you can convert the difference in hours into a unit of geographical separation.

Because the Earth spins a complete 360 degrees every 23 hours and 56 minutes, a single hour is roughly one twenty-fourth of a complete spin; the Sun moves across the sky at a rate of 15 degrees per hour. When at sea, every hour of time difference between the ship's local time and the time at home thus means the ship has sailed 15 degrees. When you sight the Sun at its upper culmination – the moment it passes the meridian line running through the zenith of the sky – you find the local noon, and you see by the ship's home-port clock that it's 6 a.m. at home, that difference of six hours means the ship has sailed 90 degrees, or a quarter of the way around the planet.

It's not that simple, of course. One degree of longitude equals four minutes' difference in time, no matter where you are on Earth; but, because lines of longitude converge at the poles, a degree can cover different distances depending on your location. At the poles, it is next to nothing, whereas at the equator it's 60 nautical miles (109 kilometres). So long as you know your latitude, however, it's not a problem.

How, then, did early mariners measure time? It's difficult to imagine today, when the exact time is usually a glance away. But knowing the exact time of day in the eighteenth century required complex and expensive equipment, even on land, and it was even

worse at sea. Back then, no timepiece yet invented could keep its time in a damp, rolling ship. The sensitive and temperamental pendulum clock, the main method of keeping time on land, could not cope with the challenges of the ocean. Constant motion threw off its balance, and it was also affected by fluctuations in pressure and magnetism. Metal rusted, wood warped, and changing temperatures caused gearing to expand or contract. Lubricating oil ran thicker or thinner, affecting the clock's mechanism.

For the British, the lack of a way to measure longitude came to a head in 1707. On a foggy, rough night in October, Admiral Sir Cloudesley Shovell was bringing his war fleet home from the Mediterranean. Shovell thought they were to the west of Brittany, France, and was aiming to sail up the English Channel home. But in fact they were near the Scilly Isles, where a dangerous rocky reef lay concealed just offshore. At 7.30 p.m., a lookout on the flagship of the fleet, the *Association*, saw waves breaking ahead and sounded the alarm. But it was too late. Four ships were splintered on the reef, drowning 2000, including the admiral, and causing a national outcry. How could their navigation methods have been so off?

In 1714, a petition launched by merchants and seamen reached Parliament, demanding that the government assemble a committee to consider the longitude problem. A parliamentary committee was established and the Longitude Act issued in 1714, offering large sums of prize money to those who could solve the problem.

For advice the committee turned to Sir Isaac Newton, the world's most famous scientist at the time, and his astronomer friend Edmond Halley, who years before had sailed to the island of St Helena in 1676 to amass a collection of southern stars, totalling over 300 new celestial bodies. He also observed a transit of Mercury. (It was Halley who realised that a transit could offer a way to measure the size of the Solar System.)

There were astronomical solutions proposed to the problem, involving the Moon and its revolutions every month. But there were also timepiece solutions. Yorkshire clockmaker John Harrison made a visit to Halley in 1730, saying he could build a chronometer, a clock that would keep correct time while at sea. The two competing methods created a race that was at times vicious, but Harrison kept up his work, producing four versions of his chronometer that were tested on journeys to Lisbon and Barbados. And a copy of one of these precious final devices, the Kendall chronometer, was entrusted to Cook, who was making his second voyage south to New Zealand.

●

Opposite top Ship Cove, in *View in Queen Charlotte's Sound, New Zealand*, by J. Webber, R.A., London, Boydell, 1809. (B-098-015, ALEXANDER TURNBULL LIBRARY, WELLINGTON, NEW ZEALAND)

●

Opposite Ship Cove today, with its prominent monument to Captain James Cook. (ROB SUISTED)

Cook's second voyage

On this voyage, the *Resolution* became the first ship to cross the Antarctic Circle, and by sweeping the Pacific Cook proved the great continent of Terra Australis to be a myth. The crew also experienced the bewitching colours of the *aurora australis*, about which the Board of Longitude had another request. It asked the ship's astronomer, William Wales, to 'make Remarks on the Southern Lights if any should appear'.

They did – in spectacular fashion. Sailing to New Zealand in the southern summer of 1773, the crew were entranced by an *aurora australis* that shimmered in the night sky. While the *Resolution* carved through chill southern seas dotted with seals, penguins and icebergs, from which they chipped hunks of fresh ice to bring on board the ship, Wales recorded the light glowing on the horizon. While Māori have stories of their Polynesian ancestors experiencing the southern aurora, the crew of the *Resolution* were really the first Europeans to do so, as Cook recorded:

> Last night Lights were seen in the Heavens similar to those seen in the Northern Hemisphere commonly called the Northern Lights, I do not remember of any Voyagers making mention of them being seen in the Southern … the officer of the Watch observed that it sometimes broke out in spiral rays and in a circular form, then its light was very strong and its appearence [*sic*] beautifull, he could not preceive [*sic*] it had any particular direction for it appeared at various times in different parts of the Heavens and difused its light throughout the whole atmosphere.[9]

The *Resolution*'s other astronomer, Lieutenant Richard Pickersgill, also saw them, and thought them 'superior to the Aurora Borealis, for the Colours are finer and the flashes more quick and beautifull'.[10] The lights continued to accompany them another few weeks, and would spread across the heavens into March as they neared the coast of New Zealand.

In February, the two ships became separated in rough conditions. Tobias Furneaux, in command of the *Adventure*, surveyed some of the coast of Tasmania before turning his ship towards their prearranged meeting point of Queen Charlotte Sound, arriving in May. Cook, meanwhile, sailed south to Dusky Bay (now Fiordland's Dusky Sound), a notch in the coastline he had noticed on his previous voyage, though it had been too squally to land. By the time he got there, the *Resolution* was in a parlous state from the voyage through punishing southern waters. The crew were tired, and the ship

A Gregorian reflector astronomical telescope made of brass and glass, similar to the one Captain Cook would have used. This one was manufactured by Heath and Wing, London, c.1765. (NS000010/1, MUSEUM OF NEW ZEALAND TE PAPA TONGAREWA)

needed repairs, water and fresh food. Cook anchored for five weeks in calm Pickersgill Harbour, which he named after Richard Pickersgill (whom midshipman John Elliott described as 'a good officer and astronomer, but liking ye Grog'[11]). Cook brewed rimu and mānuka beer, and the crew set up a forge, repaired tents and attended to scientific work.

William Wales set up camp on the top of a hill and cleared about an acre of virgin bush – 'more trees and curious shrubs and plants that would in London have sold for one hundred pounds' – creating a view to the stars above and mountains around. There was also room for a pen for the ship's sheep. The location is still called Astronomer Point today.

Despite cloudy skies and rain, his calculations of latitude were bang on; though longitude was less certain, it was one of the world's most significant advances in navigation, and a success for the Kendall chronometer. The lonely bay became one of the most accurately located in the world and provided the basis for all surveys and time-keeping in New Zealand for many years.

Meanwhile, to the north, the *Adventure* had arrived in Ship Cove (Meretoto), the bay in Queen Charlotte Sound where, three years earlier, Cook had sailed in the *Endeavour* and proclaimed British sovereignty over the South Island. Māori valued Meretoto as a welcoming shelter at the edge of the open sea, and so did Cook. It was his favoured base in New Zealand on his three voyages: it had plentiful water, timber, fish, birds, shellfish, edible native plants to protect the crew from scurvy, and easy trade with friendly and hospitable local Māori.

It was a busy place, and several hundred Māori made the area home. Motuara Island helps to shelter the entrance to the cove, and off its edge lies the smaller island of Hippah, which had been a pā site with more than 30 homes when Cook had visited three years earlier. When the *Adventure* anchored in the cove in April 1773, it was abandoned, and it was on Hippah that William Bayly, astronomer on the *Adventure*, set up his instruments, dubbing it Observatory Island.

He cut steps up the rocky cliffs, put up the observatory tent and a hut for the transit telescope, and set up the astronomical clock, digging its supports into the ground. Two marines and a Highland piper kept watch over the observatory, and Bayly observed the heavens until 19 May, establishing the sound's latitude and longitude while the ship's crew overhauled the *Adventure* nearby. As he was packing up his equipment, the *Resolution* arrived, and William Wales set up his own observatory at a beach on Ship Cove across the bay, where a large white monument to the arrival now stands.

In the intervening centuries Motuara has been cleared, farmed, regenerated and rid of pests, and it is now a bird sanctuary and a crèche for young rowi (Ōkārito kiwi). Down south, in Dusky Sound, there's a bronze plaque affixed to shoreline rocks, marking the point where the *Resolution* anchored, and a metal survey marker at the astronomical site. A careful walk around the trees reveals old stumps and mossy humps of downed logs. Otherwise, the site of New Zealand's earliest observatory has slowly grown back into the bush.

Astronomers at an observatory camp in Cawthron Park, Nelson, photographed by Frederick Nelson Jones in 1914. (1/1-009995-G, ALEXANDER TURNBULL LIBRARY, WELLINGTON, NEW ZEALAND.)

PART 3

Early New Zealand Astronomy

'What use is astronomy?'

●

Many might ask, Of what use is astronomy? One of its uses was to enable people to sleep in peace at the present time when an enormous comet was nightly rising over their heads. In days gone by it would not have been so, as comets were then objects of terror and superstition.

'THE COMET', *TEMUKA LEADER*, 11 NOVEMBER 1882

●

The early European astronomical history of our land is mostly one of cartography and surveying, finding out where, exactly, we were on Earth. When Europeans settled New Zealand, they needed to map the colony in order to parcel up and distribute land. Thus, in a similar vein to Cook, our first scientific astronomers were the surveyors who used tools of longitude and latitude to determine a piece of land's location.

The next development in professional astronomy was the official national time service. Time itself was derived astronomically in those days, from the precise measurement of stars and the position of the Sun in the local sky. Early New Zealand towns used their own clocks, set to their local noon. Wellington became the capital in 1865, and three years later it also became the reference for New Zealand's standard time zone (to the disgruntlement of those living 17 minutes ahead in Dunedin), which

was necessary for accurate shipping, telegraph and rail. In fact, New Zealand was the first country in the world to bring in one time zone across the nation.

A time service was essential to the practical functioning of the new colony, for purposes such as shipping and setting astronomical clocks to determine latitude and longitude. Then, as radio developed, the time services turned into earthquake-recording stations as well.[1] Often, these stations morphed into our very first observatories, and some are still standing today.

Alongside these professional services, amateurs answered the call of the celestial bodies. Some took a serious interest, and in fact helped to establish the early observatories or lead research projects, while others exploited public fear of the unknown by peddling pseudoscience. Although superstition and fear elicited by astronomical events has long been embedded in the human psyche, most of us today have a healthy disregard for the superstitious elements of astronomy. Yet we still retain a sense of mystery and wonder at the most visibly awe-inspiring features of the universe.

Amateur astronomy

Both professional astronomy and its serious amateur counterpart began late in New Zealand, especially compared to our neighbours across the Tasman. But, once established, amateur astronomy became an abiding passion for many. Amateur observers have always made great contributions to world astronomical knowledge, and New Zealand was no different. We owe much to the dedicated member of the local society who cannot keep themselves away from the telescope in their backyard, on mountaintops and out in fields; spending all night looking up, fitting observations into a full-time job and family life, devoting their own time and money to their passion.

In 1954, astronomer Ivan Thomsen said he had always been surprised at the interest in astronomy in New Zealand, especially considering the lack of formal instruction we had until quite recently, and that New Zealand 'must be one of the most interested countries in the world on the subject of astronomy', with more members of astronomical societies per capita than anywhere else.[2] Perhaps that was due to the low light pollution and the brilliance of our skies and their many interesting objects, and to how New Zealanders, in carving a living out of tough country at the mercy of often violent, changeable weather, have always been keenly aware of the natural world.

But we're also a country of joiners, of clubs and passionate societies. Our leading amateur astronomers during the nineteenth century and first half of the twentieth

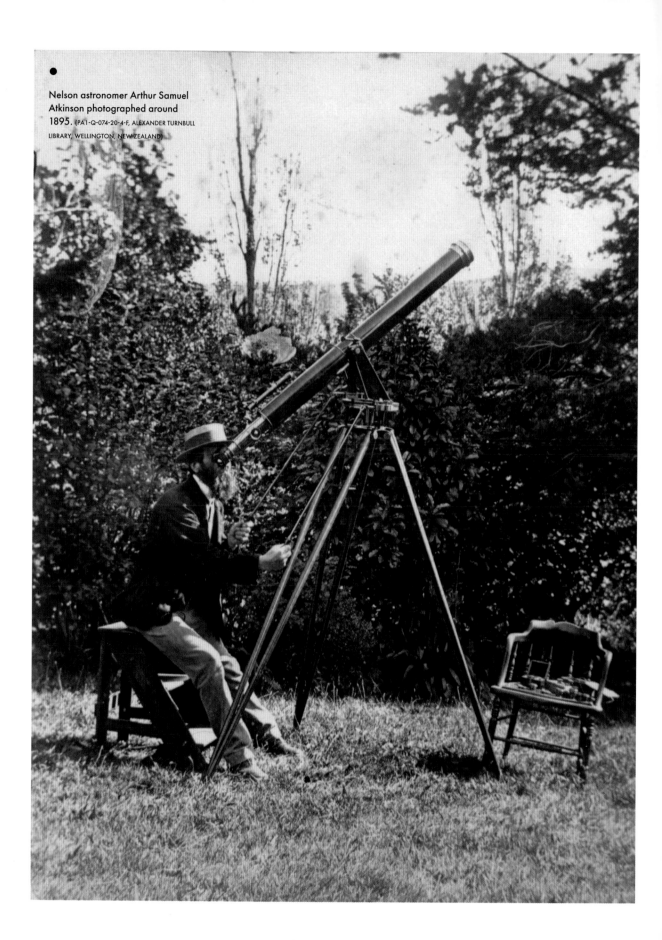

century were all devotees in this mould and, as a result, we have a respectable number of historically important telescopes and discoveries.

Auckland had an active group of astronomers by the 1870s. It was probably New Zealand's first astronomical society, and included the Reverend Thomas Cheeseman, whose son Thomas Frederic was the founder and first curator of the Auckland Institute Museum. The curious clergyman had several telescopes, some of which he had made himself, and an observatory in Remuera. Other leading amateur astronomers of the late nineteenth century included Henry Skey in Otago, Thomas King in Wellington, Arthur Beverley in Dunedin, and Nelson lawyer Arthur Atkinson. They built home observatories and bought telescopes, sometimes running them as unofficial centres for astronomy in cities. They wrote about astronomy in newspapers and gave lectures and offered meteorological information to the public.

Further transits of Venus

The astronomy bug really caught hold when the transits of Venus returned in 1874 and 1882. Keen local astronomers observed these with the help of international professional delegations, and the transit inspired the locals to take their studies of the sky further. Arthur Stock, astronomical observer at Wellington's Colonial Observatory, wrote a small pamphlet in 1874 called *The Transit of Venus and How to Observe It*.

Public interest in the December 1874 and December 1882 transits of Venus was high, after all. The 1874 event would be the first since Cook had sailed to Tahiti over a century earlier, and was an opportunity to refine the solar parallax, and thus the astronomical unit. International professional teams descended on the new country for what was New Zealand's first international astronomical collaboration. British, French, German and US observing parties visited the main islands and also the Chathams, Auckland Islands and Campbell Island. They were heroically ambitious expeditions.

Queenstown, with its elevation, clear skies and warmth, was one of the prime staging posts for the December 1874 transit, and produced some of the best results in the entire world. The town was then barely built, with farming established just a few years earlier. There were, however, a few houses, with streets and sections already laid out, anticipating future growth.

The leader of the US expedition to Bluff, and eventually Queenstown, was C.F.H. Peters, professor of astronomy at Hamilton College in New York. The second in command, Lieutenant Edgar Walcs Bass, was a professor at the West Point military

academy. He had arrived a few weeks earlier and picked Queenstown as the best place for observations. The Americans, under the auspices of the US Navy, travelled south on the USS *Swatara*, which brought all the southern hemisphere observing parties from around the globe. The ship arrived in Bluff harbour on 16 October, and the astronomers began to make their slow passage to Queenstown.

Astronomical observations back then involved enormous feats of overland travel. The astronomers and their gear travelled through Southland by stagecoach, train and wagon to Kingston, where they took the steamer up the arm of the lake. The New Zealand government helped out by freighting the boxes free to Winton; these included a large equatorial travelling telescope housed in an octagonal building with a revolving roof, a telegraph office, and a darkened chamber for photographers.

Six and a half weeks before the transit, the party established its base in Queenstown's Melbourne Street, on the site of the present-day Millennium Hotel (where a plaque now commemorates the event). Their first task was to figure out exactly where they were, establishing Queenstown's latitude and longitude using the stars. Professor Peters chose 44 stars and erected a three-metre-high wooden stockade.

But the day of the transit was 'ugly and black', according to Peters' journal, with the sky cloudy and threatening. The *Otago Witness* reported 'great anxiety' in the party. Happily, the sky cleared in the nick of time – just two minutes before the time of first contact had been calculated. The observers had a great view of the transit until about 3.30 p.m., and they took 237 pictures. It was one of the few successful observations of the transit at the time, as conditions were poor around the world.

The transit had excited people up and down the country, particularly for one observer in Taranaki. A letter to the *Taranaki Herald* gushed:

> The sight will never be erased from the mind or blotted from the memory. When the planet first struck the eye, she looked like a cricket ball passing over a liquid globe of fire; but afterwards, as the sky cleared, its beauties increased, until the ineffable sight caused ecstatic pleasure, which beggars language to portray. Venus seemed to dance in the sun with unearthly delight to herself and her beholders.
>
> It seemed like one of those rare privileges given to mortals at great intervals, to behold and wonder at the mighty and glorious works of the Great Architect of the Universe; and to those who are firm believers in a future and happier state, such sights must cause a thrill of prospective joy, knowing it to be but a glimpse of such glories. The thoughts of such amazing sights should constant joys create.[3]

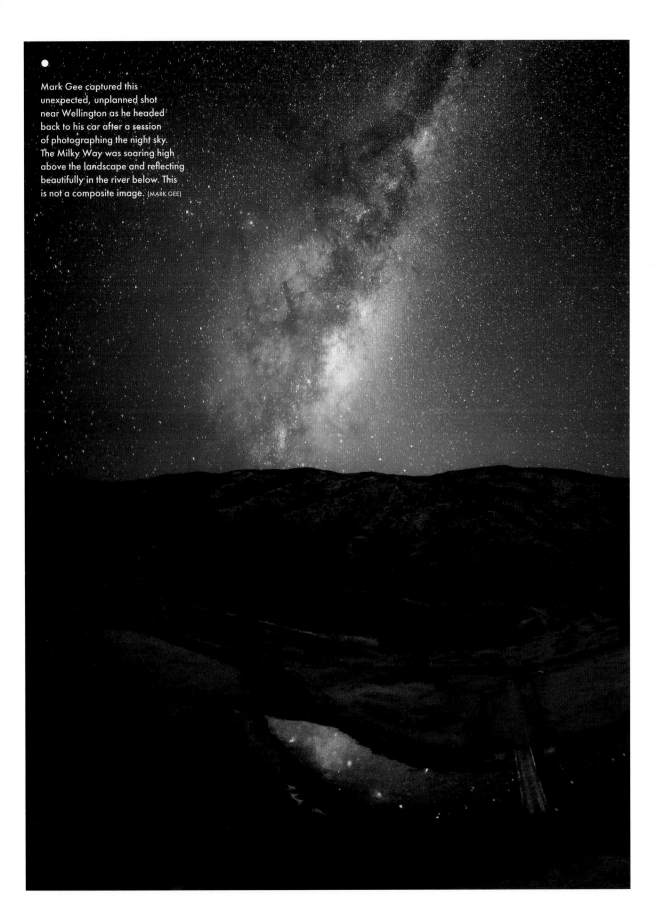

Mark Gee captured this unexpected, unplanned shot near Wellington as he headed back to his car after a session of photographing the night sky. The Milky Way was soaring high above the landscape and reflecting beautifully in the river below. This is not a composite image. (MARK GEE)

Such raptures were too much for the editor, who replied drily, 'We are afraid that if Venus danced and sang as our correspondent states, astronomers found some difficulty in taking correct observations during the transit.'

The December 1882 transit saw a similar flurry of interest. William Harkness, an organiser of the US transit programmes that included the station in Queenstown, captured the mood before the 1882 transit when he told a meeting of the American Association for the Advancement of Science:

> We are now on the eve of the second transit of a pair, after which there will be no other till the twenty-first century of our era has dawned upon the earth, and the June flowers are blooming in 2004. When the last transit season occurred the intellectual world was awakening from the slumber of ages, and that wondrous scientific activity which has led to our present advanced knowledge was just beginning. What will be the state of science when the next transit season arrives God only knows. Not even our children's children will live to take part in the astronomy of that day.[4]

In Nelson, the Royal Society of London asked Arthur Atkinson – who was brother to Premier Harry Atkinson – to be an official observer, taking precise measurements. Atkinson, the founding force behind the Nelson Astronomical Society, took the task very seriously, and observed the transit using his four-inch Browning telescope, housed in a small 'electric house', a hut made of zinc on a hill near his home, Fairfield House. The hut was connected to the local telegraph house to keep his chronometer synchronised with official time. This meant he could precisely record when Venus entered the Sun's orb and how long it took to travel across its face, which in 1882 was six hours and 18 minutes. The connection also meant all the timepieces of all the people observing the transit synched exactly.

Buoyed by the experience, Atkinson later built a special tower for stargazing, but it shook too much to be useful and he had to conduct his astronomical observations from the same knoll he had used to observe the transit. The tower became known as Atkinson's Folly, and a replica of it stands attached to Fairfield House today. He also recorded the 1885 total eclipse of the Sun using an imported 5-inch Cooke refracting telescope that would later be installed in Nelson's Atkinson Observatory. The observatory has only recently replaced this telescope, and Atkinson's instrument is now on display at the nearby Cawthron Institute.

The transit of Venus was never such a big deal again, and in New Zealand 1882 was the final call for such an expedition. In the intervening century, science has advanced to an astonishing degree. During the 2004 transit, humans observed it not from a fortified British outpost on a Tahitian beach, or from a rickety rural camp in infant Queenstown, but from space itself. The average distance from Earth to the Sun has now been conclusively calculated as 149.6 million kilometres, and NASA's Magellan mission has extensively photographed and mapped Venus's surface.

New Zealand was one of the few countries in the world to miss the 2004 transit – by the time Venus began to move across the Sun, it was past sunset. The 2012 transit was cloudy across much of the country, but the Sun came out in Gisborne's Tolaga Bay, where the event was particularly special – its people were, of course, the first to welcome Cook after the transit of 1769.

The Sun shone on the bay, and hundreds of astronomers crowded its 660-metre-long wharf to view the passage of Venus. The area also held a Transit of Venus Forum, the vision of late scientist Sir Paul Callaghan, who had founded it after he became terminally ill. Topics discussed included science and prosperity, the emerging Māori economy, using and managing resources, restoring and enhancing the environment, New Zealand's connection with the rest of the world, and the people of New Zealand.

The transit of Venus was once one of the biggest scientific questions of our time, sparking hugely expensive, dangerous and onerous missions across the unknown universe of the ocean. However, what is often forgotten when celebrating the scientific achievements of the time is recognition that the transit mission, and thus Cook's subsequent arrival in New Zealand, had devastating and far-reaching repercussions: Māori were soon to be overrun by colonisers who considered themselves the apex of humanity and brought with them all the harm that entailed. Today, the transit is a symbol of our dual heritage – Māori and Pākehā – and of our joint future as a nation, but it's still vital to recognise what it wrought on the indigenous inhabitants of New Zealand.

The first observatories

●

Following the lead of Cook and his crew's makeshift tented sites, observatories sprouted in the main and provincial centres of New Zealand during the nineteenth and early twentieth centuries. Many became the cradle of astronomical sections attached to museums, institutes or philosophical societies. Most were the base for amateurs, and usually involved public outreach, and they would develop into the modern observatories of today.

In Thames, John Grigg, New Zealand's first well-known astronomer and also a proprietor of a music shop, set up a temporary observatory to view the 1882 transit of Venus; he would later build two more. He became a distinguished amateur astronomer and a successful comet hunter, and also created the time service for the people of Thames, using astronomy to determine the exact time of day to which people could set their clocks and watches. Grigg was the first to detect the return of Encke's periodic comet in 1898. In 1910, using what was then cutting-edge technology, he took a photograph of a comet that was so good the Royal Astronomical Society of England included it in its records; that same year, he also photographed Halley's Comet, as did another early comet hunter, Charles Westland. Grigg also discovered three new

Whanganui was lucky to have Joseph Ward, who helped start the Ward Observatory and the Whanganui Astronomical Society, of which he became president. He was an expert optician and telescope-maker who held public lectures twice a week and offered viewings on his 4.5-inch refracting telescope, purchased in 1899. He was also a bookseller, librarian, violinist and poet, as well as an accomplished amateur astronomer who contributed to international catalogues of double stars.[1] In 1924, he built what was then the largest telescope in New Zealand, a 20.5-inch Newtonian reflector.

comets in the period between 1902 and 1907, and the Astronomical Society of the Pacific awarded him two medals. There wouldn't be another comet discovered until 1946, when Nelson's Albert Jones spotted Comet Jones VI from his home observatory in Timaru.[2]

Wellington

Wellington has had several observatories over time. The first official observatory in New Zealand was Wellington's Provincial Observatory, established by the provincial government in 1863 to provide a time service to ships in the harbour. The growth of shipping meant the colony needed accurate, standard times, but time was a relatively fluid concept in early New Zealand, kept by watching the heavenly bodies cross the meridian of the sky. The observatory, kitted out with clocks and a transit telescope, also operated a time ball at the next-door Customs House on Queens Wharf. A large metal ball on a pole was hoisted every day at 11.55 a.m. and dropped precisely at noon, enabling ships' captains to synchronise their timepieces.

The Provincial Observatory was home to New Zealand's first resident professional astronomer, Archdeacon Arthur Stock, who operated the time service. Stock was committed to popularising astronomy and was a public relations man of his day, often appearing in the newspapers. He wrote the first books on astronomy by a New Zealander – two books on the transit of Venus. But, once the observatory wasn't needed to keep time, its function as an astronomical observatory dwindled. In 1868 it was renamed the Colonial Time-service Observatory, staffed by Sir James Hector. It moved to Kelburn in 1907 and became known as the Hector Observatory, and was renamed the Dominion Observatory in 1926, turning into a seismological centre.

The first public observatory was the Thomas King Observatory, which opened in 1917. King, who followed Stock in the astronomical observer role from 1887 to 1911, was a Fellow of the Royal Astronomical Society and the Philosophical Society, with his own private observatory, which he used for amateur astronomy. The Philosophical Society thought the city needed a place the public could come to learn about things like Halley's Comet and added an Astronomical Section to its activities.

The Wellington City Observatory opened in 1924. It housed the Cooke and Sons 23-centimetre refracting telescope from the former Marist Seminary Observatory, which had been used to photograph the 1910 apparition of Halley's Comet. The Wellington City Observatory was most often known as the Tin Shed, owing to its corrugated iron

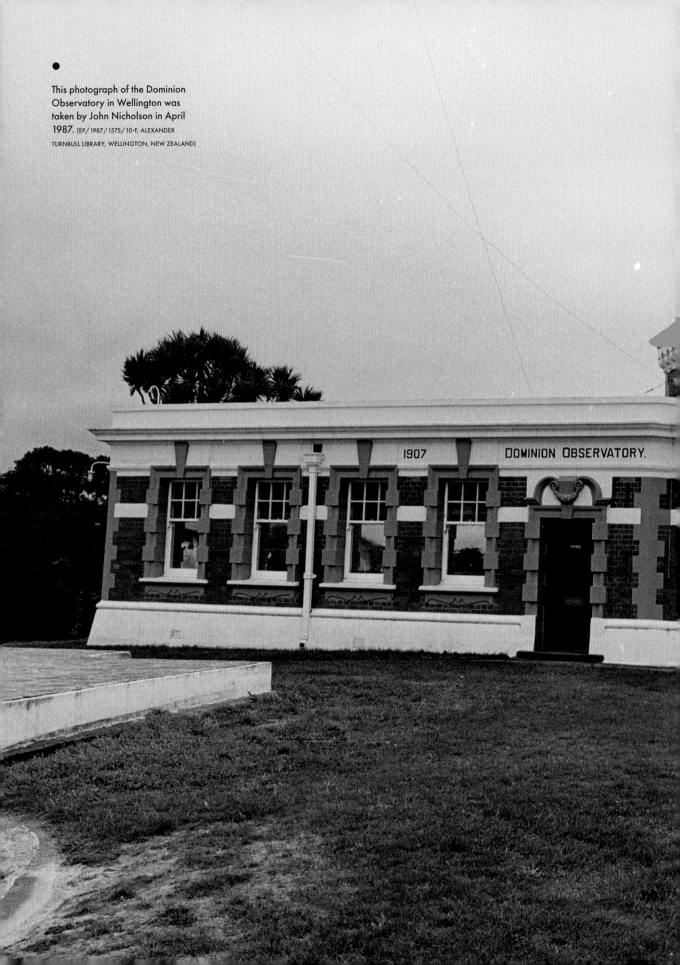

This photograph of the Dominion Observatory in Wellington was taken by John Nicholson in April 1987. (EP/1987/1575/10-F, ALEXANDER TURNBULL LIBRARY, WELLINGTON, NEW ZEALAND)

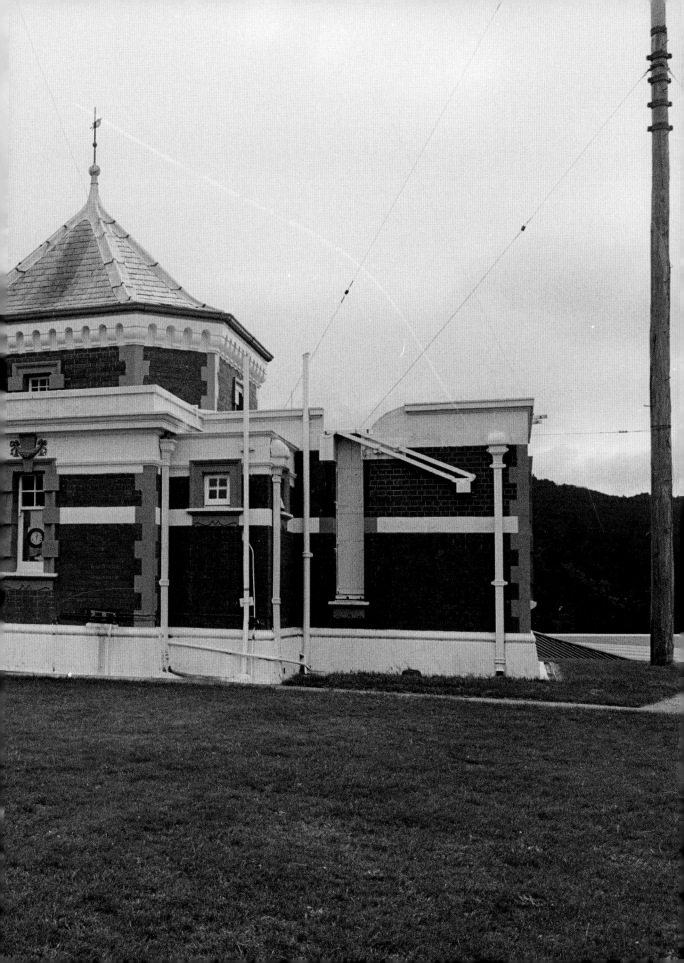

cladding. Leading New Zealand astronomers Frank Bateson and Ivan Thomsen were regulars there, and the shed was also used for public viewing nights.

Wellington's Carter Observatory was set up when politician Charles R. Carter visited a museum dedicated to Galileo and worried about the lack of scientists in New Zealand. When he died in 1896, he left a bequest to set up this observatory, and the gift resulted in the Carter Observatory Act of 1938. It opened in December 1941, and George Eiby, an eminent seismologist with a keen interest in astronomy, began what were then innovative experiments in New Zealand's first astrophysics for his master's thesis, measuring the brightness of stars with a photoelectric cell.

Another significant Wellington observatory is the Gifford Observatory, set up on the grounds of Wellington College in 1912 by maths teacher Charles Gifford. He had studied astronomy at Cambridge University, and was an early theorist concerning the origin of lunar craters as a result of meteorites. It was he who introduced the expanse of space to a teenage, and later Sir, William Pickering. Pickering became a celebrated NASA rocket scientist and head of California's Jet Propulsion Lab, showing the power of early exposure to the wonder of astronomy. The observatory was moved in 1924, and by the 1970s it was in dire need of renovation. A trust was set up in the late 1990s to raise funds to restore it, and Pickering officially reopened it in 2002. Today, it's operated by the Gifford Observatory Trust for the benefit of schoolchildren, and is also the base of the Wellington Astronomical Society.

Auckland

Opening in 1967 on the slopes of Maungakiekie/One Tree Hill, the Auckland Observatory relied on amateurs and was once called 'the best amateur observatory in the world' by Dr M.K.V. Bappu, vice-president of the International Astronomical Union. Edith Winstone Blackwell had donated money for a telescope, which became the 0.5-metre EWB Zeiss. The observatory's opening changed the Auckland astronomical scene overnight, and astronomers went on to provide valuable research to global knowledge, particularly in variable stars.

There was of course a long history of amateurs involved in observing for research and pleasure before then. The Auckland Astronomical Society grew out of the Auckland Institute and Museum in 1922, and seven years later had 29 members. They met in the physics lecture room at the university, and across the road in a paddock they had an old building housing a telescope. Noted astronomer R.A. McIntosh recalled the groaning

noises the roof made as they pushed it off once a week for their observing sessions. They observed what they could from the city, but he points out that in those days you could just have a telescope and contribute something interesting of value, unlike today. There was usually a motley audience at some of the meetings – it wasn't uncommon to see elderly women knitting in the front row, or men falling asleep in the back row during the first five minutes.

Events hyped by the media, however, could attract massive crowds. At the close approach of Mars in 1956, the society organised an open telescope evening on the top of Maungawhau/Mount Eden, and the newspapers invited Aucklanders along. Five thousand turned up, so many that people jammed the road up to the top – and this was when Auckland had a population of just 250,000.

'You could not even walk up,' one astronomer recalled. 'It was absolutely impossible. Hell was let loose at the top, I believe, where only about five or six telescopes were surrounded by the whole of Auckland it seemed, and no-one saw anything as far as I know.'[3] The chance of seeing something rare and spectacular in the skies can still draw the crowds today.

Christchurch

When the Canterbury earthquake struck in February 2010, it destroyed the Townsend Observatory, a domed tower built in 1897 to house a beautiful brass-and-wood nineteenth-century telescope.

The tower, already surrounded by scaffolding after the September earthquake a few months previously had cracked and weakened it, was once part of Canterbury University College's biological laboratory building, and later the Christchurch Arts Centre. The telescope once belonged to James Townsend Jr, who had his home nearby in Park Terrace. He was an astronomy buff who donated his beloved instrument to the college, wanting to make it available for the community.

Townsend had arrived in New Zealand in December 1850, one of the so-called 'Canterbury Pilgrims' on the first four ships that started the new settlement. As his obituary put it, he was 'a keen student of natural science', and astronomy in particular. His telescope was a six-inch refracting equatorial that allowed the user to follow stars as they travelled across the sky, compensating for Earth's rotation. It was made in 1864 by the renowned English firm of Cooke & Sons, and Townsend lent it to the British expedition visiting New Zealand to observe the 1882 transit of Venus. Walter Kitson

of Sumner operated it during the transit, and was also later its custodian, attending the college four days or evenings every month to show visitors or students how to use it, keeping it in good working order.

Townsend was in his seventies when he donated it, and in response the Astronomical Society of Christchurch gifted its funds – £420 (around $84,000 in 2018 dollars) – to the college on the understanding an observatory would be built for it. As in other places around the country, the transits of Venus had aroused a swell of interest and goodwill in Canterbury towards astronomy. The people of the province also donated money towards the observatory project. Townsend died in 1894 before he could see the building finished in 1896, which was the last major design by renowned architect Benjamin Mountfort.

The observatory tower survived for more than a century, becoming part of the Arts Centre when the university moved its campus. Weather damaged it, and the dome was replaced several times, but it was fully restored to near-new condition in the late 1970s. It was open to the public every Friday night from March to October, offering the public a chance to look through the historic telescope and glimpse the heavens. In accordance with Townsend's wishes, it had been an important focus of the university's outreach programme for years, and members of the public and children were sometimes struck breathless when they stepped in front of the eyepiece and saw the rings of Saturn for the first time. It was never upgraded or modernised for scientific research, which was part of its charm – as one writer has put it, 'the modern man or woman is no less amazed than Galileo when looking up a telescope for the first time'.[4]

All that was lost when the powerful February earthquake hit. The tower collapsed, the telescope tumbling down with it in a hail of stone and dust. When the debris settled, the historic observatory looked like it had been disembowelled, with the top on the ground and rubble spilling from its midsection. It was one of the most chilling effects of the earthquake, though luckily no one was injured in the crash.

Another stroke of luck was that, when the badly damaged telescope was retrieved from the disaster, its delicate gearing was recovered with just three small pieces lost. The tube was heavily dented, but its objective lens was still intact, to the surprise and delight of staff. Most importantly, the lens – 'like the engine of your Rolls-Royce', according to University of Canterbury technician Graeme Kershaw – was still in one piece.

At the time of writing, the observatory is still closed to the public, though parts of the rest of the Arts Centre are rebuilt and operating. But there are plans to restore a

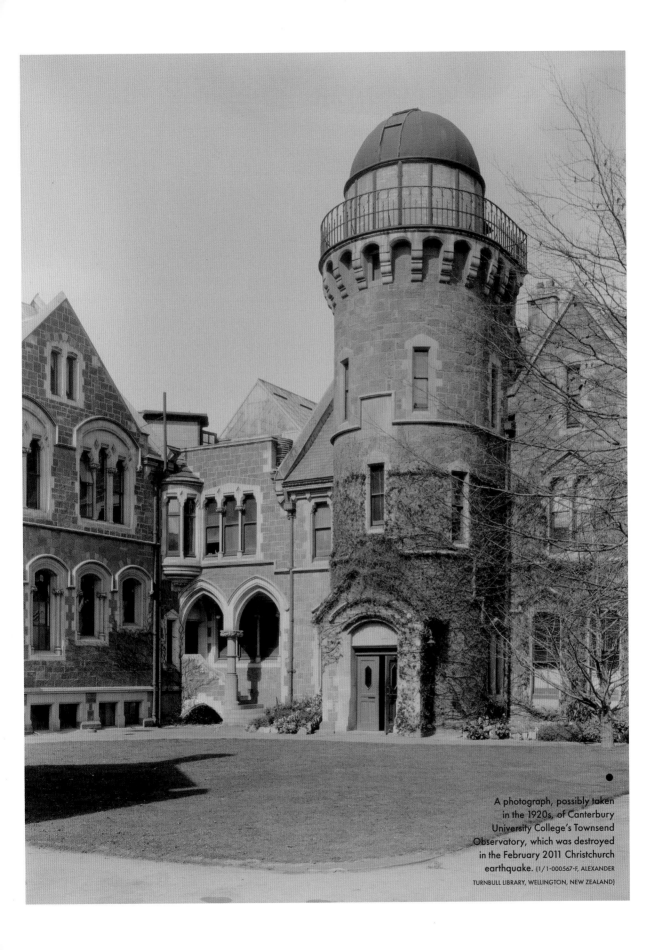

A photograph, possibly taken in the 1920s, of Canterbury University College's Townsend Observatory, which was destroyed in the February 2011 Christchurch earthquake. (1/1-000567-F, ALEXANDER TURNBULL LIBRARY, WELLINGTON, NEW ZEALAND)

replica of the tower and reinstall the telescope, which has now been fixed. An appeal to repair it was launched in 2014, and after a donation from Berkeley economist and UC alumnus David Teece to help complete the work, it was renamed the Townsend Teece telescope. More than a century on, James Townsend Jr's wish for it to be enjoyed by the people of Christchurch will be fulfilled once more.

A vision unrealised

Finally, one observatory project that unfortunately failed to get off the ground was the Nelson Solar Physics Observatory, a visionary project mooted in the early twentieth century that brought great excitement and would have made good use of the sunniest skies in New Zealand.

The observatory, completing a chain around the world, would not only have enabled the Sun to be kept under 24-hour continuous observation, but would also have made Nelson a world astronomical centre, and it would have been the biggest observatory in New Zealand at the time. As the Gifford Observatory did for William Pickering, it could have launched the careers of many young people interested in the stars.

But it was foiled by the death of its benefactor, Thomas Cawthron, who had donated £12,000 (nearly $2 million in today's money) to build it, purchasing Observatory Park for the purpose. Unfortunately, he didn't sign the trust deed before his death in 1915, and the dream died with him.

The story reflects just how much potential astronomy has in New Zealand, and at the same time its sometimes tenuous status. Many of our historic observatories, along with much of the early astronomical work, owe everything to a few keen enthusiasts, and the science has historically suffered from lack of attention and poor national funding. The Cawthron story shows how the potential of our skies can be squandered if it depends on the resources of just a few.

A national body for astronomy

A powerful force for local astronomers was the New Zealand Astronomical Society, founded in 1920 as an umbrella organisation at a level above the local societies while also connecting them. Alexander William Bickerton, a colourful Christchurch professor and astronomer, announced he wanted to set up such a national society in a letter to the Lyttelton Times, at the beginning of the 1900s.

The society was eventually created by two of New Zealand's most accomplished scientists, Charles Adams (who became the society's first president), and Charles Gifford. They sent a letter to interested parties in New Zealand arguing that although there were four separate local astronomical societies – Whanganui, Wellington, Dunedin and New Plymouth – there was no wider coordination. Isolated astronomers in other parts of the country and those in large centres, such as Auckland, Christchurch, Napier, Hawera, Nelson, Timaru and Invercargill, had no formal representation. 'It is desirable and important to have an articulate body to represent and co-ordinate all these scattered interests,' they said. 'The society would be invaluable in the circulation of astronomical information; it would increase the popular interest in astronomy, and it is hoped that it would contribute to the advancement of knowledge.'

The Society went ahead, and its instigation was praised in *The Press* the following year by Evelyn Granville Hogg, a Christ's College mathematics teacher, amateur astronomer and Fellow of the Royal Astronomical Society. He wrote that, with 84 members, the Society was well started 'on a career which all hope will be one of great usefulness to local astronomers, and of honour to the Dominion'. He had other lofty hopes:

> New Zealand is rich in amateur workers in the field of astronomy, and the new Society, by binding them together into a corporate existence and directing their energy along the channels in which it can be most profitably employed, can do a work of great value to the community. It has been said (by an astronomer) that we may judge of the degree of civilisation of a nation by the provision the people of the nation has made for the study of astronomy, for when the pursuit of astronomy for its own sake is cultivated, then we have a recognition of the supreme worth of scientific method.[5]

In November 1934, the Society's journal *Southern Stars* published its first issue, lightly clad in pale blue card, to replace the monthly set of cyclostyled notices sent out to members. In 1946, the Society received its Royal Charter and became the Royal Astronomical Society of New Zealand, and a member body of the Royal Society of New Zealand in 1967.

Celestial highlights

●

A series of dramatic astronomical events in the skies above New Zealand and elsewhere helped popularise astronomy through the late nineteenth century and into the twentieth century. In particular, the 1880s saw a flurry of interest from the wider public and amateurs. This was largely due to several partial eclipses and one dramatic total eclipse, as well as the 'Great Comets' of 1880, 1881 and 1882.

Eclipses

The partial eclipse in November 1882 frustrated Aucklanders because of cloud cover, but enchanted watchers in other parts of the country. In Wellington, amateur astronomers thronged the streets staring into the sky. Some of them protected their eyes using dark spectacles, and some used pieces of coloured glass. It wasn't at all unlike the international scenes of the total eclipse that wowed those lucky enough to see it in 2017.

The first total solar eclipse seen in New Zealand following European settlement was the two-minute-long event on 9 September 1885, and it was hugely dramatic for the new colony. The shadow that fell across the country stretched from north-west Nelson to Whanganui and the Wairarapa coast, attracting rapt attention and euphoria from the public and newspapers, in much the same way an eclipse still does today. The spectacle left the public – and even astronomers – agog. In Nelson, scores of people climbed the hills to watch, but the mood quickly turned sombre and oppressive.

As the eclipse approached, the light breeze that had been blowing died away.[1] The birds stopped twittering – except, as John Meeson from Stoke reported, some

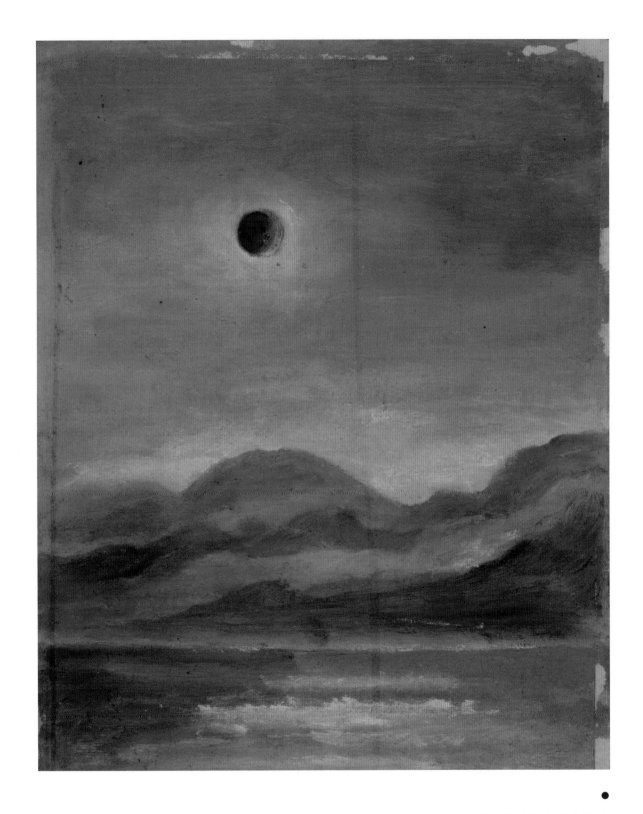

This oil painting by Emily Harris (c. 1837–1925) shows a total solar eclipse over Nelson in September 1885, viewed from Nelson's Port Road. (NELSON PROVINCIAL MUSEUM, BETT LOAN COLLECTION: AC472)

'paraquets' (presumably kākāriki) which 'were evidently much startled, and broke into the most noisy chattering as the sun disappeared, and flew away, it may be supposed, to their usual night haunts'.[2]

Everything else became hushed. It got very cold, and the mood of the people turned oppressive. Even their voices sounded unnatural. The light, Meeson said, took on a 'dim, religious quality', and the faces of those gathered to watch it had a ghastly tone. The colours of the mountains, fields, sea and sky all changed, dimming to an unearthly hue, and the sky around the Sun became a dirty yellow. As the Moon passed completely in front of the Sun, beams of light shot out from either side of it, creating a St Andrews Cross–like formation around the orb, and the stars came out – Jupiter shining just below the Sun.

The sky turned mauve, the sea became black, the mountains turned iron-grey, and the clouds looked like black heaps. Shadows crept over the land, and the Mount Arthur Ranges across Tasman Bay glowed first rose then red, then dark indigo. Finally, after two minutes of the strange darkness, a bright point of light gleamed, the Moon passed, and the once-in-a-lifetime eclipse was over.[3]

Meteorites

Despite many searches, just nine meteorites have been found in New Zealand. Seven of those were discovered mostly by farmers working their fields in Wairarapa, Southland, Canterbury, Gisborne, the West Coast and Manawatū from 1863 to 1976. Only two falls have been observed, happening a century apart.

The first in recorded New Zealand history was a meteorite called Mokoia, which fell in the Mokoia district of Whanganui on 26 November 1908, and at the time it was nicknamed 'the deadly messenger', falling from a clear blue sky. In Mokoia that day, the air was suddenly filled with what sounded like a volley of rifle shots or explosions that echoed for hundreds of kilometres. The long tail of smoke stayed hanging in the sky, sighted by people at the racecourse in New Plymouth. Stock stampeded, and witnesses reported a large boom. Some saw chunks of rock falling into the creek, and near a house where children were playing.

Later, it was found to have passed over the district and exploded, with chips breaking off and the main meteorite falling on the coast. It was quite a spectacle. A letter to the *Wanganui Herald* in November 1908 was signed ONE WHO SAW IT, and said:

Sir,— In to-night's 'Herald' I saw Mr Irvine's idea of the cause of the rumble at 12.30 p.m. to-day. I take the honour to correct this. I was near No. 1 pole, by the tramway powerhouse, when I happened to look up, and saw a huge white ball fly from the sun in a westerly direction. It had a tail like a meteor and gradually faded off into a long-silver-like line, which remained in the sky for several minutes after the ball disappeared, and then faded away like puffs of smoke. Soon after the ball disappeared I heard an explosion like the boom of a heavy gun. Perhaps astronomers can give us a reason for this.[4]

Part of the meteorite was picked up by William Syme, who visited the Whanganui Museum with a small, dark rock. The curator later found larger chunks that had gouged out a hole at the base of a tree in a pine plantation.

The Mokoia meteorite was classified as a CV3 carbonaceous chondrite, scientifically interesting and rare. Only a small fraction of meteorites worldwide have this classification. Calcium aluminium inclusions in the meteorite have been dated at 4.57 billion years old, making them the oldest known material in the Solar System, older than anything else on Earth.

No more meteorites were seen to fall upon New Zealand until one called Auckland, which landed in spectacular fashion one Saturday morning. Around 9.30 a.m. on 12 June 2004, it blasted through the roof of Brenda and Phil Archer's house in Ellerslie, bounced off a leather couch, hit the ceiling, then came to rest on the floor where their 11-month-old grandson had been playing a few minutes earlier. Brenda Archer was standing just a few steps away. The smooth, hot, dark 1.3-kilogram rock, which was 4.5 billion years old, blew up dust and a huge explosion inside their home. Scientists believe it could have been the size of a basketball and hurtling at 15 kilometres a second when it entered Earth's atmosphere. By the time it arrived at the Archer household, it would have slowed to a few hundred metres a second.

'I'm just glad no one was sitting on the couch; they would have got absolutely crowned,' Brenda told television news. The Archers were inundated with attention and appeared in media all over the world, sparking enquiries by experts and collectors and with bids for the rock in the tens of thousands of dollars. However, the Archers were nonplussed. 'There's been a huge amount of interest but it's just a lump of rock and looks little different to what you could find in a quarry anywhere,' Mr Archer told the *New Zealand Herald*. They turned down an offer of $50,000 so it could be kept in New Zealand and displayed at the Auckland Museum.

A green burst from a meteor over Lake Tekapo. Meteors can flash with different colours depending on the minerals that are burning. (FRASER GUNN)

In July 2016 there were fresh reports of a meteor, but astronomer Alan Gilmore explained to media that, based on reports of it taking half a minute to cross the sky, it was probably a piece of re-entering space junk, and probably quite large to cause such an effect. It was rare, he added, and even rarer for one to reach the ground.

Aurorae

During recent New Zealand history, one of the earliest instances of an aurora was after a violent set of earthquakes in October 1848, centred in Marlborough. The shocks were so strong they rocked ships at sea and tore up the ground – and afterward, people saw the *aurora australis* in the sky for several days. The *New Zealand Spectator* of 25 October described the unusual night sky as a 'fiery glare' in the south, and thought it was the reflection of a much stronger light. It lasted from half past eight to midnight.

The vivid light, which looked like flames, made people think that an unknown volcano had erupted, spewing forth pent-up air and fire, and they hoped it meant the earthquakes would be over. It was, in fact, the period of the solar maximum, which happens when the Sun's sunspots are at their most abundant. A red-rayed aurora was also seen throughout Europe.

During the last days of August 1859, in the northern hemisphere summer, a geomagnetic storm hit Earth. Powerful aurorae covered the planet, stretching red, green and purple from the poles almost to the equator. Eyewitnesses reported the sky turned to blood. At the seashore, too, the ocean glowed red, the shells on the beach reflecting the light like coals of fire. Across the northern hemisphere, telegraphic systems went haywire, with bells ringing erratically, and receivers overheating and exploding in flames. Operators hit with electric shocks fell unconscious, compasses and instruments failed, and overhead cables melted off their poles. International communications were destroyed – and no one knew what had caused it.

One man saw what happened. On the morning of 1 September, amateur solar astronomer Richard Carrington had walked up the stairs to his observatory on his estate near London. It was a routine solar observation and, with the Sun's disc projected onto a white screen, he began to draw the sunspots he could see on its surface. Just before lunchtime, without warning, two spots erupted into bright explosions of intense light, which flared for a few minutes before dying on the surface. Unable to believe what he was seeing, Carrington dropped what he was doing and called for someone else to come. By the time he returned a minute later, the spots were fading – but highly charged

cosmic particles were racing towards Earth. The coronal mass ejection released energy equivalent to billions of atomic bombs, and its effects reached us within hours, turning night into bloody day. As aurorae blew up the sky, birds began to sing, people got up to go to work, and the first telegraph machines began to sizzle.

That solar storm, one of two that occurred in August and September 1859, is now known as the Carrington Event. There has never been an event to match it, and it has gone down in solar astronomy history. In New Zealand, the *aurora australis* appeared in our skies too, but the country managed to escape electric shocks and melting telegraph wires. Reports in newspapers ranged from a single line in the *Daily Southern Cross*'s weather section ('August 29. S.W.; a.m., heavy rain; evening, brilliant aurora') to an effusive rush of emotion from the *Taranaki Herald*, which found the mysterious phenomenon created a rosy, fiery, brilliant backdrop for the snowcap on Mount Egmont/Taranaki, veiling the stars around with a reddish gauze.

Back then, people still didn't know what caused aurorae, but Carrington's work was a step towards understanding. He was presented with the Royal Astronomical Society's Gold Medal that year, in company with the likes of John Herschel, Albert Einstein, Edwin Hubble and Jan Oort.

In July 1864, the lights also appeared to poor Thomas Musgrave, a British-Australian captain who was stuck on the subantarctic Auckland Isles with his five crew members for nearly two years after their ship was wrecked. During a spell of clear weather in some fine days after a storm, Musgrave saw the most vivid and beautifully brilliant aurora he had ever witnessed, north or south. The castaways had seen aurorae frequently from their spot in the depths of the Southern Ocean, but usually only as pale, ghostly streamers in the sky. This set shot from the horizon to the zenith of the sky, in streamers of magnificent, varied shades of light. It was a chance for a little beauty and magic in the middle of a desperate situation.[5]

Aurorae even found their way into our colonial fiction. In 1873, pioneer writer Vincent Pyke published *The Story of Wild Will Enderby*, which contained this beautiful passage about the quality of starlight and aurorae in Central Otago.

> The night season at the Dunstan is peculiar. After sunset it becomes very dark for a while; then, without apparent cause, light diffuses itself with increasing intensity until midnight. During this interval, a bright red glare often shows on the hill-tops against the distant sky, and ever to the south or south-west. This is usually ascribed, by unaccustomed beholders, to bush fires; but it is really

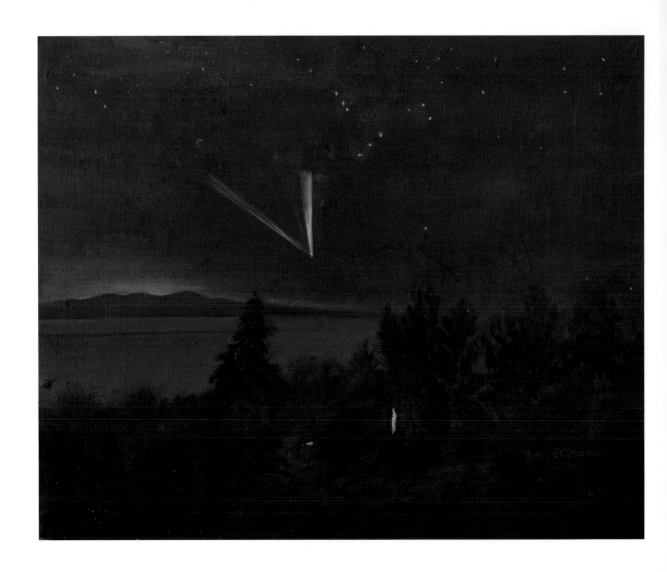

Looking north-west from Nelson's Port Hills, perhaps in an autumn in the 1880s, Emily Harris painted a comet passing below the constellation of Orion. Nelson's Boulder Bank lies across the sea in the foreground. (NELSON PROVINCIAL MUSEUM, BETT LOAN COLLECTION: AC807)

due to electrical agencies. Frequently the magnificent Aurora Australis streams upwards to the zenith in broad bands of yellowish white, and pale green, and fiery red – a gorgeous spectacle, such as never presents itself to the dwellers on the coast. And shooting stars traverse the skies in such prodigious numbers, that the gazer incontinently concludes that a lively stellar frolic is going on somewhere overhead. I do not know any place in the Middle Island so well suited for an inland observatory as the Dunstan or Upper Clutha terraces.[6]

We now know that while aurorae are beautiful and moving, the Carrington Event shows the power of the forces that cause them. Even though there hasn't yet been one to match it, if a similar event were to happen today, the effect would be unmitigated disaster. Radiation inside aeroplanes could reach extreme levels, and there would be blowouts of power, satellite and GPS systems – essentially, everything upon which our society depends. According to a 2008 report from the United States' National Academy of Sciences, a similar solar storm could cause 'extensive social and economic disruptions', at a projected cost of US$1–2 trillion.

Comets

Aside from a total solar eclipse, one of the most dramatic astronomical events to grip the wider public must be the arrival of a comet. From 1880 to 1882, three 'Great Comets' were seen in the skies of New Zealand 'and could not fail to attract the attention of even the most disinterested of individuals', as Wayne Orchiston says.[7]

THE GREAT SOUTHERN COMET OF 1880

An evening in early February brought many observations of a magnificent comet in the south-west, with a slightly curved, narrow tail that stretched over an eighth of the distance between the horizon and the zenith of the sky and was therefore easily seen with the naked eye. Pale violet in colour, it faded as the Moon rose, but was visible for several nights afterward.

It was in fact a new visitor to the skies, discovered on 1 February in Australia, and would eventually be named Comet C/1880 C1. It 'seems to have created an extraordinary excitement all over the colony', the *Hawke's Bay Herald* reported, 'as every little village has thought it necessary to telegraph that the comet could be seen there'.[8]

THE GREAT COMET OF 1881

Reported widely across New Zealand, this comet was originally thought to be the same one that had visited in 1861, but it turned out to be a new comet, discovered on 22 May by Australian amateur astronomer John Tebbut and eventually dubbed Comet C/1881 K1. It was the subject of early astrophotography, with American Henry Draper taking the first wide-angle photograph of a comet's tail and the first spectrum of a comet's head.

Passengers on the Wellington–Lyttelton ferry SS *Rotomahana* reported seeing it, and so did Wellington astronomer Archdeacon Arthur Stock on the evening of 24 May. He wrote that it was 'a very pretty object', with a bright white head, evenly surrounded by light, and a tail twice the length of the Moon's diameter. He added, 'A comet was seen by Mr Meek and Mr Travers, about ten days ago, in the northeast, which seems to have escaped notice' – perhaps beating Tebbutt's discovery.[9]

The comet became known as the Great Southern Comet in the newspapers of England, where it arrived over the horizon on 23 June and was a spectacular sight in the night sky of the northern hemisphere – the night streets of Paris, London and New York thronged with viewers. It finally faded from sight in the autumn.[10]

Astronomers reporting their thoughts on the comet in the newspapers drew complaints from one writer to the *Oamaru Mail*. Sorely Troubled said they were 'very much exercised about the comet' and fearful the comet would be absorbed by the Sun and 'we shall all be burned up'.

> This makes me very uneasy, because I was thinking of making some improvements about my place … I wish these astronomers would not affect one's feelings so strongly. If they, knowing what was going to happen, could just lay hold of the comet by the tail and turn its head in another direction … they might be of some value to us poor mortals. But where's the use of terrifying us so terribly?

'Go on with your improvements,' the editor replied.[11]

THE GREAT SEPTEMBER COMET OF 1882

This comet has achieved lasting fame in New Zealand thanks to Ralph Hotere, who immortalised it in his 1972 painting *Comet over Mount Egmont (Taranaki) and Parihaka (Tūnui-a-te-ika kei runga o Taranaki me Parihaka)*.

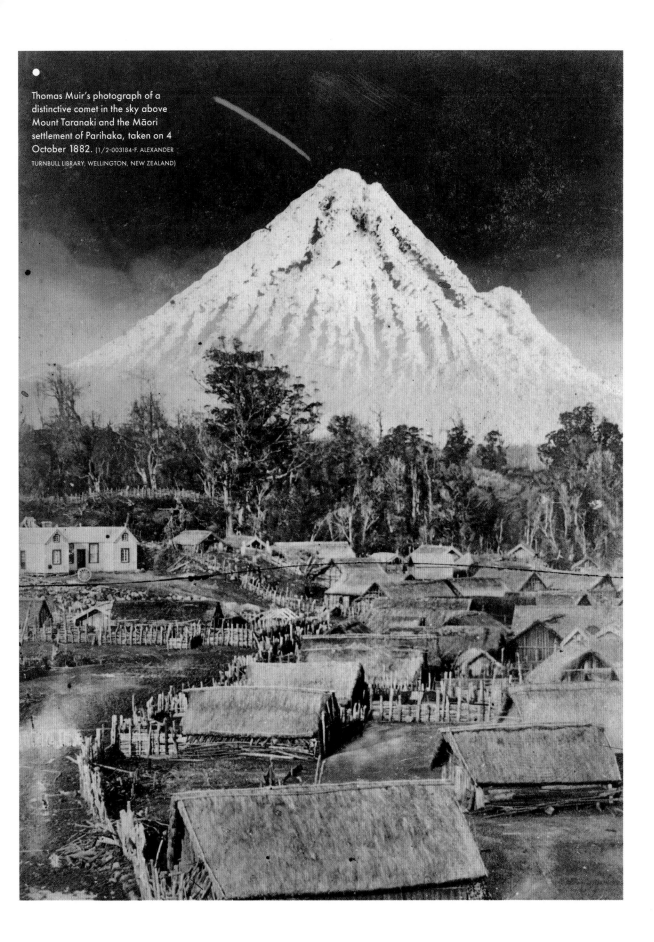

Thomas Muir's photograph of a distinctive comet in the sky above Mount Taranaki and the Māori settlement of Parihaka, taken on 4 October 1882. (1/2-003184-F. ALEXANDER TURNBULL LIBRARY, WELLINGTON, NEW ZEALAND)

Hotere based his work on a well-known photograph by T.S. Muir, one of a series about the European occupation of Parihaka. The comet, painted streaking towards the mountain's summit, appeared over Mount Taranaki in September 1882, a year after the invasion. It was so bright that it was seen over most of the southern hemisphere, and was one of the first in the world to be photographed; though its appearance as a bright streak tailing over Taranaki was added or enhanced later, its position and the way it would have appeared is thought to be accurate. A comet also inspired Colin McCahon's 'Comet' series of 1974.

HALLEY'S COMET, 1910

It is difficult to find mention of Halley's Comet's appearance in 1835 in New Zealand – the first New Zealand newspaper wasn't printed until 1839 in London – but by the latter half of the nineteenth century newspapers were occasionally chewing over the idea of humanity being incinerated in a sudden cosmic blaze, and the headline of the *New Zealand Herald* in January 1910 could hardly have been more alarming. 'THE DOOM OF THE WORLD,' it reported. 'ASTRONOMER'S FEAR OF COMET.'

That terrified astronomer was the eminent Frenchman Camille Flammarion, who was something of a celebrity in his day. His predictions were frequently published in the pages of New Zealand newspapers, helping to stoke fear of comets and other sudden, potentially devastating astronomical phenomena among the general populace.[12] (After his assertion of the world-destroying comet proved false, the French reportedly danced in the streets, their lives spared.)

Halley's Comet, thought Flammarion, would cause poisoning as its tail passed over Earth; this was a common fear. The newspapers reported Oxford astronomy professor H.H. Turner suggesting people bottle some air as the comet passed, to hand down to their grandchildren. New Zealanders also feared the atmosphere would be dissolved, the surface of Earth irradiated or the planet hit with debris. People stayed inside with their doors and windows sealed, and enterprising salesmen spruiked protective 'comet pills'.

However, New Zealand newspapers of the 1910s did show some responsibility, reassuring the populace as well as stoking terror with Flammarion's and other punters' predictions. By the early twentieth century, the ancient idea that comets brought death and destruction was based less on superstition than on the more scientific worry there might be a collision with a head or tail. Though it was widely known that Earth would pass through the tail of the comet this time, most educated people knew it was thin gas and posed no danger.

The Colonist reported: 'HALLEY'S COMET – NOTHING LIKELY TO HAPPEN'. The *Auckland Star* quoted a well-known meteorologist, Clement Wragge, who thought that, although 'there is a possibility of this world's denizens being slightly poisoned', it wouldn't be serious, and there certainly wouldn't be any earthquakes or tidal waves. At least, he added in jest, if we were all asphyxiated we'd go together.

All in all, it was an uncertain run-up to the comet's appearance, and University of Auckland mathematics professor Hugh Segar gave three packed public lectures in Auckland's St James Theatre, calming the fears of some of those gathered.

In fact, when the much-feared comet did finally arrive, it was an utterly spectacular sight, the likes of which no New Zealander alive then had seen before, and which no New Zealander alive now has yet seen in their lifetime. Professor Segar was the first New Zealander to report glimpsing the comet, on 13 May. By 18 May, its tail was huge, filling 45 degrees of sky, with most of Auckland gazing upward in wonder. On 20 May, it was spotted in the morning sky, with its head below the horizon, and a faint tail that spanned as much as 90–120 degrees across the sky.

Those who saw it were transfixed. Some described it as being like a searchlight beam cast into the heavens. Ida Lough, of Christchurch, was seven years old that night, and remembered her father got her out of bed to see it blazing through the sky. 'Now you remember what you are seeing!' he told her. Ida doubted anyone could forget. It was like a 'beautiful, wide, scintillating, diaphanous scarf' trailing across the entire sky, with a brilliant blob of light at the end. Gazing up, she could still see the dark sky and its stars through this ghostly tail, like a spangled net.

It stunned the whole country. Twelve-year-old Elizabeth Freeman was living on a farm in Massey, then known as Lawsonville, in West Auckland. Though scared of being gassed, she got up at five one morning and went out to the verandah to see a great arch of silvery light illuminating the sky. But not all were so enthralled.

> I gazed in wonder at it and thought the great sight well worth leaving a warm bed to see. My parents did not think so. So soon I heard a bellow. Probably they thought a burglar had opened the door.
>
> 'It's me, I'm looking at Halley's Comet, you should get up and see it.'
>
> 'Get back to bed, you'll catch a cold out there.'
>
> I wondered at my parents' preferring a warm bed to the sight of a lifetime.[13]

One of the first photographs of Halley's Comet, taken in Hawke's Bay in 1910. (SOCIETY OF MARY – MARIST ARCHIVES WELLINGTON, GREENMEADOWS COLLECTION)

MEEANEE OBSERVATO

Marist Fathers, phot

lley's Comet.

15 5 1910

N. Z

At its closest point, the comet passed within 23 million kilometres of Earth and 88 million kilometres of the Sun. In comparison, during the relatively disappointing viewing of the 1986 return, it would be 63 million kilometres from the Earth.

By then, spectroscopy, which reveals an object's composition by analysing the light coming off it, had showed that the comet's tail was made of cyanogen, a lethal poison – so there was some basis for the concern about inhaling dangerous gases.

Finally, as if to give those ancient theories of cosmic intervention an ironic nod, King Edward VII of England actually did expire during the May 1910 appearance of Halley's Comet – one of many rulers to pass during a comet's blaze throughout history, including Attila in 453, Valentinian III in 455, Muhammad in 632, Louis II in 875, Henry I of France in 1060, and King Harold II of England in 1066.

The coincidence was felt here: the Māori lament at the official New Zealand mourning ceremony for the king included:

> Go thee, O our ariki . . . go to thy ancestors in heaven. Go on the path of Awanui-a-Rangi [the Milky Way], which even now gleams from the sky earthward, a glowing sky-print known as Auahiroa [Halley's Comet] and as the messenger of Rongomai. It appears as a brilliant ladder whereupon thou mayest ascend to the tenth heaven.[14]

Physics was better understood by 1910, and astrophysics was emerging as a discipline, becoming a valuable tool in the study of the skies. There were improved telescopes and, with the advent of photography on glass plates allowing people to preserve images and also to see fainter ones, the arrival of Halley's Comet was a chance to learn more about comets and to make high-quality photographs and spectrographs.

The most impressive photographs were some of the first ever taken of Halley's Comet. They were world class, and were included in NASA's *Atlas of Comet Halley 1910*. They were shot and developed by two seminary students, Joseph Cullen SM and Ignatius Gottfried SM,[15] in Hawke's Bay, at St Mary's Scholasticate, Meeanee. Started by the forward-thinking Reverend Dr David Kennedy SM, who was born in New Zealand in 1864, this astronomical and meteorological observatory had been built by Marist priests and lay brothers and was the most up-to-date at the time. Its equipment was imported from England on Kennedy's behalf by another pioneer astronomer, Joseph Thomas Ward, who started Whanganui's Ward Observatory in 1903.

It's difficult to truly appreciate the work of these early comet-catchers today, when Instagram offers a constant stream of amateur and professional astrophotography taken all over the world and a ten-minute tutorial is enough to show anyone how to capture a decent star trail. But in the early twentieth century taking photographs of the stars required a great deal of skill and exposures ranging from 30 minutes to more than an hour. Capturing something moving was even more complex, and even more so when it came to photographing something moving in the dark, at night, in the sky.

The photographer-astronomers had to follow the celestial object as it moved, to make sure it stayed on the same part of the glass plate. To do so, they used a driving clock, a motorised mechanism that enabled the telescope with camera attached to travel in the same direction at the same rate as the object, keeping it in the field of view, as well as physically and continuously tracking the target through a guiding telescope. The process required a great deal of patience and fortitude.

HALLEY'S COMET, 1986

Observatories saw a huge upswing of interest when Halley's Comet returned. It was the most closely studied comet in history at that stage, and was carefully observed throughout 1984–87, with the three major research observatories in New Zealand – Auckland, Carter and Mount John – contributing photoelectric photometry research as part of a network of about 50 observatories worldwide. (A photometer is an instrument that measures the brightness of astronomical objects.) New Zealand observatories were important because there are so few other observatories at our longitude on Earth, and measurements to study changes in the tail of the comet have to be made continuously around the clock. The tail can 'wag' over several degrees in days. Some of the sudden changes in a comet's plasma tail can be spectacular indeed, with, at times, the entire tail unrooting itself from the head of the comet and receding from the Sun, only to be replaced by a new tail.

September 1985 also saw NASA space probe *Voyager 2* approaching Uranus, causing great excitement in the astronomical world and bringing a remote part of the universe alive for the first time. But it was Comet Halley that caused a stir for New Zealanders, with a variety of promotions, newspaper supplements, television programmes and educational opportunities capitalising on the appearance. With people still alive who had seen it in 1910, anticipation was high.

In late 1985, the comet was drawing closer to visibility, and media was touting the tourism potential for New Zealand because of our clear skies. A booklet, *An*

Encounter with Halley's Comet, 1985–86, by Auckland Observatory's Stan Walker and Carter Observatory's Graham Blow, was a collaboration between leading New Zealand astronomers and featured an in-depth explanation of the comet, how to see it, and what it all meant. It was a hit, immediately selling out of its first printing of 15,000 copies.

Observatories readied themselves for throngs of guests, with Carter Observatory receiving $30,000 in government money (approximately $80,000 today). Auckland hired a part-time secretary manager; at that stage it was the only public observatory in New Zealand running public nights throughout the year. Mount John, however, wasn't in on the game. Superintendent Mike Clark told the *Listener*:

> We've got nothing for the public. We're a research station. This Halley's Comet hype is becoming a runaway train. We've had a lot of inquiries from overseas; people think they can just come along with 50 holiday-makers from overseas and wander in … Halley's Comet is coming to be a bit of a prima donna. It's getting some astronomers' backs up. There is lots in the sky besides Halley's Comet.[16]

Mount John is more welcoming to the public today, recognising the value of public outreach and preparing for it. But still, you can't argue with a comet. People swarmed observatories. And although anywhere free of smog and light pollution was a pretty good place to see it, that didn't stop enthusiastic capitalism. Travel companies took groups of tourists up Mount Ngongotaha on the shore of Lake Rotorua to enjoy dinner and 'the best view in the world' of the comet. Thousands of passengers departed Auckland and Sydney on the luxury ship *Royal Viking Star* with guest astronomers including Carl Sagan, though it was impossible to use telescopes on board the rolling vessel. The *Listener* reported on Palmerston North management consultant Kenneth Irons, who chartered two return flights of Concorde together with British Airways, allowing views of the comet at supersonic speeds.

The Central Otago town of Omarama was singled out as an ideal viewing spot for a bunch of Tourplan Pacific guests, with the help of Wellington's Carter Observatory. Colin Mackay's new woolshed provided the location gratis, and he kitted it out with Portaloos, astronomers, travel agents, telescopes, charts, films, tea and scones made by a fleet of Omarama locals. Profits would go to a new non-denominational church made of stone and timber and, if there was anything left over, a bigger swimming pool for the local school.

BP sponsored a Halley's Comet Tour and were very generous. When a team asked them to fund the publication of some teacher and correspondence school notes on the comet to be sent to all primary schools, they agreed to print 3000 copies, buy 500 copies of an imported poster and 500 copies of Walker and Blow's book, and distribute a free observational diary for pupils. BP also agreed to send 50 keen science pupils from all over New Zealand to the observing site at Omarama. From all accounts of staff and students, the tour was a huge success; the comet was 'a round smudge of light with a short wide faint tail'.[17]

Unfortunately for the rest of the country, the comet was a fizzer. 'A ball of fluff,' one disappointed person told a news television reporter at a Mount Albert Lions Club viewing, where entry to see the comet cost $5 (about $12 today). 'It didn't look like much. I expected it with a tail.'

'A puff of smoke,' her dejected partner added.

One elderly woman recalled seeing it in 1910 and said she was disappointed with this one. 'I felt I would never see anything quite so perfect as I had seen then.'

The reporter interviewed an astronomer to explain this disappointing phenomenon, who snapped, exasperated, 'If you want to see a rainbow across the sky, wait until it's raining and watch a rainbow. It's a faint fuzzy ball.'

It was, however, a perfect opportunity for merchandisers, the reporter added consolingly. If you were disappointed with your $5 comet, you could buy a $4 teaspoon instead.

Great communicators

●

I f dramatic events in the heavens excited popular interest in astronomy, it was also helped
along by a series of colourful personalities who travelled the country holding lectures.
Like whizz-bang popular science shows today, full of colour, explosions and excitement,
some ebullient scientific lecturers in the late nineteenth and early twentieth centuries knew
the power of a well-honed piece of theatre, and were able to convince their audiences of all
sorts of pseudoscientific wonders as well as explain facts that still hold true today.

New Zealanders flocked to national exhibitions with complex installations, including
geology, geothermal activity and cave systems. But assorted travelling lecture series, fronted
by charismatic showmen took the wonder of nature, science and astronomy to the people.

Clement Lindley Wragge

One such showman was Clement Wragge, a British meteorologist who inherited a great
deal of money and emigrated to Australia, becoming Queensland's first meteorologist
from 1887 to 1902. Wragge has the distinction of being the first person to systematically
give human names to tropical cyclones, a tradition that continues today. He first called them
after letters of the Greek alphabet, and later names of women of the Pacific, referring to
them as 'soft bubbling names of bewitching maidens of the South Sea Islands'.[1] He really
found his stride in naming very troublesome storms after unpopular politicians or those
who had refused subsidies for his various projects, taking evident delight in reporting that

●

A poster advertising one of
Wragge's talks in Wellington.
(EPH-B-SCIENCE-1909-01, ALEXANDER TURNBULL
LIBRARY, WELLINGTON, NEW ZEALAND)

PLEASE TURN OVER

they were 'causing great distress' or 'wandering aimlessly about the Pacific'. He christened one destructive storm in August 1904 'Ward' after Joseph Ward, the Minister for Railways and later the seventeenth prime minister of New Zealand. Others he called after people who supported him: '"Kidston" in honour of the genial member for Rockhampton, who takes a sympathetic interest in the work of the Weather Bureau and declares that we should be subsidised in proportion to the results obtained,' for example.[2]

In Queensland, Wragge tried to make rain by firing into clouds, buying a number of Stiger Vortex cannons, which were apparently up to the job. Not only did two test firings not work, but Wragge had also left town by the time of the actual experiment, having had a run-in with the local council. Nicknamed 'Inclement' or 'Wet Wragge', he irritated established Australian weathermen by filing reports from 'Chief Weather Bureau, Brisbane'. He quarrelled with the premier and left under a cloud in 1903, saying the New Zealand government had been much more welcoming.

In New Zealand, as mentioned earlier, he talked and was consulted by the media on Halley's Comet, but also on Easter Island statues, tropical vegetation and the history of the Pacific, and he put on astronomical magic-lantern shows with titles such as 'The Immortality of the Skies' and 'The Majesty of Creation'.

Meteorology was sometimes linked to astronomy in those days, and Wragge advertised his talks with great relish as 'Splendid! Appalling! And Sublime!!!' Wragge, who was tall, thin, impervious to the cold, and with a thick mop of red hair, talked to sold-out audiences, demonstrating the wonders of radium, explaining that sun storms caused earthquakes (they don't) and aurorae (they do), discussing how astronomy and religion are indivisible, and introducing astronomical concepts that we take for granted nowadays to the people of New Zealand, many of whom would be learning them for the first time. 'He held that, just as our sun has a solar system, so also have other suns, many times larger than our own, also their own systems,' one newspaper reported.[3]

It's easy to forget today, when we know so much about it, but the Moon was a mystery to many, and someone like Wragge could explain it.

> The concluding portion of the lecture was devoted to an intensely interesting description of conditions existing on the moon – a place which [Wragge] likened to the realms of His Satanic Majesty. The temperature there varies from 300 above zero to 250 below; there are no blue skies, no clouds, no water or even aqueous vapour, no life of any kind, and with no atmosphere, over all eternal silence reigns.[4]

He was a frequent public predictor of weather conditions, drought, storms both earthly and solar, and disastrous happenings that would cause seismic, magnetic and other disturbances on the Moon and in the atmosphere. He was, a newspaper once said, 'one of the best authorities we have of things heavenly', which would have irked his detractors.

His talent was that his language was so simple and direct that even the youngest could understand. He was really one of New Zealand's first professional science communicators – and if we laugh at some of the concepts he came up with, we should remember that some of today's science and technology will likely be thought hilariously daft in a century's time, too.[5]

Richard Anthony Proctor

Another popular speaker was the famous British astronomer and author Richard Anthony Proctor. From 1880 to 1882 he toured New Zealand giving talks, and wrote books with titles such as *The Expanse of Heaven* and *Our Place Among Infinities*. Astronomy historian Wayne Orchiston describes him as 'the Patrick Moore of the 1880s'. Proctor so impressed one young attendee, schoolboy Martin Maxwell Fleming Luckie, that as an adult he went on to play an important part in developing the Carter Observatory in Wellington.

Proctor scared the world by predicting in the *Victorian Review* in 1880 that 'a menacing comet' would fall into the Sun in 1883, destroying all life on Earth. The theory bounced around for years, and when the great comet approached archdeacon and astronomer Arthur Stock was getting so many worried enquiries that he wrote to the Wellington *Evening Post* to reassure the public.

Alexander Bickerton

The most prominent astronomer of the nineteenth century was surely Alexander William Bickerton, a foundation professor at the new Canterbury University College. He dominated public astronomical thought, but unfortunately his astronomical pedigree was far from lustrous. The *Dictionary of New Zealand Biography* labels Bickerton 'scientist, university professor, eccentric', and he did indeed fulfil all those roles, elevating eccentricity in particular to the greatest possible heights.

He was a charismatic and popular speaker, once saying that science classes should be 'as entertaining as a music hall and as sensational as a circus'. He taught Nelson-born physicist Ernest Rutherford, nudging him into physics and from there to global

fame; Rutherford described him as a 'most lovable character … [and] unusually clear and stimulating, whose enthusiasm and versatility were of great value in promoting an interest in science in a young community'.[6]

Bickerton was an evolutionist and early socialist, believing in a benefit to be paid to the unemployed. An outspoken supporter of 'the common man', he turned his home among the sandhills of Christchurch into a social centre for undergraduate students, and later a commune, and then an amusement park with an art gallery, aquarium, Punch and Judy show, merry-go-round, theatre, fireworks and a live mock naval battle on the pond. A zoo was later added. His reputation is tied to a pet theory he defended long after it had been disproven, and which is now largely forgotten: the dramatic Partial Impact Theory.

It attempted to explain the appearance of novae – new, bright stars that disappeared quickly, within a year or even a day. He believed they were formed by stellar bodies 'grazing' each other, chipping off a chunk of matter (he imagined the star having a solid body with a cool crust and hot core, more like our Earth) that formed a new third star between them. The new, temporary star would shine brightly, he said, but then eventually dissolve, being too hot to hold together. Later, he would extend this theory to encompass other types of variable stars, the origin of the Solar System, the birth of stars, the formation of the Milky Way, and many other aspects of the sky. All could be explained by his theory of stars and heavenly bodies colliding with each other.

He published his idea in *The Romance of the Heavens* in 1901, but it was instantly derided. That was clouded, however, by the charm and skill of his lectures, with practical demonstrations to keep the audience's interest. Later, he entered into a long-running war with the university administration and was relieved of his post in 1902, which outraged the people of Christchurch.

When Bickerton died, he was cremated, and his ashes sent to new college head Ted Howard, along with his request to be buried in the walls of the college's Great Hall. The Bishop of Christchurch refused, so Howard buried them in a sandhill, then rescued them when he thought they might be disturbed by a dog. He put them in the railway left-luggage lockers until a reluctant bishop allowed them to be interred in the walls of the college; Howard had threatened to send them to the bishop's palace. Bickerton got the last laugh after all.

Grandiose, bellicose, convinced of his own brilliance, Bickerton is now largely forgotten in astronomical history. *The Pall Mall Gazette* summed him up best in a review of his book, saying, 'Those of us who enjoyed Jules Verne in boyhood will enjoy Professor Bickerton in old age.'

Canterbury scientist, university professor and eccentric Alexander William Bickerton was a colourful figure in the early New Zealand science community.

(1/2-038594-F, ALEXANDER TURNBULL LIBRARY, WELLINGTON, NEW ZEALAND)

The allure of variable stars

•

The tradition of the keen do-it-yourself astronomer typical of the early New Zealand stargazers lived on into the twentieth century. For some, it led to a full-time career in astronomy; others retained their amateur status while nevertheless helping to develop the science, both in New Zealand and internationally. One particularly appealing and productive area of study for local astronomers was the observation of variable stars – stars that change brightness over time – and two of them in particular made major discoveries that were a significant contribution to the study of these phenomena.

Frank Bateson

Bateson's interest in astronomy was piqued when he was a child, after he read Sir Robert Ball's *Great Astronomers* (1895). Living in Sydney, he borrowed all the books from the city library, then all those from the Sydney Observatory, a building above the Rocks district where he would attend public talks. The professor and his assistants encouraged him, lending him a telescope and leading him to build his first observatory: two packing cases of different heights, creating a place for his star atlas, a place to put his elbows and a place for his telescope. He found every star he could see in the atlas, drew the constellations, learned their names, and began learning the individual stars, then began to observe meteors and plot their paths. He joined a group observing variable stars, sparking an interest that was to absorb him for the rest of his life. The child was suddenly an astronomer.

Bateson trained as an accountant, since astronomy then offered no opportunity to make a living – it was just a serious hobby. But after Bateson moved to New Zealand he

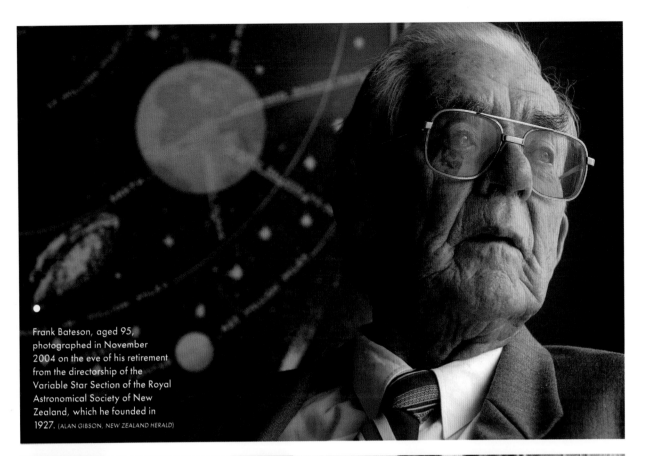

Frank Bateson, aged 95, photographed in November 2004 on the eve of his retirement from the directorship of the Variable Star Section of the Royal Astronomical Society of New Zealand, which he founded in 1927. (ALAN GIBSON, *NEW ZEALAND HERALD*)

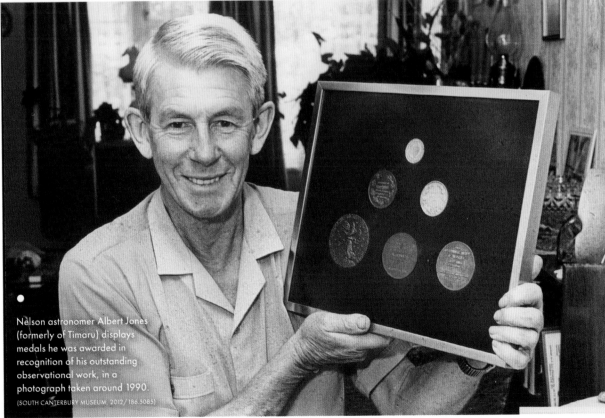

Nelson astronomer Albert Jones (formerly of Timaru) displays medals he was awarded in recognition of his outstanding observational work, in a photograph taken around 1990.
(SOUTH CANTERBURY MUSEUM 2012/186.5085)

continued his observations of variable stars at the Wellington City Observatory, which was then still a tin shed in the Botanic Gardens, on the site where the Carter Observatory stands now. At just 18, he convinced the (Royal) Astronomical Society of New Zealand to let him set up a variable star observing section (now Variable Stars South).

During World War II, he and his wife, Doris, moved to Rarotonga, where he established a simple observatory in his back garden at Avatiu with a 20-centimetre aperture refracting telescope. At this point he had two goals in mind: to find more observers for variable stars and to establish himself as a headquarters for them, so the results could be collected and published. He also wanted to expand the numbers and types of variable stars that were being observed. Even amateurs could make an impact when their results were combined.

He was rewarded when, in 1942, Nova Puppis suddenly appeared, becoming one of the brightest stars in the southern sky for a short while – a very faint blue star suddenly exploded, shooting matter off into space and increasing in brightness. Two members of a group called the Variable Star Section had discovered this independently: Alec Crust and Norman Dickie. It helped Bateson realise how many different types of variable star there were in the southern sky and how little they were understood.

Albert Jones

When Albert Jones joined the section in 1941, Bateson began receiving invaluable assistance from him. Born in Christchurch, Jones was then working as a miller in Timaru. As a young man, he had become obsessed with astronomy and he was further encouraged after seeing an aurora in 1939 and submitting his notes to a newspaper.

In the early 1950s, Jones and Bateson decided to monitor little-appreciated dwarf novae – pairs of stars in a binary system where one is losing mass to the other, meaning the accretion disk (the disk of matter pulled off one of the stars) gets much brighter by several magnitudes in 24 hours or less. The data would later prove essential to professional astronomers. Nikolaus Vogt, today a professor at Chile's Instituto de Físcia y Astronomía at the University of Valparaíso, used the data and commented that, thanks to the Variable Star Section's efforts, the southern hemisphere had better data than the north. The section became a vital source of data for many international programmes examining these stars. Charts that Bateson made for the amateurs' reference, detailing the surrounding sky around these variable stars, became international standard references.

This Hubble Space Telescope image shows Supernova 1987A. The bright ring around the central region of the exploded star is material ejected by the star about 20,000 years before its demise. (NASA, ESA, R. KIRSHNER, HARVARD-SMITHSONIAN CENTER FOR ASTROPHYSICS AND GORDON AND BETTY MOORE FOUNDATION, AND M. MUTCHLER AND R. AVILA [STSCI])

In 1963, Jones became just the sixth astronomer to make 100,000 observations of variable stars, and in 2004 was the first to rack up more than 500,000. He also became a noted discoverer of supernovae and comets and the world's most prolific amateur astronomer. Often described as 'modest' and a 'quiet achiever', he holds the record for the longest time between discoveries of comets, a testament to his decades of dedication to science. He co-discovered Supernova 1987A in the Large Magellanic Cloud, the closest exploding star in 400 years and the brightest naked-eye supernova explosion since 1604. He also discovered the comet C/1946 P1 (Jones), along with co-discovering C/2000 W1 (Utsonomiya-Jones) with a Japanese astronomer, making him the oldest person to discover comets. A minor planet, 3152 Jones, is named in his honour.

Albert Jones was known for his phenomenal skill as a variable star observer, with eyes described as 'photometric'; he was very precise with his observations of visual brightness. Most observers can distinguish variations of one-tenth of a magnitude, but Jones could detect variations of one-twentieth of a magnitude.

As well as working as a miller, Jones owned a grocery shop and worked in a car assembly factory. Nevertheless, he regularly helped out more than 30 professional astronomers working around the world and received many international awards for his work, including the Merlin Silver Medal and Prize of the British Astronomical Association and the Edgar Wilson Award, administered by the Smithsonian Astrophysical Observatory, for his discovery of Comet C/2000 W1. In 1987, he was awarded an OBE for his services to astronomy.

Jones built his own reflecting telescope, named Lesbet, in 1948 and made all his observations with it over 60 years, frequently in his backyard in Stoke, Nelson. He was awarded an honorary doctorate of science from Victoria University in 2004, though he had never formally trained in astronomy, having gone to work during the Depression instead. 'Later on, people urged me to retrain in the hope of finding a better job, but by that time I was so hooked on variable star astronomy that I wondered whether I might not have much time for observing if I did better myself, so I was happy as long as I could carry on observing,' he said in a 2009 interview.[1]

He liked to start observing as soon as it got dark, though as he got older he became so tired after observing for three hours that he would have to stop. He would then go to bed and get up again an hour or two before dawn to observe the stars that had come up in the east. 'The thrill of seeing with my own eye how variable stars change has not palled a bit, and to know that what I report is of value to science is an added bonus.

Especially, on a cold winter morning, when I may feel reluctant to leave a warm bed. Once I have put on a few extra layers of clothes and dragged the telescope out of the shed I feel it is so worthwhile,' he said. 'If I [went to university] I would never have time to look at the stars,' he told the *Nelson Mail* in 2011. 'I don't mind getting my hands dirty at work – at least I can look at the stars. I have never amassed much money, but I have had a lot of fun.'[2]

Jones died in 2013 after a short illness, aged 93. *Sky & Telescope* magazine mourned the loss of one of the international astronomy community's 'greatest visual observers'.[3]

Towards a national observatory

•

By the middle of the twentieth century, the southern skies were still relatively unexplored, despite the fact that we have some of the richest regions of the universe available. Though amateur astronomy was in respectable health, New Zealand still did not have a professional research observatory, and indeed there weren't many in the southern hemisphere at all. (City observatories weren't dark enough for serious astronomical work; observatories should ideally be in a place of high altitude, and with as little moisture, light and clouds as possible.)

It was a global problem for astronomy. In 1960, there were only 10 observatories set up in the entire southern hemisphere, compared to 88 in the northern hemisphere. None of those were in a site carefully chosen for the quality of its skies. Even if they were, as Puerto Rican astronomer Victor Blanco wrote in 1993 when outlining the problem, those 1960 southern hemisphere telescopes could only collect 10 per cent of the light of northern ones.

Most astronomers recognized that this imbalance in the world-wide distribution of optical telescopes was especially objectionable because of the location in the southern skies of many singular astronomical objects. Such astrophysically unique objects of the southern sky as the Magellanic Clouds, the brightest globular clusters, and the clusters and nebulae-rich Carina-Centaurus Milky Way region, to name but a few, were inaccessible to many astronomers unless

they were lucky enough to be invited to a southern observatory. Astronomical problems requiring the study of such objects and also of all-sky observations were often neglected or were very difficult to carry out.

It is no wonder that more than a century ago the leading observatories of the world, which were located either in Europe or in the United States, started sending so-called 'astronomical expeditions' to the southern hemisphere.[1]

Several people were teaching astronomy at the University of Canterbury in the 1960s, but there was concern that New Zealand lacked not only an observatory, but also a depth of formal training for staff and research students. This meant ambitious New Zealand astronomers, astrophysicists and cosmologists went overseas after their undergraduate years – where they often performed exceptionally well. Notable examples include Sir William Pickering, who became one of the world's leading rocket scientists; Sir Ian Axford, director of Germany's Max Planck Institute for Aeronomy from 1974 to 1990; Gerry Gilmore, who went on to head the Gaia space telescope project in the UK; Warrick Couch, who went on to direct the Australian Astronomical Observatory, the country's largest; and Beatrice Hill Tinsley (see p. 235).

The dearth of a suitable facility wasn't due to poor location. New Zealand was ideally placed, with its clear, dark skies and its position deep in the South Pacific able to fill a gap in the global chain of professional research observatories. With the pioneering era long over, there was a lot of ground to make up. The United States recognised this potential, and in the 1920s, Yale University set out to establish New Zealand's first professional observatory. Professor Frank Schlesinger, professor of astronomy at Yale University, wanted to find somewhere suitable to install a large 26-inch refracting telescope of 36 feet focal length, designed specifically for use in the southern hemisphere.

The plan was that Yale would pay for the telescope, and New Zealand would pay for the observatory, which would eventually be run entirely locally. But as Frank Bateson wrote in his memoir *Paradise Beckons*, the project 'foundered on parochial jealousy between different centres, so that Yale went off to South Africa in disgust'.

The search for a site

It was Bateson's dream that New Zealand should have a national observatory where young people could study astronomy at university level, and from the 1940s onwards he began collecting information, including some of Yale's reports, to try to figure

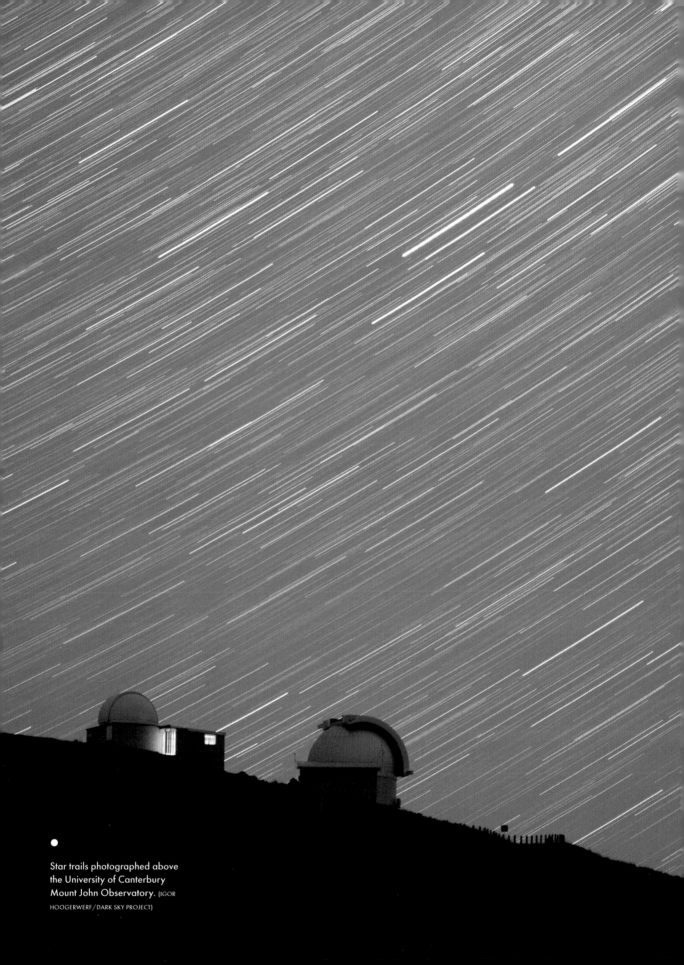

Star trails photographed above
the University of Canterbury
Mount John Observatory. (IGOR
HOOGERWERF/DARK SKY PROJECT)

out which were the best sites. One problem was a lack of available meteorological data in the country.[2]

Bateson had been communicating with astronomers overseas, looking for a telescope to borrow, and was offered the loan of an 18-inch refracting telescope from the University of Pennsylvania. It was made by the acclaimed J.A. Brashear Co. in Pittsburgh, but was dismantled and sitting in storage. It would need a large and expensive dome, so Bateson couldn't house it in his garden – but he foresaw that it could play an important role in the establishment of a new New Zealand observatory; the astronomer who offered it, Professor Frank Bradshaw Wood, was keen to collect southern hemisphere observations.[3]

A lecture tour of the United States in 1957 orchestrated by Wood saw Frank and Doris Bateson sail from Rarotonga on the SS *Waitemata*, with Frank carrying a carefully prepared lecture series to 'sell' New Zealand astronomically, hitting all the top spots on the international astronomical circuit. The tour would turn out to be life-changing. In 1960, Bateson heard that the United States' National Science Foundation had adopted his proposal and given a one-year grant to the University of Pennsylvania in order to find a suitable place for an astronomical observatory in New Zealand.

The couple left Rarotonga and returned to New Zealand. Bateson was looking for a place that was high altitude (to escape pollutants below) and free from artificial light, with a calm atmosphere and the greatest number of clear nights – 'steady seeing' in astronomical terms ('seeing' describes the stability of star images seen through Earth's atmosphere). It would have to be a mountain, but the Meteorological Service didn't have any records of cloud cover, sunshine and rainfall on mountains, because people didn't generally live on top of them. It also couldn't be too high, because it needed good access.

Frank and Doris began their search on 1 February 1961, as they travelled the country, with Doris driving and Frank, by now 51 years old, climbing the mountains. They were met in places by the local astronomical societies, who kept records of cloud cover for them. They were initially interested in the Bay of Plenty, Hawke's Bay, Marlborough, Nelson, South Canterbury and Central Otago, but the Bay of Plenty and Hawke's Bay had far too much artificial light. Poverty Bay was too cloudy, with unstable land. And, on visiting Nelson in 1962, Frank found the sunshine paradise counted only on the coast; the mountains inland were rough.

He and Doris went to Blenheim to check out the Black Birch Range, a steep ridge above the Awatere Valley, near Seddon.[4] The site seemed suitable, but it needed testing,

and Frank and Doris needed somewhere to stay and do the observations. Volunteers set up some bare-bones facilities, and New Zealand's first professional observatory was born.

Black Birch

The living quarters for the southern hemisphere's newest professional observatory was a mountain hut 5.5 by 3 metres with one small window, a space for stretchers with sleeping bags, and a stove that looked like it had been rescued from the tip.

The hut had a tiny table, a tiny desk and an iron roof that fed a rainwater tank, which froze solid for five months of the year; the water came from melting snow, with a foot of snow providing a couple of centimetres of water. The outhouse was nearly 50 metres away. A rope clothesline, where the washing never actually dried, attracted kea, who turned it into a swing then, after a few days, chewed it to bits. The birds also turned the hut into a climbing frame, sliding from the ridge pole to the gutters then climbing back and doing it over and over.

The drive to the hut was as hair-raising as the location was promising. As Bateson explained in his autobiography:

> The road to Black Birch snaked upwards in a series of hairpin bends. Even the Land Rover had to back before taking some of the bends. You looked up and saw the sky; you looked down the other side to sheer drops of two thousand feet [600 metres]. It was barren, bleak, dotted with tussock and outcrops of rock … the altitude of the station was 4,580 feet [1,400 metres], far above worry level.[5]

Indeed, the site was nearly one and a half kilometres above sea level, higher than Mount Tarawera in the North Island. Frank had positioned the hut so it was tucked up against an outcrop of rock, in the vain hope it would provide some protection against the dense fog, sweeping blizzards, and gales so strong he found he could not stand up against them. He ended up piling snow into a wall near the hut in an effort to get more protection. Wire ropes tied everything down to stop it blowing away, and reflective poles guided the way between the structures to lessen the chance of someone falling off the side of the mountain when the fog rolled in. Sometimes the wind was so strong Frank would have to crawl from the hut to the weather station enclosure, and some nights saw him completely covered in frost at the end of his work, though the instruments were safe and dry under layers of cover.

The MOA (Microlensing Observations in Astrophysics) telescope at the University of Canterbury Mount John Observatory during a winter sunset. MOA is a collaborative project between New Zealand and Japan. (FRASER GUNN)

There was, however, a telescope for site testing, along with a dark, clear view of the southern night sky. Volunteers built an iron-and-wood shelter, with a roof that slid off to open it to the heavens. Here, Frank would spend long periods of time alone, sometimes with Doris joining him, while he tested the visibility and suitability for an observatory.

It was a punishing schedule. For the first year there wasn't even a radio link, just a supply and mail drop every weekend. Determined to get as complete a record as possible, Frank would take a weather observation at 9 a.m., then repeat it every three hours during daylight. At night, he took a 6 p.m. weather reading, then began the astronomical observations, repeating the weather observations every three hours, skipping only in blizzards.

It was tough work, and at times Frank wondered what the point of it all was. One day, he sat smoking his pipe, alone beneath a cloudless sky and looking out to Cook Strait in the distance. He watched cars crawl along the highway below and questioned if he was a fool chasing this mad dream of a professional observatory. He heard a voice answer, telling him to carry on – that he was doing the right thing. He thought he might be suffering from a hallucination, but continued in his mission regardless.

Eventually he decided a more solid building was needed, one that allowed the site to train enough people to turn Black Birch into a continuously manned base station, which would enable other sites to be tested against it. The Marlborough community rallied, with volunteer labour building a road, holes for power poles, and new quarters. The US National Science Foundation granted more money for further testing, and Frank put ads in newspapers for young men aged 18 to 27, 'wanting Antarctica adventure without leaving New Zealand'.

But from the beginning, the project was dogged with mistrust. The American involvement was just too suspect for some New Zealanders. People thought Bateson was doing secret work for the United States, or was a CIA agent. One day, he was in Auckland collecting instruments loaned from the US Naval Observatory when a reporter stopped him on Queen Street, asking him about the 'secret research' he was doing 'down Blenheim way'. Bateson thought the inquiry must have been prompted by an explosion that had just happened at the Woodbourne Air Force Base. It was nothing to do with the observatory project and Bateson said so, but the reporter wasn't convinced. 'If you don't believe me then get your paper to send you down to have a look,' Bateson told him. 'If you think one man alone on a mountain can be doing secret work, then you're nuts.' The observatory on Mount John would later face similar allegations, which plagued its staff for years.

It was time to get a university on board. The University of Canterbury's Physics Department, which included one of New Zealand's few professional astronomers at the time, Dr Clif Ellyett, had an interest in astronomy, and agreed to take part in a joint project. As Bateson later recalled, 'Canterbury had made it clear from the start that they had no money for the project, but would provide some facilities in Christchurch and moral support'.[6] A formal arrangement was entered into with the University of Pennsylvania in 1962 and, leaving assistants at Black Birch, Frank moved into a musterer's caravan to test conditions at Mount John — with Godley Peaks Station's Connie Scott frequently filling the meat safe outside with venison steaks.

Marlborough had provided outstanding community support, and Frank wanted to choose Black Birch to reward the town for all the effort they had put in. But the meteorological data meant the choice was clear. By Christmas 1962, he had decided that Mount John was the best place to dig.

The following July, the universities of Canterbury and Pennsylvania announced the barren brown hilltop overlooking Lake Tekapo would be the site for a new astronomical base, the beginning of the modern era of New Zealand astronomy, and a valuable spot on the globe where worldwide research could be undertaken. The observatory opened in July 1965, on a savagely cold winter's day dulled by heavy snow. Frank Bateson was appointed the first astronomer-in-charge.

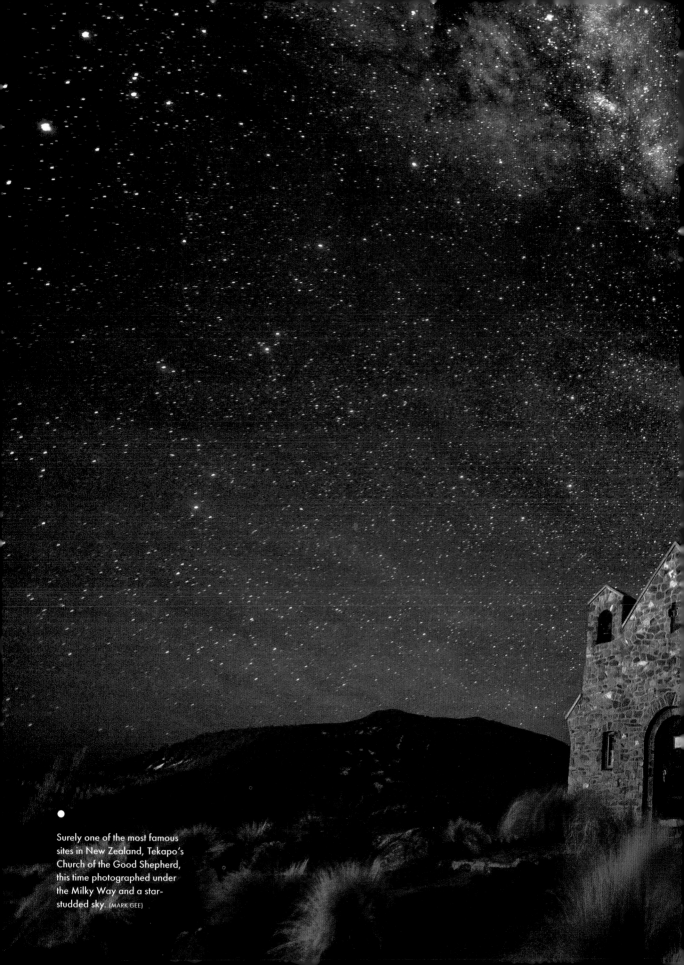

Surely one of the most famous sites in New Zealand, Tekapo's Church of the Good Shepherd, this time photographed under the Milky Way and a star-studded sky. (MARK GEE)

The View from Here

•

Eyes on
the sky

●

J ust a few years after the opening of the observatory at Mount John, following a heart attack and disagreements with university management over his vision for a national observatory and not just a research station, Frank Bateson left. But the observatory he built was beginning to find its feet. In 1981, the Mackenzie District Council put a lighting ordinance in place to keep the growing town's lighting needs constrained for the observatory. At night, residents drove the streets under the soft orange glow of low-pressure sodium lights hatted with small caps. It meant the village stayed as dark as possible, growing up with its face to the sky – and, as it did so, Bateson's vision of it as a default national observatory for both professionals and the public would begin to take form. Though 'national observatory' was a status never conferred in name, it was a role effectively filled in practice.

Mount John had slowly untangled itself from its patrons. Pennsylvanian professor Frank Bradshaw Wood's passion for eclipsing binary stars – two stars that eclipse each other as they orbit – had led to that becoming one of the key research areas for Mount John. This work, along with the study of variable stars, which Bateson pioneered, continues to be important today. Later, in 1970, Mount John partnered with the University of Florida in Gainesville when Wood moved there. Both universities continued to support the observatory until Florida stopped in 1979 and Pennsylvania finished its relationship in 1981. The US had invested in observatories in Chile that were better suited, with more reliable weather, and also had National Science Foundation funding. The US involvement slowly dropped out as the University of Canterbury began to develop its observational programmes and, after some uncertainty over whether it could continue, Mount John was on its own as a dedicated New Zealand observatory.

Today, the University of Canterbury Mount John Observatory, a scattering of white puffballs on a brown sandstone knob rising 300 metres above Lake Tekapo, is the centre of New Zealand's booming starlight industry, and of the nation's astronomical research. With its border of snowy mountains looming crisp and close in winter, Mount John itself is one of the world's most breath-taking sites for astronomical observation, just 52 kilometres as the crow flies from Aoraki/Mount Cook. Since dark skies are becoming scarce, in June 2012 a 4500 square-kilometre region of the Mackenzie Basin was declared an International Dark Sky Reserve. This has dramatically changed the future of Tekapo, with the local government agreeing to keep streetlights shielded, among other measures.

Fifty years ago, when Bateson arrived, there wasn't much of anything at Tekapo. Carved by glaciers, gripped by mountains, and with just one main road in and out, it was and would remain until quite recently just a beautiful, brief stop-off between Christchurch and Central Otago.

Tekapo's first residents were the Waitaha people, predecessors of modern Ngāi Tahu. For centuries, they lived in and travelled through the area, though a measles epidemic had devastated them by 1855, when sheep rustler James Mackenzie and his dog Friday stumbled through a mountain pass with a stolen flock. Waitaha hunted moa and established a pā on Motuariki, the island in the middle of the icy-blue lake. They navigated and lived by the stars, and were a people who never made weapons of war. They were proponents of peace and used the area to hunt eels and weka. After them were Ngāti Māmoe, and then came Ngāi Tahu.

The modern township grew from a base for hydro-power construction in the 1930s, a speck in the broad sweep of arid, tussock-brushed land. For tourists, reaching Tekapo meant a chance to soak in the hot springs, easing the aches of a long drive. It was obligatory to stop and take a photo of the Church of the Good Shepherd, and of its small wooden cross silhouetted against glacial waters, not to mention the plucky brass sheepdog statue. It was a nice place to have a pie, fill up the car with petrol and rifle through stacks of merino jerseys in the dingy row of shops near the lakefront. Otherwise, Tekapo was left to farmers, the rabbits, the power station and the war games of the army, which controlled much of the Crown-owned land. Even in 2001, the census of all the Mackenzie District, including the town of Fairlie, revealed there were just 3717 residents – making it, the country's third-smallest district, behind Kaikōura and the Chatham Islands. Tekapo itself is home to between 300 and 400 residents.

Winter at the University of Canterbury Mount John Observatory in Tekapo offers some of the best stargazing in New Zealand. In winter, not only is the night longer and starts earlier, but the core of the Milky Way is overhead and cold air holds less water vapour, so viewing conditions are clearer. (STEPHEN VOSS)

The stars changed all that. It was a good thing Tekapo was so rudimentary, because the absence of anything – light, dust, moisture, wind, traffic – was what drew Bateson there. The Southern Alps, the Two Thumb Ranges and the other mountains that surround the area create a microclimate, collecting rain, cloud and humidity, with the lake appearing to stabilise the atmosphere. It's become a centre for astro-tourism, with more than a million people visiting the observatory in the last 10 years.

The stars here don't twinkle as much as they do elsewhere, because these skies are some of the clearest and most stable in the country. Even so, conditions in the Mackenzie Basin aren't perfect for astronomy, owing to New Zealand's changeable climate, and it is sometimes difficult to achieve many consecutive nights of clear weather. It means that we aren't ever likely to have a major optical observatory here.

But New Zealand researchers have still contributed a lot to global research from their base at Mount John. More than a thousand papers have been published, and more than 150 graduate students have written their theses on data gathered at the observatory. Since it's at 44 degrees south – the southernmost observatory in the world – observers can see objects such as the Magellanic Clouds at all times of the year. In more northerly southern hemisphere observatories they can be seen only in the short summer months. Also, its position at longitude 170.5 degrees east of Greenwich, a spot held by no other major observatory in the world, means it is well placed to support global astronomical campaigns that require international collaboration and constant monitoring as Earth moves. For example, in 2015, just two weeks before the *New Horizons* probe passed the dwarf planet Pluto, astronomers from around the world flocked to the Mackenzie Country to watch Pluto passing in front of a star. Known as a stellar occultation, the 90-second event created a silhouette of Pluto's atmosphere, allowing astronomers to measure its depth and density as the star dimmed before Pluto completely blotted it out.

Mount John is the centre of the Japanese–New Zealand Microlensing Observations in Astrophysics (MOA) collaboration, which uses New Zealand's largest telescope to look for new extrasolar planets – ones outside our Solar System, also known as exoplanets. We tend to think that light travels in a straight line, but it doesn't always. MOA uses the gravitational bending of light, also known as gravitational microlensing, to detect extrasolar planets, dark matter and stellar atmospheres. Einstein first described gravitational lensing, of which microlensing is a class, in 1936, postulating that a star, which is a high-gravity object, has a gravitational field that causes light to bend around it. The phenomenon enables a distant star to be essentially 'magnified'. One of MOA's biggest accomplishments was the discovery, in 2008, of the smallest known extrasolar planet.[1]

So, Mount John is our unofficial 'national observatory' – but has never been funded as such. Government support for astronomy has always been erratic. Wellington's Carter Observatory was once our national observatory, but since its status and funding were revoked the government has consistently refused to endow New Zealand with a proper national observatory, funded appropriately. For somewhere at our point on the globe, with our low levels of population and air pollution, that has never made much sense.

Echoes from space

New Zealand's strength has traditionally been in optical astronomy, but we do have a centre for radio astronomy in Warkworth, at the Auckland University of Technology's Institute for Radio Astronomy and Space Research. With its own 30-metre radio telescope, a former Spark telecommunications dish, it conducts programmes that look deep into space.

It was also one of the monitoring stations for the SpaceX Falcon launch, Elon Musk's 2018 project that saw a reusable payload launch a red Tesla sportscar into orbit. AUT also won the 10-year contract to track SpaceX's flights.

The SpaceX opportunity came because New Zealand was part of a group of countries that collaborated on the early stages of SKA, a global mega-radio project that will build the world's largest and most capable radio telescope. New Zealand was excited to be involved with the project when it was announced in 2008, keen to see radio dishes based here and New Zealand tech companies helping process mammoth amounts of data.

But hosting duties were eventually split between Australia and South Africa, and in 2018, the government decided to opt out of becoming a full member, which would have meant a contribution of $25 million over 10 years. Much had changed in New Zealand astronomy in the 10 years since it signed on, including the Canterbury earthquakes, which threatened optical astronomy at Mount John as the university struggled to cope financially with the quakes' aftermath. The withdrawal caused significant ructions in the radio astronomy and wider astronomical community; Auckland University of Technology and tech companies had invested in the project for several years.

Although astronomers disagreed on whether New Zealand should be a member of SKA, what many do agree on is that the New Zealand government needs a 10-year astronomy funding plan like those in other countries, allowing astronomers to present a united front publicly.[2]

CHAPTER 16

'Our lady astronomers'

•

Women simply do not feature in the early records of New Zealand astronomy, which is not surprising given that the journals, societies, classes and discussions were overwhelmingly initiated by men, for men. The accounts male astronomers have left behind imply that if women were involved they mostly did clerical work or supported their astronomer husbands. For example, when Frank Bateson's wife, Doris, passed away, he regretted the significant loss of her unpaid labour in his success: 'Doris had contributed so much in typing and other work that I now sorely miss her. A typist is essential, but there is just no money with which to pay for such assistance.'[1]

In colonial days, women could not even speak at scientific meetings. However, there were a few women out there observing. The New Zealand journal *Southern Stars* ran a small item on 'Our Lady Astronomers' in March 1947. The article talked about 'a rather interesting development in the astronomical progress of our country', which was the number of women actively studying the heavens. Judging by the tone of the article, their activities seemed to have been viewed with paternal benevolence, tinged with surprise that they could be showing such aptitude at all – though again, they carried the bulk of the drudge clerical work.

'Their sunspot drawings are exceedingly good and useful and would put many a male observer on his mettle to better,' the article said of three junior solar observers. 'There is no doubt, however, that this has also partly come about by the traditional good work established by Mr Morshead [and] Mr Snelling.' Meanwhile, 'everyone who has had the honour of visiting our grand old man of astronomy in New Zealand Mr. A. C. Gifford', it said, 'cannot help but be impressed how his good wife assists and inspires him in his work'.[2]

Little is known about 'Miss Hirst', an astronomical observer in Auckland in the mid-nineteenth century – not even her first name, date of birth or date of death. She was, however, described as a practical and careful observer who had been working on astronomy for 16 years, including early work on Jupiter's coloured belts and spots, before the Great Red Spot was discovered in 1878.

In the twentieth century, however, a handful of women blazed a trail by taking up the study of astronomy and attaining prominent positions within the science, most notably Elizabeth Alexander and Beatrice Hill Tinsley.

Elizabeth Alexander

Although she was born in Britain, Frances Elizabeth Somerville Alexander carried out much of her pioneering work in New Zealand. Her first subject was geology, but she was a physicist too. In 1942, already working for the Royal Navy in Singapore in radio direction finding, she was ordered to evacuate her children to New Zealand, her husband's country, then return to Singapore. But Singapore fell to the Japanese before she made it back. Stranded in New Zealand, she was told, wrongly, that her husband was dead.

Alexander's work was already known to New Zealand's Navy and Intelligence Services, and New Zealand's DSIR invited her to set up and run its Operations Research Section in Wellington's Radio Development Laboratory (ROL), where she worked as a senior physicist for three years. Her job was to analyse the performance of New Zealand–made radar.

During World War II, radar operators on Norfolk Island, which was then part of New Zealand's wartime command, had noticed strange bursts of radio noise at sunrise and sunset. Alexander interpreted the anomalous signals as coming from the Sun. Commissioning further research to confirm the effect, she shared her interpretation with colleagues in the Commonwealth Scientific and Industrial Research Organisation (CSIRO) in Sydney, where it helped initiate Australia's radio astronomy research programme. (Radio astronomy is different from observational, telescope-based astronomy in that it looks at objects using the radio part of the spectrum rather than the visible light part.) Astronomy was not part of RDL's remit and radio-astronomy research did not continue in New Zealand at the end of the war for financial reasons.

In 1945, Alexander's husband, who had been interned by the Japanese, returned to New Zealand, starved and traumatised, on six weeks' compulsory sick leave. Unable to manage his children, he returned to Singapore to rebuild Raffles College, where he had worked before the war. Alexander took her children to England to leave in

●

By recognising that a Norfolk
Island 'radar' signal was
actually coming from the sun,
Elizabeth Alexander initiated the
development of radio astronomy
in the Antipodes. (MARY HARRIS)

her sister's care and returned to Singapore, where she became temporary registrar in the transitioning of Raffles College to the University of Malaya. Then, commissioned by the government to survey Singapore for sources of granite for reconstruction, she drew a geological map of the country – still in use today – while preparing samples to establish teaching in the university's geology department.

In 1952, the couple moved to Nigeria, where she lectured in soil science at Ibadan's University College. Just three weeks after becoming the first head of the university's new department of geology, she suffered a stroke. A week later, she died, aged 49.

Beatrice Hill Tinsley

The most outstanding woman in New Zealand astronomy is surely cosmologist Beatrice Hill Tinsley. Intensely driven from a very young age to excel and achieve fame, Hill Tinsley provided evidence to help prove the universe was changing, evolving, expanding, and would continue to expand forever, a test of Einstein's theory of relativity. She worked at the very forefront of new knowledge of the universe during the 1960s and 70s. She was the first to imagine that the life histories of the galaxies could be modelled in the same way as individual stars, a scientific acquaintance would later say.

The dominant theory at the time was that the universe had reached the peak of its expansion and would gradually shrink before eventually collapsing. The *New York Times'* belated 2018 obituary, part of its Overlooked No More series, which focused on people other than white men, said that thanks to Tinsley's work, galaxies went from being considered 'isolated blobs of starlight' to 'dynamic changeable weather centers of energy and radiation, influencing and being influenced by the cosmos around them'.[3]

Hill Tinsley's work was the basis for modern theories of galactic evolution – but it was in theoretical aspects of the universe: as a cosmologist, she did almost no direct astronomical observation, instead using the observations of others to model her galaxy calculations using computers, not telescopes, in which she had almost no interest.

Nonetheless, she bridged both worlds. American astrophysicist and University of California chancellor George Blumenthal would later remember her as scientifically one of a kind, spanning the separation between theoreticians and observational astronomers. Before Beatrice, there was a gulf between the two, Blumenthal said. 'Beatrice was unique in trying to see the birth through to adulthood of galaxies. This was crucially important to astronomy.'[4]

The research of British-born New Zealand cosmologist Beatrice Hill Tinsley made fundamental contributions to our understanding of how galaxies evolve, grow and die. (THEODORA LEE-SMITH)

'Beatrice Tinsley views galaxies from the end of a lead pencil,' a *New Haven Register* reporter once wrote. Indeed, her elegant, economical calculations working out the chemical age of stars, and therefore their evolution, growth and death, helped gauge the age of the universe since its expansion after the Big Bang. The universe behaves like a rocket shot through the atmosphere, she said in one of her classically down-to-earth and comprehensible answers to the newspaper journalist. If there's enough velocity to get it through the atmosphere, it will go on forever.

She corrected the work of Einstein, applying her knowledge of stellar evolution. Her papers positing that the universe was open, ever-changing and growing was a radical shift from the dominant view at the time that it was closed, finite and destined eventually to shrink.

She was born Beatrice Hill in 1941 and studied at New Plymouth Girls' High School, where she insisted on taking scholarship-level mathematics, which no previous student of the school had ever done. The only woman in physics at that level, she gained her master's degree in physics at Canterbury University College (later the University of Canterbury) before moving to Dallas, Texas, for her husband's job in 1963. They had married two years earlier, when she was 20.

She apparently hadn't given much thought to the bias against women in academic employment until she was denied a spot on the college staff because her husband was already employed there. She felt betrayed, and was eventually to grow frustrated and chafe at the lack of opportunities afforded her as one of a very small number of women cosmologists, battling anti-nepotism rules, which favoured men, and blithe sexism for much of her career.

In 1967, Hill Tinsley's PhD, 'Evolution of galaxies and its significance for cosmology', was published, two years before the Moon landing. Prior to this, people believed that galaxies were fixed, immobile and unchanging in the universe. New technology meant more data could be collected from space, and her PhD used data from computer models. It was a major advance in astronomical thinking, and her models helped make sense of all the data, adding to the acceptance of the Big Bang theory as an explanation for the origins of the universe. But she still struggled with being taken seriously as a junior staff member, and with the restrictions on work that came with being a woman during that era.

In 1974, after gaining her PhD by commuting to the University of Texas in Austin, after adopting two children, and shouldering all the domestic burden as was typical at the time – and still is – she did away with years of restrictions: she left their two adopted children with her husband at his request and went to Yale, which hadn't even admitted

women as undergraduates until 1969. That same year, she became the youngest-ever recipient of the prestigious American Astronomical Society's Annie J. Cannon Prize for women. The following year, at the age of 34, she became the first woman assistant professor of astronomy, achieving freedom, happiness and security – personally, financially and academically. 'I have a sense of hope and power over the future that had escaped me for many gloomy years,' she wrote to her family during this time. Those years at Yale were her best ever, and she was credited as a source of infectious scientific energy, having sparked a renaissance in the department. She published 100 papers in 18 years.

Hill Tinsley died of melanoma in 1981, at the heart-breakingly early age of 40. Her death drew an outpouring of grief and upset from the scientific community at the loss of a woman who was just beginning her independent scientific career.

But Hill Tinsley also suffered from the 'Matilda effect', a bias that means women scientists are ignored and their achievements diminished, devalued or attributed to male colleagues. That she faced a battle to be taken seriously throughout her career, and experienced outright hostility, makes her achievements all the more remarkable.

Hill Tinsley was not outspoken on this subject – or perhaps, having died so young, she did not get the chance to openly reflect on her career in that way. She seethed privately, and was acutely sensitive to giving people, especially students, their due. She still smarted from the unacknowledged exploitation of her 1968 thesis work by her superiors at Caltech – Searle, Sargent and Bagnuolo, who published a paper based on her work in 1973. She also had difficulties getting her PhD published, discussed and accepted, and her later work taken seriously at all. She had to rely on male colleagues' largesse in entering the scientific networks, introducing her and giving her positions. She had to make her own opportunities and find her own funding, and received no domestic support in her marriage.

In fact, she came to despise marriage, was a staunch advocate for a woman's right to choose pregnancy and children, and also for the Zero Population Growth movement – and when, in Texas, she found herself with two adopted children and newly pregnant to her husband with a child which she was adamant her career or marriage did not need, she discovered she needed her husband's permission to get a legal abortion outside the state.

At the end of her life, Tinsley attributed her cancer to the emotional toll of leaving her family to do her own work, no matter how happy it made her. She is memorialised in New Zealand by Mount Tinsley, in Fiordland's Kepler Mountains (which are named after astronomer Johannes Kepler). The main-belt asteroid 3087, discovered in 1981 at Mount John Observatory, is also named after her.

In the United States she is memorialised with the Beatrice M. Tinsley Prize, awarded by the American Astronomical Society in recognition of creative, exceptional research in astrophysics or astronomy. In 2016, the New Zealand Association of Scientists renamed its Research Medal to the Beatrice Hill Tinsley Medal, the first New Zealand science award named after a woman.

Breaking down barriers

In more recent times, women in all sciences have been increasingly able to push through both blatant and invisible barriers to further education and career advancement, though sexism can still camouflage their achievements. A number have attained prominent roles in New Zealand astronomy.

Mazlan Othman, Malaysian astrophysicist and former director of the United Nations Office for Outer Space Affairs, studied for her BSc and then PhD in physics at the University of Otago in 1981 – the first woman to do so since the university was founded in 1869. Another pioneer was Pamela M. Kilmartin, a New Zealand astronomer and co-discoverer of minor planets and comets. With her astronomer husband, Alan Gilmore, she discovered 41 asteroids, naming each one in honour of New Zealanders or New Zealand places. The minor planet 3907 Kilmartin, discovered by German astronomer Max Wolf in 1904, is named after her.

To name just a few, Dr Karen Pollard is the director of Mount John Observatory; Nalayini Davies is an astronomer and dark-sky activist; and Victoria University astrophysicist, science lecturer and research fellow Dr Pauline Harris (Ngāti Rongomaiwahine and Ngāti Kahungunu), who has a PhD in astroparticle physics, is involved in the search for extrasolar planets. As noted elsewhere in this book, she is a key figure in the revitalisation and teaching of Māori astronomy. Pounamu Tipiwai Chambers, who studied Māori astronomy with Harris at the University of Victoria, has used Māori astronomical and navigational knowledge to help her voyage across the Pacific.

Dr J.J. Eldridge, of the University of Auckland and a Fellow of the Royal Astronomical Society, is a non-binary theoretical astrophysicist who works on exploding binary stars. Dr Eldridge, who uses the gender-neutral pronouns 'they' and 'them', says their view of the history of science has changed since exploring their non-binary gender identity. That was thanks partly to teaching the history of astronomy to first-year students, where a woman student pointed out that it was so difficult to see themselves in astronomy as all our stories were of 'old bearded white men'.

Within the dome at the University of Canterbury Mount John Observatory red light is used to protect night vision. (STEPHEN VOSS)

Sparking interest

•

Today, some of the old ways are becoming new again. Although much Polynesian celestial navigation knowledge and Māori tātai arorangi was lost due to colonisation, urbanisation, land loss and a push for cultural assimilation, various historical and cultural developments over the past 50 years have piqued public interest in both traditional and modern astronomy. Not only have public science communication and observatory offerings improved, but the descendants of those who travelled to New Zealand using traditional celestial navigation are revitalising and sharing the practices of their ancestors.

Ancient knowledge rediscovered

The beginnings of the Polynesian celestial navigation revival lie in the 1920s, when Sir Āpirana Ngata and Sir Peter Buck helped revitalise waka-building traditions, along with other traditional arts and crafts. Then, in the 1930s, the centennial of the 1840 signing of the Treaty of Waitangi was acknowledged with an immense waka-building project that taught new generations the skills of their ancestors. The 37-metre single-hulled waka taua (war canoe) *Ngātokimatawhaorua* was commissioned by Tainui's Princess Te Puea Hērengi, and is still used in Waitangi Day observances today.

Across the Pacific in the 1970s, the cultural reclamation movement gathered pace. It began with *Hōkūle'a*, a replica of a Hawaiian ocean-going waka, which sailed to Tahiti in a hugely successful voyage that terminated with half the island's population greeting her as she arrived in Papeete. *Hōkūle'a* visited New Zealand in a two-year voyage from 1985 to 1987.

The group that built her, the Polynesian Voyaging Society, had formed from the conviction that cultural knowledge of navigation was nearly extinct, and they needed to find who held it. In Satawal, Micronesia, they found Mau Piailug – 'Papa Mau' – who had learned the voyaging traditions from his grandfather and was willing to share what he knew. It was a good thing: according to *National Geographic*, which followed the project, it was likely he was one of the last people on Earth who could do so.

Piailug learned his craft as a five-year-old. He would lie down next to his grandfather, who told him that if he, too, became a navigator, he would be held in higher regard than a chief, because it was he alone who would be able to safely cross the vast bodies of water to home. What's more, he would get to eat navigators' food: the best meals. The knowledge was considered sacred and not usually divulged to foreigners; sensing the precariousness of his knowledge, however, Piailug broke with tradition and taught the secrets of celestial navigation to everyone who wanted to know, including New Zealanders, who in turn have passed it on. He trained a crew to navigate using the star compass, and after a test voyage they sailed from Hawai'i to Tahiti using only traditional methods. They were followed by the *National Geographic* film crew, which was able to demonstrate and confirm that Piailug's knowledge meant they were off by only about 40 nautical miles (74 kilometres) at any one time.

Other Pacific nations subsequently adapted the star compass using their own language, star names and terminologies. In New Zealand, where a traditionally carved waka hadn't been tested in 400 years, a small group of Northland Māori began the celestial navigation renaissance in New Zealand in 1991. They were led by the late Hekenukumai Ngā Iwi Puhipi, also known as Sir Hector Busby, a builder and bridge-building contractor who was to become the driving force behind waka revival in New Zealand. He was honoured with a knighthood for services to Māori in 2018, at the age of 85, and died in May 2019. Hec Busby held the oral histories of his people, and traced his ancestry back a thousand years to Taputapuatea Marae on Ra'iātea in the Society Islands – the same marae where Cook's navigator Tupaia learned his skills.

Born in 1932, the young Busby had admired *Ngātokimatawhaorua* at Waitangi, and wondered if he would ever see a waka like that in the water. He set about creating New Zealand's own double-hulled waka hourua, *Te Aurere*, from the trunks of two kauri trees pulled from the bush. In 1992, it became the first modern waka hourua to sail from New Zealand back to Rarotonga in the Cook Islands, on a nearly month-long voyage known as Waka Tapu. *Te Aurere* was a lightning rod for the revival of traditional celestial navigation techniques in this country, creating a core group of people who would go on

to inspire and educate hundreds of others in the old traditions and knowledge, such as Auckland's Stanley Conrad, Tauranga's Jack Thatcher, and Waikato Tainui's Hoturoa Kerr. Many voyages have been completed since, connecting the people and countries of the Pacific with their shared history and traditions.

The documentary *Kupe: Voyaging by the stars* follows the journey from Tahiti to the forests of New Zealand, where Busby and his team cut two trees from the Herekino Forest, reciting this prayer to appease Tāne for taking his children:

> Let your prow know the stars to follow
> As the sweeping tide rests
> Raising one to a fleeing Orion
> Aligning with the lesser of Magellan's clouds
> As the moon appears on the horizon
> Then I too will complete the crossing.

The logs then began their journey from Tāne to Tangaroa, with Busby inspired by photographs of a waka found on Aurere Beach, near Taipa in Northland. (This waka is now at Auckland Museum.) Building the new waka where the old one was found, Busby decided to recarve the ancient waka's tauihu (prow) to guide his own new waka, the figureheads becoming guardians.

To build *Te Aurere*, which took teams working through the winter under large marquees, Busby used expertise from around the South Pacific, drawing on the knowledge of people including Mau Piailug. While it was being carved, crew were chosen from around New Zealand for their knowledge of waka and their ability to pass this on to others.

Helping to inspire a voyaging renaissance throughout the Pacific was Nainoa Thompson, the first native Hawaiian since the fourteenth century to practise long-distance navigation.[1] With his help, New Zealanders began to study the essentials of celestial navigation, learning the oral histories of voyaging, understanding how to steer by the same stars as their ancestors, and realising that this voyage presented a vital chance to go back and touch the past. As one voyager, Pakake Winiata, said, the waka was a symbol of the heritage shared by all Pacific peoples; *Te Aurere* itself was a chance to 'weave a korowai' to connect all the peoples of the Pacific.

'For ourselves as Māori people this particular exercise of sailing, voyaging and using traditional navigation techniques helps to lend credibility to our own tikanga and

Top Sir Hector Busby with the twin-hulled waka *Te Aurere*, at Shelley Bay, Wellington. (MELANIE BURFORD, *THE DOMINION POST*, EP/1998/0365/33, ALEXANDER TURNBULL LIBRARY, WELLINGTON, NEW ZEALAND)

Above *Hōkūle'a*, the iconic Polynesian voyaging canoe that helped inspire Sir Hector Busby, departs the Hawai'i Convention Center by way of the Ala Wai Canal in Honolulu, Hawai'i, in April 2019. (SHUTTERSTOCK/PHILLIP B. ESPINASSE)

culture,' she said. 'There are a lot of people out there who are doubters, disbelievers and are puzzled about things Māori, and something like this helps strengthen the acceptance and appreciation of our own tikanga.'[2]

One of the students back then was Jack Thatcher. He was a 32-year-old meatworks employee when asked to train as a celestial navigator, and he hadn't done anything of the sort before. Although the prospect of the open ocean was frightening, he was determined to see it through. 'I don't know what it's like out there,' he said. 'I've never done anything like this before. The only thing I can do is look forward to it. I'm just keen to get away.'[3]

For 24 days, the waka sailed across the Pacific using no instruments, voyaging nearly three thousand kilometres. For the crew, it was a chance to feel a strong sense of pride and understanding of their heritage, and to connect with ancestors across the wind and the waves.

Te Aurere arrived in Rarotonga safely, the first waka in 400 years to do so, retracing in reverse Kupe's mythical course across the Pacific. It was incredibly emotional for the voyagers and for those receiving them. When *Hōkūle'a* had arrived in New Zealand, a stone was brought with them and placed on the home marae – and now it had been returned.

The experience had a lasting impact on everyone involved. Busby built a second waka hourua, *Ngahiraka Mai Tawhiti*, named after his late wife. Thatcher went on to lead Te Kura o Ngā Kuri o Tarawhata – the School of Traditional and Celestial Navigation. Years later, Busby returned to Ra'iātea in *Te Aurere*, and the waka sailed all over the Pacific, including to Rapa Nui (Easter Island), closing the 'Polynesian Triangle' of ancient exploration. There is no danger of the sacred knowledge being lost again.

Re-examining tātai arorangi

As mentioned, celestial navigation also helped spark a resurgence of interest in Māori astronomy, and this has been largely led by a group of experts clustered around the Society of Māori Astronomical Research and Traditions (SMART). They include Tūhoe Māori astronomy and Māori culture expert Dr Rangi Matamua.

One day in 1992, Matamua, then an undergraduate at university, went to his grandfather Jim Moses (Timi Rāwiri Matamua) and asked the older man what he knew about Matariki, the dawn rising of the constellation Pleiades. He knew it heralded the Māori New Year, but knowledge of the constellation and its associated traditions was

Māori astronomer and Univeristy of Waikato professor of Māori Studies Dr Rangi Matamua is committed to sharing the astronomical knowledge of his ancestors. (UNIVERSITY OF WAIKATO)

only just beginning to spread after lying dormant for many years. Timi Rāwiri went to his bedroom, reached into a cupboard and brought out a 400-page manuscript, written in te reo Māori. He gave it to his grandson, and it changed the course of the young man's life.

The manuscript was an astronomical record compiled by Timi Rāwiri's grandfather, Rāwiri Te Kōkau, who had written it with his father, Te Kōkau Himiona Te Pikikotuku of Ruatāhuna, a tohunga of Tūhoe and Ngāti Pikiao. Written over two lifetimes from the late nineteenth century, it contained precious star lore, including the names of 1000 stars and 103 constellations and how to establish a whare kōkōrangi, or house of astronomical learning. It was knowledge that had nearly been lost from New Zealand as colonisation put pressure on Māori to assimilate with Pākehā in language, spirituality and way of life. Later, towards the end of Timi Rāwiri's own life, he told his grandson to find a way to share what it contained. Knowledge hidden, he said, wasn't knowledge at all – and that set Matamua on a mission.

It was fortunate for all New Zealanders that Matamua's ancestors so diligently wrote it down, and even more fortunate that it made its way into the hands of Matamua. He has spent the past 20 years steeping himself in both Tūhoe and wider Māori astronomy. In his current role at the University of Waikato he travels frequently, holding lectures and wānanga (workshops), gathering information from other iwi and people with traditional knowledge. Much of the astronomical record he uses is in te reo Māori, and a portion of his work involves correcting the record to reflect actual historical narrative.

Matariki is a good example of this. Celebrating the Māori New Year has grown popular in recent years, but its meaning and its timing have become distorted. Many people get the basic dates, name and meaning wrong, and the errors compound year after year. It's also becoming over-commercialised – it's questionable whether Matariki supermarket specials are in keeping with the power and import of its original meaning.

Matamua is on a journey to help people rediscover the connection that we all have to the cosmos and the universe, and he dreams of establishing a modern whare kōkōrangi, a house of astronomical learning. It is past time the space is decolonised, to enable Māori to tell their own stories.

Peter Read's *Night Sky*

Lecture halls turned to living rooms when television arrived in the 1960s, and for many young New Zealanders it was presenter and astronomer Peter Read who sparked their interest in the universe.

Read was a Wellingtonian, born in 1923, and a self-taught stargazer. He first learned about the stars at Rongotai College, where he started an astronomy club. Once, a teacher wrote on his astronomy essay: 'Very interesting; you should try and develop your ideas further.' Develop them he did. Read later served in World War II as a naval mechanic, but also developed an interest in performing during concert parties in Bougainville, where he was stationed. He was also a keen artist, later painting his own television set backdrops.

In 1947, he began to give lectures at Carter Observatory as an honorary observer at the invitation of Ivan Thomsen, then became vice-president of the Wellington Planetarium Society and a Fellow of the Royal Astronomical Society. He built his own observatory in the backyard of his Miramar home; and then a street-corner conversation with an old friend, producer Roy Meiford, launched his television career.

Coinciding with the launch of television in New Zealand and manned spacecraft, which caused the world to look twice at what is above our heads, it was the right time for Read and his astronomy shows: *A Closer Look at the Moon*, *The Infinite Sky*, *Night Sky* and *Horizon*. *Night Sky* was New Zealand's longest-running television show when it was eventually cancelled in 1974, and Read was the longest-serving presenter. Called the People's Astronomer, the genial man became very well known, a conduit to New Zealanders learning more about the technological leaps happening in global space flight.

The highlights of his 10-year anniversary show included the 1965 total solar eclipse seen from the Far North; the first man in space, Yuri Gargarin; Colonel Yurnov's first space walk in 1961; Edward White, who died in the first Apollo fire; the Moon landing; space vehicles to Mars; and Read's visit to the United States to watch the launch of Apollo 15.

Read died in 1981, and the Gisborne Astronomy Society bought his five-inch brass f12 refracting telescope, which was similar to the one through which Cook would have observed the transit of Venus. In 2011, the Carter Observatory celebrated Read's life and work in the exhibition *Peter Read – The People's Astronomer*. The observatory's Brian Wood remembered *Night Sky* as 'compulsory viewing' for those growing up at the time. '[It was] a wonderful mix [of] colourful character, amateur astronomy knowledge, media nous and interviews with NASA astronauts and local astronomers.'

Watching the grainy 1969 footage of man walking on the Moon on Read's show, an event still remembered by probably close to a million New Zealanders, it's remarkable to think how far we have come since then. Twenty-five years later, the students of tiny Middleton Grange School in Christchurch became the first school outside the United States to contact a NASA space shuttle, the *Discovery*, as it soared over Fiordland, thanks

to a local dad who rigged up aerials on the school's roof. You can't help but think that Peter Read would have got wind of it somehow and crept into the classroom to ask a few questions.

Rocket Lab

Though the New Zealand Space Agency was set up in 2016, New Zealand got its own space programme when Peter Beck's Rocket Lab successfully launched a rocket into orbit in 2009. In 2018, it launched the Humanity Star, which was designed to flash as it orbited Earth, bringing people's attention to their shared skies and thus a shared understanding between cultures.

At the time of writing, Rocket Lab has just launched a rocket named Electron, on a quiet late-spring afternoon on Hawke's Bays' Mahia Peninsula, at the very tip of New Zealand's eastern point, into orbit. Featuring a carbon-fibre body and 3D printed Rutherford engines, it is small and light, and marked New Zealand's entry to the commercial space race. Peter Read would surely have been thrilled to hear the unexpected, unmistakeably flat-vowelled Kiwi voice counting down the seconds to lift-off.

Stonehenge Aotearoa

Stone circles may be symbols we think of as pagan or unsophisticated, but they are the traces of our ancestors mapping and understanding their world, how to best live in it, and how to survive. What would Stonehenge have looked like if it had been built in New Zealand? Stonehenge Aotearoa is something of an answer to that, a working open-sky observatory and astronomical park out away from cities, on a site where the skies are blessedly dark.

Built by astronomer and star-lecturer Richard Hall and the Phoenix Astronomical Society on Hall's land east of Carterton, it's quite an unexpected structure on the rolling farmland. At 30 metres wide and 4 metres tall, it took $56,000, 18 months and 150 volunteers around 11,000 hours to build, and was completed in 2005.

The observatory's purpose is to stimulate wider interest in not just astronomy, but also associated disciplines of history, geology, physics and more. It takes people away from remote high-tech devices such as large telescopes, night sky mobile apps and screens to help them understand space, the seasons, and how the mathematical precision of the universe affects us all; a star computer you can walk through.

Hall, originally from England, arrived in New Zealand in 1973. He is a former senior public programmes officer at Carter Observatory in Wellington, a co-founder of the Phoenix Astronomical Society, and past president of the Herschel Society in England and the Whangarei and Wellington astronomical societies. In 2009 he was awarded the Royal Astronomical Society of New Zealand's most prestigious honour, the Murray Geddes Memorial Prize, for his outstanding contribution to astronomy in New Zealand.

He bought 10 acres in the Wairarapa in 1997 with former wife Lesley Hall, when he had driven over the Remutakas and seen how pristinely dark the skies were out on the plains. He put aside some space for the astronomical society observatories, but then he and astronomer Kay Leather, now his partner, were working at Carter Observatory when they realised how fascinated people were by stone circles and pyramids at talks such as 'Legends and Mysteries of the Night Sky'. He realised that if you want people to remember something, you house it within a story and a place.

The original Stonehenge, on England's Salisbury Plain, is actually the third incarnation of what was originally there on the site. Created over the course of a millennium, it was completed about four thousand years ago, and experts differ on its use. It's changed over time; the stones had to be moved as the stars came out of alignment. It's likely that it meant different things to different generations of people. As people moved from a nomadic existence into settling and began to farm, they looked for guidance to the cycles of the Moon, the Sun and the seasons. It is known that henges – stone or timber circles – were aligned with the axis oriented towards sunrise at the summer solstice in one direction, and sunset at the winter solstice in the other, so Stonehenge was probably a form of timekeeping.

Similarly, Stonehenge Aotearoa is designed specifically for its Wairarapa site, and links ancient astronomy with new science today. It brings together modern knowledge with Celtic, Egyptian and Babylonian astronomy, along with Polynesian celestial navigation techniques. It's also a learning centre for tātai arorangi and maramataka (the calendars of time and seasons).

In its construction, Hall wanted to highlight how connected different cultures are across time and space. The Royal Society of New Zealand used its opening in February 2005 to launch New Zealand's programme to celebrate the World Year of Physics, and Nobel Laureate Alan MacDiarmid – himself Wairarapa born – paraphrased Isaac Newton in saying, 'Stonehenge Aotearoa is an example of where we stand on the shoulders of the giants. Giants from five thousand years ago, giants of Māori wisdom of the last few hundred years, and the emerging wisdom of the twenty-first century today.'[4]

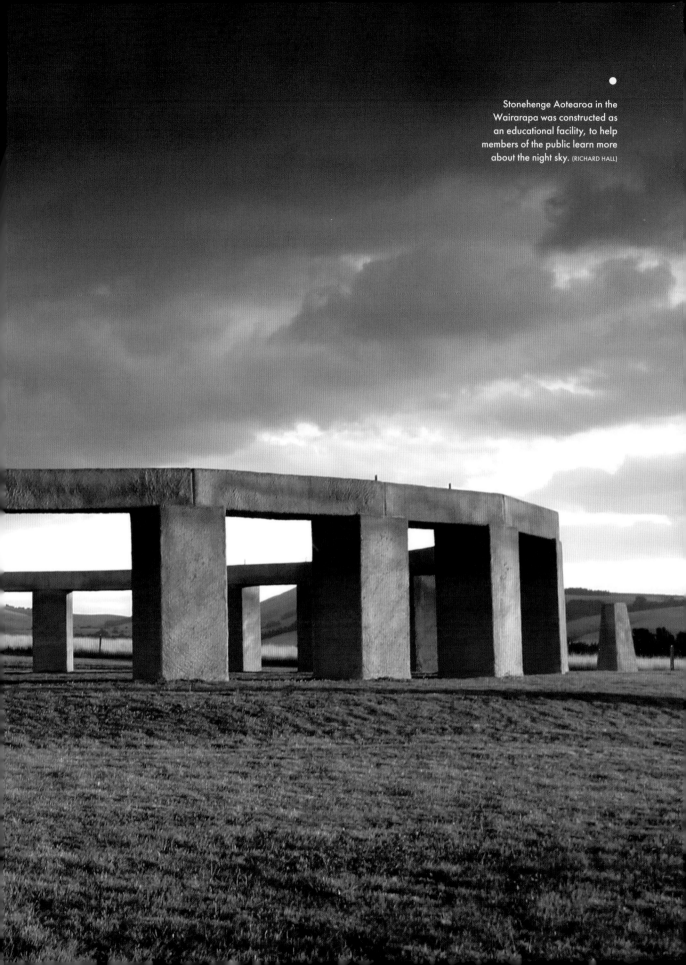

Stonehenge Aotearoa in the Wairarapa was constructed as an educational facility, to help members of the public learn more about the night sky. (RICHARD HALL)

The working henge is the same diameter as Stonehenge's sarsen (outer) circle. It's picked out by 24 four-metre 'stone' pillars. (They're really wooden frames wrapped in cement board and sprayed with concrete; funds didn't stretch to blocks and they would have been at risk of falling in an earthquake.) The Royal Society granted $55,000 to complete it.

The pillars support horizontal lintels, and it is the ring of lintels that creates the observatory. With a flat circular plane, the sky becomes a dome, smoothing the fractured horizon of the Wairarapa hills around it and enabling measurements to be made. The lintels also create windows, giving frames to the rising and setting of the Sun, Moon and stars.

A five-metre-tall obelisk in the centre, standing on a north–south axis, has a hole that lines up directly with the south celestial pole, giving people of all heights an obvious point around which the stars rotate each night. The shadow cast by the obelisk is an effective timekeeper, the shadow falling on the analemma, which is the figure-of-eight pattern that the Sun traces on the ground over a year. At this Stonehenge, it falls on a 10-metre-long pattern of tiles, and at 12.18 p.m. each day (1.18 p.m. in daylight savings time) the tip of its shadow marks the day and date.

Outside the circle are six heel stones. Throughout the year, the stones mark out the changing points of the Sun as it moves across the horizon on its northward journey during winter and southward during summer, telling stories at the same time.

Stonehenge Aotearoa's Māori star knowledge comes from manuscripts on tātai arorangi that Leather's uncle sent to her. The stones of Hine Takurua and Rongomai-tahanui mark the winter solstice sunrise and sunset; Hine Raumati and Rongomai-taharangi mark the summer solstice sunrise and sunset. There is also the Tāne heel stone and the Hine-nui-te-pō heel stone, marking the sunrise and sunset of the equinox, the dates in March (20 or 21) and September (22 or 23) when the Sun is over the equator, the seasons are moving through autumn and spring, and neither the northern or southern hemisphere is tilted towards the Sun. Archways are also named: Meridian, Autahi, Te Tatau o Te Pō, Matariki.

The stones and the archways are so named to support some of the mythology of tātai arorangi. One of these is marking out the journey of Te Rā, the Sun, between his two wives over the course of the year. At the equinox, Te Rā rises over the Tāne stone, between his wives, the Hine Takurua and the Hine Raumati heel stones. Tāne is the personification of the Sun, the son of the sky father Ranginui and Moon mother Papatūānuku, and god of the forests and birds. At the beginning of the Māori

New Year, when Matariki first appears in the dawn again, the cluster rises above the stone of Hine Takurua in the north-east, and the archway under the cluster is named Matariki.

The Milky Way, Te Ikaroa, moves northerly through Stonehenge's eastern windows each night as it rises in a slightly different place throughout the year. It has several names to Māori. Te Ikaroa, the basket holding the stars, is also known as the Parent Way, and holds bright stars along its length that mark out the seasons. The stone circle's two solstice heel stones on its western side, Rongomai-taharangi and Rongomai-tahanui, are the guardians of the seasons along Te Ikaroa.

With the Tāne heel stone marking the front post of the First House, or wharekura, and the four winds (or four doors) of the house marked by the four points of a compass, the back post is represented by the goddess of death, Hine-nui-te-pō. The end, or passing, of the Māori year – right before Matariki rises in June's dawn – is marked here, too, when, after sunset in late May, a vertical line of four stars is seen in the sky above the stone.

There are also monolith stones named for the Phoenix Astronomical Society, surveyor and astronomical calculator Robert Adam, and the core members of the Stonehenge crew: Lesley Hall, Kay Leather, Graham Palmer, Chris Cahill, Geoffrey Dobson and Alan Green.

The nearby Phoenix Observatory, opened in 1999, has housed various telescopes at different times, including one belonging to Peter Read, which was on loan from the Carter Observatory and is now back in place.

Planned is the Matariki Research Laboratory, which will incorporate into its structure part of the former US Naval Observatory at Black Birch. In 1996, when the Americans decided to pull out, Hall (then at the Carter Observatory) and Kotipu Place Observatory astronomer Gordon Hudson asked them what they intended to do with the dome, and discovered it was going to Operation Deepfreeze in Christchurch, which runs the Antarctic programme. 'It's yours,' Operation Deepfreeze said. Hudson, Hall and colleagues broke it down, filming themselves so they could figure out how to put it back up again.

When rebuilt, the dome will house the country's largest and most powerful telescope. A 0.6-metre Cassegrain[5], it will have a 40-inch diameter mirror, be able to look at deep space objects such as galaxies and nebulae, and have enough power to see cracks on the floors of the Moon's craters, as well as Saturn's rings and moons. The telescope was designed by the late Norman Rumsey, a leading New Zealand optical

designer and astronomer, who died in 2007. Rumsey was head of the optics section of the Department of Scientific and Industrial Research from the 1950s until he retired. He also developed the optical system for Mount John's McLellan telescope, as well as for astronomers throughout the country. He has a minor planet named after him: 4154 Rumsey, discovered by Alan Gilmore and Pamela Kilmartin at Lake Tekapo in 1985. The telescope he designed for the Matariki Observatory will be perfect for astrophotography, allowing images to be taken of sky objects that not long ago required the largest telescopes in the world.

Located within the complex, the Nankivell Solar Observatory is named after Garry Nankivell, who worked with Rumsey in optics, and with the purchase of a solar telescope will be automated and able to transmit images to the nearby lecture theatre. Radio astronomy will also be set up and data sound and images can be transmitted in this way as well.

The astronomical society still holds regular observing evenings and community events there, marking occasions such as the solstice and equinox, as well as Stardate, an astronomical convention in January.

The henge is also popular with pagans, druids and Wiccans. The first druid ceremony was held in March 2006 to mark Alban Elfed, the autumn equinox. In June that year, Stonehenge hosted its first Celtic festival of Yule, a winter solstice ceremony. Druids, pagans and Wiccans from around New Zealand gathered at the stone circle again to pay homage to the Sun and celebrate the coming warm days. That summer, the solstice was celebrated by 5000 people.

Along with people of all spiritual persuasions, Hall welcomes everyone – rock stars, opera singers, a choir performing a Gregorian chant – to Stonehenge Aotearoa. At festivals, people camp overnight, bring their cauldrons, and raise music like their Anglo-Saxon and Celtic forbears did 4000 years ago. The modern-day stone circle is for all who seek a greater connection with the universe – whether they're from the world of science, culture or spirits.

In 2019, New Zealand Post released a set of stamps sprinkled with real meteorite dust to celebrate some of New Zealand's most accomplished space pioneers.

(HANNAH FORTUNE/NEW ZEALAND POST)

CHAPTER 18

Seeing clearly

●

The stars matter in our lives because they offer a consoling encounter with grandeur, because they invite a helpful perspective on the brevity and littleness of human existence ... Such pleasures can be termed small because they don't usually have big, immediate, dramatic consequences. We don't crave them; they come to us fairly quietly and are easily missed against a background of distractions and preoccupations. We don't have to do anything about them. And so, lovely though they are, they easily slip out of view.

ALAIN DE BOTTON, *ON STARS*

●

In our modern night, the twinkling of city lights has replaced the twinkle of stars. What do we lose when we lose the dark sky? Why do we need it, and what is our lack of contact with the sky doing to us biologically and culturally? The rise of dark sky tourism in New Zealand is attempting to connect us to our shared heritage of the night, and a true dark-sky experience can be both thrilling and disheartening as you realise how much you have lost from your day-to-day (or night-to-night) life.

New Zealand's relatively undeveloped rural areas still hold pools of dark, and as a truly black night becomes scarcer, many of our far-flung areas have recognised

the benefits of dark-sky tourism and sought to certify themselves as worthy of visits, including Great Barrier Island and Stewart Island. As the dark-sky movement grows more popular around the world, and more communities seek to be recognised for the clarity of their night skies, the different designations and growing list of international dark-sky sanctuaries, parks and reserves can be a little confusing.

The International Dark Sky Association has five types of designation, and there are several of these sites in New Zealand. International Dark Sky Communities are legally organised cities and towns that adopt quality outdoor lighting ordinances and undertake efforts to educate residents about the importance of dark skies. International Dark Sky Parks are publicly or privately owned spaces protected for natural conservation that implement good outdoor lighting and provide dark-sky programmes for visitors. International Dark Sky Reserves have a dark 'core' zone surrounded by a populated periphery where policy controls are enacted to protect the darkness of the core. International Dark Sky Sanctuaries are the most remote (and often darkest) places in the world, whose conservation state is most fragile.

Finally, Dark Sky Developments of Distinction recognise subdivisions, master planned communities, and unincorporated neighbourhoods and townships whose planning actively promotes a more natural night sky but does not qualify them for the International Dark Sky Community designation.

The Bortle dark-sky scale (see p. 262) is a nine-level numeric scale that measures the brightness of the night sky, and enables us to quantify the brilliance of the universe at a particular site through the ability to observe certain celestial objects, and also the impact of light pollution. It was published in the February 2001 edition of *Sky & Telescope* in order to help amateur astronomers to evaluate and compare night-sky observing sites, and though there are limits to the table based on individual eyesight it's still a useful tool for the interested amateur.

Light pollution

One of the newer challenges to our dark skies is posed by LEDs (light-emitting diodes), which make light pollution worse. Many urban cities in New Zealand have installed LEDs in their streetlights, replacing the familiar orangey-yellow sodium-vapour lamps. LEDs

●

Overleaf The Bortle dark-sky scale can help you assess how much light pollution there is where you live – and give you a sense of what you're missing out on. (BIG SKY ASTRO CLUB)

Class	Naked-eye limiting magnitude	Sky description	Milky Way
1	7.6–8.0	Excellent, truly dark skies	Shows great detail, an light from the Scorpio/ Sagittarius region cas obvious shadows on th ground.
2	7.1–7.5	Typical, truly dark skies	Summer MW shows gre detail and has a veine appearance.
3	6.6–7.0	Rural sky	MW still appears compl dark voids and bright patches and meanderir outline are all visible.
4	6.1–6.5	Rural/suburban transition	Only well above the horizon does the MW reveal any structure. Fin details are lost.
5	5.6–6.0	Suburban sky	MW appears washed-out overhead and is lost completely near the horizon.
6	5.1–5.5	Bright, suburban sky	MW only apparent overhead and appears broken as fainter parts a lost to sky glow.
7	4.6–5.0	Suburban/urban transition	MW is totally invisible o nearly so.
8	4.1–4.5	City sky	Not visible at all.
9	4.0 at best	Inner-city sky	Not visible at all.

Astronomical objects	Zodiacal light and constellations	Airglow and clouds	Night-time scene
M33 (the Pinwheel Galaxy) is an obvious object.	Zodiacal light has an obvious colour and can stretch across the entire sky.	Bluish airglow is visible near the horizon and clouds appear as dark blobs against the backdrop of the stars.	The brightness of Jupiter and Venus is annoying to night vision. Ground objects are barely lit and trees and hills are dark.
M33 is visible with direct vision, as are many globular clusters.	Zodiacal light is bright enough to cast weak shadows after dusk and has an apparent colour.	Airglow may be weakly apparent and clouds still appear as dark blobs.	Ground is mostly dark, but objects projecting into the sky are discernible.
Brightest globular clusters are distinct, but M33 is visible only with averted vision. M31 (the Andromeda Galaxy) is obviously visible.	Zodiacal light is striking in spring and autumn, extending 60 degrees above the horizon.	Airglow is not visible and clouds are faintly illuminated, except at the zenith.	Some light pollution evident along the horizon. Ground objects are vaguely apparent.
M33 is a difficult object, even with averted vision (looking slightly to the side). M31 is still readily visible.	Zodiacal light is clearly evident, but extends less than 45 degrees after dusk.	Clouds are faintly illuminated except at the zenith.	Light pollution domes are obvious in several directions. Sky is noticeably brighter than the terrain.
The oval of M31 is detectable, as is the glow in the Orion Nebula.	Only hints of zodiacal light in spring and autumn.	Clouds are noticeably brighter than the sky, even at the zenith.	Light pollution domes are obvious to casual observers. Ground objects are partly lit.
M31 is detectable only as a faint smudge; Orion Nebula is seldom glimpsed.	Zodiacal light is not visible. Constellations are seen and not lost against a starry sky.	Clouds anywhere in the sky appear fairly bright as they reflect back light.	Sky from horizon to 35 degrees glows with greyish colour. Ground is well lit.
M31 and the Beehive Cluster are rarely glimpsed.	The brighter constellations are easily recognisable.	Clouds are brilliantly lit.	Entire sky background appears washed-out, with a greyish or yellowish colour.
The Pleiades cluster is visible, but very few other objects can be detected.	Dimmer constellations lack key stars.	Clouds are brilliantly lit.	Entire sky background has an orangish glow and it is bright enough to read at night.
Only the Pleiades cluster is visible to all but the most experienced observers.	Only the brightest constellations are discernible and they are missing stars.	Clouds are brilliantly lit.	Entire sky background has a bright glow, even at the zenith.

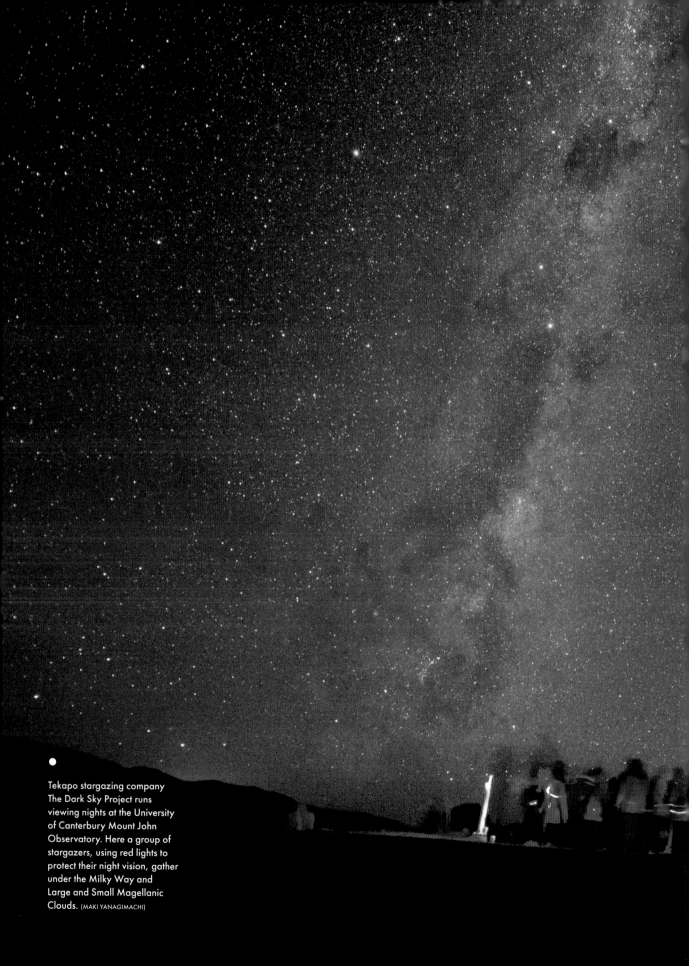

Tekapo stargazing company The Dark Sky Project runs viewing nights at the University of Canterbury Mount John Observatory. Here a group of stargazers, using red lights to protect their night vision, gather under the Milky Way and Large and Small Magellanic Clouds. (MAKI YANAGIMACHI)

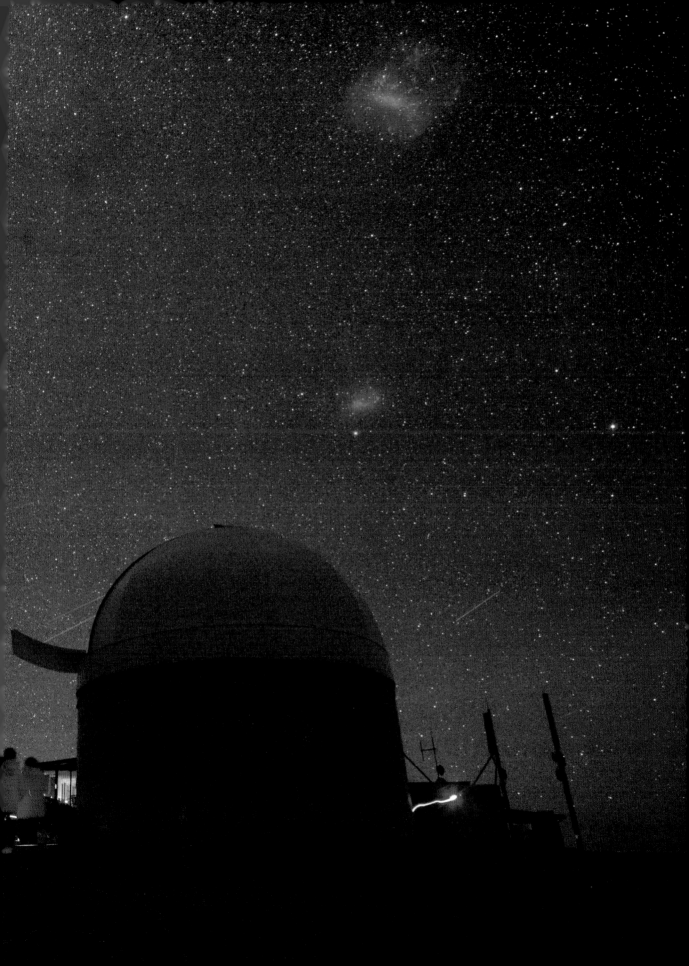

are cheaper and more efficient, but they make a big change to our nightscape. The most common bulbs are blue with a special coating that makes them appear white to human eyes, and which also causes them to peak in the short wavelengths astronomers commonly use to observe the night sky.

Why does this matter? Today, bright days continue long after sundown in our homes and on our streets; but, despite our technological advances, we evolved with a dark sky at night, and our bodies are still Stone Age. We continue to need a dark sky, and dark homes and cities at night, for a host of physiological reasons. Exposure to blue light outside of our normal circadian cycle affects our body clock and has been implicated as a cause of depression, cancers, insomnia and obesity. It's so powerful that the World Health Organization has classified shift work as a probable carcinogen.

More than half of New Zealand has a pristine dark sky, but only three per cent of us actually live under it. In much of the United States these days you can only see the Milky Way in a blackout. It simply doesn't get dark any more, to the point where some northern hemisphere observatories have been forced to close or move telescopes to dark-sky sites, as you need pitch-black skies to see faint stars and other objects in universe.

In 1994, after an earthquake brought down the power supply in Los Angeles, emergency centres reported a flurry of anxious residents calling in about a strange giant, silvery cloud in the sky. It was the Milky Way, which they'd never seen before.

Lighting sucks up more than a quarter of the world's electricity, but much of it isn't necessary. As in Tekapo, outdoor lighting, including street lighting, needs to be shielded to reduce it escaping into the atmosphere. We need to see the stars.

This isn't just a matter of romanticism, energy waste or even preserving astronomy. Light at the wrong time is a health hazard. Life evolved with a regular night–day cycle, and too much light when it should be dark interrupts the normal circadian rhythms of not just our bodies but those of animals, birds and insects, suppressing melatonin production and interfering with brain waves and cell regulation, all with potentially dire effects. Light pollution also affects plants: prolonged exposure to artificial light affects the seasonal changes of trees, for example.

For those animals that emerge at night, too much light interferes with their cycles of hunting, predation, migration, navigation and reproduction. We've all seen moths fluttering urgently around a streetlight. They're not just confused – such lights are having a biological effect on those creatures. This, in turn, affects us too, as we depend on the normal functioning of insects for the health of our environment and food chain.

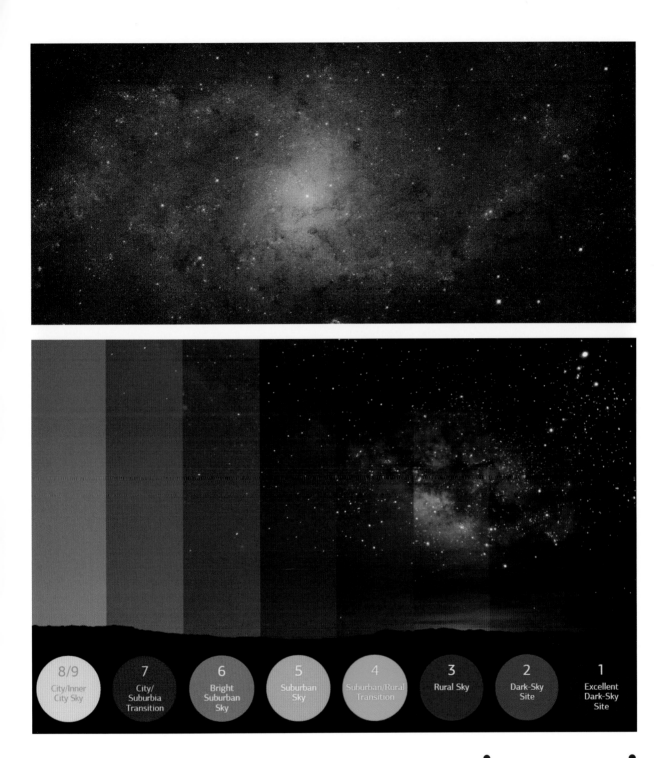

Bortle scale visualisation:

| 8/9 City/Inner City Sky | 7 City/Suburbia Transition | 6 Bright Suburban Sky | 5 Suburban Sky | 4 Suburban/Rural Transition | 3 Rural Sky | 2 Dark-Sky Site | 1 Excellent Dark-Sky Site |

Top The sharpest image ever taken of the Triangulum Galaxy, the third-largest member of the Local Group of galaxies, after Andromeda and the Milky Way. It can be seen with the naked eye, though this was taken by the Hubble Telescope. (NASA, ESA, M. DURBIN, J. DALCANTON, AND B.F. WILLIAMS)

Above This light-pollution visualisation shows just how bright our city 'night' has become. (SKYGLOW)

For us, light is a biological trigger, and exposure to artificial light at night can harm your health. Too much light in our night-time environment (especially inside the home) suppresses natural melatonin production and increases the risk of obesity, depression, sleep disorders, diabetes and some types of cancer: for instance, there is strong epidemiological evidence for a link between indoor artificial light and prostate and breast cancer. It's not proven that the light causes cancer, but laboratory studies show that exposure to light at night can disrupt circadian and neuroendocrine physiology, accelerating tumour growth. Melatonin is essential for health, ensuring normal function of our immune and hormonal systems. The worst culprit is blue light, which is found in TVs and computer screens and in the new LEDs that have replaced the orange sodium lights in many modern street lamps.

How to fix this? Campaign for a dark sky in your area, encourage councils to adopt appropriate lighting, and take a look at what kinds of light fixtures you have at home. A 2016 American Medical Association report recommended shielding all light fixtures and using only lighting with a colour temperature of 3000K or less. You can also simply turn off unnecessary lights as the sun goes down, using as little artificial light as possible, thereby allowing your brain to ease into its night-time hormonal profile and then to sleep. New Zealand could become the world's first dark-sky nation.

Reconnecting with the stars

For tens of thousands of years, knowledge of the stars and their cycles was vital to human survival on Earth, while also adding layers of meaning to our existence. Over the centuries our knowledge of the night sky has moved from a religion to a science, separating into astrology and astronomy, and our culture still holds echoes of that development today.

At their simplest, the stars are a map, compass and timekeeper – and although we're hardly ever without a device that will tell us where we are, knowing the stars is like greeting old friends, a private and personal way to mark time outside of the calendar, as you map their cyclical passage through the sky in your head.

See how Scorpius is a little higher above the neighbour's roof, the bright spot of Jupiter caught in its claws? Winter is waxing. Or how about when it's in the opposite sky, and at 10 p.m. you can just see the hook of its tail? It's springtime, and Scorpius will soon disappear, with Orion, the Pot, rising in the eastern sky instead. Point out the Pot to a child, and explain that when it's high in the sky in late February, it means summer

is nearly over, and that Scorpius and the Pot never appear in the sky at the same time. Why? Tell them the stories of their ancestors. Emerge from the house at dawn and see Matariki returning for the first time, glistening just before the Sun – that means the kūmara should be in by now, or you're in trouble for the winter.

Noticing how the stars are moving through the sky during the year is like seeing the first magnolia bloom in your garden and feeling the anticipation of warmer weather. Or it's like seeing the turning of the local park's oak trees and thinking of a warm fireplace; or realising at winter solstice that the sunset has reached its farthest point on the mountain range, and tomorrow, the day will be a little longer. It's a deep pleasure to be in tune with the rhythms of the sky, connecting them to your own place in the world. When so much of life on Earth is uncertain, paying regular attention to the sky helps us feel grounded. Everything can be turning upside down, but the night sky is a reassuring certainty.

Learning more about the stars can be as complicated or as simple as you want. You can go outside with an app or star chart and learn the constellations, their stories and how they move throughout the year, or you can delve into cutting-edge cosmological research and theories of space and time. But knowing the stars means being able to calculate where they are at any time of day or night.

It also helps us remember our place in the march of evolution. We might think we are the top of the food chain now, but it's humbling to remember who and what has come before – and it might help us care a little more about the rest of the planet's inhabitants – humans, plants and animals.

When you begin to notice how the sky moves at night and learn why and how, the stars and planets are no longer just pins of light in a blanket that wraps around Earth every night. You're not taking the world for granted any more, but becoming more deeply connected with the universe – and with that comes the shock of realisation about what a marvel it is. The more you learn, the more you realise you don't know. It's no wonder we put our gods in the heavens.

Thinking regularly about the universe also makes it easier to gain perspective on everyday frustrations. Those calm white, blue, yellow and red lights don't have anything to do with our problems and passions; they were there when we were born, and they'll still be there when we die. In fact, if you were to parcel out the entire history of Earth into a single calendar year, humankind and all of its problems, wars, inventions, crises and deaths would occupy the last 40 seconds on 31 December. That's not to say nothing matters; but it is a reminder that, in the great scheme of things, today's personal

problems might not be so important in a year's time, when the stars have gone through their cycle and returned to the same position they're occupying now.

Being with the sky is also a rare opportunity to be silent, look up and wonder. With the proliferation of mobile devices and artificial light, we have less opportunity for quiet contemplation and unstructured, rejuvenating thought – unless we make a concerted effort to escape our cities and go out to where the sky is dark and there's no mobile reception.

We once relied on the full moon for lighting at night, but electricity has moved us indoors instead. Even indoor plumbing has played a role in this, as Australian author Anson Cameron once wrote in the *Sydney Morning Herald*: 'Night-time ablution was once topped and tailed by a show of pulsing atomic pointillism as people walked to and from the outhouse. But when our cities were plumbed these night-time journeys ended and the stars played to an empty theatre.'

It's calming to look at the stars for a few minutes, hearing and feeling only your heartbeat and breathing. Our bodies evolved with regular patterns of sunlight and darkness, and to subsume yourself back into the night is a kind of meditation in itself. What do you lose when you look up and see just a few pricks of light, or nothing at all? What connection to a greater, wilder, yet entirely orderly power is lost when the stars blink out and our attention is directed instead only downward, at ourselves? If we accept that we and everything on Earth are made of stardust, then by ignoring the sky we've lost our ancestry, a tangible connection to our origins, and a powerful sense of kinship with every other living and inanimate object on Earth.

●

Clear skies on the snowfields
near Tekapo make for brilliant
viewing of the Large and Small
Magellanic Clouds. (MAKI YANAGIMACHI)

Endnotes

CHAPTER 1 ● The oldest science

1 In every 25,772-year cycle, the axis of Earth's rotation moves around in a wide circle. This was discovered by the Greek astronomer Hipparchus, who compared his 200 BCE records with star charts from 150 years before and found the Sun's equinoxes were different. Thus, the stars seem to drift over time. The north star is currently Polaris, but 5000 years ago it was Draco, used by the ancient Egyptians; in the future, it will be Vega. Precession also means the tropics of Cancer and Capricorn are moving towards the equator by 14 metres every year, and it also influences weather patterns – for example, it may be partly responsible for the Sahara Desert alternating between sand and grassland in a 41,000-year cycle. Our own Southern Cross was last seen on the horizon of Jerusalem around the time Christ died on the cross, and 5000 years ago, it was viewable across North America, Greece and Babylonia (present-day Iraq). Today, in the Florida Keys around late April, you can see the Southern Cross just above the horizon. It won't mark the south celestial pole until the year 8600.

2 The proposal emerged during what is now known as the Great Debate, or the Shapley–Curtis Debate, a discussion held on 26 April that year between astronomers Harlow Shapley and Heber Curtis at the Smithsonian Museum of Natural History, Washington, D.C.

3 Couper, Heather and Nigel Henbest, *The Story of Astronomy: How the universe revealed its secrets.* London: Hachette, 2011, p.9.

CHAPTER 2 ● Patterns in the night sky

1 In 2005, NASA demoted Pluto, which has a diameter about half the width of the United States, to a dwarf planet. Its status continues to be debated.

2 To be exact, a Sun 20.7149 metres in diameter was used for this exercise and resultant numbers were rounded to the nearest whole using the average orbit radius.

3 Eldridge, J.J. 'Much can be learned from stellar death throes', *New Zealand Herald*, 6 January 2018, p.A7.

CHAPTER 3 ● Guiding lights

1 Couper and Henbest, p.23.

2 SMART was formed in the International Year of Astronomy, 2009. The group, comprising Māori scientists, navigators, researchers and astronomical experts, has a mission to preserve and revitalise Māori astronomical knowledge in a similar way to those who have spearheaded fresh interest in other aspects of indigenous culture, such as language, medicine, arts, crafts and health, and the celestial navigation renaissance of the 1970s and 1980s that spread across the Pacific, including New Zealand.

CHAPTER 4 ● Signs and wonders

1 'Total Eclipse', in Dillard, Annie, *Teaching a Stone to Talk*. New York: HarperCollins, 2013.

2 Hall, Richard, *How to Gaze at the Southern Stars*. Wellington: Awa Press, 2004.

3 But Earth also loses weight – about 100,000 tonnes of hydrogen and helium gas escapes the planet annually. And spacecraft shot into the sky represent material gone from Earth forever – a loss that has been calculated at 3473 tonnes over the first 53 years of the space age.

4 Moore, Patrick, *Guide to Comets*. Cambridge: James Clarke & Co., 1977, p.22.

5 *Julius Caesar*, Act II, Scene ii.

6 Paine, Albert Bigelow, *Mark Twain, a Biography: The personal and literary life of Samuel Langhorne Clemens, vol. 3*. New York: Harper & Brothers, 1912, p.1511.

7 People sometimes argue about how to pronounce the name of this comet. It's often pronounced 'Hailey's', probably due to 1960s rock group Bill Haley and the Comets. But Halley rhymes with 'valley'.

8 Eilmer's consternation is recorded in William of Malmesbury's twelfth-century history of the kings of England, *De gestis regum Anglorum*.

9 Giotto di Bondone's 1303 fresco *Adoration of the Magi*, showing a burning red comet-like star of Bethlehem, was influenced by the 1301 apparition of Halley's Comet. As the first recorded 'scientific' drawing of the comet, the spacecraft was named in his honour nearly 700 years later.

CHAPTER 5 ● The stars down under

1 Taka Ruka, *Pipiwharauroa*, 1 April 1899, p.3; retrieved from https://paperspast.natlib.govt.nz/periodicals/PIPIWH18990401.2.5.

2 Harris, Pauline, Rangi Matamua, Takirirangi Smith, Hoturoa Kerr, and Toa Waaka, 'A Review of Māori Astronomy in Aoteaora–New Zealand', 2013, *Journal of Astronomical History and Heritage*, 16(3) p.331.

3 Best, Elsdon, 'Star Names', in *The Astronomical Knowledge of the Maori, Genuine and Empirical*, Wellington: Government Printer, 1922, p.35; retrieved from http://nzetc.victoria.ac.nz/tm/scholarly/tei-BesAstro-t1-body-d1-d1a.html.

4 Best, *Astronomical Knowledge of the Maori*, pp.35–36.

5 For more on Matariki, see Dr Rangi Matamua's book, *Matariki: The star of the year*. Wellington: Huia Press, 2017.

6 Cowan, James, *The Maori: Yesterday and to-day*. Christchurch: Whitcombe & Tombs, 1930, p.88; retrieved from http://nzetc.victoria.ac.nz/tm/scholarly/tei-CowYest-t1-body-d1-d7.html.

7 'Te Waka o Tama Rēreti', Milky-Way.Kiwi; retrieved from https://milky-way.kiwi/through-new-zealand-skies/november/te-waka-o-tama-rereti/.

8 'Jewel Box', Deep Sky Observer's Companion, www.docdb.net, accessed 25 June 2019.

9 A solar mass is a standard unit of astronomical measurement, equal to the mass of our Sun.

CHAPTER 6 ● Lighting the way

1 Parsonson, G.S., 'The Settlement of Oceania: An examination of the accidental voyage theory', *Journal of the Polynesian Society*, vol. 71 (1962), no. 3, pp.11–63, quoting from Taylor, Eva G.R., *The Haven-finding Art: A history of navigation from Odysseus to Captain Cook*. London: Hollis & Carter, 1956.

2 Ibid.

3 Ibid, quoting from Dalrymple, Alexander. *An Historical Collection of the Several Voyages and Discoveries in the South Pacific Ocean*, vols 1–2. London: Nouse, 1770.

4 Sidereal time is based on Earth's rotation relative to stars rather than the Sun.

5 Parsonson, 'The Settlement of Oceania', pp.11–63, quoting from Beaglehole, J.C., (ed.), *The Journals of Captain James Cook on his Voyage of Discovery*, vol. 1. Cambridge: Cambridge University Press, for the Hakluyt Society, 1955.

6 Ibid.

7 Adds, Peter. 'Pacific Voyaging and Navigation by Dr Peter Adds.' The Transit of Venus Lectures. Radio New Zealand, 8 June 2004.

8 Forster, G., *A Voyage Round the World*, 1777, Forster's account of Cook's second voyage.

9 Simmons, D., 'C.F. Goldie – Maori Portraits,' *The Art Galleries and Museums Association of New Zealand News*, 1974, vol. 5, no. 2, p.38.

10 Clarke, Jacquie, 'C. F. Goldie: The old master revisited', *New Zealand Geographic*, no. 38 (April–June 1998).

11 Parsonson, 'The Settlement of Oceania', pp. 11–63.

12 Ibid.

13 King, Michael, *The Penguin History of New Zealand*. Auckland: Penguin, 2003, p.40.

CHAPTER 7 ● Māori astronomy

1 Harris, Pauline, and Rangi Matamua, 'Revitalising Māori Astronomy and Inspiring Our Next Generations: Māori astronomy, modern astrophysics and bridging the divide', conference paper presentation at the Third International Starlight Conference, Lake Tekapo, June 2012.

2 Harris, Matamua, Smith, Kerr and Waaka, 'A Review of Māori Astronomy', p.333.

3 Ibid., p.326.

4 Orchiston, Wayne, *Exploring the History of New Zealand Astronomy: Trials, tribulations, telescopes and transits*. Berlin & Heidelberg: Springer International Publishing, 2016, p.34.

5 Ibid., p.37.

6 Pipiri not only means the first month, but also the stars Hamal and Sharatan in the constellation of Aries, which are visible in the mornings earlier in the year than Matariki.

7 'Nga Marama', *Pipiwharauroa*, no. 37, 1 March 1901, p.6; English translation from 'Matariki', The Māori Dictionary, https://maoridictionary.co.nz.

8 Best, Elsdon, *Maori Agriculture: The cultivated food plants of the natives of New Zealand, with some account of native methods of agriculture, its ritual and origin Myths*. Wellington: A.R. Shearer, 1976, p.214; retrieved from http://nzetc.victoria.ac.nz/tm/scholarly/tei-BesAgri-t1-body-d4-d18.html.

9 Ibid.

10 Best, *The Astronomical Knowledge of the Maori*, p.5.

11 Researchers Tui Britton and Duane Hamacher note that this is a Bay of Plenty name, with other names including tūmatakōkiri, kōtiri, kōtiritiri, tamarau, and possibly unahi o Taero; see 'Meteor Beliefs Project: Meteors in the Māori astronomical traditions of New Zealand', *Journal of the International Meteor Organisation*, 2013, vol. 42(1), pp.31–34.

12 Best, *The Astronomical Knowledge of the Maori*, p.16.

13 Cowan, James, and M. Pomare, *Legends of the Māori*, vol. 1. Wellington: Whitcombe & Tombs, 1930–34, p.17; retrieved from http://nzetc.victoria.ac.nz/tm/scholarly/tei-Pom01Lege-t1-body-d3-d3.html.

14 Chadwick, Stephen Robert, and Martin Paviour-Smith, *The Great Canoes in the Sky: Starlore and astronomy of the South Pacific*. Berlin and Heidelberg: Springer, 2016. pp.31–32.

15 McFarlane, Turi, 'Maori Associations with the Antarctic', 2008, unpublished thesis, University of

Canterbury Graduate Certificate in Antarctic Studies, p.6; retrieved from https://ir.canterbury.ac.nz/handle/10092/14205.

16 Best, Elsdon, *Maori Religion and Mythology, Part 2*. Wellington: P.D. Hasselberg, Government Printer, 1982, p.589; retrieved from http://nzetc.victoria.ac.nz/tm/scholarly/tei-Bes02Reli-t1-body-d4-d6-d4.html.

17 Smith, Stephenson Percy. *Hawaiki: the Whence of the Maori: With a sketch of Polynesian history, being an introd. to the native history of Rarotonga*. Christchurch: Whitcombe and Tombs, 1898, p.91.

CHAPTER 8 ● Voyage to a new sky

1 Another mathematical quirk is that if Venus transits the lower half of the Sun during the first in a pair of transits, it'll cross the upper part in its second, and vice versa. But if it crosses the middle, there won't be a second transit in eight years – though this situation is so rare it will next happen in 3089.

2 Beaglehole, J.C., ed., *The Journals of Captain James Cook on His Voyages of Discovery*. Rochester, New York: Boydell Press, 1999, pp.182–183.

3 Ibid.

4 There is some dispute over whether the measurements were a success. Cook biographer J.C. Beaglehole has argued that they weren't, but Wayne Orchiston says in his paper 'James Cook's 1769 Transit of Venus Expedition to Tahiti' that, although Beaglehole was a revered figure and leading authority on Cook, he was not an astronomer and did not have access to all the astronomical evidence to inform such a claim.

5 Salmond, A., *Aphrodite's Island*. Berkeley: University of California Press, 2010, pp.261–262.

6 Orchiston, Wayne, 'Cook, Green, Maskelyne and the 1769 Transit of Venus: The legacy of the Tahitian observations', *Journal of Astronomical History and Heritage*, 2017, 20 (1), pp.35–68.

7 J.C. Beaglehole, cited in Wayne Orchiston, *Exploring the History of New Zealand Astronomy*, p.127.

8 Beaglehole, J.C., *The Life of Captain James Cook*. Stanford: Stanford University Press, 1974, p.215.

9 Beaglehole, J.C., ed., *The Journals of Captain James Cook on his Voyages of Discovery, Vol II: The Voyage of the Resolution and Adventure 1772–1775*, Cambridge: Cambridge University Press, 1961, p.95.

10 Ibid.

11 Ibid., p.xxxvi. Pickersgill, a Yorkshireman, would turn out to have the unfortunate distinction of sailing several voyages through some of the roughest waters in the world, being one of the first Europeans to set foot on Tahiti and New Zealand, mapping the coast of New Zealand, and surviving it all, only to drown in the mill-pond-calm Thames while boarding a ship in 1779. He was just 30.

CHAPTER 9 ● 'What use is astronomy?'

1 The stations were 'a curious mixture of seismology and time service with a taint of astronomy', as Kiwi astronomer Ivan Thomsen later put it.

2 Thomsen, I.L., 'The Amateur in Astronomy', *Southern Stars*, no. 16, 1954, pp.79–80.

3 *Taranaki Herald*, vol. XXII, issue 2262, 12 December 1874, p.2; retrieved from https://paperspast. natlib.govt.nz/newspapers/TH18741212.2.17.2.

4 Harkness, W., 'Address to the Members of the Section of Mathematics and Astronomy', Proceedings of the 31st Meeting of the American Association for the Advancement of Science, 1882, p.77; retrieved from https://hdl.handle.net/2027/hvd.32044106432560.

CHAPTER 10 ● The first observatories

1 A double star may look like one star from Earth but is actually two – or more. A famous double-double star is Epsilon Lyrae, in Vega, which is two sets of two double stars bound gravitationally, all loo like one star from Earth.

2 Other comets include the one found in 1973, when Michael Clark at Mount John University Observatory discovered Comet Clark (1973v) as he was on a routine sky survey. William Bradfield is New Zealand's most successful comet hunter – though he made his dozen-plus discoveries from Australia. Rod Austin, a New Plymouth professional astronomer and journalist, found comets in 1982, 1984 and 1989. Other successful comet hunters include Alan Gilmore and Pamela Kilmartin, directors of the Comet and Minor Planet Section of the Royal Astronomical Society of New Zealand. Comet 26/PGrigg-Skjellerup is the most famous comet with a connection to New Zealand: John Grigg first discovered it in 1902, and it returns every five years.

3 'People and Events', *First 50 Years of the Auckland Astronomical Society*, Auckland Astronomical Society; retrieved from www.astronomy.org.nz/pages/Info.aspx?ContentID=12; accessed December 12, 2018.

4 Tobin, William, 'The Townsend Telescope: A century of university stargazing', in Tobin, William, and Evans, G.M. (eds), *Stars in a Cluster: Mt John University Observatory: Tenth anniversary of the McLellan telescope: Hundredth anniversary of the Townsend telescope: Publications 1979–1995*. Christchurch: Department of Physics and Astronomy, 1996, p. 83.

5 'Astronomical Notes for November', *The Press*, volume LVII, issue 17291, 1 November 1921, p.10. https://paperspast.natlib.govt.nz/newspapers/CHP19211101.2.88; accessed May 2, 2019.

CHAPTER 11 ● Celestial highlights

1 Research has discovered that the 'eclipse wind' – the wind changing or slackening during an eclipse – is caused by variations to the boundary layer, which is the body of air that usually

separates high-level winds from those at the ground. The ground cools and warm air stops rising, causing a slowing of air moving across the land.

2 'Art. LIX – The Total Eclipse of the Sun of the 9th September, 1885; being a Digest of the following Communications to the Institute on the subject', *Transactions and Proceedings of the Royal Society of New Zealand 1868-1961*, Volume 18, 1885, http://rsnz.natlib.govt.nz/volume/rsnz_18/rsnz_18_00_004110.html; accessed May 2, 2018.

3 The only total solar eclipse viewable from New Zealand in the twentieth century was in the Far North in 1965, when total darkness fell just after sunrise on 30 May. Teams from the Auckland Astronomical Society drove up, their cars loaded with tents and caravans; some even chartered planes to see it from a higher perspective. The site was on the cliffs above Matauri Bay, where a friendly local farmer had gone to the trouble of laying concrete foundations for the telescopes to keep them steady on the wet ground. New Zealand also sent an expedition to Manuae in the Cook Islands to view it, headed by highly regarded amateur astronomer Frank Bateson.

4 *Wanganui Herald*, vol. XXXXIII, 27 November 1908, p.2; retrieved from https://paperspast.natlib.govt.nz/newspapers/WH19081127.2.6.1.

5 Musgrave, Thomas, *Castaway on the Auckland Isles.* London: Lockwood and Co., 1866; retrieved from http://nzetc.victoria.ac.nz//tm/scholarly/tei-MusCast-t1-body-d5.html. Musgrave and the rest of the crew managed to rebuild their ship's dinghy and sail it to Rakiura/Stewart Island a year later. He promised his wife (with whom he had 16 children, including three sets of twins, nine of whom died as infants) he would never go to sea again, and became a lighthouse keeper instead.

6 Pyke, Vincent, 'The Story of Wild Will Enderby', Dunedin: R.T. Wheeler, Dunedin, 1873; retrieved from http://nzetc.victoria.ac.nz/tm/scholarly/tei-PykWild.html. The last line would prove strangely prescient, as, nearly a hundred years later, the Upper Clutha and Dunstan would be one of the sites scouted for a potential national observatory, which became Tekapo's Mount John.

7 Orchiston, Wayne, *Exploring the History of New Zealand Astronomy*, p.460.

8 *Hawke's Bay Herald*, vol. XXI, issue 5605, 6 February 1880, p.2; retrieved from https://paperspast.natlib.govt.nz/newspapers/HBH18800206.2.8.

9 *New Zealand Times*, vol. XXXVI, issue 6278, 26 May 1881, p.3; retrieved from https://paperspast.natlib.govt.nz/newspapers/NZTIM18810526.2.18.

10 Reports from England and the United States contained high hopes for a 'Comet Year', which 'have ever been famous for good weather and agricultural abundance; their vintages excel all others, and their cereal harvests are splendid'. England's hopes, however, were dashed by severe weather not long after.

11 *Oamaru Mail*, vol. IV., issue 1322, 16 June 1881, p.3; retrieved from https://paperspast.natlib.govt.nz/newspapers/OAM18810616.2.13.

12 Flammarion's paper '*L'Astronomie'* was the bread and butter for many amateur stargazers around

the world, and among his ambitions was a desire to drill straight down into Earth to explore the crust. His astronomical predictions were exciting, reflecting the mystery with which such phenomena were held around the turn of the century. The *New Zealand Herald* described him as 'the weirdest and most imaginative astronomer in France'. He was certainly one of the most famous and admired pop-scientists out there, on a par with a rock star today. An unidentified French countess who died young of tuberculosis fell in love with him while reading his work. She was so devoted to him, and so wretched with unrequited love, that she bequeathed him a large strip of skin from her back and shoulders to be used to bind his next book, which is now one of a few examples of anthropodermic bibliopegy surviving in the world. He did not know her name. It's hard to believe a scientist achieving such devotion today.

13 'Memories of Elizabeth Freeman who saw Halley's Comet in 1910', R174397, Archives New Zealand; retreived 6 March 2018.

14 Blow, Graham and Stan Walker, *An Encounter With Halley's Comet, 1985–86*. Auckland: Wilson & Horton, 1985, p.12.

15 'sm' indicates they are members of the Society of Mary.

16 Rudman, Brian, 'The Countdown (and Count-up) to the Comet', *New Zealand Listener*, January 25, 1986, pp.11–13.

17 'Halley's Comet School Tour Records', Department of Education, Head Office, W3490, Archives New Zealand, Wellington; accessed 6 March 2018.

CHAPTER 12 ● Great communicators

1 Adamson, Peter, 'Clement Lindley Wragge and the naming of weather disturbances', *Weather*, Royal Meteorological Society, vol. 58, no. 9, September 2003, p.361.

2 Ibid.

3 'Through the Universe', *Auckland Star*, vol. XL, issue 73, 26 March 1909, p.3; retrieved from https://paperspast.natlib.govt.nz/newspapers/AS19090326.2.30.

4 Ibid.

5 By 1920, Wragge had created tropical gardens at Birkenhead that were open to visitors daily. He took up yoga and the occult later in life, and died in Birkenhead in 1922, leaving the *Australian Dictionary of Biography* to remark: 'Wragge exercised a significant influence on the foundations of Australian meteorology, even if his tempestuous career followed the growth, turbulence and eventual decay characteristic of the Coral Sea tropical revolving storms which so fascinated him.'

6 Ernest Rutherford's letter to *The Times* (London) after Bickerton's death was quoted in New Zealand newspapers, including 'The Late Professor Bickerton', *Evening Star*, Issue 20122, 12 March 1929, p.12.

CHAPTER 13 ● The allure of variable stars

1 Simonsen, Mike, 'Albert Jones – The Interbiew [sic]', CVnet, 26 November, 2009; retrieved from https://sites.google.com/site/aavsocvsection/cv-blog/albertjones-theinterbiew; accessed 1 December 2018.

2 Moore, Bill, 'City Award-winning Astronomer Dies', *Nelson Mail*, 13 September 2013; retrieved from www.stuff.co.nz/nelson-mail/news/9161597/City-award-winning-astronomer-dies; accessed 1 December 2018.

3 Sharma, Amar A., 'Albert Jones (1920–2013)', Sky & Telescope.com; retrieved from www.skyandtelescope.com/astronomy-news/albert-jones-1920-2013/; accessed 1 December 2018.

CHAPTER 14 ● Towards a national observatory

1 Blanco, Victor, *Brief History of the Cerro Tololo Inter-American Observatory*; retrieved from www. ctio.noao.edu/noao/node/78; accessed 3 May 2019.

2 University of Canterbury Emeritus Professor in Astronomy John Hearnshaw says the whole history of observational astronomy in New Zealand might have been quite different if adequate data on the weather in the Mackenzie Basin had been available in the mid-1920s.

3 Ironically, the Brashear telescope was never installed at Mount John – a building and dome that the University of Canterbury was meant to provide but never built. Bateson realised it would have limited scientific potential. The telescope that started everything at Mount John was stored for 50 years instead, going on public display in the Yaldhurst Museum of Transport and Science in Christchurch from 1990 to 2013 as an example of Victorian engineering. It went to Fairlie to be refurbished before being installed in the Dark Sky Project's new building in Tekapo in 2019.

4 The ranges had already been assessed by the Carter Observatory's Ivan Thomsen for suitability. Thomsen, who would go on to be one of New Zealand's leading astronomical lights, had attended college in Dannevirke, went to Wellington, met Bateson at the tin-shed observatory there, and entered the civil service as a junior in the Agriculture Department. He later transferred to the Dominion Observatory and became responsible for the Time Service and recording of earthquakes.

5 Bateson, Frank, *Paradise Beckons*. Waikanae: Heritage Press, 1989, p. 186.

6 Ibid., p. 204.

CHAPTER 15 ● Eyes on the sky

1 This record was broken in 2013 when the Kepler space telescope discovered Kepler-37b in the constellation Lyra.

2 Eloise Gibson covers the SKA saga in her excellent April 2019 *Newsroom* investigation 'Smears

and Fury in Big Telescope Lobbying', www.newsroom.co.nz/2019/04/15/531143/smears-and-fury-in-big-telescope-lobbying.

CHAPTER 16 ● 'Our lady astronomers'

1 'Our lady astronomers', *Southern Stars*, vol. 13, no. 2, March 1947, p.17–18.

2 Ibid.

3 Overbye, Dennis, 'Overlooked No More: Beatrice Tinsley, astronomer who saw the course of the Universe', *New York Times*, 18 July 2018; retrieved from www.nytimes.com/2018/07/18/obituaries/overlooked-beatrice-tinsley-astronomer.html; accessed 2 May 2019.

4 Catley, Christine Cole. Bright Star: Beatrice Hill Tinsley, astronomer. Auckland: Cape Catley, 2006, p.245.

CHAPTER 17 ● Sparking interest

1 Today, Nainoa Thompson is president of the Polynesian Voyaging Society, and in 2017 he was a recipient of the Explorers Club medal, the most prestigious honour in exploration. Piailug also inducted him into *ppwo*, a sacred ritual of the Caroline Islands in Micronesia, through which navigation students become master navigators. Piailug was the last person to go through *ppwo* in 1951, and then, as the influence of Westernisation and missionaries took hold on the Caroline Islands, the practice disappeared. Decades later, when Piailug resurrected it, one of the honorees was Sir Hector Busby.

2 Turei, Peter (director), *Kupe: Voyaging by the stars*. Wellington: Nimrod Films, 1993.

3 Ibid.

4 Kim Griggs, 'NZ unveils Stonehenge replica'. BBC News, 14 February 2005. The metaphor of standing on the shoulders of giants, to convey the meaning of building on discoveries that have come before, has been traced to the twelfth century but is most popularly remembered as being written by Sir Isaac Newton in a letter to rival Richard Hooke (later to become his enemy). He wrote: 'If I have seen further [into the universe] it is by standing on ye shoulders of Giants.'

5 Kim Griggs, 'NZ unveils Stonehenge replica'. BBC News, 14 February 2005. The metaphor of standing on the shoulders of giants, to convey the meaning of building on discoveries that have come before, has been traced to the twelfth century but is most popularly remembered as being written by Sir Isaac Newton in a letter to rival Richard Hooke (later to become his enemy). He wrote: 'If I have seen further [into the universe] it is by standing on ye shoulders of Giants.'

Further reading

BOOKS AND ARTICLES

Bateson, Frank, *Paradise Beckons*. Waikanae: Heritage Press, 1989.

Beaglehole, John, *The Life of Captain James Cook*. Wellington: A. & C. Black, 1974.

Best, Elsdon, *The Astronomical Knowledge of the Maori, Dominion Museum Monograph No. 3*. Wellington: Government Printer, 1922.

Blow, Graham, and Stan Walker, *An Encounter with Halley's Comet, 1985–86*. Auckland: Wilson & Horton, 1985.

Britton, Tui R., and Duane W. Hamacher, 'Meteors in the Māori Astronomical Traditions of New Zealand', *Journal of the International Meteor Organization*, June 2013.

Campbell, Hamish, Richard Hall, Peter Adds, Duncan Steel, Anne Salmond, Paul Callaghan and Marilyn Head, *The Transit of Venus: How a rare historical alignment changed the world*. Auckland: Awa Press, 2007.

Catley, Christine Cole, *Bright Star: Beatrice Hill Tinsley, astronomer*. Auckland: Cape Catley, 2006.

Chadwick, Stephen Robert, and Martin Paviour-Smith, *The Great Canoes in the Sky: Starlore and astronomy of the South Pacific*. Berlin & Heidelberg: Springer, 2016.

Clark, Stuart, *The Sun Kings: The unexpected tragedy of Richard Carrington and the tale of how modern astronomy began*. Princeton, NJ: Princeton University Press, 2007.

Couper, Heather, and Nigel Henbest, *The Story of Astronomy: How the universe revealed its secrets*. London: Hachette, 2011.

Dillard, Annie, 'Total Eclipse', in *Teaching a Stone to Talk*. New York: HarperCollins, 2013.

Dodds, K., and K. Yusoff, 'Settlement and Unsettlement in Aotearoa/New Zealand and Antarctica'. *Polar Record*, no. 41 (2005), pp. 141–155.

Galfard, Christophe, *The Universe in Your Hand*. London: Pan Macmillan, 2016.

Gilmore, Gerard, 'Alexander William Bickerton: New Zealand's colourful astronomer', *Southern Stars*, no. 29 (March 1982), pp. 87–108.

Hall, Richard, *How to Gaze at the Southern Stars*. Wellington: Awa Press, 2004.

———, *Stonehenge Aotearoa: The complete guide*. Wellington: Awa Press, 2005.

Harris, Pauline, 'Revitalising Māori Astronomy and Inspiring our Next Generations: Māori astronomy, modern astrophysics, and bridging the divide', proceedings of the Third International Starlight Conference, Lake Tekapo, June 2012.

Harris, Pauline, Rangi Matamua, Takirirangi Smith, Hoturoa Kerr and Toa Waaka, 'A Review of Māori Astronomy in Aotearoa–New Zealand', *Journal of Astronomical History and Heritage*, vol. 16, no. 3 (November 2013), pp. 325–336.

Hearnshaw, John, and Alan Gilmore, *Mt John: The first 50 years*. Christchurch: Canterbury University Press.

Hyde, Vicki, *Night Skies above New Zealand*. Auckland: New Holland, 2003.

King, Michael, *The Penguin History of New Zealand*. Auckland: Penguin, 2003.

Kraus, Louis J., 'Human and Environmental Effects of Light Emitting Diode (LED) Community Lighting'. American Medical Association (AMA) Council on Science and Public Health, report 2-A-216; http://darksky.org/wp-content/uploads/bsk-pdf-manager/AMA_Report_2016_60.pdf ; retrieved from https://docs.wixstatic.com/ugd/e9e6f8_8180d2775620479b99742d9f558ad4d0.pdf.

Leather, Kay, and Richard Hall, *Work of the Gods: Tātai Arorangi: Māori Astronomy*. Paraparaumu: Viking Sevenseas, 2004.

Lomb, Nick, *Transit of Venus: 1631 to the present*. New York: The Experiment, 2012.

McFarlane, Turi, 'Māori Associations with the Antarctic: Tiro o te Moana ki te Tonga', University of Canterbury Graduate Certificate in Antarctic Studies, 2007/08

Mackrell, B., *Halley's Comet over New Zealand*. Auckland: Reed Methuen, 1985.

Matamua, Rangi, *Matariki: The star of the year*. Wellington: Huia, 2017.

Matamua, R., P. Harris and Hoturoa Kerr, 'Māori Navigation', in 'Maramataka Māori'. Society of Māori Astronomical Research and Traditions publication, www.maoriastronomy.co.nz.

Moore, Patrick, *Stars of the Southern Skies*. Auckland: David Bateman, 1994.

Orchiston, Wayne, *Exploring the History of New Zealand Astronomy: Trials, tribulations, telescopes and transits*. Berlin & Heidelberg: Springer International Publishing, 2016.

Overbye, Dennis, 'Overlooked No More: Beatrice Tinsley, astronomer who saw the course of the universe, *New York Times*, 18 July 2018.

Parsonson, G.S., 'The Settlement of Oceania: An examination of the accidental voyage theory', *Journal of the Polynesian Society*, vol. 71 (1962), pp. 11–63.

Priestley, R., *The Awa Book of New Zealand Science*. Wellington: Awa Press, 2008.

Sobel, Dava, *Longitude: The true story of a lone genius who solved the greatest scientific problem of his time*. London: Walker, 1995.

Somerville-Ryan, Gendie, and Richard, and Nalayini and Gareth Davies, *Sanctuary: Aotea/Great Barrier Island International Dark Sky Sanctuary*. Gendie and Richard Somerville-Ryan, 2017.

Southern Stars: The journal of the Royal Astronomical Society of New Zealand. Auckland: Starman Productions, 2005.

Taylor, Paul, *Naked Eye Wonders: A short guide to the stars as seen from Aotearoa New Zealand*. Auckland: Starman Productions, 2005.

Tobin, William, *Stars in a Cluster*. Christchurch: Dept of Physics and Astronomy, University of Canterbury, 1996.

Warner, Lionel, *Stars and Planets of the Southern Hemisphere*. Auckland: A. H. & A. W. Reed, 1978.

WEBSITES AND VIDEO

Matamua, Rangi, Living by the Stars, www.facebook.com/livingbythestars.

New Zealand Astronomy Directory, www.nzastronomy.co.nz.

Ngā Whetū Resources, www.ngawhetu.nz.

Royal Astronomical Society of New Zealand, www.rasnz.org.nz.

Royal Astronomical Society of New Zealand Education Group, www.astredu.nz.

Turei, Peter (director), *Kupe: Voyaging by the stars*. Wellington: Nimrod Films, 1993.

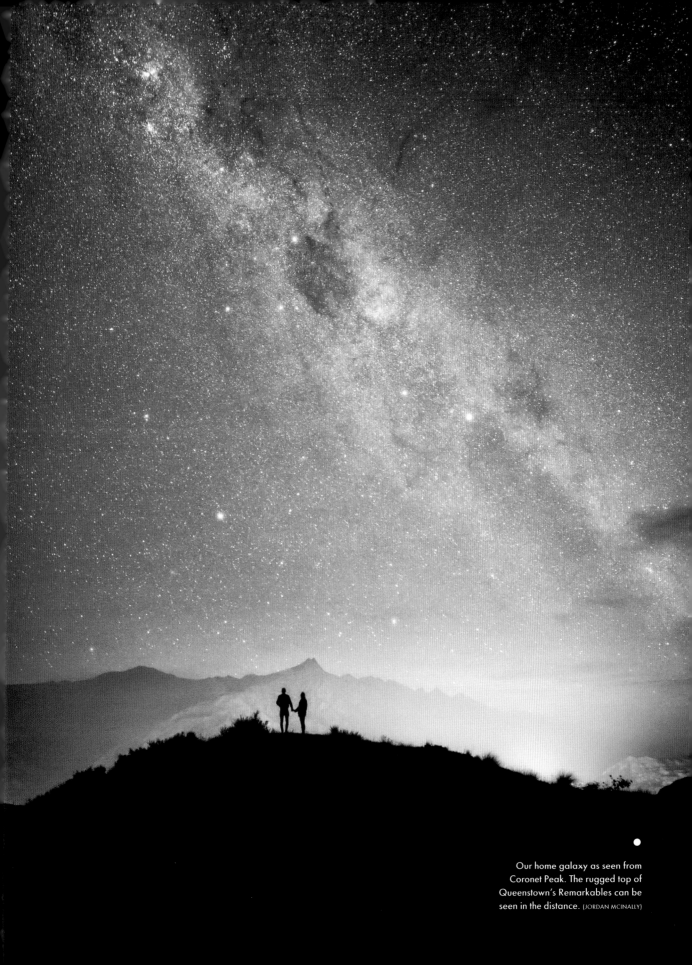

Our home galaxy as seen from Coronet Peak. The rugged top of Queenstown's Remarkables can be seen in the distance. (JORDAN MCINALLY)

Acknowledgements

Thank you, Dr John Hearnshaw and Dr Rangi Matamua, for your expertise and great generosity in sharing your knowledge and reading versions of this text, though any remaining mistakes are entirely mine.

Thank you to University of Auckland PhD student Darcey Graham for proofing this text.

Thank you to the Surrey Hotel, Steve Braunias, Madeline Chapman and The Spinoff for the 2018 Surrey Hotel Steve Braunias Memorial Writers Residency Award in Association with The Spinoff fellowship, which gave me four days to work on this book at Grey Lynn's Surrey Hotel.

Thanks to Scott Forbes, Matthew Turner and Alex Hedley for your work in shaping this book.

Thank you, Hinemoana Baker, Kate Evans, Michelle Langstone and Adam Roberts, for your support and eyes on the text.

Thank you to my journalism editors for extended deadlines and patience while this was written, and rewritten.

For moral and professional understanding and support, thank you, Lora Bailey, Fergus Barrowman, Aimie Cronin, Kimberley Davis, Eloise Gibson, Michelle Duff, Beck Eleven, Lauren Fletcher, Holly Hunter, Kirsty Johnston, Andrew Macdonald, Kirsten McDougall, Anke Richter, Samuel McGlennon, Felicity Mountfort, Kate Newton, Clare North, Skye Patterson-Kane, Anna Pearson, Jesse Bray Sharpin, Haidi

Spence, Susan Strongman, Sarah Wilson, Ashleigh Young, and stellar booksellers Thomas Koed and Stella Chrysostomou at Volume Nelson.

I am indebted to Margaret and Brian Jameson, Mala Miller and Sam Sachdeva for accommodation during spells in Wellington.

Thank you to Great Barrier Island folk Anne Marie and Paul McGlashan, Caroline Leys, David and Gendie Somerville-Ryan, Rodger Jack, Loma Cleave, Good Heavens's Deborah Kilgallon and Hilde Hoven, and Nicola MacDonald and Cat Munro for hosting me at Orama Oasis and for island astronomy discussions. Thank you to astrophotographers Jack Burden, Mark Gee, Tamzin Henderson, Talman Madsen and Rachel Stewart for sharing your passion.

Thank you, Richard Hall and Kay Leather, for kindly showing me Stonehenge Aotearoa.

Thank you to the staff of Ngā Taonga; the Alexander Turnbull Library, Wellington; Earth & Sky, Tekapo; and Archives New Zealand.

This project was made more manageable by the decades of painstaking, meticulous research compiled by astronomical historians Wayne Orchiston and John Hearnshaw in countless papers and publications, as well as the many patient media discussions held by Alan Gilmore and other astronomer contributors to Radio New Zealand. Thank you.

Thank you for all the hard work done by the daily journalists who record and write about our world, upon whom I've relied for this book – and, in fact, upon whom we all rely for our first and subsequent drafts of history. We are all in your debt.

Thank you, Rebekah White – this and much else would not exist without you.

Finally, thank you, Doug Brooks, for your deep astronomical knowledge and passion, and for everything else.

HarperCollins*Publishers*
First published in 2019
by HarperCollinsPublishers (New Zealand) Limited
Unit D1, 63 Apollo Drive, Rosedale, Auckland 0632, New Zealand
harpercollins.co.nz

HarperCollins*Publishers*
Unit D1, 63 Apollo Drive, Rosedale, Auckland 0632, New Zealand
Level 13, 201 Elizabeth Street, Sydney NSW 2000, Australia
A 53, Sector 57, Noida, UP, India
1 London Bridge Street, London, SE1 9GF, United Kingdom
Bay Adelaide Centre, East Tower, 22 Adelaide Street West, 41st floor,
Toronto, Ontario M5H 4E3, Canada
195 Broadway, New York NY 10007, USA

A catalogue record for this book is available from the
National Library of New Zealand.
ISBN: 9781775541288 (hardback)

Layout and cover design by Megan van Staden
Front cover image: Milky Way over Cable Bay, Nelson, by Mark Gee/The Art of Night
Back cover image: Aurora over Southland by Stephen Voss
Author photograph by Virginia Woolf

Printed and bound in China by RR Donnelley

6 5 4 3 2 21 22

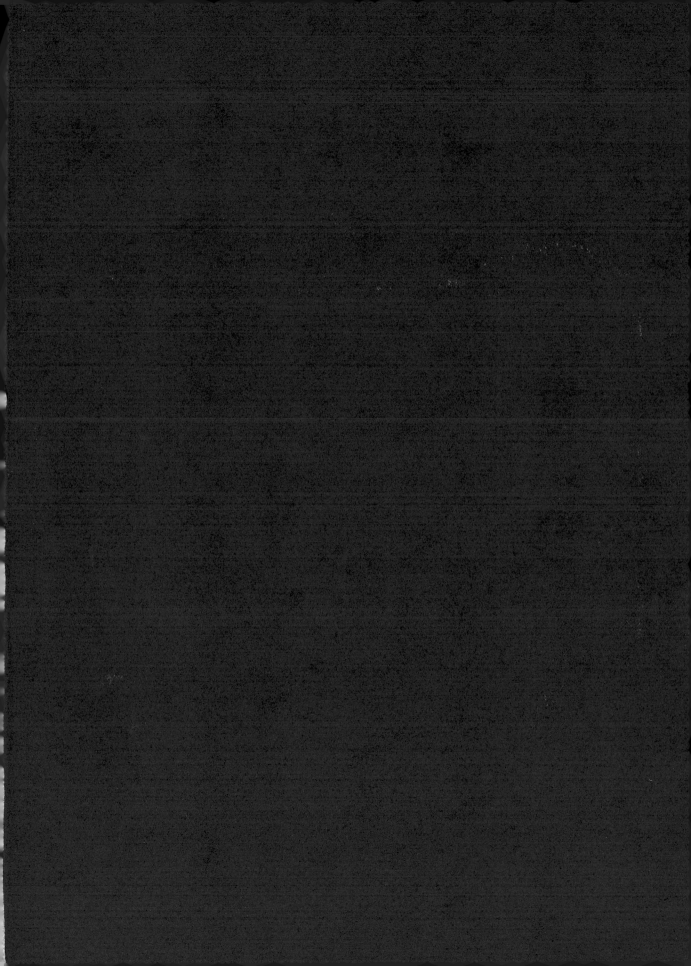